PRAISE FOR
WAKING GIANT

"A lively account of the battles in which Jackson's political and economic democracy ultimately prevailed over the old establishment represented by John Quincy Adams. . . . Reynolds devotes close to half the text to an illuminating appreciation of the Jacksonian influence on literature and art, with shorter discussions on religion and popular fads."

—*The Boston Globe*

"As David Reynolds shows in his astute and concise history of the period, *Waking Giant*, the times defined Jackson as much as he defined the times."

—*Slate*

"This Bancroft Prize winner weaves a richly suggestive picture of the period's fascinating social and intellectual history. . . . The result: The whiplash changes and conflicts in the nation's mores and morals come alive in a well-paced, entertaining narrative."

—*American History Magazine*

"Excellent. . . . Outstanding. . . . Expansive. . . . Jackson and his presidency figure large in Reynolds's account. But he reserves equal space for the era's great evangelical and reform movements, its fads and inventions, its growing partisan and regional divisions as the country drifted toward civil war, and its burgeoning sense of 'manifest desti̶ ̶ ̶ ̶ ̶ ̶ ̶ ̶ ̶ ̶ ̶ ̶ ̶ ̶ ̶ ̶ ̶o Florida and Texas, int̶ ̶ ̶ ̶ ̶ ̶ ̶ ̶ ̶ ̶ ̶ ̶ ̶ ̶ ̶ ̶ ̶ ̶ es now part of the Unite̶ ̶ ̶

—̶ ̶ ̶ *̶lelphia Inquirer*"

"*Waking Giant* is a pioneering look at one of the most important unaddressed problems in American historiography—how society and culture influenced politics. . . . Recent narratives of the Jacksonian period have focused on the era's politics at the expense of the culture. In contrast, *Waking Giant* enthusiastically embraces the era's 'bumptious, nonconformist, roistering elements, its oddities and cultural innovations.' . . . Reynolds writes history as entertainingly as anyone out there, and *Waking Giant* is no exception."

—*The Providence Journal*

"An engaging new book. . . . Some of the best chapters of *Waking Giant* explore the influence of President Andrew Jackson, a rough-hewn man of the people who managed to lead despite his well-deserved reputation as a thin-skinned brawler who never met an insult he wouldn't really like to kill someone over. . . . *Waking Giant* is at its most entertaining when Reynolds sifts through the nonpolitical world, tracking the rise of abolitionists, feminists, utopians, union leaders, and more than a few crackpots."

—*The Christian Science Monitor*

Waking
Giant

Waking Giant

AMERICA IN THE AGE OF JACKSON

→ David S. Reynolds ←

HARPER PERENNIAL

NEW YORK • LONDON • TORONTO • SYDNEY • NEW DELHI • AUCKLAND

HARPER ⬤ PERENNIAL

FIRST HARPER PERENNIAL EDITION PUBLISHED 2009.

Designed by Emily Cavett Taff

The Library of Congress has catalogued the hardcover edition as follows:
Reynolds, David S.
 Waking giant : America in the age of Jackson / David S. Reynolds.—1st.ed.
 xi, 466 p. : ill. ; 24 cm.
 Includes bibliographical references (p. [419]–435) and index.
 ISBN 978-0-06-082656-7
 1. Jackson, Andrew, 1767–1845—Influence. 2. United States—History—
1815–1861. 3. United States—Politics and goverment—1815–1861. 4. United
States—Social conditions—To 1865. I. Title.
E338.R38 2008
973.5 22 2007051751

ISBN 978-0-06-082657-4 (pbk.)

09 10 11 12 13 WBC/RRD 10 9 8 7 6 5 4 3 2 1

To my wife, Suzanne Nalbantian Reynolds

Contents

List of Illustrations

Prologue

The years from 1815 through 1848 were arguably the richest in American life, if we view the whole picture of society, politics, and culture. The United States moved rapidly toward its eventual place as the world's major power. Through treaties and the Mexican War, it gained vast western territories extending across the continent all the way to the Pacific Ocean. Its population nearly tripled, surpassing twenty-two million by 1848. Expansion was fanned by an intense nationalism that gave rise to Manifest Destiny, the phrase coined in John L. O'Sullivan's *Democratic Review* that expressed the nation's determination to move westward and spread democracy. The Monroe Doctrine solidified America's place in the Atlantic, and the so-called Tyler Doctrine extended it in the Pacific.

Although the United States remained mainly agricultural, the growth of its cities far outpaced the rise of its rural population. Much of the urban surge came from immigration. By the late 1840s, over two hundred thousand Europeans arrived each year, the bulk of them Irish, with many others from Germany, England, and elsewhere. The influx of foreigners created a polyglot society but also provoked a backlash that lay behind an outpouring of anti-Catholic literature and nativist political movements.

Protestantism saw tremendous growth in evangelical denominations as well as in numerous sects, cults, prophets, and reform movements aimed at improving society. Cultural flowering brought a renaissance in literature and art. Some of America's greatest authors—including Ralph Waldo Emerson, Henry David Thoreau, Edgar Allan Poe, and Nathaniel Hawthorne—date from this period, as do

several of its finest painters, such as Thomas Cole, Asher B. Durand, and George Caleb Bingham.

Scientific progress bred a host of inventions, most notably the railroad, the telegraph, improved steam travel, the mechanical reaper, the revolver, the sewing machine, anesthesia, and photography. In the long run, these and other inventions proved immensely important, but it took time for their full economic repercussions to be widely felt; claims that a transportation and communications "revolution" transpired before 1850 are easily overstated.

How about the economy as a whole? Did a so-called market revolution occur that carried the nation from a bygone subsistence economy to a capitalist one? Some argue that the market economy had a destructive effect, bringing alienation, isolation, and dehumanization. Others suggest that it nurtured progress and human rights.

Revolution is again too dramatic a word to describe the changing economy. But there was an accelerated shift toward capitalism that had both positive and harmful effects. Although this shift contributed to broadening prosperity and a healthy growth in the GNP, it also worsened class divisions and exacerbated the tensions that led to the Civil War. These tensions centered on slavery but cannot be separated from economics or culture.

Debates still swirl around the period's central figure, Andrew Jackson, who rose to fame in 1815 at the Battle of New Orleans and later served two terms as president, aggressively defending average Americans against moneyed institutions. Was Jackson good or bad for America? A savior of the people or a reckless autocrat? Democracy's champion or a lawbreaking white supremacist? This book suggests that Jackson had many deep flaws, but that there was also much to admire about him, including his strengthening of presidential power essential to maintaining the American Union in a time of escalating sectional crises. His shortcomings reflected his era, as did those of other great leaders, from Jefferson to Lincoln. But understanding Jackson, perhaps more than most leading Americans of his time, requires an ability to

resist either vilification or veneration, to see the man whole—his failings as well as his successes.

Jackson was the main catalyst behind the growth of a viable two-party system, a defining feature of American democracy. His supporters, the Democrats, successfully presented themselves as champions of the working class and became ardent promoters of westward expansion. His opponents, the Whigs, emphasized scientific advance, improvements in infrastructure, and an economy guided by centralized institutions. Although it is tempting to side retrospectively with either the Democrats or Whigs, as some have done, it is important to recognize that both parties had a major impact on politics, economics, and culture.

Jacksonian America was a place of turbulence and excess. Its youthful vigor gave rise to brashness and a sense of experimentation. Most overviews of the period slight its bumptious, nonconformist, roistering elements, its oddities and cultural innovations—its Barnum freaks, crime-filled scandal sheets, erotic pulp novels, frontier screamers, mesmeric healers, half-mile-long paintings; its street-fighting newspaper editors, earth-rattling actors, incarcerated anarchists; its free-love communes, time-traveling clairvoyants, polygamous prophets, and table-lifting spirit-rappers—all of which created social ferment and provided fodder for energetic American literary and artistic masterpieces.

These phenomena, usually relegated to the fringe, actually characterized the unfettered, individualistic spirit fostered by small government and a zest for expansion. Such excess was visible not only in the general culture but in leading figures—in Jackson, bullet-riddled from brawls and duels; in Henry Clay, a gambler, duelist, and drinker; in John Randolph of Roanoke, the eccentric Virginian who guzzled alcohol as he harangued in the Senate; in a writer such as Poe, who dismissed the era's reformers as "*Believers in everything Odd*" but was himself the oddest figure of all. The period's favorite slang expression spoke volumes: *Go ahead!*

By 1848, with its victory in the Mexican War, the United States stretched from sea to shining sea. Over the previous four decades it had witnessed the rise of large cities, vibrant religious and reform movements, original thinkers and artists—as well as a popular, if controversial, president, whose policies, leadership, and emerging democratic outlook would properly give the era its name.

But the nation was left with a giant problem that only a devastating war would resolve.

1

Forging a National Identity

The United States emerged from the War of 1812 battered but confident. "The Star-Spangled Banner," written late in the war by the poet-lawyer Francis Scott Key, caught the nation's mood of cockiness in the face of ordeal, with its words about the American flag waving proudly in "the rockets' red glare, the bombs bursting in air."

The war had been hard militarily for America but had produced its share of stars, including William Henry Harrison, who had defeated British and Indian forces in the Northwest; Oliver Hazard Perry, with his inspiring victory on Lake Erie; and, above all, Andrew Jackson, who had overwhelmed rebellious Indians in the South before rebuffing a British invasion of New Orleans in January 1815.

Jackson at New Orleans boosted the nation's morale, reviving the spirit of 1776. His ragtag army compensated for America's lackluster performance through much of the war by defeating the world's greatest military power. Jackson himself, already known as Old Hickory for his toughness in battle, earned another nickname as well: The Hero. At forty-seven, Jackson cut an imposing figure in the saddle. Wiry and ramrod straight—he never weighed more than 145 pounds despite his six-foot frame—he had a look of severe earnestness, with gray hair that formed a V on his forehead and swept upward from his gaunt, weather-beaten face.

The son of Scotch-Irish immigrants, Jackson had been raised in

the backcountry of South Carolina, where he received a haphazard education. During the Revolution he joined the patriots in the Battle of Hanging Rock and was taken captive. A British officer whose boots he refused to polish slashed him with a sword, leaving his head and his left hand scarred for life. He inherited money from his grandfather but wasted it on loose living. Impoverished, he studied the law—without reading a law book completely through, it was said—and was admitted to the bar, moving west to serve as a public prosecutor in Tennessee. He was married in 1791 to Rachel Donelson Robards, who mistakenly believed she had won a legal divorce from her first husband. Two years later a divorce was finalized, and he and Rachel were remarried; but they never escaped insults about allegedly having lived in adultery.

Jackson served briefly as Tennessee's first congressman and then as a U.S. senator, but, disillusioned by the Washington scene, he abandoned politics, opting for a career in the law and the military. Financial success allowed him to establish the Hermitage, a plantation near Nashville on which he raised cotton and bred racehorses. He had bought his first slave in 1788 and in time owned 150 chattels. He treated his slaves with paternal kindness but responded savagely to disobedience, as when he ran a newspaper ad offering $50 for a runaway slave "and ten dollars extra for every hundred lashes any person will give to the amount of three hundred."

Level-headed but tempestuous, Jackson followed the South's code of honor, answering insults with violence. He attacked one enemy with a cane, battered another with his fists, and participated in a street gunfight that left him with a lead ball in his shoulder.

He also engaged in three duels. His 1806 duel to the death with the Nashville lawyer Charles Dickinson typified his attitude of Southern machismo. The duel originated in an obscure affront to Jackson involving a horse race and an insult about Rachel. Jackson challenged Dickinson to a duel with pistols, and the two met on a field, standing eight paces apart. Dickinson, an expert marksman, fired first. His bullet en-

tered Jackson's chest, shattering two ribs and settling close to the heart. Because of Jackson's loose overcoat, Dickinson did not see the wound and, astonished, assumed that he had missed his foe. Although Jackson was bleeding profusely under his coat, he fired back. "I should have hit him," Jackson later boasted, "if he had shot me through the brain." Jackson's bullet ripped through his opponent's bowels, leaving a gaping wound. Dickinson died in a few hours. Although for the rest of his life Jackson suffered from abscesses caused by the bullet in his chest, he kept the pistol with which he had killed Dickinson, showing it off and recounting details of the duel.

In the War of 1812, Jackson served as a U.S. army colonel and a major general in the Tennessee militia. A competent but not brilliant strategist, he proved himself a potent killing machine. He led a series of strikes on hostile Creek Indians that culminated in the Battle of Horseshoe Bend, which resulted in the deaths of some eight hundred Indians. Having defeated the Creeks, he forced on them a treaty by which they turned over to the United States more than twenty million acres of their land, including large sections of Alabama and Georgia.

Jackson next drove allied Spanish and British forces out of Pensacola, Florida, before proceeding to New Orleans, which was threatened by a fleet carrying more than ten thousand British redcoats. He cobbled together a small force of army regulars, militiamen, Choctaw Indians, liberated Haitian slaves, and Baratarian pirates. A series of skirmishes against the British led to the major encounter at Chalmette, Louisiana, on January 8, 1815. Jackson's troops, protected by a wall of earth, wood, and cotton bales, fired at will on the swarming redcoats, who had forgotten to bring the ladders they needed to scale the American ramparts. By the time the battle ended, nearly two thousand British had been killed, wounded, or captured, compared to about sixty of Jackson's men.

The American victory at New Orleans had tremendous repercussions. The Treaty of Ghent, ending the war with England, was not finally ratified until February 1815. Had the British won the Battle of New Orleans, they would have been in a position to claim the southern

Mississippi River Valley, which, combined with their holdings to the north, would have given them virtual control over large portions of America's vast western territory.

Jackson's triumph inspired the war-weary nation. "ALMOST INCREDIBLE VICTORY!" crowed a Washington newspaper. "This Glorious News . . . has spread around a general joy, commensurate with the brilliance of this event, and the magnitude of our Victory." Patriotic illustrations of the battle proliferated through the rest of the century, many of them picturing Andrew Jackson on horseback in the midst of battle scenes.

The war had forged a true democratic hero, who went on to become the first American president from a nongentry background, the first not born in either Virginia or Massachusetts, and one who seemed driven by deep passions. "His temperament was of fire," wrote a contemporary, "always more attractive than one of marble."

The war also stimulated democracy by finishing off the Federalist Party. Anglophile and elitist, the New England–based Federalists had opposed the war at every turn. Five New England states sent representatives to a secret convention held in Hartford, Connecticut, from December 15, 1814, to January 4, 1815, to protest the war and discuss the possibility of New England's secession from the Union. The war's end nullified the convention's arguments. Federalism was dead as a national force. The Democratic-Republican Party now stood alone on the political landscape.

Although the war had cost some $200 million and had resulted in nearly seven thousand American casualties, it renewed confidence that the United States could stand up to a strong foreign power. Sparked in part by War Hawks like John C. Calhoun and Henry Clay, it fed the expansionist impulse by securing the West and winning new territory from Indians. Between 1816 and 1819, the rush to the frontier resulted in the admission of four new states into the Union: Indiana, Illinois, Alabama, and Mississippi. The population of the Mississippi River

Valley nearly doubled in the decade after 1810, as easterners moved west in what was known as the Great Migration.

★ ★ ★ ★

ALTHOUGH AMERICA WAS STILL mainly agricultural, it was inching toward capitalism and industrialism. Thomas Jefferson had envisaged a nation of self-sufficient yeoman farmers. The agrarian dream was kept alive by a small number of so-called Radicals like Nathaniel Macon of North Carolina and the Virginians John Randolph and John Taylor, who opposed the rising commercial interests. But the pursuit of economic prosperity directed the nation toward business and commerce.

Even the Democratic-Republican Party, founded by Jefferson in opposition to Alexander Hamilton's nationalistic economic program, now supported tariffs, a national bank, and internal improvements. The federal government's active involvement in the economy gave rise to the so-called American System, introduced by the Kentucky statesman Henry Clay.

Few dominated the political landscape of early-nineteenth-century America more than Clay. Born and raised in Hanover County, Virginia, Clay had only three years of formal education but through brilliance and charisma gained early success as a lawyer in Lexington, Kentucky, before moving on to politics. Repeatedly elected either to the U.S. Senate or the House of Representatives, he went on to serve as Secretary of State under John Quincy Adams, and he ran for the presidency three times.

Slender and loose-limbed, with long arms and an ambling gait, Clay had a plain but expressive face, with a broad forehead, curved nose, beady blue eyes, and pale lips that stretched in a long, thin line, making it hard for him to whistle or spit tobacco juice. Although he could be domineering and supercilious, he had a puckish smile and radiated charm. In 1792 he married the Lexington socialite Lucretia Hart, as homely and amiable as he. He enjoyed the company of women and was a shameless flirt, though

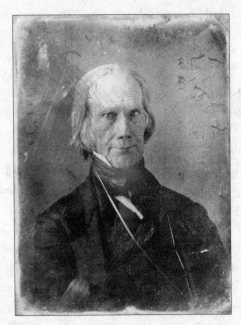

Henry Clay

there was no evidence to support the oft-made charge that he was unfaith-
ful to Lucretia. He loved gambling, tippling, quick repartee, and off-color
stories. His charm was indicated by many of his nicknames, such as Gal-
lant Harry of the West, the Cock of Kentucky, the Western Hotspur, the
Mill-Boy of the Slashes, and the Sage of Ashland.

In typical Southern fashion, he engaged in two duels, one that left
him with a thigh wound and another that merely damaged the clothing
of his opponent.

Clay's mercurial moods contrasted with his consistency of political
purpose. From 1815 onward, his economic plan centered on a national-
istic agenda. Prosperity, he argued, depended on the federal govern-
ment's strong guidance of the economy.

His ideas got an appreciative hearing in the nationalistic atmosphere
after the War of 1812. President Madison not only enacted a protective

tariff (raising duties above what was necessary for government revenue in order to protect certain industries and agricultural producers) but also helped to revive the Bank of the United States and supported internal improvements such as roads and canals.

England inadvertently nurtured American factories with a trade embargo during the war and then threatened them after it by dumping surplus textile and iron goods on the American market. Trying to shield fledgling businesses from foreign competition, the Madison administration in 1816 imposed a heavy duty on many imported goods. Although the Tariff of 1816, America's first protective tariff, seems to have had minimal economic impact, it was symbolically important. It signaled the federal government's intervention in the economy, as did the revival of the Bank of the United States (BUS).

The charter for the First BUS having expired in 1811, Madison in 1816 signed a bill for a twenty-year charter for the Second BUS, headquartered in Philadelphia. Attitudes toward the BUS had reshuffled due to the changing economy. Because the war had created runaway inflation in the South and West by draining specie (silver and gold) reserves and flooding those regions with paper notes, the formerly antibank spokesmen Clay of Kentucky and Calhoun of South Carolina now promoted the BUS, which they thought would stabilize currency there. Meanwhile, the New Englander Daniel Webster opposed the bank he had once endorsed, because of the relatively healthy economy of his section.

The other plank of Clay's American System, internal improvements, got a boost during the Madison administration. Madison and his successor, James Monroe, praised such projects, which they saw as crucial to national growth and unity. Both hoped for constitutional amendments that would broaden the federal government's scope in funding beneficent improvements. Madison emphasized in 1815 "the great importance of establishing throughout our country roads and canals which can be best executed under national authority," noting that new transportation would succeed in "binding more closely together the various parts of our extended confederacy."

Transportation improvements occurred in three main phases: The period between 1790 and 1810 brought construction of common roads that continued in later years. Robert Fulton's steamboat voyage in 1807 and the beginning of work on the Erie Canal in 1818 triggered steamboat progress and canal building from 1811 to 1830. And John Stevens's demonstration in New Jersey of a steam locomotive in 1826, followed by the opening of the Baltimore and Ohio Railroad, initiated three decades of railroad growth.

Transportation changes fed the movement toward a capitalist economy, which gained momentum in the opening decades of the nineteenth century. The subsistence economy of the past, in which most Americans lived on what they produced on their own land, shifted toward a market economy, in which goods were produced, sold, and bought outside the home. Economic development and westward migration were closely linked to transportation of goods and people.

Early roads in America were little more than wide dirt paths that became mud in the winter and spring and dust in the summer and fall. But by 1815 a number of major road projects were under way. The Cumberland Road, soon called the National Road, was the nation's first federally funded road and the first to use the new surface developed by the Scottish engineer John Loudon MacAdam. Consisting of stones compacted for toughness and graded for drainage, this surface, known as macadam (or, when tar was later added, tarmac), dramatically increased the long-term usability of roads.

Construction of the National Road began in Washington, D.C., in 1811 but was interrupted by the war, resuming in 1815. Soon the road stretched to Cumberland, Maryland. By 1818 it reached Wheeling, Virginia, and eventually it ran all the way to Vandalia, Illinois. So many towns sprang up along it that it became known as the Main Street of America, celebrated in popular songs, paintings, and poems. At first a mail route, the National Road became a major artery for trade and travel, fed by other roads from north and south. The federal government

funded the road until 1835, when the states took it over. Its eastern section became a turnpike, or toll road.

Turnpikes, usually state-chartered and privately funded, flourished before 1825. Pennsylvania's Lancaster Turnpike, connecting Philadelphia and Lancaster, opened in 1794, initiating a craze for toll roads. By 1816 turnpikes linked the major cities in the Northeast and formed a roughly continuous line from Maine to Georgia. The state of New York led the way in toll-road construction, followed by Pennsylvania and New England. Although turnpikes were sometimes macadamized, they were usually crude roads, dotted with tree stumps, that forded swamps with so-called corduroy, or sawed logs connected to form a firm but bumpy surface. Every six to ten miles was a tollbooth that charged between ten and twenty-five cents.

Investor optimism fed the turnpike boom. Before 1830, turnpike companies evidently won more state corporate charters than any other kind of private business. But few turnpikes paid off in the long run. They were expensive to build and costly for their users, who frequently avoided paying tolls by traveling when collectors were off duty or by following "shunpikes" around tollbooths. With the rise of canals and railroads, turnpikes became increasingly unattractive for carriers of freight.

More crucial to early commercial development than roads was water travel. Steamboats and canals developed simultaneously, creating a water network that linked America's coasts and oceanic commerce with the ever-growing settlements to the interior. What is now called economic globalization began with advances in water transportation during the two decades after 1815.

Steamboats simplified the movement of both passengers and freight. Introduced on the Delaware River by James Rumsey and John Fitch in 1787, the steamboat became commercially successful in the hands of the American engineer Robert Fulton and his business partner Robert R. Livingston. On August 17, 1807, Fulton sailed a steamboat from New

York City to Albany, 150 miles up the Hudson River. This historic voyage launched the era of steam transportation.

Improvements in steamboats brought increases in speed. The same voyage that Fulton had made in thirty-six hours took a quarter of that time in 1840. Ralph Waldo Emerson remarked, "The Americans would sail in a steamboat built of Lucifer matches, if it would go faster." In the East, steamboats were used mainly for passenger travel. Fulton and Livingston established ferry lines on the Hudson, on the Raritan, in New York Harbor, and on Long Island Sound. In the West, they stimulated commerce by introducing steam travel on the Mississippi River.

Shipping freight on rivers had previously been arduous, limited to sailing vessels or pole-driven flatboats and barges. Upstream passage was especially difficult. Steamboats met the challenge of river currents. As the ease of transporting consumer goods increased, prices began to equalize in different parts of the country.

Although Robert Livingston had helped found steam transportation, a historic legal decision against him created a host of new opportunities for others. In *Gibbons v. Ogden* (1824), the Supreme Court, under Chief Justice John Marshall, ruled that Livingston's monopoly of the ferry business between New York and New Jersey was unconstitutional. By giving federal sanction to competing interstate steamboat companies, this ruling, as one judge commented, "released every creek and river, every lake and harbor in our country from the interference of monopolies." The decision, followed by a series of antimonopolistic state laws, is sometimes referred to today as the Emancipation Proclamation of American Commerce. Movement of people and freight by steamboat increased dramatically.

To be sure, steamboat travel had its problems. Accidents and breakdowns were common. Eastern steamboats averaged ten to fifteen years of active service, and Western ones a mere four to five years. As Mark Twain would record in *Life on the Mississippi*, navigating rivers involved unending vigilance for snags and sandbars. By 1840, nearly a third of America's steamboats had been lost to accidents. Gamblers and thieves

infested the western steamboats, so that most passengers felt compelled to arm themselves with bowie knives or other weapons. (Herman Melville's portrait of crime and chicanery aboard a Mississippi steamboat in *The Confidence-Man* had roots in real life.) Tobacco juice was sprayed in all directions, and excessive drinking was common on board.

Still, steamboats were hugely successful, and America excelled at building them. Rival companies tried to outdo each other by creating gilt-decorated "floating palaces," with elegant berths, dining areas, and saloons. As one foreign traveler noted, "The finest [steamboats] we have in Europe are much inferior to the smallest, the wretchedest ferry-boat over here."

The economic impact of steamboats was amplified by the rapid expansion of the nation's canal system. As late as 1816, America had just one hundred miles of canals. By 1840, over three thousand miles of canals created a vast transportation network among many settled parts of the country.

By far the most successful canal was the Erie Canal, variously called the Eighth Wonder of the World, the $7 Million Bet that Made America, and the Granary of the World. The idea of a canal to improve east–west commerce had been around a long time. In 1784 George Washington opened the Patowmack Company, aimed at connecting the Potomac River with the West, but the firm went bankrupt.

Building a canal between the Hudson River and the Great Lakes meant hacking through over 360 miles of dense forests that rose through rocky hills. Thomas Jefferson found the idea "little short of madness," declaring that so daunting a project would have to wait a century. Neither he nor his immediate presidential successors were about to commit federal funds to this improbable enterprise.

It was left to the New York politician DeWitt Clinton to make the dream of the great canal a reality. The well-heeled, Columbia-educated Clinton, whose uncle, George Clinton, was James Madison's vice president, was himself a four-term governor of New York, a U.S. senator, and a presidential candidate in 1812. Clinton thought that building a

canal to the Great Lakes was crucial to America's prosperity and unity. He rallied support for it, persuading enough New Yorkers to sign a memorandum that the state legislature allocated seven million dollars to the project.

Construction began on July 4, 1817, near Rome, New York, in a flat region chosen to insure speedy progress in order to silence those who dismissed the canal as "Clinton's Big Ditch" or "Clinton's Folly." Laborers, many of them German or Irish immigrants, toiled for less than a dollar a day. They chopped, cut, and dug their way westward, creating a channel that was twenty-eight feet wide at the bottom and forty feet at the top. A short stretch near Lockport, with cliffs that had to be blasted away, took several years to cross. Many locks, or enclosed sections where water could be raised and lowered, were built at steep places. Aqueducts with waterproof sides carried rivers above the canal.

The Erie Canal opened to tremendous fanfare on October 26, 1825. Dignitaries gathered at Buffalo, where booming cannons and cheering crowds orchestrated the launching of the first fleet of boats headed east through the canal. Aboard one of the boats was DeWitt Clinton along with kegs of Lake Erie water that on November 4 he poured into New York Harbor, celebrating the new passageway between distant continents and America's heartland. Nathaniel Hawthorne wrote of the canal, "In my imagination, De Witt Clinton was an enchanter, who had waved his magic wand from the Hudson to Lake Erie, and united them by a watery highway, crowded with the commerce of two worlds, till then inaccessible to each other."

The canal triumphantly fulfilled its promise. It sharply reduced shipping costs between Albany and Buffalo. Within a year of its opening, more than thirteen thousand boats plied the canal's waters. The canal went on to become the nation's most profitable trade route. Heavily laden barges, hauled by mules on towpaths bordering the canal, transported manufactured goods and farm produce west and east. Wheat production in the West, fueled by the sudden access to eastern markets, grew exponentially. Towns and cities mushroomed along the canal,

whose waters, Hawthorne commented, "must be the most fertilizing of all fluids." Existing communities expanded rapidly. Europeans and New Englanders used the canal as a principal emigration route to the Old Northwest. The population of four northwestern states—Illinois, Indiana, Michigan, and Ohio—quadrupled between 1820 and 1840.

The canal helped New York City become the financial capital of the world. The city also benefited from the creation of a stock exchange in 1817 and, the next year, the founding of the Black Ball Line of sailing ships, which made scheduled voyages to and from Liverpool. Stimulated by the new trade that passed through it, New York's population grew from 126,000 in 1820 to over 800,000 on the eve of the Civil War, when nearly two thirds of America's exports passed through it.

Many other new canals were constructed. New York State soon had, in addition to the Erie Canal, the Oswego, the Chenango, the Cayuga-Seneca, the Champlain, the Delaware and Hudson, and several smaller canals. Other canals nourished the economies of other states. There were two great canals in Ohio, one running between Cleveland and Portsmouth, the other between Cincinnati and Toledo. Pennsylvania's impressive Main Line of Public Works linked Philadelphia and Pittsburgh. Canals were also built in Virginia, Indiana, New Jersey, Maryland, Illinois, and elsewhere.

In time, many canals became losing propositions because of poor choice of sites, strained state budgets, and inefficient construction. Costs of building a canal soared. Many canal projects were ill conceived and did not pay off. Others fell victim to the railroad. But the Erie Canal, enlarged three times and renamed the New York State Barge Canal, continued to prosper, carrying millions of tons of freight as late as the 1950s. Only the building of the New York State Thruway and the St. Lawrence Seaway made it dwindle to what it is today: mainly a recreation area.

The cumulative effect of canals, steamboats, and roads was not only to stimulate the economy but also to enhance national unity. Many viewed internal improvements as a means of binding together a geographically divided nation.

DeWitt Clinton thought the Erie Canal would help save the American Union. "Dismemberment of the Union," he predicted, would not come from "collisions between the north and the south" but from an east-west division, since "the most imminent danger" is "that a line of separation may eventually draw between the atlantic and western states, unless they are cemented by a common, an ever acting and powerful interest." Clinton feared that the western states, as they became autonomous with settlement, might secede from the Union. In order to "avert this awful calamity" of "a dissolution of the union," Clinton argued, "the people should be habituated to frequent intercourse and beneficial inter-communication, and the whole republic ought to be bound together by the golden ties of commerce and the adamantine chains of interest." His canal would "bind the union together by indissoluble ties."

Similarly, John Calhoun, in an 1817 congressional speech on internal improvements, asked, "On the subject of national power, what can be more important than a perfect unity in every part, in feelings and sentiments? And what can tend more powerfully to produce it, than overcoming the effects of distance?"

*　*　*　*

THE ELECTION OF THE Virginia statesman James Monroe as president greatly bolstered this feeling of national unity. In his first inaugural address in March 1817, Monroe affirmed that "the improvement of our country by roads and canals" would "bind the Union more closely together." The new nationalism sprang not only from improved transportation but from the condition of society and politics as a whole. Monroe noted "the increased harmony of opinion which pervades our Union," declaring, "Discord does not belong to our system." Three months later a Boston newspaper announced that Monroe had ushered in "an era of good feelings."

Monroe looked and behaved very differently from the president he succeeded. Whereas Madison (the smallest president in American history) stood five feet five and weighed only a hundred pounds, Monroe

was over six feet tall, with broad shoulders and a massive frame. Monroe, who had frank gray-blue eyes, was plodding and pragmatic, as opposed to Madison, known for his rapid mind and wide-ranging intellect.

Both presidents suffered from physical and psychological debilities. Madison was an arthritic hypochondriac with a vocal impairment and periodic seizures that may have been mental in origin. Monroe, who had a bullet in his shoulder from his days as a Revolutionary soldier, was beset by recurrent malarial fever and some undefined, seemingly stress-related illness.

The two were similar politically. Both had been crucial to the cause of liberty, Madison as an intellectual architect of the Constitution, Monroe as an officer in the American Revolution and a political leader after it. Like two previous Virginian presidents, Washington and Jefferson,

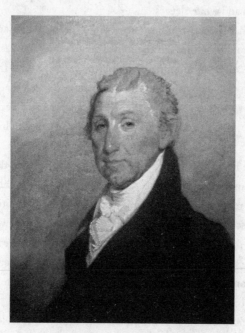

James Monroe, *by Gilbert Stuart*

they not only owned slaves but did so while in office. Both had helped Jefferson shape the Republican Party. Given their political affinities, it is understandable that Madison had chosen Monroe to serve twice in his cabinet, first as secretary of state and then as secretary of war.

Courteous and shy, Monroe was the picture of respectable mediocrity. "Turn his soul wrong side outwards," Jefferson said, "and there is not a speck on it." He was the plain Virginia farmer, likable in his averageness.

Even his odd habit of wearing old-style clothing for public events had a consoling effect on many Americans. Shortly after assuming office, he went on a four-month meet-the-people tour through the North, dressed in his Revolutionary costume of a blue coat trimmed in red, doeskin knee-breeches, buckle-top boots, and a three-cornered soldier's hat with a black ribbon cockade. He left Washington on June 2, 1817, on a barge lined with crimson velvet and propelled by rowers dressed in scarlet vests and white sleeves.

Everywhere he went on his tour—New York, New England, west to Michigan, and back through the mid-Atlantic states to Washington— he was welcomed by dignitaries and crowds. Bland and friendly, he was a soothing holdover from an earlier time. As an observer noted, "He was not a star, but a member of the company, a stock actor, one of themselves. . . . For the first time, the people met their Chief Magistrate as such, and they felt that they were a nation."

Monroe helped lift the nation's self-image by speeding the rebuilding of its capital, which had been destroyed in the war. The executive mansion, a red sandstone structure blackened when the British burned it in August 1814, became known as the White House when refurbished and painted white in 1817 under the direction of a Monroe appointee, the Irish-born architect James Hoban. Monroe selected another architect, James Bulfinch of Boston, to redesign the Capitol building, which was completed in 1826.

Monroe's two terms as president ran from March 4, 1817, to March 4, 1825. Because of the lull in party conflict, he won his second term with

all but one electoral vote. He created a stellar cabinet consisting of erstwhile or future political rivals, among them Secretary of Treasury William H. Crawford, the Georgian states-rights advocate who had competed against him for the presidency in 1816; Secretary of State John Quincy Adams, the improvement-minded ex-Federalist from New England; Secretary of War John C. Calhoun, the proslavery Southerner; and Attorney General William Wirt, the brilliant lawyer from Maryland.

It was long held that this cabinet of prima donnas was mainly responsible for the achievements of Monroe's administrations. Each of them outshone the president in intelligence and talent, and each made important contributions, especially Adams in the area of foreign policy. But recent historians have shown that Monroe was an activist president, directing affairs with methodical steadiness.

Monroe's presidency strengthened nationalism and expanded democracy but also planted seeds of future conflict. Under his watch, America expanded its territory, solidified its position in the world community, and abolished restrictions that had prevented certain white males from voting. At the same time, however, it waged a cruel war against blacks and Indians in Florida, suffered a devastating economic depression, and endured a flare-up over slavery that anticipated the Civil War.

A seasoned diplomat, Monroe had in earlier years been instrumental in securing from Spain navigation rights for U.S. boats on the Mississippi River and in arranging the Louisiana Purchase with Napoléon. In 1816, as Madison's secretary of state, he proposed an agreement with England that would reduce the number of naval vessels left from the war on the Great Lakes and Lake Champlain. Early in his presidency, such an agreement, known as the Rush-Bagot Treaty, was reached, starting a process that resulted in a demilitarized zone between the United States and British North America. In 1818 another treaty with England fixed a large portion of the northwestern boundary between the United States and Canada at the 49th parallel, though it left the Oregon Country in limbo. The Adams-Onís Treaty of 1819 arranged the purchase of Florida from Spain and defined the border between

Mexican and U.S. territory as running up the Sabine River in Texas, northwestward to the Rocky Mountains, and then west to the Pacific Ocean on the 42nd parallel on the southern border of Oregon Country. Also known as the Transcontinental Treaty, this agreement gave America access to the Pacific and stands as a landmark of world history.

John Quincy Adams, comparing the limited map of the nation in the 1780s to the expansive one of the 1820s, declared that "the change, more than any other man, living or dead, was the work of James Monroe." This was an exaggeration, but not by much. There was justification for Monroe's boast in 1821, "The United States now enjoy the complete and uninterrupted sovereignty over the whole territory from St. Croix to the Sabine."

Given Monroe's interest in expanding the nation and defining its borders, it is understandable that he took advantage of an international incident to introduce a principle that would become a cornerstone of U.S. foreign policy.

What came to be known as the Monroe Doctrine, demanding noninterference of foreign nations in the affairs of the two American continents, arose from the issue of how to deal with plans by several European nations—France and Spain, backed by others—to retake South American countries that had rebelled and declared independence from Europe. England wanted to launch a joint operation with the United States to prevent the European incursion. President Monroe, following the advice of Secretary of State Adams, responded by insisting that if any action were to be taken, the United States would take it alone. Neither England nor any other foreign power had any business meddling in the West. As the president announced to Congress in 1823, "The American continents . . . are henceforth not to be considered as subjects for future colonization by any European powers." Although the United States would remain neutral on Europe's existing colonies in the Western Hemisphere, any further European intrusion would be regarded as "the manifestation of an unfriendly spirit toward the United States."

The Monroe Doctrine later became an important component of the nation's self-image, contributing both to isolationism and expansionism. It was affirmed at moments when the United States wanted to flex its muscles in disputes with other nations over territory or influence. Theodore Roosevelt expanded on it to justify U.S. intervention in Latin America. John F. Kennedy cited it during the Cuban Missile Crisis. It was variously reapplied in the war on communism, the Iran-Contra Affair, and the post-9/11 campaign against terrorism.

One facet of President Monroe's program—the winning of Florida from Spain—illustrated the violence often involved in U.S. expansion. The War of 1812 had left Spain in charge of East and West Florida and the Seminole Indians inhabiting much of the territory. After the war, Spanish and British settlers were suspected of inciting the Seminoles against whites living in southern Georgia. Raids and counterattacks broke out between the Seminoles and the Georgians. Meanwhile, the Seminole territory, long a haven for Maroons, was increasingly sought out by fugitive slaves from the South, who added their number to a group known as Black Seminoles.

In December 1817, Monroe sent General Andrew Jackson to police southern Georgia. It's unclear if the president intended Jackson to proceed into Spanish territory, but Old Hickory did so anyway. He crossed the border into Florida with a force of two thousand, the initial federal action in what came to be called the First Seminole War. His army swelling steadily with new recruits, Jackson in April 1818 seized St. Marks and destroyed Seminole and black settlements on the Suwannee River and on Lake Miccosukee. He captured and court-martialed two British traders, Alexander Arbuthnot and Robert Ambrister, for aiding hostile natives. He then ordered their immediate execution despite questionable evidence against them. This action enraged England, where newspapers spewed saber-rattling rhetoric at the United States. The next month, Jackson took the Spanish capital, Pensacola, establishing an interim government that would reign, he said, until Florida's fate was decided diplomatically.

Returning home to Tennessee, Jackson left the Monroe administration in a fix. The international community was outraged, and Monroe, along with everyone in his cabinet except Adams, considered Jackson's takeover of Pensacola an act of war against Spain. But American public opinion supported Jackson. Monroe tried to appease Spain by giving Florida back to it, but in 1819 Spain, recognizing its fragile military position, sold Florida to the United States for $5 million.

A government official restored millions of acres of land to the Seminoles, but the Indians and their black confederates faced a bleak future. In 1821, while Andrew Jackson was serving a brief term as Florida's territorial governor, some of his followers raided a black community near Tampa called Angola. Three hundred blacks were captured; only forty of them were returned to their owners, and the rest disappeared, presumably sold into slavery by their profit-hungry captors. As for the Indians, some retreated to the Everglades, and many others were pushed west to Indian Territories (now Oklahoma) along with other tribes of the American South. It would take two more bloody Seminole Wars to uproot the remaining Florida natives from their ancestral home.

* * * *

THE FATE OF THE Seminoles represented the dark underside of the treatment of Native Americans in general. The two decades after 1818 brought both philanthropic efforts to aid American Indians and political or military ones to displace them.

In 1819, as the First Seminole War ended, the federal government extended a hand to Native Americans by offering to educate them, reflecting Monroe's stated desire to foster "their improvement in the arts of civilized life." Thomas L. McKenney, Monroe's Commissioner for Indian Affairs, established forty schools where missionaries would teach Indians, who were expected to absorb Western customs and religion. McKenney said of the Indians, "their whole character, inside and out; language, and morals, must be changed." America's goal, he added, was

"to civilize the whole [Native American population] (I mean the rising generation, of course) *in a single generation.*" Religious groups such as the American Board of Commissioners for Foreign Missions aided the government's efforts, which proved, at best, only partly successful in winning Indians to Western ways. Growing frustration over the natives' failure to adopt mainstream norms contributed to the fraud, betrayals, and violence that would frequently characterize federal Indian policy for much of the century.

During Monroe's eight years as president, voting rights increased dramatically for white males. The stiff property or taxpaying requirements that had formerly restricted the vote to a small percentage of the nation's population had largely disappeared by the mid-1820s. Federalist establishments crumbled before the rising forces of democracy. Connecticut's so-called Standing Order, a Federalist-Congregationalist autocracy that had long imposed suffrage restrictions based on religion and property, dissolved after 1818, when a more tolerant Reform government took power. Similar limitations on the franchise fell three years later in Massachusetts when open-minded Federalists like Daniel Webster won the day over the old-style Federalism of John Adams, who had held that the vote must be based on property. In New York, the so-called Bucktail wing of the Democratic-Republican Party, led by Martin Van Buren, sparked a revolt against Governor DeWitt Clinton's conservative regime that resulted in an 1821 constitutional convention reducing the voting requirements for white males to a modest taxpaying stipulation that was soon dropped altogether.

The end of the caucus system also spurred democracy. Since the late eighteenth century, many state and national political candidates had been chosen by caucus, or congressional committee. Cronies within state legislatures formed tight-knit groups that selected candidates for office. On the national level, a party caucus in Congress nominated candidates for president and vice president. As late as 1816, nine of the nineteen states still used the caucus, as did Congress, where a Democratic-Republican committee nominated Monroe for president.

Monroe was the last candidate chosen by caucus to win the presidency. The suffrage reform that accelerated during his administration fanned the people's abhorrence of "King Caucus." In the presidential election of 1824, the sole caucus-chosen nominee, William Crawford, fared badly. By then, just six states employed the caucus, and by 1832 only South Carolina did. What Lincoln would call a government "of the people, by the people, for the people" began to emerge as the caucus was replaced by the party convention or popular vote.

There were some spectacular holdouts to suffrage reform. The master-race democracy of the South reached the level of caricature in South Carolina and Virginia, where only a select group of rich slaveholders could vote. In Rhode Island, the old charter granting the vote to the propertied elite, once the most democratic system in the British colonies, had become among the least democratic in the United States. It would take the revolt of the Dorr War in 1844 to initiate a process that opened the franchise in Rhode Island to most white males.

Even more disturbing than these isolated exceptions to expanded voting rights was the deliberate negation of these rights for women and blacks. Women had long been excluded from the political process; New Jersey, the one state that had originally given women the right to vote, withdrew it in 1807. Free blacks, facing ever-worsening racial prejudice, experienced the anguish of first having the vote and then losing it.

At the nation's founding, ten of the thirteen states had allowed free blacks to vote. By the eve of the Civil War, only five of America's thirty states—New Hampshire, Vermont, Massachusetts, Maine, and Rhode Island—did so, and these states contained a tiny fraction of the nation's total free black population. In the interim, one state after another legally excluded blacks from voting. Several states that had originally given blacks the vote, including New Jersey, Maryland, and Connecticut, formally withdrew it before 1820. Other states, such as North Carolina and Pennsylvania, achieved racial exclusion simply by inserting the adjective *white* before *males* in voting regulations. Elsewhere, de facto racial exclusion resulted from harsh new voting requirements for blacks. The same

New York provision of 1821 that rescinded property requirements for white males raised them for blacks, who now had to own at least $250 in property and reside in the state for three years to vote—an impossible dream for the vast majority of the state's forty thousand blacks. As for new states, they denied blacks the franchise from the start. No state that joined the union after 1819 gave blacks the vote.

If free blacks increasingly lost the vote during Monroe's presidency, they also faced the threat of being relocated abroad. Monroe had long advocated colonization, or shipping free blacks to a colony on the west coast of Africa or elsewhere. Monroe was among a group of political leaders—others included Henry Clay, Andrew Jackson, John Randolph, and William Crawford—who met in Washington in January 1817 to found the American Colonization Society. The ACS consisted of two groups from opposite sides of the political spectrum: slave-owners who wanted to solidify slavery by ridding the country of free blacks, who, they feared, might incite slave revolts; and antislavery philanthropists and clergymen who saw colonization as a way of funneling off blacks once they were emancipated from slavery.

Both groups assumed the blacks could not be successfully integrated into American society. One famous slave-owner, Henry Clay, said that because of "unconquerable prejudice resulting from their color, [blacks] never could amalgamate with the free whites of this country." Another, John Randolph, called free blacks "promoters of mischief."

A tenth of the two million blacks then living in America were free persons of color. The prospect of shipping them to Africa was daunting, but the ACS eagerly pursued the goal. At Monroe's urging, Congress in 1819 gave $100,000 to the ACS. The next year, the society's first ship, carrying eighty-eight blacks and three whites, set sail for Sierra Leone. The deaths of the whites and many of the blacks during the voyage did not discourage Monroe, who sent another ship in 1821. In the next decade, over two thousand blacks were relocated to the newly formed African colony of Liberia, whose capital city was named Monrovia in honor of Monroe's contribution to the cause of colonization.

Over time, the achievements of the ACS proved numerically insignificant. By the end of the Civil War, it had managed to deport only around thirteen thousand blacks, a small portion of the total black population during this period. But colonization had vast symbolic importance. As an idea, it had far greater acceptance among prominent Americans than did the radical abolitionism of William Lloyd Garrison. Among notables who endorsed some version of colonization (besides those already mentioned) were Thomas Jefferson, Daniel Webster, John Marshall, Francis Scott Key, Catharine Beecher, Harriet Beecher Stowe, Henry David Thoreau, and Abraham Lincoln. Lincoln typified the antislavery side of colonization, which he promoted until the second year of the Civil War. He thought free blacks must be shipped abroad because he thought there was a physical difference between whites and blacks that forbade their enjoying equal rights in America. He explained, "What I would most desire would be the separation of the black and white races."

Blacks were understandably ambivalent about colonization. Many, appalled by racism within the movement, insisted that free blacks should be integrated into American society. In 1817, just after the launching of the ACS, blacks in Philadelphia organized a large rally in support of a petition saying, "We have no wish to separate for any purpose whatsoever." Similar demonstrations followed over the next two years.

Some blacks, however, viewed colonization as a potential source of empowerment. In 1815 Paul Cuffee, a Quaker ship owner of black and Native American ancestry, had led a group of thirty-eight African Americans who relocated to Sierra Leone. Later black separatists such as Martin Delany, the Rev. Henry Highland Garnet, Alexander Crummell, and Henry McNeal Turner also endorsed colonization, envisaging an independent black state in a spirit anticipatory of Marcus Garvey's back-to-Africa movement in the twentieth century. Ironically, Liberia in fact resembled Southern slave society: It had a peonage system like slavery, it profited from the slave trade, and a number of its towns were named after places in the South such as Louisiana and Virginia. Also, racial and class prejudice tainted the relationship between mulattoes

and pure blacks there. Still, Liberia remained a symbol of liberty for both black and white colonizationists in America.

* * * *

DURING THE MONROE YEARS, American workers got a harsh lesson in the vicissitudes of capitalism when the economy crashed. The Panic of 1819 initiated the nation's first major depression.

The crash resulted from a confluence of national and international events. In the heady atmosphere after the war, both imports and exports surged. European demand for American goods, especially agricultural staples like cotton, tobacco, and flour, increased. To feed the overheated economy, state banks proliferated, and credit was easy. The federal government offered for sale vast tracts of western lands, fueling real estate speculation funded by bank notes. Reserves of specie, or hard money, plummeted, especially in the West and the South. As early as 1814, Thomas Jefferson warned, "We are to be ruined by paper, as we were formerly by the old Continental paper." Two years later, he asserted that "we are under a bank bubble" that would soon burst.

The Second Bank of the United States was supposed to steady the economy, but gross mismanagement in its early phase sapped its effectiveness. The bank's first president, William Jones, instead of taking steps to regulate the nation's currency, doled out huge loans that fed speculation and inflation. He also kept lax watch over state banks, where fraud and embezzlement created chaos. A congressional committee's proposal to terminate the nearly insolvent BUS had little backing because forty members of Congress held stock in the bank.

The bank's problems arose at precisely the wrong moment, when the economy needed a firm rudder during its postwar expansion. Jones resigned and was replaced by the South Carolina congressman Langdon Cheves and later by the Philadelphia lawyer Nicholas Biddle. Although the bank sharply contracted loans in 1818, the damage had been done. The BUS, far from helping the economy, was among the destabilizing forces that led to the depression of 1819.

At the same time, swelling crop yields in Europe reduced the demand for American farm products, whose prices plunged. An economic contraction in Europe led banks there to reduce credit. The crisis abroad, coupled with the contraction at home, forced American banks to call in their loans as well.

By early 1819, credit, once so easy, was unavailable to many Americans. With specie reserves depleted, many American banks failed, and other businesses followed. Sales of public lands plummeted. Unemployment soared, and in some regions food and other basic necessities were difficult to come by. Especially hard hit were cities outside of New England like Philadelphia, Pittsburgh, and Cincinnati. Farmers suffered too, though many survived by resuming a subsistence lifestyle. With insolvency rife, prisons were overcrowded with debtors. The depression lingered for two years. It was the first of several severe downturns that would tarnish America's otherwise vigorous economy throughout the nineteenth century.

The Panic of 1819 fostered mistrust of banks, bankers, and paper money. The volatile Tennessee politician Davy Crockett spoke for many when he dismissed "the whole Banking system" as nothing more than "a species of swindling on a large scale." The aging Thomas Jefferson complained that the new generation, "having nothing in them of the feelings or principles of '76, now look to a single and splendid government of an aristocracy, founded on banking institutions, and money incorporations . . . riding and ruling over the plundered ploughman and beggared yeomanry."

This mistrust of corporations was aggravated by landmark decisions handed down in 1819 by the Supreme Court under Chief Justice John Marshall. In *Dartmouth College v. Woodward*, the Court protected private corporations against interference by the state governments that had created them. In *McCullough v. Maryland*, it ruled that the Bank of the United States, though privately run, was a creation of the federal government that could not be touched by the states.

To radicals like the Virginia statesmen John Taylor of Caroline and

John Randolph of Roanoke, these rulings were part of a larger movement against states' rights and agricultural interests. In treatises like *Construction Construed* (1820) and *Tyranny Unmasked* (1821), Taylor anticipated John C. Calhoun and the secessionists by laying out the Southern agrarian position. Taylor defended the sovereignty of each state and criticized what he saw as encroachments on individual liberties by commerce and the federal government. Randolph, an outspoken congressman, lambasted all facets of federal control—the tariff, the BUS, internal improvements, and the Marshall court—while taking states' rights to a new extreme. "When I speak of my country," he announced, "I mean the commonwealth of Virginia."

* * * *

SOUTHERNERS' DEVOTION TO STATES' rights combined with proslavery ideology in the fierce debate over Missouri's admission to the union. Although the debate was resolved by the Missouri Compromise of 1820, for the first time slavery emerged as an explosive issue.

Slavery in the early republic had been widely viewed as a temporary evil. The founding fathers, shaped by Enlightenment values of human rights and democracy, had generally opposed slavery even when they owned slaves. Washington, who owned over two hundred slaves, nonetheless said of slavery, "There is not a man living who wishes more sincerely than I do, to see a plan adopted for the abolition of it." He freed some of his slaves just after his presidency and manumitted the remainder in his will. Another famous slave-owner, Jefferson, said of slavery, "I tremble for my country when I reflect that God is just." Yet another, Madison, called slavery "the most oppressive domination ever exercised by man over man."

The founders' ambivalence about slavery was reflected in the Constitution, which avoided mentioning slavery while tacitly condoning it in its clauses about three-fifths representation in the South and the return of fugitives from labor. Congress banned the international slave trade in 1808. In many of the original thirteen states, there was a trend

toward abolition. When Vermont broke from England and became an independent republic in 1777, it banned slavery. Within two decades eight northern states had made provisions for emancipation.

Powerful indictments of slavery on moral grounds came from Enlightenment rationalists like Benjamin Franklin and Benjamin Rush, from Quakers like Anthony Benezet and John Woolman, and from orthodox Calvinists like Samuel Sewall and Jonathan Edwards Jr. Even in the South, abolition had a hearing. In 1796 the Virginia lawyer St. George Tucker wrote a pamphlet calling for gradual emancipation. The legislatures of Maryland, Delaware, and Virginia considered abolition bills.

But the invention of the cotton gin, and the ensuing cotton boom, increased the South's dependence on slavery. Cotton production doubled between 1815 and 1820, then doubled again before 1825. By the Civil War, the United States produced two thirds of the world's cotton. Slaves became ever more valuable to the plantation economy, especially in the Deep South. Prices for slaves increased steadily.

Where the economy led, moral argument followed. Some defended slavery on religious and historical grounds, such as a Georgia congressman who pointed out that the Bible supported slavery "from Genesis to Revelation" and that "there never was a government on the face of the earth, but what permitted slavery." Others brought up the racial factor, later essential to the Southern view. In his 1818 tract *Arator*, John Taylor of Caroline insisted that slavery properly kept blacks, by nature vicious and morally inferior, in a dependent position—an argument also developed by the South Carolina doctor Thomas Cooper, who branded blacks as "a permanently degraded people" who merited no legal rights.

The South's growing support of slavery, combined with intensifying antislavery sentiment in the North, fueled the explosion over Missouri. In 1819 a numerical balance existed between eleven slave states and eleven free ones. Discussion arose over admitting Maine as a free state, while the slave-holding Missouri territory had also applied for admission to the Union. Congress decided to consider Maine and Missouri

simultaneously. The New York congressman James Tallmadge raised the stakes of the discussion by proposing that slavery be banned from Missouri. The predominantly antislavery House of Representatives passed his measure but the Southern-dominated Senate voted it down.

Congress debated slavery in arguments that caught fire in cities and towns throughout the nation. "Missouri engulfs everything," an Alabama senator declared. Many of the points about slavery, pro and con, that would later lead to the Civil War were aired. William Pinkney of Maryland described to the Senate the alleged blessings of slavery. "The great body of slaves," he asserted, "are happier in their present situation than they could be in any other, and the man or men who would attempt to give them freedom, would be their greatest enemies." John Randolph of Roanoke laid out the Southern states'-rights position, calling the effort to restrict slavery another example of federal tyranny. Northerners like New York Senator Rufus King answered that slavery not only violated natural and divine laws but also ran counter to the American ideal of equality. Slavery could be tolerated where it already existed, but its spread must be prevented.

Senator Jesse B. Thomas of Illinois offered a compromise admitting Missouri as a slave state and Maine as a free state, with the key stipulation that slavery would be thereafter banned above latitude 36° 30' in territories west of Missouri. The compromise won enough support to pass Congress and to be signed into law by President Monroe in 1820 over the protests of Southerners like Randolph, who excoriated it as a "dirty bargain" made possible by "doughfaces," a label he coined to describe Northerners who leaned to the South.

Some correctly saw the contest over Missouri as an omen of worse battles to come. The elder statesmen John Adams and Thomas Jefferson peered apprehensively into the future. Jefferson wrote, "This momentous question, like a fire bell in the night, awakened and filled me with terror. I considered it at once as the knell of the union." Adams confessed that slavery "hangs like a Cloud over my imagination" and predicted "the Calamities which slavery is likely to produce in this Country."

Even more prescient was Adams's son, John Quincy Adams, who in his diary pronounced slavery "the great and foul stain upon the North American Union" that would be eradicated only by "a dissolution, at least temporary, of the Union" followed by a reorganization of the nation "on the fundamental principle of emancipation." Adams wrote prophetically, "A dissolution of the Union for the cause of slavery would be followed by a servile war in the slave-holding States, combined with a war between the two severed portions of the Union. It seems to me that its result might be the extirpation of slavery from this whole continent." Though this war would be "calamitous and desolating," Adams added, "I dare not say that it is not to be desired," since "so glorious would be its final issue."

But most Americans in the early 1820s were not contemplating a civil war over slavery. Buoyed by expansion and economic recovery, they thought that the Missouri Compromise had settled the slavery issue.

Still, the social problems that had surfaced during Monroe's terms in office were not about to disappear. They signaled profound contradictions in the nation's identity. America promised equal rights for all and yet restricted them for marginalized groups such as Indians, women, and blacks. It championed human equality but tolerated slavery. It moved toward prosperity yet could fall quickly into hard times. It had achieved a kind of unity during "the era of good feelings," but by the end of Monroe's term was feeling strains that in time would lead to civil war.

2

Political Fights, Popular Fêtes

John Quincy Adams, who won the disputed election of 1824, should have been a great president. Few have been better qualified for America's highest office than he. Wonderfully educated, raised by the nation's second president and his accomplished wife, he had entered public life at fourteen and never left it for long, gaining prominence as a diplomat, senator, and cabinet member. The prime mover behind President Monroe's nationalistic foreign policy, he was perhaps the most important secretary of state in American history. He also had a sharp understanding of domestic issues. His heart was in the right place on the key social problem, slavery.

His presidency, however, began in turmoil and met with frustration. True, America under him was generally content and prosperous. But Adams failed to implement many of his programs. Congress resisted him at every turn, partly because of internal divisions and partly because of his own shortcomings as a politician. In the end, he was less effective during his presidency than before or after it.

Still, his presidency was more successful than is commonly thought. And if we consider his whole career in light of America's long-term priorities, we realize that he defined the nation as much as anyone in his day.

Subject to bouts of depression, John Quincy Adams nonetheless had remarkable energy. Privately, he could sparkle with wit. Publicly, when orating in his shrill voice, gesticulating and swaying, his bald head

flushed with passion, he delivered forceful speeches laced with sarcasm. Elected to Congress two years after his presidency, he became known as Old Man Eloquent. "He is no literary old gentleman," Emerson observed, "but a bruiser, & loves the mêlée. He is an old roué who cannot live on slops, but must have sulphuric acid in his tea."

It was not easy being the son of a founding father. Born in Braintree, Massachusetts, in 1767, Adams from early childhood believed he would lead the nation—a common enough fantasy for young Americans but uniquely justified in his case. His often absent father, John Adams, and domineering mother, Abigail, had stratospheric expectations of him. They told him that with his background he must aim to be a "great man," "a Guardian of the Laws, Liberty and Religion of your Country."

Predictably, such demands produced a man at once egotistical and insecure, snobbish and self-critical. At twenty-five he complained of being in a "state of useless and disgraceful insignificancy, . . . as obscure, and as unknown to the world, as the most indolent, or the most stupid of human beings." Fame failed to bring self-confidence. Late in life he described himself as "a man of reserved, cold, austere and forbidding manners"—an assessment seconded by others, like a judge who said he showed "a formal coldness that froze like the approach of an iceberg." Adams realized that many saw him as "a gloomy misanthropist" but confessed, "I have not the pliability to reform it."

If his bland predecessor, James Monroe, was the era's Gerald Ford, John Quincy Adams was its tortured Richard Nixon. "The devices of my rivals to ruin me have been sorry pictures of the heart of man," Adams once lamented. He listed those who "have used up their faculties in base and dirty tricks to thwart my progress and destroy my character." In old age he wrote, "The best actions of my life make me nothing but enemies," and "All around me is cold and discouraging, and my own feelings are wound up to a pitch that reason can scarcely endure."

No American so full of self-doubt ever accomplished as much as did

Adams. He felt the weight of his country on him since the age of seven, when his mother took him to witness firsthand the Battle of Bunker Hill. At twelve, when he was about to go to Europe with his father, he began a diary that eventually ran to fifty-one volumes; sometimes he devoted six hours a day to it. His entries veered between informative accounts of the political scene, introspective rambling, and acidic remarks on others.

He had much to write about. Having mastered French by his early teens—eventually he spoke seven languages—he served as a translator in a U.S. diplomatic team sent to St. Petersburg, Russia, in 1781. He remained abroad for six more years, then returned to study at Harvard, where he took special interest in math and science. He graduated second in a class of fifty-one and earned Phi Beta Kappa honors. At his parents' urging, he entered the law, a profession he detested. Under President Washington, he served as minister to the Netherlands, and later his father gave him a similar post in Prussia.

While in London in 1796, Adams met the petite, chestnut-haired Louisa Catherine Johnson, the daughter of the American consul there. A talented musician and charming socialite, Louisa was dazzled by the young celebrity, as he was by her, though he had already left behind the love of his life, Mary Frazier, a Massachusetts teenager he had courted after college but had reluctantly given up under pressure from his parents and hers. After a difficult courtship, Louisa and he were married in 1797. His affection for her grew in sympathy for her suffering during four miscarriages.

But their marriage was stormy. Louisa, like him, struggled with depression. They had four children, three of whom met with tragedy: a daughter died in her first year, a son died of tuberculosis as a young man, and another son became an alcoholic and, in a moment of delusion, apparently killed himself. Although Louisa kept up an active social life and eventually became a voice for abolitionism and women's rights, she did not enjoy lasting happiness with her crotchety husband,

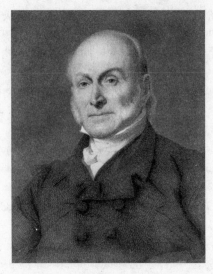

John Quincy Adams

who once said that he "reverenced" women yet always "treated them individually with coldness and reserve."

A well known Federalist, Adams was elected a Massachusetts state senator in 1802 and a U.S. senator the next year. His independent streak soon surfaced when he joined a Republican protest against the British seizure of the American frigate *Chesapeake*. The Federalists stripped him of his Senate seat, and he turned his attention to a new position as the Boylston Professor of Rhetoric and Oratory at Harvard. By 1809 he was back in public service as President Madison's minister to Russia. After playing a key role in working out the Treaty of Ghent, he became minister to England. It was as President Monroe's secretary of state, beginning in 1817, that he achieved his greatest diplomatic victories. Adams was mainly responsible for extending U.S. territory through his skilled negotiations with Spain over Florida and with England and Russia over the West. Adams also promoted the principles of European nonintervention and commercial freedom on the seas that underlay the Monroe Doctrine.

His vast governmental experience made him a natural for the presidency in 1824. But it also hindered him. Like three of the other four candidates who ran for president that year—William H. Crawford, Henry Clay, and John Calhoun—Adams came off as a Washington insider, distant from the people. In his case, the situation was made worse by his stiff, bookish demeanor. He had none of the popular appeal of the man who emerged as his chief rival, Andrew Jackson.

Jackson had never liked holding public office. He had served briefly in the House of Representatives and the Senate in the 1790s and was Florida's territorial governor in 1820–21 and then again a U.S. senator in 1823–24. He relinquished each post after a short period. At first he didn't seek the presidency, confessing in 1822, "I never had a wish to be elevated . . . to the executive chair. . . . My sole ambition is to pass to my grave in retirement." When the Tennessee state legislature brought his name forward as a presidential candidate, he declared, "I mean to be silent—let the people do as seemeth good unto them."

The presence of his rivals Clay and Crawford in the race stirred Jackson's interest in campaigning. Not one to back down from a challenge, he gathered a core of able supporters that in time grew into a political machine. He already showed signs of being the people's candidate. His haziness on issues like the tariff or internal improvements was in fact a boon, since he avoided the hard positions that made the other candidates seem sectional. A widely reprinted newspaper article proclaimed that Jackson "will be the President of the whole people, the enlightened ruler of an undivided empire, and not a sectional magistrate devoted to the 'universal Yankee nation' of the East, or the mixed, mingled, confused population of the South." What especially attracted voters were his personal qualities—firmness, passion, shrewdness—as tested on the battlefield. A campaign slogan touted him as "Old Hickory, the Nation's Hero and the People's Friend."

John Quincy Adams was well disposed toward Jackson but didn't see him as presidential material. He quipped that Jackson's supporters could only brag about the "8th of January and battle of New Orleans." They

retorted that Adams was just "a closet man" who learned from books and knew "little of man as he is." A political ditty presented the choice:

John Quincy Adams
　　Who can write,
Andrew Jackson
　　Who can fight.

Adams the scholar, Jackson the warrior: Actually, the poem was not far off. An omnivorous reader, Adams knew by heart long passages of many authors in various languages, and he had an extraordinary memory for names and dates in history, even minute ones. He loved exploring everything from drama to science to math. An astronomy enthusiast, he often scanned the heavens at night. He was fascinated by horticulture and botany; throughout his presidency, he planted trees and plants of all varieties in Washington gardens. He knew Russian, was an expert in Chinese history, and studied international currency and weights and measures. He even took time as president to write elaborate letters to his son Charles on a range of thinkers from Plato and Cicero through Pascal and Newton to Madame de Sévigné.

Jackson, in contrast, had few intellectual interests. A contemporary biographer, James Parton, claimed that that Jackson had read completely only one secular book, Oliver Goldsmith's novel *The Vicar of Wakefield*. Jackson reportedly told a member of his family he didn't believe the world was round. "His ignorance was as a wall round about him—high, impenetrable," wrote Parton. "He was imprisoned in his ignorance, and sometimes raged round his little, dim enclosure like a tiger in his den." John Quincy Adams once dismissed Jackson as "a barbarian who could not write a sentence of grammar and hardly could spell his own name."

While it is true that Jackson's grammar was shoddy and his reading limited, he had an eloquence that came through in his letters and speeches. He also had natural political instincts and a populist touch. To many, he was the rough-hewn hero, the man who had served in the

Revolution, thrashed Indians on the frontier, and vanquished the British at New Orleans. Charges that he was a duelist and a murderer didn't hurt him much and actually helped him in the South, where violence was part of a gentleman's code of honor. He had a charisma Adams lacked. The short, pudgy Adams cared little about dress. The tall, lean Jackson often appeared in pictures looking striking in his general's uniform or tailored suits.

The three other presidential candidates—all of them, like Adams and Jackson, Democratic-Republicans—had their own strengths and supporters. The Virginia-born William H. Crawford presented himself as a true Jeffersonian, a states'-rights Old Republican who would provide continuity with the past. John Calhoun of South Carolina advertised a new Jeffersonianism that balanced agriculture and commerce, states' rights and federal power. Henry Clay of Kentucky, who as speaker of the House pushed through a new tariff in 1824, promoted his American System, based on tariffs, internal improvements, and the national bank.

Of the three, Crawford was the most attractive to voters. Large and muscular, Crawford had a bluff charm similar to Jackson's. His booming laugh and hot temper gave him an appeal to the common man, as did his crudeness. Like Jackson, he had once killed a man in a duel, adding to his prestige in the South. He had extensive government service, as ambassador to France, secretary of war under Madison, and secretary of the treasury under Monroe. He offered himself as an extension of the Virginia dynasty that had ruled for twenty-four years.

But Crawford's candidacy faltered when in October 1823 he had a terrible illness (possibly a stroke) that left him partly paralyzed and nearly deaf and blind. He bravely stayed in the race, but his doom was spelled when a relatively small congressional caucus formally nominated him. This old system, by which states chose presidential electors by legislative caucus, was by then widely regarded, as one newspaper noted, as having "too much regard for the *private* & too little respect for the

public interest." Labeled a relic of the past, enfeebled by his illness, Crawford lost appeal.

Like Crawford, Calhoun and Clay were experienced politicians who had trouble shedding the impression that they were sectional candidates. Despite high expectations, Calhoun dropped out of the race when Pennsylvania failed to nominate him; he would settle for the vice presidency. Clay suffered by association from the recent economic panic, for which his American System was seen as partly responsible.

The public couldn't decide between the candidates. Jackson won 43 percent of the popular vote, Adams 31 percent, and Crawford and Clay 13 percent apiece. These numbers were deceptive. Due to widespread apathy, less than a third of eligible voters cast ballots. Since six states still chose presidential electors by caucus, many voters did not have a direct say in the election. At any rate, no one received the required majority of electoral votes. It was left to the House of Representatives to choose between the top three vote getters. Clay was thus eliminated from the race, but he wielded power in the decision. As speaker of the House, he could play a swing role by endorsing one of the three remaining candidates.

The three jockeyed for Clay's support. Clay, unenthusiastic about all three, called the decision "painful," "only a choice of evils." He selected Adams because he considered Crawford too sick to hold office and Jackson merely an army man. On the evening of January 9, 1824, Clay met privately with Adams for three hours and assured him of his backing. Smelling collusion, the Pennsylvania Jacksonian George Kremer charged that Clay was giving Adams his support in return for a future cabinet appointment. Although Clay was so offended that he called his critic "a base and infamous calumniator" and challenged him to a duel, over the next few weeks Clay convinced the delegates in the three states he had won (Kentucky, Ohio, and Missouri) to vote for Adams. New York also went for Adams, who won the House vote, and hence the presidency, in a close election.

Jackson, though perturbed, took the result quietly. But what happened next infuriated him. President Adams appointed Henry Clay his

secretary of state. Jackson instantly charged that Adams had stolen the election by making a "corrupt bargain" with Clay, trading the cabinet post for the presidency.

Many have speculated why Adams and Clay allowed themselves to fall into an arrangement that, whatever the truth about it, appeared sleazy. Part of the reason lies in Adams's distance from political reality. Adams had approached the presidential race unsurely. "Whether I ought to wish for success is among the greatest uncertainties of the election," he had said. He craved the presidency yet feared it, expressing uncertainty about whether he wanted to win or lose. "To me both prospects are distressing in prospect," he confessed. "The most formidable is that of success. All the danger is on the pinnacle." Like most other presidential candidates of the time, he did not campaign actively. "I will not take one step to advance or promote pretensions to the Presidency," he declared. When making appointees, he paid no attention to personal friendship or party loyalty. On the contrary, he thought he could keep alive Monroe's spirit of unity by rising above favoritism and rewarding merit. Although he disliked Clay personally (and the feeling was mutual), he admired his experience and therefore chose him for his cabinet.

Clay, for his part, supported Adams mainly because of his doubts about Jackson, whom he called a "military chieftain" whose only qualification for office was "killing 2,500 Englishmen at New Orleans" He had no qualms about accepting the cabinet post. He noted that his opponents "abuse me for it" but added, "They would have abused me more if I had declined it," since it would have made suspect his pure intentions. The deal between Adams and Clay was less a corrupt bargain than a naïve blunder.

But for Jackson the nature of the deal was crystal clear. "Clay voted for Adams and made him President," he declared, "and Adams made Clay secretary of state. Is not this proof as strong as holy writ of the understanding and corrupt coalition between them?" The "corruptions and intrigues at Washington," he charged, had "defeated the will of the People in the election of their President."

Outraged by the alleged bargain, Jackson began rallying his forces to undermine Adams and prepare for the next presidential race. The Tennessee legislature formally nominated him for the presidency in the summer of 1825. On October 13 Jackson resigned from the Senate to defuse the charge that he might use political power to stage-manage his own election. On that count, he didn't have to worry; he had skillful followers who stage-managed for him.

The opposition to Adams was at first a loose association of Jacksonians, Crawfordites, and Calhounites known as the Combination. Within a year, the group had formed a wall of resistance Adams couldn't hope to penetrate.

Ironically, Adams helped build the wall by refusing to replace opponents with political friends. To the frustration of Clay and others close to him, Adams took the high road, appointing those he saw as talented, regardless of their political views, and hesitating to fire people unless they were obviously incompetent. He appointed the Crawfordite James Barbour as secretary of war, the Calhounite Samuel L. Southard as secretary of the navy, and the Jacksonian John McLean as postmaster general. He offered the position of secretary of the treasury to his presidential opponent William Crawford, who declined it for health reasons (Philadelphia's Richard Rush, a Clay supporter, won the job). Opponents of the administration dominated the lower levels of government. The postal department was full of Adams's enemies, as were the U.S. customs houses. In all, Adams fired only twelve officials during his presidency.

Adams realized he might be hurting himself by not getting rid of his foes. In May 1825, he noted in his diary that four fifths of the customs officers in the nation had been "opposed to my election" and reflected, "They were now all in my power, and I had been urged very earnestly, and from various quarters, to sweep away my opponents, and provide with their places for my friends." But he did *not* sweep them away. He operated under the principle, as he put it to Daniel Webster, that he would "exclude no person for political opinions, or for personal opposition."

Loath to reward friends or punish enemies, Adams was nonetheless charged with manipulating appointments to strengthen his power. Senator Thomas H. Benton declared that every Adams appointee understood, *"I will VOTE as he wishes, and he will GIVE me the office I wish for."* Benton backed this ludicrous claim by proposing six bills to limit presidential power. Although the bills failed, they helped fix Adams's reputation as a power-hungry chief executive who went to all lengths to push his views.

Surrounded by opponents, Adams sought refuge in diversion and self-improvement. He rose early—usually around 5:00 a.m., sometimes as early as 3:30. He devoted a couple of hours to exercise. In the winter, he took long walks. From late spring through mid-fall, he went with his son John and his valet Antoine to the Potomac, where he swam nude, as was then the custom. (An apocryphal anecdote, long thought true, had the reporter Anne Royall waiting for him by his rolled-up clothes on the riverbank until he came back from his morning swim.) Once he went fully clothed with Antoine out on a small boat that capsized when a storm came up. The naked Antoine quickly swam ashore but the president, encumbered by his clothes, floundered in the water for over an hour. When at last he reached shore, he stripped and waited shivering as his valet went to the White House to fetch clothes. Toward the end of his presidency, Adams took up horseback riding, going for rides of up to fourteen miles in the fields and woods around Washington.

After exercising, Adams read and wrote until breakfast, and then spent the hours between 9 and 5 accepting visitors, with time off for lunch. Unlike today, when the president is sealed off from the public, in that era almost anyone could make an appointment with the chief executive. Adams's only staff member, besides his domestic servants, was his inexperienced son John, who was a poor buffer to the endless officials, job seekers, and assorted citizens who flowed into the White House. A hands-on president who didn't believe in delegating duties, Adams faced a daily barrage of visitors. On a typical day he lamented, "The succession of visitors from my breakfasting to my dining hour,

with their variety of objects and purposes, is inexpressibly distressing." "They crawl upon one like a nest of spiders," he wrote, adding, "I can scarcely conceive a more harassing, wearying, teasing condition of existence. It literally renders life burdensome."

Even a would-be assassin got to see the president. One of the period's small tragicomedies involved a disgruntled army surgeon, Dr. George Todson, who was court-martialed for embezzlement and took out his anger by issuing a threat to kill President Adams. The threat was relayed to Adams, who ignored warnings to take extra care on his morning walks, saying that his life was in God's hands. Todson managed several times to visit the president. The prospective killer turned into a bothersome beggar, hounding Adams for money and job help. After much back and forth, Adams remitted the $47 fine of the court-martial and got Todson appointed first as a surgeon on a ship carrying blacks to Africa and then as a doctor with an Indian tribe. Adams thus took to a new extreme his habit of employing his opponents.

Evenings found the president relaxing and studying. After dinner, he played billiards, then read, wrote, and signed papers until bedtime, anytime between 8:00 and midnight. Bed, however, often provided little respite from care, since Adams suffered from insomnia, which along with other recurrent conditions—constipation, indigestion, loss of appetite—was sometimes accompanied by depression. At a particularly stressful moment he complained of an "uncontrollable dejection of spirits; . . . a sluggish carelessness of life, an imaginary wish that it were terminated."

Deeply religious, Adams attended at least two church services every Sunday at different churches, according to his preference. Though raised a Congregationalist, he was skeptical of doctrines, confessing that had not the least clue about the Trinity, miracles, or the afterlife. He simply accepted Christianity and clung to it. In October 1826, he made an official confession of faith, joining the Unitarian church in his hometown of Quincy, Massachusetts. He spent an hour each morning reading the Bible, averaging two chapters per day. He tried to read through the

entire volume once a year in English, French, or German. Active in the American Bible Society, he went on to become its vice president.

★ ★ ★ ★

ONE MIGHT THINK THAT America, with its troubled president and growing tensions in Washington, would have been in a subdued mood in the mid-1820s. But the opposite was true. Under Monroe, America had discovered itself as a nascent world power. Under Adams, it celebrated itself wildly. "I celebrate myself, and sing myself," Walt Whitman would announce in his poem *Song of Myself*. The optimistic Whitman absorbed his nation's exuberant spirit at a time when he was a young boy growing up in Brooklyn. Whitman never forgot the thrilling reception his town gave to the Marquis de Lafayette, the aged Revolutionary hero who was on a long tour of the United States. Late in life, Whitman recalled Lafayette at the laying of the cornerstone of Brooklyn's Apprentices' Library, where the legendary veteran bent down, picked up the six-year-old Walt, and kissed him on the cheek.

Lafayette's tour was one of four memorable events—three of them planned, the other accidental—that made the mid-1820s a time of jubilee. Besides Lafayette's visit, there were the laying of the cornerstone of the Bunker Hill Monument, the opening of the Erie Canal, and the passing of Thomas Jefferson and John Adams, who died within hours of each other on July 4, 1826, the fiftieth anniversary of the nation's independence.

These events had deep roots in the nation's founding. Each sparked an outpouring of national pride that went beyond the giddiest exhibitions of previous times. Each was proclaimed a special moment in history. Each fed into the vision of America as a chosen nation, passed down from the Puritans and soon to reach apotheosis as Manifest Destiny.

The Marquis de Lafayette held a high place in the hearts of Americans. Inspired by the American Revolution, this French nobleman had in 1777 left his comfortable surroundings and joined Washington's

army, serving without pay as a major general at Brandywine (where he was wounded) and in many subsequent battles, including Yorktown, where he contributed to the defeat of Cornwallis. Unswervingly loyal to Washington, he proved himself fearless as a commander and adept in securing military support from France.

His dedication to republican values did not cease with America's victory over the British. He promoted the abolition of slavery and the democratic revolutions in South America and in Greece. A large, refined-looking man with a receding chin and forehead and thin red hair that turned a distinguished gray, Lafayette was living proof that even a European aristocrat could espouse the cause of the people.

When President Monroe invited him to be the "nation's guest," Lafayette gratefully accepted. Having sailed from Le Havre on July 12, 1824, in an American merchantman, he arrived on August 15 in New York, where several days of festivities initiated a thirteen-month journey through all twenty-four states. He went north to Boston, then circled back down through New York to Pennsylvania, Maryland, and Washington. In November he visited Virginia, where he stayed ten days with Jefferson and four with Madison. The next month Congress voted to give him $200,000 and a township in Florida. His Washington visit was capped by a New Year's Day fête attended by John Quincy Adams and Andrew Jackson, still in the limbo of the undecided election, and many other notables.

Lafayette then toured the South. His pleasure over the warmth shown to him there was qualified by his revulsion over American slavery. He went up the Mississippi to St. Louis, then proceeded to Cincinnati, Pittsburgh, and back east to Boston, where he participated in the ceremony for the Bunker Hill Monument. After crisscrossing New England, he returned to Washington and stayed in the White House with the recently elected President Adams until his return home on September 7, 1825.

Crowds, frequently numbering in the tens of thousands, greeted Lafayette with reverence. At one banquet for him, a transparency at the end of the hall showed him holding Washington's hands at the altar of

liberty. At another, a picture depicted his castle, La Grange, with its five towers and moat, with the caption "Here is his Home." Counties, towns, parks, and streets across the nation were named after him or his castle. Lafayette busts, portraits, and poems abounded. The final ceremony held for him at the White House reeked of sentimental patriotism. Tears flowed from the government officials present as President Adams and Lafayette gave celebratory speeches. Even the icy Adams broke down as he gave the old general a farewell hug.

Coming on the heels of the Missouri crisis and the divisive presidential contest, Lafayette's tour had a unifying effect on the nation. A journalist noted that a "great act of public salutation . . . swept from state to state, and from section to section, one long, unbroken career of rapturous welcome,—banishing feuds, appeasing dissensions, and hushing all tumults but the acclamations of joy." President Adams declared that Lafayette's visit had brought "to the people of the union, a year of uninterrupted festivity and enjoyment," saying that the general had "heard the mingled voices of the past, present, and future age, joining in one universal chorus of delight."

One of the ceremonies Lafayette attended—the laying of the cornerstone of the Bunker Hill Monument on June 17, 1825—stood out from the rest. The day was crisply beautiful. Hordes gathered at Breed's Hill to see Lafayette and three hundred other Revolutionary veterans march with companies of blue-clad Masons to consecrate the monument. Since 1794, the historic spot had been commemorated by a twenty-eight-foot stone. The new, much taller, monument, a granite obelisk thirty feet square at its base, was designed to crown the Boston landscape.

For those who gathered to see the laying of its cornerstone, that June day was as sacred as the battle fifty years earlier, in which the outnumbered American army had stood tough against the attacking British. A reporter trumpeted the celebration as "one of the most remarkable events of our time; and that is to say, of all times." Another claimed that the event had "a style of grandeur unprecedented in the annals of our country." Lafayette and his fellow veterans were not the only ones present

who helped magnify the moment; there was also the orator of the day, Daniel Webster.

Webster was a forty-three-year-old Massachusetts congressman who had distinguished himself as a constitutional lawyer in landmark cases such as *Dartmouth College v. Woodward* and *McCulloch v. Maryland*. Of middle height, with wide shoulders and a barrel chest, he seemed to dominate every scene he entered. The old-style knee breeches and waistcoat he donned for public occasions enhanced his histrionic majesty. His jet-black hair, swarthy complexion, and smoldering dark eyes beneath his broad brow accounted for his nickname, Black Dan. His resonant voice mesmerized audiences. Emerson called him "a great cannon loaded to the lips" whose words were "like blows of an axe" and "as real as a blast furnace."

As he strode to the lecture platform, the air rang with "Webster! Webster! Webster!" and "Welcome, welcome, Lafayette!" Webster addressed Lafayette: "Fortunate, fortunate man! . . . You are connected with both hemispheres and with two generations. Heaven saw fit to ordain, that the electric spark of liberty should be conducted, through you, from the New World to the Old."

If Lafayette linked the past and the present, the old and the new worlds, and if the Bunker Hill Monument connected 1775 with 1825, there was even better news: America was progressing harmoniously, and the world was following its example. The advance of knowledge, Webster declared, bode well for world peace. Future wars "will be less likely to become general and involve many nations" than past ones. Democracy was spreading. One of "the great events of the half-century," said Webster, was "the revolution of South America," with numerous countries escaping Spain's "despotic misrule." Greece, too, was fighting heroically for independence from the Ottoman Empire. America was prosperous and happy. "Let us cultivate a true spirit of union and harmony," Webster intoned. "Let our object be, OUR COUNTRY, OUR WHOLE COUNTRY, AND NOTHING BUT OUR COUNTRY."

Daniel Webster

How would national unity be maintained? By keeping alive the spirit of the founders and by stimulating the economy. "Let us develop the resources of our land," Webster exhorted. "Our proper business is improvement. Let ours be the age of improvement."

Four months after Webster rhapsodized about unity through improvement, the nation celebrated it with the completion of the Erie Canal. On October 26, 1825, the waters of Lake Erie for the first time flowed into the long canal that had taken more than eight years to build. Lafayette by this time had gone home, but he wasn't missed at the canal festivities, which celebrated the nation's future. Reporters again strained to capture the grandeur of the spectacle. One wrote, "The pageant was the most magnificent which America, and perhaps the world, had ever seen."

At exactly 10:00 a.m., Lake Erie was opened into the canal at Buffalo, where a booming cannon set off an orchestrated chain of responding booms from other cannons that took an hour and twenty minutes to go along the canal route and down the Hudson to Sandy Hook below Manhattan, where the river met the Atlantic. Sandy Hook then started return volleys that reached Buffalo at around 1:30 p.m. A delirious crowd at Buffalo cheered Governor DeWitt Clinton and other dignitaries as they set off on the *Seneca Chief*, a canal boat drawn by four caparisoned horses. When the boat reached Albany, a steamboat took over the tugging duties.

At several aqueducts along the canal there was a staged question-and-answer exchange intended to reflect the momentousness of the occasion:

> *"Who comes there?"*
> "Your brothers from the West, on the waters of the Great Lakes."
> *"By what means have they been diverted so far from their natural course?"*
> "Through the channel of the Erie Canal."
> *"By whose authority and by whom was a work of such magnitude accomplished?"*
> "By the authority and enterprise of the people of the State of New York."

Other boats joined the *Seneca Chief*, creating a procession. There was *Noah's Ark*, carrying "products of the west," including a bear, two eagles, two fawns, and other birds and animals, as well as two Indian boys in their costumes. Another boat, the *Lion of the West*, had on board wolves, deer, raccoons, and a fox "to denote the subjection of the wilderness to man." By November 4, when the *Seneca Chief* reached Manhattan, a fleet of flag-draped boats trailed it. On shore, crowds cheered, cannons roared, and bands played martial music. The *Seneca Chief* went beyond Sandy Hook, where the "Who comes there?" ritual initiated a ceremony capped by Governor Clinton's emptying a keg of Erie water into the Atlantic. A barrel was filled with ocean water to be sent back to Lake Erie. After speeches about the unparalleled benefits of the canal,

the fleet headed back to Manhattan. Parades, banquets, and fireworks lasted into the night.

Among those who sent congratulatory messages about the canal were the ex-presidents Thomas Jefferson and John Adams. Within nine months of the canal celebration, their deaths would create an even greater stir than it had.

On July 4, 1826, the ninety-year-old Adams awoke in his home in Quincy, Massachusetts, and exclaimed, "It is a great day. It is a good day." By the early afternoon, he was fading. "Thomas Jefferson survives," he murmured. These were his last words. By the late afternoon, he was gone. He could not know that Jefferson had died just hours before at Monticello, his estate in Albemarle County, Virginia.

The passing of two founding fathers on the fiftieth anniversary of America's independence seemed providential. It was, according to various journalists, "a coincidence so remarkable, that . . . the mind readily ascribes it to the decrees of Divine Wisdom"; "among the most extraordinary events in history—if not the most extraordinary event"; a "matter of reverence and admiration," which "may show to ourselves and to the world, that this great republic, marked in its early history by so many proofs of divine favour, is still guided in its career by that Omnipotent Power which raised it from depths of misery, and placed it high among the nations of the earth, a proud example of the golden prosperity and happiness."

The coincidence appeared all the more remarkable when other facts emerged. Newspapers pointed out that Jefferson died just before 1:00 p.m., the very time of day when Congress had passed the Declaration of Independence half a century earlier. Adams died around 5:00, almost fifty years to the minute after the Declaration was publicly read for the first time. Other supposed correlations made the event appear even more astonishing. Taking liberties with birth dates, one journalist reported, "John Adams was eight years older than Thomas Jefferson; Thomas Jefferson was eight years older than James Monroe; and James Monroe, eight years older than John Quincy Adams."

It all seemed God's great arrangement. The pious John Quincy Adams, accepting his father's death with Christian resignation, wrote, "The time, the manner, the coincidence . . . are visible and palpable marks of Divine favor." Daniel Webster in a eulogy to Adams and Jefferson at Faneuil Hall affirmed, "The great epic of their lives, how happily concluded! . . . If we had the power, we could not wish to reverse this dispensation of Divine Providence!"

Lafayette, Bunker Hill, the Erie Canal, and the deaths of Adams and Jefferson solidified America's image of itself as "one nation, under God." They bolstered the optimism of the nation soon known for its "go-ahead" spirit, the land of unlimited promise. But amid this growing national self-confidence, new political and social conflicts were brewing.

★　★　★　★

EVEN AS AMERICANS JOINED in jubilee, the political scene fragmented. In the summer of 1826, Vice President John Calhoun scribbled an alarmed note to James Monroe about the political upheaval of the past two years:

> Never in any country . . . was there in so short a period, so complete an anarchy of political relations. Every prominent publick man feels, that he has been thrown into a new attitude, and has to reexamine his position. . . . A new and dangerous state of things has suddenly occurred, of which no one can see the result. It is, in my opinion, more critical and perilous, than any I have ever seen.

While President Adams tried to revive the harmony of the era of good feelings, the political sands shifted beneath him. After Andrew Jackson resigned from the Senate to plot a run for the presidency, his followers and those of Calhoun and Crawford scrambled to reposition themselves.

Calhoun himself was a prime example of shifting political loyalties. He had once been close to John Quincy Adams, despite their different backgrounds. Born in 1782 on a plantation in the South Carolina back

country, Calhoun had a patchy childhood education but, brilliant and self-taught, attended Yale, where he had an outstanding record. Taking up the law, he soon became embroiled in politics. Like Adams, he denounced the British for their attacks on American ships and supported the embargo that contributed to the War of 1812. At the time, Calhoun was an ardent nationalist who supported Clay's American System. He served as a congressman from South Carolina and then as secretary of war under Monroe. Tall and gaunt, he had a massive head with a square jaw, an inflexible mouth that turned down at the corners, and bushy eyebrows that jutted over his intense eyes. Harriet Martineau called him "the cast-iron man who looks as if he had never been born, and never could be extinguished."

During the Monroe years, Calhoun grew apart from Adams. The Missouri debate crystallized deep differences between the slaveholding Southerner and the antislavery New Englander. Rivals in the 1824 presidential race, they were driven further apart after Calhoun dropped out and accepted the vice presidency (an office in those days determined separately from the presidency). Like Jackson, Calhoun was outraged by the alleged bargain between Adams and Clay, calling it "the most dangerous stab, which the liberty of this country has ever received." Soon Calhoun, a former nationalist and supporter of the American System, was the South's chief opponent of the tariff and defender of states' rights.

President Adams thus found himself in the extraordinary position of having a vice president who opposed him. As the head of the Senate, Calhoun undermined Adams. Among his duties was choosing the Senate's standing committees. Although eight of the fifteen committees Calhoun appointed consisted of Adams loyalists, he put the other committees—including key ones like the Foreign Relations, Military Affairs, Finance, Indian Affairs, and Judiciary committees—in the hands of the president's foes. A special thorn in the president's side was New York's Martin Van Buren, who as head of the Finance Committee continually fought Adams and rallied Jackson's forces.

John C. Calhoun

The hostile atmosphere in the Senate, coupled with Adams's own re-
fusal to oust foes, reduced the president's effectiveness. His policies were
farsighted but had little chance of coming to fruition. Ridicule greeted
his December 1825 annual message to Congress. Adams proposed a
range of cultural and social improvements, including an astronomical
observatory, scientific expeditions, a national university, standardized
weights and measures, a patent law to encourage inventions, and govern-
ment support for commerce, roads, and canals to be funded by the tariff
and the sale of public lands.

Many of these ideas would prove important in the long run, but they
met with harsh resistance. Even the most apparently innocent proposal, for
the observatory, aroused bitter mockery. In his speech Adams noted that
Europe had more than 130 of these "light-houses of the sky," while America

had none. It was time, he declared, for America to engage in the scientific study of space. Adams's foes twisted his praise of Europe, dredging up his former association with the Federalists to claim that he was slurring his own nation. They also made fun of the lighthouse metaphor, which they called haughty and professorial. In the decade after Adams left office, astronomy would become a national craze, with observatories popping up everywhere and Andrew Jackson in 1830 funding a scientific project that led to the establishment of a national observatory. But the hapless Adams, thwarted by rivals, could not bring his observatory into being.

Nor could he win agreement on foreign policy. This area, of course, was his strength, especially in matters relating to the Monroe Doctrine, which he had deftly sculpted to reduce Europe's interference in the Western Hemisphere. But even on this topic, about which he knew more than anyone, he met congressional interference.

At issue was the relation between the United States and the newly liberated countries to the south. Between 1804, when Haiti freed itself from France, and 1822, when Brazil escaped Portuguese rule, a total of eleven Latin American countries had gained independence. Although the spectacle of one nation after another fighting for liberty was inspiring, it also raised new problems. There was the question of Cuba, still under Spanish rule. Colombia and Mexico appeared ready to launch a joint invasion of the island or foment revolt there in order to liberate it from Spain. That threat fizzled, but in the meantime the Venezuelan revolutionary leader Simón Bolívar led a movement to unify the various South American countries militarily and politically. To that end, Bolívar organized a congress of nations to be held in Panama in June 1826.

Adams had maintained a cautious approach to the South American nations. On this point he differed from his secretary of state, Clay, an expansionist who wished to push the interests of the United States aggressively abroad. Without adopting Clay's forceful policy, Adams believed America should participate in the Panama conference to witness the proceedings and protect trade routes by ensuring that neutrality on

the high seas was preserved. He appointed two ministers, the diplomat Richard C. Anderson Jr. of Kentucky and the Philadelphia lawyer John Sergeant, to represent America at Panama.

Decades ahead of its time, this gesture toward a friendly relationship with the southern continent aroused a storm of controversy. Prominent Southerners opposed any involvement in Latin America, since they associated Haiti with slave revolts and feared that Bolívar still might lead an army of blacks against Cuba. For weeks, congressional debate raged over the Panama mission. Violence erupted, and nearly turned deadly when Virginia Senator John Randolph unleashed abuse against President Adams and Secretary of State Clay.

The cantankerous Randolph veered between brilliance and ridiculousness. Over six feet tall, with gangly arms and a small head, he typically wore an oversized coat that hung to the top of his white boots. He would stride into the Senate wearing spurs and carrying a horsewhip, trailed by a hunting hound who curled up under his desk. Part Native American (he claimed to be descended from Pocahontas) he was paradoxically both anglophile and pro-Southern. In a high, squeaky voice, he delivered rambling speeches that sometimes lasted ten hours. Every fifteen minutes or so he paused to swig from a glass of malt liquor or a brandy-and-water concoction; he could go through several quarts in an afternoon. Well lubricated, he lambasted his enemies with abandon. He did not shrink from calling Daniel Webster "a vile slanderer" or Edward Livingston "the most contemptible and degraded of beings, whom no man ought to touch, unless with a pair of tongs." It was no surprise, given his hostility to the Panama mission, that he attacked its originators, Adams and Clay, whom he labeled "the coalition of Blifil and Black George [two rascals in Henry Fielding's novel *Tom Jones*],—the combination, unheard of till then, of the Puritan and the blackleg."

Clay, though in grief over the recent deaths of his two daughters, retaliated by challenging Randolph to a duel. On April 8, 1826, the two met on a field near the Potomac. Clay's bullet ripped through Randolph's

white flannel coat without wounding him. Randolph's hit a tree behind Clay. In a second round, Clay again missed Randolph, who raised his gun and fired into the air. The men talked and reconciled. Randolph joked, "You owe me a coat, Mr. Clay." Clay replied, "I am glad the debt is no greater." Randolph respected Clay because of his courage in demanding the duel, like a true Southern gentleman. Later on, when Randolph knew he was dying, he rushed to the Senate in order to hear Clay speak, shaking his hand as he tearfully bid farewell.

The duel climaxed the Panama controversy, which ended quietly when the House approved Adams's appointees. The debate had delayed the departure of the American envoys. Sergeant, fearing disease that could come from the heat of the tropics, did not leave for Panama in time for the congress. Anderson started out but died on the way. The congress itself ended in failure. Only one of the nations represented there, Colombia, ratified the South American union.

After all the fuss, the Panama commission did little more than to worsen tensions in Washington, especially those between Adams and his vice president. Adams was livid at Calhoun for not putting a halt to Randolph's inebriated ramblings that led to the "Blifil and Black George" remark. From May through September 1826, a series of vituperative letters between "Patrick Henry" and "Onslow" appeared in the Washington newspaper *National Journal*. The former was an Adams representative; the latter was Calhoun.

On the domestic front, a major frustration for Adams was the Native American issue. Although Adams shared the prevailing prejudice of his day against Native Americans, he was more respectful than most of the natives' claims to sovereignty over their own land. He found himself confronted with a conflict in Georgia over the Creek Indians. The Creeks were the largest of the southeast's Five Civilized Tribes (called civilized because they had adopted some white ways), which also included the Cherokees, Choctaws, Chickasaws, and Seminoles. In former times, the Creeks had controlled nearly all of Georgia, but battles against whites and Cherokees had forced them to retreat to smaller lands, a third

of which they sacrificed to Andrew Jackson in the War of 1812, dividing the tribe between the Upper and Lower Creek nations.

The white leaders of Georgia resolved to move the Creeks west of the Mississippi and seize their land. George Troup, elected Georgia's governor in 1823, used persuasion and intimidation to win a treaty, signed at Indian Springs in February 1825, which would transfer Creek lands to the state within two years. Troup's cousin George McIntosh, a half-breed chief of the Lower tribe, facilitated the treaty. In May, McIntosh and several other Creeks were assassinated by members of their own tribe who saw the treaty as a despicable concession to whites. Governor Troup nonetheless carried forward with surveying the Creek land in preparation for taking it over.

In January 1826, President Adams, who considered the Indian Springs treaty fraudulent because it had not been approved by the whole Creek people, worked out the Treaty of Washington, which called for the cession of some but not all of the Creek territory. Troup continued to force both the Lower and Upper Creeks from Georgia, threatening war if the Adams administration tried to enforce the Treaty of Washington. Troup insisted that Georgia was a sovereign state and that federal interference in its affairs warranted military reprisal. Neither Adams nor Clay wanted to push the issue, since they considered Indians an inferior race that would disappear anyway. They backed down, and by 1827 virtually all Creeks were gone from Georgia.

Although Adams later criticized Jackson's Indian policy as ruthless, Adams's irresolution had the same result as Jackson's firmness: the removal of natives from their ancestral lands. In 1812 Thomas Jefferson had said of the Indians, "We shall be obliged to drive them, with the beasts of the forests into the Stony [Rocky] mountains." By 1828 the federal government had arrived at a plan to give all eastern tribes western land that would be "a *permanent* home, and which shall, under the most solemn guarantee of the United States, be, and remain, theirs forever." In the 1830s came Jackson's removal measures. Although there were some, such as the congressman John Woods, who thought the na-

tives should be allowed to stay where they were, the irresistible movement on both the state and national levels was toward forced removal.

<p style="text-align:center">★ ★ ★ ★</p>

AMERICA WAS NOT READY for President Adams's federally supported cultural programs. His proposals for military academies and an astronomical observatory failed. However, his request for a nationally funded South Seas exploring expedition eventually bore fruit. After a struggle, Adams managed to win from Congress $50,000 to support a scientific voyage to the South Seas and the Pacific, though squabbles over staffing postponed the project, which was not implemented until 1838.

The nation *was* ready, however, for continued improvements in its transportation networks. In 1825 Adams declared, "The spirit of improvement is abroad upon the earth." Having endorsed publicly funded transportation as early as 1807, he said of the American System, "I and not Henry Clay was its father." Adams had none of the constitutional scruples James Monroe had displayed when in 1824 Monroe founded the Board of Internal Improvements. For Adams, government-backed transportation was essential to America's development. Not only did the Erie Canal open under his watch, but many other canals sped to completion, including the Ohio, the Dismal Swamp, the Chesapeake and Delaware, and the Miami canals.

The canals stimulated the economy by reducing transportation costs, as did improvements to steamboats, roads, and ports. The number of steamboats and their operating tonnage both doubled during the 1820s, while upstream shipping costs dropped dramatically. The competition from canals and steamboats affected wagon shipping rates, which fell by half during the decade. The National Road was extended from Wheeling to Zanesville, and progress was made on a new road from Charleston to New Orleans. Adams also signed legislation for the improvement of the nation's harbors from Maine to Louisiana, invigorating both international and interstate shipping.

The tariff of 1824 and the Second Bank of the United States proved

beneficial as well. The modest tariff helped protect American factories without causing a large increase in the cost of foreign goods. Both imports and exports rose during Adams's presidency. The BUS under Nicholas Biddle had a steadying influence. Appointed in 1823 to replace Langdon Cheves as the head of the bank, the calm, industrious Biddle, a Philadelphia lawyer and magazine editor versed in Ricardo and Adam Smith, avoided both the rapid expansion and the rapid contraction of the money supply that had formerly hurt the economy.

The net result of these influences was a strong economy during President Adams's term. A large portion of the principal and interest of the public debt was paid. The percentage of Americans living in cities grew by more than 60 percent between 1819 and 1829, while agricultural population increased by a third. Employment in nonfarm businesses enjoyed one of its highest gains in American history.

Especially vigorous was the cotton-textile industry. For the whole Jacksonian era, cotton production approximately doubled every decade. Not only did cotton exports soar, but cloth that was once woven in American homes was increasingly manufactured in textile mills, most of them in New England. Capitalist growth, however, meant new challenges for many workers. In an era before minimum wage and other kinds of labor protection, those on the lower end of the social scale suffered severely.

There were two factory systems used for cotton production, the Fall River and the Lowell systems. In the Fall River system, which dominated the southern New England and mid-Atlantic regions, entire families were employed in the spinning and weaving of cotton. The system saved on wages by the extensive use of women and children. For a seventy-hour workweek, women received around $2.00, while the weekly wages of children went as low as ten cents. In 1816 nine of ten workers in southern New England's cotton mills were women or children. By 1832 the labor reformer Seth Luther complained that two fifths of the textile mill workers in America were under sixteen and a tenth under twelve, working long days that left no time for education. A

Massachusetts law of 1836 banned the employment of children who did not attend school for part of the year, but it and similar laws soon passed in other states were weakly enforced. As late as 1866 a government commission reported "a saddening amount of testimony" of "the frequent and gross violation" of child-labor laws.

The Lowell system developed during the Adams administration. In 1811 the Boston businessman Francis Cabot Lowell during a visit to England discovered a technique for weaving cotton cloth that he wanted to duplicate in the United States, while avoiding the wretched working conditions of British factories. He and other entrepreneurs formed the Boston Manufacturing Company and in 1814 established a factory for spinning and weaving at Waltham, near Boston. Soon another site was chosen on the Merrimack River near a tall waterfall that supplied additional power. Called Lowell, the new factory town opened in 1823. It rapidly became the nation's most productive site of textile manufacturing. Factories on its model sprang up throughout northern New England.

The Lowell system used single women, who were usually between the ages of fifteen and twenty-five. Typically they were farmers' daughters who worked for a few years before returning home or getting married. They toiled more than seventy hours a week for the relatively high average weekly wage of $2.50, half of which went toward board in company boardinghouses, where matrons closely watched them. Sunday was a day of required church attendance, reading, and meditation. The factories were brick structures of several stories capped by white belfries. Nearby were churches, schools, and libraries built by the company to create a salubrious environment. Despite their heavy work schedules, the women remained intellectually active. By 1840, when twenty thousand people lived in Lowell, the town boasted no fewer than seven journals, the most famous of which, the *Lowell Offering*, was completely written and edited by the mill women.

Lowell showed many of the strengths and some of the shortcomings of the American factory system. Economically, it was a success. In the jubilee year, 1826, it was touted along with the Erie Canal as a symbol

of the nation's bright economic future. Over the next two decades, Lowell became an obligatory stop for touring foreigners like Harriet Martineau and Charles Dickens, who raved about it. By 1844 its factories used an eighth of the cotton grown in the United States, producing a hundred million yards of printed cotton a year. Cotton cloth was the nation's leading industrial product, and Massachusetts factories produced a quarter of it. Under the Lowell system, women enjoyed independence, conviviality, and culture.

Still, toiling up to fourteen hours a day in noisy rooms filled with suffocating cotton particles was not pleasant. Nor was living in boardinghouses so crammed that in some cases six women shared the same room, two to a bed. The church-attendance requirement and the constant moral policing could also be burdensome. Discontent among workers was present from the start and increased over time. In 1828 came the nation's first strike by women textile workers at a Dover, New Hampshire, factory, where hundreds of women turned out to protest against factory regulations. In 1834 a cut in wages prompted a huge strike at Lowell, followed by another one two years later. The 1840s brought widespread actions for a ten-hour day.

None of these demands was new in the history of American labor. As early as 1791, Philadelphia carpenters had struck for a ten-hour day and higher wages. But just as the 1820s brought new dimensions of economic growth, so they brought intensity to labor protest. President Adams was living dangerously when he pushed the American System in the years just after the depression of 1819–23. Many still regarded the panic as the product of manipulation by bankers and other capitalists. The Supreme Court's landmark probusiness decisions during these years made the alleged capitalist conspiracy seem all the more threatening. In 1825 the richest 1 percent of Americans living in large cities controlled a quarter of the wealth there. The numbers were similar in smaller cities and rural areas.

As corporate America strengthened, so did opposition to it. Widening class divisions alarmed those who contrasted the increasing wealth

of the so-called idle rich with the hardscrabble lives of workers. "There appears to exist two distinct classes," announced a labor paper in 1828; "the rich and the poor; the oppressor and the oppressed; those who live by their own labor, and they that live by the labor of others."

The movement toward labor unions and political organization, which had flickered since the beginning of the century, flamed in the 1820s. In 1824 weavers in Pawtucket, Rhode Island, struck to prevent wage cuts and extended hours. The next year the newly formed United Tailoresses of New York took similar action. Labor activity heated up in Philadelphia, where house carpenters in 1827 went on strike to achieve reduced summer hours. Although nothing came of the action, several Philadelphia crafts joined that year in forming the Mechanics' Union of Trade Associations, which started the nation's first labor newspaper, the *Mechanics' Free Press*, and organized a large (though unsuccessful) strike for a ten-hour workday.

One of the most original challenges to economic inequality came from an unlikely source: an affluent owner of textile mills. The British magnate Robert Owen got rich from cotton and yet was horrified by the injustices of the industry. As the owner of textile factories at New Lanark, Scotland, he created a safe, sanitary environment and avoided hiring children younger than ten. A deist and utopian socialist, he lectured widely and wrote books criticizing sectarian conflicts and economic competition. Planning to put his social ideas into practice in America, in 1825 he purchased a large tract by the Wabash River in Indiana. Owen named his community New Harmony. With nine hundred followers he settled in New Harmony and established a cooperative community where workers received credit at the local store instead of wages. Owen soon instituted a form of communism by which residents shared ownership of lands and buildings.

Like most utopian experiments of the day, New Harmony was short-lived. Within four years it had collapsed, the victim of infighting and apathy. But it spawned many imitators; before 1830 some twenty-nine Owenite communities had sprouted in several states. One of them, at

Nashoba, Tennessee, was led by Frances Wright, another freethinking British émigré, who formed a community that combined Owenite cooperation with Abolitionism and opposition to traditional marriage. Nashoba proved as fleeting as New Harmony. The tall, auburn-haired Wright, a striking presence on the lecture platform, went on to become a fiery advocate of radical causes, among them labor reform, which she promoted along with Owen's son, Robert Dale Owen.

Owen and Wright settled in New York, where they edited a progressive newspaper, the *Free Enquirer*, and became part of a labor-reform crowd that also included the editors George Henry Evans and Thomas Skidmore. Similar groups appeared in Boston, led by Seth Luther and Theophilus Fisk, and Philadelphia, headed by William Heighton, Stephen Simpson, and Langdon Byllesby. All resented the class divisions they believed resulted from exploitation of workers by capitalists.

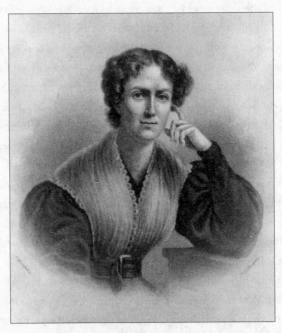

Frances Wright

The reformers differed in their proposals. Skidmore called for redistributing wealth by abolishing inheritance. Owen and Wright, holdovers of the Enlightenment, pushed a universal system of public education to combat the ignorance and religious intolerance they thought held workers down. Simpson lambasted "the *banking system*," calling it "that fruitful mother of unutterable affliction to the sons of industry, which brought us, at one fatal step, into the vortex of English aristocracy." Evans demanded that the government give free western land to urban workers, an agrarian dream he later revived in his National Reform Association, with its slogan "Vote Yourself a Farm"; modified, land reform was adopted by the Free-Soil and Republican parties, leading to the Homestead Act of 1862.

The lack of early consensus explains the failure of workers to establish a lasting political party. Philadelphia's labor leaders in 1828 formed the Working Men's Party, which advocated the ten-hour day, a mechanics' lien law, and free public schools. A Workie party also emerged in New York, with its own paper, the *Working-Man's Advocate*. The New York Workies ran strongly in the 1829 election, winning a seat in the state senate, another in the assembly, and almost electing the radical Thomas Skidmore.

But the Workie flame soon died, snuffed out by internal dissension and co-opted by the major political parties, which succeeded in attracting workers with their populist rhetoric. In two years, the working-men's parties in Philadelphia and New York were gone, though many small groups survived elsewhere.

Meanwhile, there raged one of the greatest storms in American political history, sweeping into the presidency the nation's most charismatic leader.

* * * *

THE FLUID POLITICAL ATMOSPHERE produced two major blocs that faced off in the presidential contest of 1828: the National Republicans, headed by Adams and Clay, and the Jacksonians (soon called

Democrats), an assembly of Adams's opponents who gathered around Old Hickory.

At the same time, another movement, the Antimasons, had unexpectedly appeared. Originating in 1827 in western New York, Antimasonry at first seemed like a splinter group that would disappear. Surprisingly, the party grew rapidly in New York and through much of New England and Pennsylvania. Soon it was a national force.

The cause of the Antimasonic movement was the kidnapping and apparent murder of William Morgan, an unemployed bricklayer in Batavia, New York. Morgan had joined a local chapter of Masons but fell into a dispute with its members. Morgan enraged the Masons by threatening to publish a retaliatory book revealing their secret rites. Morgan was jailed on a trumped-up charge for debt, released, and then quickly jailed again. On September 12, 1826, men later exposed as Masons appeared at the jail and paid his debt. They carried him off in a carriage, taking him to Fort Niagara. Then all trace of him disappeared. It was widely assumed that the kidnappers had murdered Morgan. A year later a man's decomposed body was discovered in the Niagara River. Though positive identification of the corpse was impossible, the story spread that the murder victim had been found. Was the cadaver really Morgan? It was "a good-enough Morgan until after the election," the saying went.

Four men confessed to the abduction and were brought to trial but received light sentences. Antimasons charged that the crime was committed by a wicked cabal that had infiltrated American life. Not only had Masons murdered Morgan, but his killers had gotten off virtually free as the result of a rigged trial in which most of the participants were Masons. Dangerous and widespread, the Masons threatened to create "a state of society as revolting as would be the vicinity of the prowling savage, with his midnight tomahawk and scalping knife," one journalist wrote. The Morgan case, in this view, showed the amorality of a secret brotherhood that victimized common people.

But how about the many distinguished Americans who had been

Masons, such as Washington, Franklin, Hancock, Patrick Henry, Monroe, and Lafayette? Yes, said the Antimasons, in a former time Freemasonry and patriotism fit, but not now. The Masonic brotherhood, they argued, was undemocratic in its secrecy, sacrilegious in its rituals, and elitist in its exclusiveness.

The Antimasonic movement became the home for those who felt left out of the major parties, especially rural evangelical Christians and opponents of slavery. Because Freemasonary increasingly attracted upwardly mobile professionals, it seemed clubbish and aristocratic, stirring resentment among the country folk who swarmed to the Antimasons. The Rochester editor Thurlow Weed organized the movement, which became the training ground for some of the period's most prominent figures, including William Henry Seward, Thaddeus Stevens, Horace Greeley, William Lloyd Garrison, and Millard Fillmore—all, except the last, destined to be leading antislavery spokesmen.

In state elections between 1827 and 1830, the Antimasonic Party performed well in New York and several other northern states. By the early 1830s the movement had become a vocal opponent of Andrew Jackson, a well-known Mason. In 1832 it became the first political party to hold a national convention, nominating William Wirt for president. By then, the party boasted over one hundred newspapers nationwide. It won the governorships of Pennsylvania and Vermont. The movement soon died, however, as the perceived threat of Freemasonry faded and the Whig Party took its place in challenging the Jacksonians.

One of the main targets of Antimasonic wrath was Martin Van Buren, the U.S. senator from New York who organized the emerging Democratic Party. By the time the Antimasons appeared, Van Buren's chief goal was the victory of Andrew Jackson in the presidential election of 1828. Van Buren wanted the presidency for himself but knew he would have to wait his turn. Neither the Antimasons nor anyone else would outsmart the smooth manipulator whose nicknames, the Red Fox and the Little Magician, reflected his political savvy.

Born in Kinderhook, New York, in 1782, Van Buren was the son of a

farmer and tavern keeper descended from early Dutch settlers. His father's tavern was a political gathering place, and as a boy Van Buren heard debates over candidates and issues. At thirteen he quit school and apprenticed in law. Five years later he got a law job in New York City, where he stayed three years before returning to Kinderhook to practice law and run for office. In 1807 he married his childhood sweetheart and distant cousin, Hannah Hoes. They had four sons before her untimely death twelve years later. Van Buren became associated with Tammany Hall politicians known as the Bucktails for the buck's tail they wore on their hats at political meetings. Van Buren was elected a state senator and went on to become New York's attorney general.

Short and paunchy, Van Buren had thinning sandy-red hair, muttonchop whiskers, and glittering eyes. A dapper man of great charm, wit, and manners, he was an effective organizer and strategist. As a leading Bucktail, he founded the political machine known as the Albany Regency, which controlled thousands of political jobs in the state. It was he who masterminded the change in New York's election laws that opened the vote to most white males. A Jeffersonian Old Republican, he was elected in the early 1820s to the U.S. Senate.

He supported William Crawford in the 1824 presidential race, but when Crawford's fortunes dimmed, he saw Jackson as the potential unifier of the anti-Adams forces. In the Senate, he helped stonewall Adams's policies and open the way for Jackson. A perennial foe of Federalism, Van Buren wanted to revive the two-party system that pitted the nationalist American System against a party that stood for states' rights and a limited federal government. Although Jackson waffled on such issues, he was so popular a hero, and so different from the crusty Adams, that he seemed the perfect presidential candidate.

In December 1826, Van Buren met with Vice President Calhoun to plot Jackson's election and coordinate opposition to the Adams administration. Calhoun desired the presidency just as much as did Van Buren, but he too sensed that his time had not come. Having abandoned

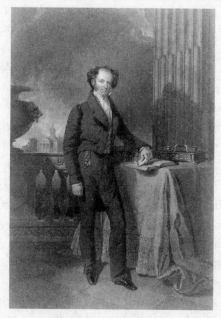

Martin Van Buren

nationalism for states'-rights republicanism, Calhoun agreed to throw his weight behind Jackson. Van Buren then contacted the influential Richmond editor Thomas Ritchie about reestablishing the Virginia–New York Republican axis that had formerly opposed New England Federalism. Ritchie jumped on the Jackson bandwagon, promising to support him in the columns of the *Richmond Enquirer.* The Richmond junto was aboard.

Soon enough, so was the Nashville junto. Jackson's home state of Tennessee already had in place a tight team, which included the planter and bank president Judge John Overton, the ex–Indian fighter Major William B. Lewis, the lawyer-politician John H. Eaton, and the militia officer Sam Houston. When Van Buren approached the group about a coordinated effort behind the general, it responded enthusiastically.

The Little Magician then strengthened Southern backing of Jackson in a March 1827 tour that took him to Savannah, Raleigh, Charleston, and Richmond.

By mid-1827 the Jackson juggernaut was a reality. Van Buren had helped get it moving, but even he could not foresee its power. Andrew Jackson was one of the rarities of American politics: a man whose personal magnetism transcended his flaws. To his opponents, he was ignorant, violent, politically inexperienced, even immoral. But few could deny his courage, his self-reliance, and his ability to rise above adversity.

At sixty, the white-haired Jackson was a sick man. The bullet in his shoulder had created a chronic bone infection, and the one in his chest aggravated a lung condition that caused uncontrollable coughing fits, producing what he called "great quantities of slime." He was arthritic, nearly toothless, and given to headaches. But he endured. He was tough. He expressed strong passions. He had come from a modest background and had become a leader. Though wealthy, he was unmistakably the people's hero. More than ever, he was Old Hickory.

Melville in *Moby-Dick* praises the "great democratic God! . . . who didst pick up Andrew Jackson from the pebbles; who didst hurl him upon a war-horse; who didst thunder him higher than a throne!" But one does not have to look to God to explain Jackson's rise to power, which resulted from careful planning, tight organization, and well-timed mudslinging.

By late 1827 every state in the Union had established a network of committees in support of Jackson. Local committees were linked with county and state committees that communicated with committees in other states. If President Adams pointed toward the future in his federally funded improvements and firm foreign relations, Jackson was prophetic in his ability to garner such passionate support that many states around the nation organized on his behalf.

He was also innovative in campaigning for himself. Presidential candidates did not usually do so. As one politician commented, "Candi-

dates for the Presidency . . . ought not to say one word on the subject of the election. Washington, Jefferson, & Madison were as silent as the grave when they were before the American people for this office."

Jackson, in contrast, was not silent. He wrote a steady stream of newspaper articles (edited by others to correct his faulty English) in which he warded off attacks and defended his views. He corresponded with politicians around the country. He supervised a team of busy campaigners who traversed the country distributing pamphlets and handbills. He encouraged the creation of a huge nationwide network of supportive newspapers, led by Washington's *United States Telegraph*, edited by the aggressive Duff Green.

Unlike Adams, Jackson knew how to make the most of an important appearance. When Adams was asked to woo Pennsylvania farmers by appearing at a canal celebration and using his knowledge of German, he declined, explaining that electioneering was against his taste and principles. He refused many other opportunities to campaign as well. Although Jackson did not abandon altogether the code against personal campaigning, he exploited his magnetic effect on crowds. When invited to appear in New Orleans on January 8, 1828, the anniversary of his famous battle, he agreed to do so if the event were kept "non-political."

The result was a celebration almost as grand as those for the Erie Canal opening or the Bunker Hill Monument. Jackson arrived by steamboat, and as soon as he landed, an explosion of cheers and cannon greeted him. Laudatory speeches and the general's ceremonial review of his surviving troops followed, with a tremendous dinner in the evening. The event was, said a reporter, "the most stupendous thing of the kind that had ever occurred in the United States"; from another perspective, it was "like a Dream. The World has never witnessed so glorious, so wonderful a Celebration."

It took more than special appearances or aggressive campaigning to ensure Jackson's victory. Also significant were practical efforts in Congress to sway certain states in the Hero's direction. One avenue Jackson's supporters chose was surprising: a new tariff. Traditionally, the

tariff was associated with the American System endorsed by Adams and Clay. Adams's opponents turned the tables on him by pushing a high tariff that they believed would wound the president. They were right.

Martin Van Buren's Bucktail ally Silas Wright, who had been elected to the House of Representatives in 1826, proposed a high tariff that raised duties between 30 percent and 50 percent on raw materials like wool, hemp, and iron, as well as on molasses and sail duck. A ploy to gain votes for Jackson, the tariff offered high protection to Middle Atlantic and Western states that produced certain raw goods while leaving the South and the East largely unprotected. The measure seemed so unfair that many then and since have assumed it was created by opponents of tariffs in order to be defeated. Henry Clay said the authors of the tariff did "not really desire the passage of their own measure" but instead hoped to make tariffs look absurd by presenting a caricature of one. Historians have shown, however, that the Jacksonians sponsored the tariff in order to court states like Pennsylvania, New York, Ohio, Kentucky, and Missouri that were crucial to Jackson. The South was appalled by the tariff but was securely in the Jackson camp anyway, with no intention of going for Adams. And so, with strong encouragement from the states it promised to benefit, the measure passed over the complaints of those who labeled it the Tariff of Abominations.

In the end, the tariff backfired on Jackson and created the greatest crisis of his presidency. The South's revulsion for the tariff found expression in Calhoun's pamphlet *Exposition and Protest*, which laid the ground for the nullification controversy of 1832, in which South Carolina's rejection of the tariff almost led to its secession from the Union. But in the 1828 election, the tariff did its intended work, since the states it helped went overwhelmingly for Jackson.

As the election approached, mud flew in all directions, creating one of the nastiest races in American history. The Jacksonians repeated ad nauseam the charge that Adams was president as result of a corrupt

bargain. They also painted him as a pampered aristocrat who filled the White House with leisure items such as a billiard table and a fancy chess set, purchased with public money. His wife, they charged, was born out of wedlock, and Adams had lived with her before marriage.

Their wildest accusation was that Adams had a history as a pimp. According to a story that circulated in the Jacksonian press, Adams, while serving as a minister to Russia, had turned his attractive nurse-maid, Martha Godfrey, over to Czar Alexander, exchanging sexual favors for political ones.

In his diary, Adams fumed that this fabricated tale was "a new form of slander—one of the thousand malicious lies which outvenom all the worms of the Nile, and are circulated in every part of the country in newspapers and pamphlets." He publicly corrected the story by explaining that the czar had met the maid briefly with not the least suggestion of illicit intentions. But his opponents ignored the explanation just as they dismissed evidence that he had bought the billiard table with his own money or that he and Louisa were sexually irreproachable.

While Adams griped about "the numberless calumnies and forgeries now swarming in the newspapers against me," his supporters hurled lots of mud too. They made much of the anomalies of Jackson's marriage, claiming that when Jackson wed Rachel Donelson before making sure her first husband had divorced her, the pair lived illicitly for two years before getting legally married. As one opponent asked, "Ought a convicted adulteress and her paramour husband to be placed in the highest offices of this free and Christian land?" Another asked, "If General Jackson should be elected President, what effect, think you, fellow-citizens, will it have upon the American youth?" Nor did the sexual slurs stop with Jackson himself. His mother, it was reported, had been "a COMMON PROSTITUTE" who "afterwards married a MULATTO MAN, with whom she had several children, of which number General JACKSON IS ONE!!!" In this imaginative tale, Jackson had an older brother who was sold as a slave in South Carolina.

Then there was Jackson's violence, which his opponents portrayed as uncontrollable and brutish. His duels, canings, and street fights marked him as a murderous thug, they said, and he had executed, without just cause, six militiamen during the Creek War and several other soldiers and Indians in different conflicts. The Philadelphia editor John Binns sensationalized Jackson's alleged crimes by publishing a sheet known as the Coffin Handbill, which featured pictures of eighteen black coffins and stories illustrating "Some Account of some of the Bloody Deeds of General Jackson." Meant to harm Jackson, this and similar handbills may have piqued additional interest in him. For an American public that would soon dive enthusiastically into sensational penny newspapers and P. T. Barnum's freak shows, coffin handbills held a lurid fascination.

At any rate, being bombarded by filth did not much diminish Jackson's popularity. Pro-Jackson rallies, parades, barbecues, and other festivities abounded. Towns and villages around the nation put hickory poles in public squares or along streets. Hickory canes, hickory sticks, hickory brooms were everywhere. Placards blazoned the words "Jackson and Reform." The meaning of the words was not clear, given the General's fuzziness on major issues. But Jackson had the genuine conviction that he was the people's champion come to wage war on corruption and patronage.

For President Adams, the hoopla surrounding Jackson was a dreary spectacle. Completely averse to campaigning, Adams virtually conceded victory to Jackson as early as December 1827, long before the election. He told Clay that there was a "base and profligate combination" against him, and "General Jackson will therefore be elected."

His words were prophetic. Jackson won the election by a comfortable margin. In the staggered balloting process of those days, different states held elections from September through November. In the electoral college, which met on December 3, Jackson gained an overwhelming victory. He won all the states to the west and south of New Jersey, except for Maryland and Delaware. In New York, where electoral votes

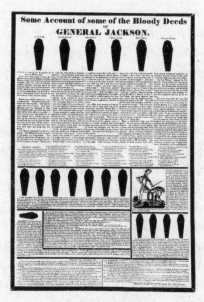

The Coffin Handbill

were split, he beat Adams twenty to sixteen. As anticipated, New England went for Adams, though Jackson managed to squeeze one electoral vote out of Maine.

The popular vote was closer, with 642,553 going to Jackson and 500,897 to Adams. Since the general had only a small popular edge in the swing states of Ohio, Kentucky, and New York, even the electoral race was tighter than it appeared. Nationally, though, 56 percent of all those who voted chose Jackson, a margin unmatched in the nineteenth century.

Voter participation surged. More than twice as many eligible voters cast ballots than four years earlier. The increase was partly due to the fact that four states—New York, Vermont, Georgia, and Louisiana—had recently transferred the selection of presidential electors from the legislature to the people. But the swelling turnout also owed much to the

unprecedented excitement of the campaign, particularly the magnetism of the man known as the Hero of New Orleans, or simply the Hero.

Jackson called his victory "the triumph of the virtue of the people over the corrupting influence of executive patronage." But he had qualms about his forthcoming presidency. "Responsibility so great," he wrote, "I cannot anticipate without disquietude or fear," because of "my inadequacy to meet its numerous, and arduous requisitions." The harshness of the campaign had left him feeling down. He confessed, "I am filled with gratitude, still my mind is depressed."

Within a month of the certification of his victory, he suffered a tremendous blow: the death of his wife, Rachel. The deeply pious Rachel had always looked askance at her husband's political activities. She wanted the White House for him, but not for herself. She prized the small chapel he had built for her on the grounds of the Hermitage more than she did the trappings of power. "I would rather be a door-keeper in the house of my God," she said, "than to dwell in that palace in Washington." She was disturbed that her husband was so wrapped up in politics that he didn't make a public profession of faith (that would come after her death, when grief drove him to piety).

But she supported him—and, in private life, governed him. Having experienced chest pains for a year, she suffered her final illness while preparing a massive victory celebration to be held for him at the Hermitage on December 23, 1828. Reportedly, she was shopping in Nashville when she went to relax in the parlor of an inn, where she overheard locals gossiping about reports of her having committed adultery and bigamy—the kind of reports her husband had tried to shield her from during the campaign. She was overcome with heart spasms. After several days of seizures, she died. The many notables who arrived at the Hermitage for a victory banquet attended a funeral instead.

Convinced that his wife had been killed by vicious rumormongers, Jackson had her buried near his home beneath a granite slab inscribed with an epitaph that included the line: "A being so gentle, and yet so virtuous, slander might wound, but could not dishonor." The memory of

Rachel obsessed him. Until his death, he wore a miniature of her. In his room, he kept a picture of her as a young woman, plumply beautiful with lustrous eyes, full lips, and dark ringlets accented by a lace cap that hung veil-like to her shoulders. He constantly read her Bible and prayer book, and he insisted on being driven around Washington in a carriage he had bought for her.

He found female companionship in Emily Donelson, the twenty-one-year-old wife of Rachel's nephew, and Sarah Jackson, who was married to Rachel's adopted son. The beautiful, headstrong Emily and her husband moved into the White House, where she served as hostess and gave birth to three of her four children before her death of tuberculosis in 1836. Sarah tended to the Hermitage, then took over as unofficial First Lady when Emily fell ill. Surrounded by relatives, Jackson had the semblance of a family atmosphere.

President Adams also confronted tragedy. In the months after losing the election, Adams retired to his home in Quincy, where he and Louisa struggled with melancholia and even more so with signs of mental disorder in their son George. Given to loose living, George had been a constant worry for his parents. He dabbled in Massachusetts politics, serving briefly in the state legislature, but never showed the ambition or the discipline of his father or grandfather. He fought alcoholism and grew irritable.

His parents barraged him with advice and admonition, but to no avail. By the spring of 1829 his erratic behavior gave way to lunacy. In the early morning darkness of April 30, while on a steamboat between Providence and New York, George had hallucinations, wandered around the boat, and fell (or jumped) overboard. Several weeks later his body washed ashore. His parents were paralyzed with grief.

It is a testament to the resiliency of Jackson and Adams that both rebounded from these crushing blows. Although Jackson never regained his former happiness after losing Rachel, he not only persevered but proved himself over two terms to be one of the most forceful and influential presidents in American history. Although Adams's depressive

tendencies worsened after his son's apparent suicide, he gained unexpected prominence as a congressman who stood firm against the Southern slave power.

Jackson had taken the presidency from Adams, but Adams had not wholly lost. Time would prove that "John Quincy Adams / Who can write" could also fight. And "Andrew Jackson / Who can fight" could use words as dexterously as he had once used pistols.

3

Jackson's Presidency: Democracy and Power

The people's president had arrived—the first from the West, the first born in a log cabin.

Andrew Jackson's inauguration on Wednesday, March 4, 1829, sparked raucous enthusiasm. Crowds flanked the Hero as he walked in a military procession down Pennsylvania Avenue to the Capitol to deliver his inaugural address. Wearing black in memory of Rachel, the silver-haired Jackson waved at the cheering horde as gigs and carts pursued him. After witnessing the swearing-in of his vice president, John C. Calhoun, in the Senate chamber, he emerged on the Capitol's east portico. The thousands who had gathered outside roared in greeting (amid the distraction, pickpockets had a field day).

The president delivered a short speech that prompted more clamor from the onlookers, who, after the oath of office was administered, rushed forward and swarmed around him. Forced inside the Capitol, he soon came out another exit and mounted a white horse that took him to the White House, which was open for a public reception. People, many of them office seekers, flocked to the mansion to see the president and enjoy the spiked punch that was brought out in tubs. "The reign of KING MOB seemed triumphant," wrote an observer. The multitude pushed so eagerly that the president finally fled through a rear exit. When the celebration ended, the White House was a mess, with shattered glass and

china strewn about and furniture torn by those who had stood on it to gape at the president.

In the inaugural address, Jackson vowed to balance federal authority with states' rights, to deal with foreign nations from a position of strength, and to get rid of abuses in government. Committing himself to "the task of *reform*," he pledged to take government jobs out of "unfaithful or incompetent hands" and give them to "men whose diligence and talents will insure in their respective stations able and faithful cooperation."

Bold proposals. How did he live up to them?

Better than most had expected. No one was quite sure what a Jackson presidency would bring. In 1824 Jefferson had exclaimed, "I feel much alarmed at the prospect of seeing General Jackson President. He is one of the most unfit men I know of for such a place." Jefferson explained, "His passions are terrible. He is a dangerous man." Just before Jackson took office Daniel Webster said: "Nobody knows what he will do. . . . The city is full of speculation." Jackson himself knew that he was widely viewed, in his words, as having "a savage disposition," as one who "carried a scalping knife in one hand, and a tomahawk in the other, allways [*sic*] ready to knock down, and scalp any and every person who differed with me in opinion."

But the years had mellowed Jackson. Rachel's death in particular had sobered him. As president, he proved firm, at times irascible, but tactful and judicious, with a surprising ability to hear opposing points of view and to respond wisely to difficult situations. Not that his presidency was altogether successful. His eagerness to reform the government led him to make some ill-advised appointments that mired him in unnecessary battles. His removal of Indians from their native lands laid him open to charges of cruelty and racism. He found it difficult to deal with France, Latin America, and slavery. His single-minded effort to destroy the Bank of the United States blinded him to certain benefits that a well-managed bank could offer.

Still, even in his failings he showed a consistency of purpose related

to his goal of serving the American people. His many civil service appointments reflected his zeal to democratize a system that he believed had become corrupt and aristocratic. His Indian policy, though severe, was actually a firm implementation of the weakly pursued policies of previous presidents. In foreign affairs, his failures in Latin America were countered by several successes, especially in establishing trade agreements with other nations. Whatever one might think of his hostility to the Bank of the United States, it is hard to ignore his fundamental motive of fighting for the rights of average Americans against entrenched institutions; besides, he always had in mind establishing some sort of institution to carry out what he came to understand were the bank's legitimate and beneficial functions.

A believer in small government and individual freedom, Jackson nonetheless strengthened the executive office, setting a pattern for many activist presidents to come. He used the veto power frequently and boldly. He respected the rights of individual states but stood firm for the Union when South Carolina threatened secession during the nullification crisis. He opposed internal improvements when he thought they were not national in scope, but in the end he exceeded even John Quincy Adams in federally funded projects, spending $16 million in eight years, compared with Adams's $6.2 million in four.

Critics of Jackson note that the president who rose to power criticizing patronage and partisan politics outdid his predecessor in both. In this view, Jackson fathered the corrupt spoils system. But for Jackson, patronage was in the Adams camp, not his. To freeze civil service jobs, Jackson believed, was wrong because it prevented reform. The American people had called for change. This was made clear not only in the presidential contest but also in the congressional race. The 1828 election left the Jacksonians in control of both houses of Congress—of the House of Representatives by a large margin. The people had spoken. The president simply followed their will by appointing those who shared his views.

Actually, patronage had long been part of presidential appointments, starting with Washington and peaking with Jefferson, then

subsiding. It took on new intensity with Jackson. Presidents from Washington through John Quincy Adams had removed and replaced a total of 212 presidential officers. Jackson replaced 252. In the first month, he made as many as John Quincy Adams had made in four years. Notoriously, some fifty-five of Jackson's appointees were newspaper editors who had backed him in the election. Current officeholders were dismissed without the customary written charges demanding explanation or refutation.

But Jackson over the years has been unfairly associated with the clumsy boast made by his supporter Senator William T. Marcy of New York, "To the victor belong the spoils of the enemy." The record shows that Jackson was no spoilsman. During his eight years in office, he replaced only around a tenth of the nation's civil servants. Still, he believed in what he was the first to call rotation in office, used by many later presidents. Rotation, he thought, brought democratic ventilation. Almost any able person was capable of filling a government job. As he declared in his first message to Congress, "The duties of all public offices are, or at least admit of being made, so plain and simple that men of intelligence may readily qualify themselves for their performance."

He held previous chief executives responsible for fostering corruption through their reluctance to make reappointments. The charge was valid: Over the previous decade, nearly half a million dollars had been embezzled in the Treasury Department, and other irregularities arose in military contracts, Indian affairs, and the Bank of the United States. "Officers in their public and private relations," Jackson insisted, "should be examples of fidelity & honesty; otherwise . . . they will have to be removed." Observing this principle, he wrote, would "elevate the character of the government, and purify the morals of the country."

There can be no doubt of Jackson's wholesome intentions. He made several strong appointments of people who exemplified the uprightness and capability he sought. Still, his judgment in making appointments was often mediocre and sometimes abysmal.

His worst choice was Samuel Swartout as the collector of the Port of

New York. This post demanded high integrity, since it meant handling millions of dollars yearly. Swartout did not fill the bill. Held suspect by Van Buren and the New York Regency, he was a lax, undisciplined man whose strongest qualification was long-term loyalty to Jackson; he once stated that anyone who supported Adams instead of Jackson deserved to hang. Van Buren warned Jackson against appointing Swartout, but the president did so anyway. Within four years, Swartout had pocketed over $200,000 of public funds. By the end of his eight-year tenure, the amount had reached an astounding $1.22 million—a figure that exceeded all the thefts in the Adams administration combined. When the crime was discovered, Swartout fled to Europe.

Jackson's selection of his first cabinet was generally inept. The exception was Van Buren, who immediately surrendered the governorship of New York (which he had just won) to accept Jackson's offer of the State Department. Van Buren had been a chief architect of Jackson's rise to power and proved to be an invaluable asset to the president. The prudent, shrewd Van Buren genuinely admired Jackson's mind and character. The feeling was mutual. The Little Magician still had his eye on a later run at the presidency. Over the next few years, he used his closeness to Jackson to undermine his chief competitor, John C. Calhoun.

Jackson wanted to retain Adams's postmaster general, John McLean, who instead opted for a place on the Supreme Court. Jackson filled his place in the postal department with the incompetent William T. Barry, a Kentucky politician who eventually resigned under charges of corruption. Jackson gave the attorney generalship to John McPherson Berrien, a senator from Georgia who sided with the president on Indian removal. The Navy Department went to another crony, John Branch, a North Carolina senator who shared Jackson's views of banks and states' rights. For the Treasury, Jackson chose the Pennsylvania politician Samuel D. Ingham to please the Calhounites. It was not a distinguished group. "The Millennium of the Minnows!" a wag quipped.

As it turned out, one big fish caused most of the minnows to die. Jackson wanted someone very close to him in the cabinet. For the War

Department, he focused on two possibilities: Hugh Lawson White and John H. Eaton, colleagues from Tennessee. White was the more qualified of the two, but Jackson went with Eaton, the better friend. It was the height of folly to hand over the important position of secretary of war to John Eaton, who was at the center of a sex scandal. By making this ill-advised appointment, Jackson put his entire presidency on the line.

Two months before Jackson's inauguration, Eaton, a stout, genial widower, married the dark-haired beauty Margaret (Peggy) O'Neal Timberlake. Independent and outspoken, she was the daughter of the keeper of a Washington boardinghouse where many politicians, including Eaton and Jackson, often stayed. Peggy had married the Navy purser John Timberlake and had three children by him. Struggling financially, Timberlake went to sea as a Navy lieutenant. While he was away, Peggy was seen with other men, including Senator Eaton. Timberlake, reportedly devastated by her rumored infidelities and financial irresponsibility as well as by his own fragile health, appears to have slit his throat while on a ship in the Mediterranean. After his apparent suicide, Peggy wed Eaton, with Jackson's blessing. Washington society was horrified by Eaton's marriage to an allegedly loose woman with whom he appeared to have committed adultery. "Eaton," sneered one politician, "has just married his mistress, and the mistress of eleven doz. others!"

Jackson never believed the tawdry stories that surrounded the newlyweds. For one thing, Eaton was, like himself, a Mason, as had been John Timberlake. According to the oath of the brotherhood, a Mason, unless he was "the basest man on earth," would never sleep with another Mason's wife, Jackson wrote. More important, a woman's virtue was under attack—an issue that had always stirred Jackson's deepest sense of honor, as when his beloved Rachel had been labeled a bigamist.

Washington split into warring factions. One side, led by the president and his secretary of state, ardently defended the Eatons. The other, led by the wives of various cabinet members, turned a collective cold shoulder to Peggy Eaton, refusing to appear with her at social gatherings. Jackson also faced disruption in his private life; his niece Emily

Donelson disapproved of Mrs. Eaton and left the White House for Tennessee, remaining estranged from the president for a year. Two clergymen, the Reverend John M. Campbell of Washington and the Reverend Ezra Stiles Ely of Philadelphia, presented Jackson with supposed evidence of the Eatons' immorality.

The matter would have been trivial if it hadn't consumed Jackson's time and energy. The president devoted much of his first six months in office to sparring over Peggy's virtue. He wrote scores of pages of letters about the matter. He even called a cabinet meeting that culminated in his outcry, "She is as chaste as a virgin!" When the Washington social season came around, Peggy Eaton was snubbed by one political wife after another. The spouses of John Branch, Samuel Ingham, and William Barry refused to see her. At the head of the prudish pack was Floride Calhoun, the vice president's wife.

The division between Jackson and his vice president was exacerbated not only by the Eaton malaria or Petticoat Affair, as it was called, but also by the quarrel over state sovereignty. Jackson was committed to states' rights, but not at the expense of the Union. He had once declared he would rather "die in the last Ditch" than "see the Union disunited." He was appalled when Calhoun, the former nationalist, wrote South Carolina's nullification pamphlet *Exposition and Protest* in response to the Tariff of Abominations. The issue gained new urgency in January 1830 after the exchange on the Senate floor between South Carolina's Robert Y. Hayne and Daniel Webster of Massachusetts. Hayne argued that a state, as a sovereign entity, could nullify federal rulings when it chose, even to the extent of seceding from the Union. Webster in his famous second reply to Hayne—parts of which a generation of schoolchildren would be forced to recite—insisted that the Union was comprised of people, not states, and that federal laws were binding on all. "Liberty *and* Union," Webster thundered, "now and forever, one and inseparable!"

Jackson vented his hatred of nullification at the annual Jefferson birthday dinner held at the Indian Queen Hotel on April 13. As the day approached, he could see from newspapers that the Calhounites planned to

make the dinner "a *nullification affair altogether*," as he put it. At the dinner, over a hundred formal toasts were given, with Hayne and others hailing state sovereignty. When Jackson's turn came, he fired a rhetorical bullet: "Our Union: it must be preserved." Calhoun's response—"Our Union, next to our Liberty, the most dear"—was dulled by added phrases.

The rift between Jackson and Calhoun widened when a letter surfaced suggesting that in 1818 Calhoun, then secretary of war, had recommended to President Monroe that Old Hickory be punished with imprisonment for his invasion of Florida. Stunned by this revelation, Jackson demanded an explanation. Calhoun, instead of trying to be diplomatic, replied with a lengthy missive that began with the hostile statement: "I cannot recognize the right on your part to call into question my conduct." Exhibiting deep resentment over his declining political fortunes, Calhoun suggested that there was a conspiracy against him organized by Martin Van Buren.

The Petticoat Affair, nullification, Florida—now the breach between Jackson and his vice president was irreparable. Worse, Jackson's former mouthpiece, Duff Green's *United States Telegraph*, had gone to Calhoun's side, supporting nullification. Calhoun, astonishingly, had Green publish his bitter Florida letter in the *Telegraph* in February 1831. Suddenly the whole nation knew about the wars in Washington. Jackson, it appeared, presided over a fractured government, and his closest adviser, Van Buren, was an alleged conspirator against the vice president.

The situation was untenable. Van Buren felt that only a major change could help his leader. He offered himself for sacrifice. In April he submitted his resignation as secretary of state. Jackson, who considered Van Buren one of his soundest advisers, at first demurred but then reluctantly agreed, knowing that other resignations would follow and thereby ease the controversies that swirled around him. John Eaton heard of Van Buren's plan and resigned four days ahead of the secretary of state. With these two gone, Jackson solicited resignations from Ingham, Branch, and Berrien, who soon gave up their posts. Except for William Barry, who stayed on as postmaster general, Jackson had a clean slate.

The new cabinet Jackson assembled was generally stronger than his first. His choice for attorney general was Roger Brooke Taney, a Maryland judge celebrated for his brilliance. Also impressive were his other appointments: the jurist and statesman Edward Livingston as secretary of state; the ex-senator and diplomat Louis McLane of Delaware in the Treasury; Lewis Cass, longtime governor of Michigan, for the War Department; and Levi Woodbury, the capable senator from New Hampshire, as secretary of the Navy.

Jackson also consulted unofficial advisers—including political associates, friends, and family members—who came to be known as the Kitchen Cabinet because they supposedly got to see the president by entering through the kitchen rather than more formally through the parlor. The Kitchen Cabinet was never fixed. Its membership changed according to Jackson's needs of the moment. But there were a few who formed its core: the Kentuckian Amos Kendall, a Treasury auditor who defended Jackson in the press and helped draft his speeches; the New Hampshire editor and politician Isaac Hill; the Nashville tycoon John Overton, an old friend; and the editor Francis P. Blair, who came to the capital from Kentucky to direct the administration's new newspaper, the *Globe*.

Jackson listened to the advice of these and others but always made his own decisions. He was receptive to outside opinions yet didn't surrender his firmness. Nowhere did he show his firmness more than in his exercise of the veto. He vetoed twelve bills—more than all previous presidents combined. Among the twelve, he aggressively used the pocket veto (killing measures by delaying action on them until Congress adjourned), resorting to it seven times, five more than James Madison, the only previous president who had used it. Although he received a congressional censure and opened himself to charges of tyranny, he changed the presidency by strengthening the executive branch of the American government. In his second annual message to Congress he affirmed "the undoubted right of the Executive to withhold his assent from bills on other grounds than their constitutionality."

He made his first important stand against Congress when it passed a bill in May 1830 that would have provided funds for a road between Maysville and Lexington, Kentucky. Supporters of the bill argued that since the road was a continuation of the National Road, it merited federal support. Jackson vetoed the bill. Some historians have claimed that this veto and three others on similar issues show that Jackson stood opposed to internal improvements because he wanted to dismantle Henry Clay's American System. But Jackson was as enthusiastic about internal improvements as any of his predecessors. Actually, he ended up approving double the funds slated for the National Road by all previous administrations, in part because the road favored areas like the Upper South, populated largely by Democrats. Still, he drew a strong line between projects he saw clearly national in scope and those that were solely the concern of individual states. He said in his Maysville veto message that he considered the Kentucky measure "of purely local character."

His response to the Maysville bill reflected his ability to be both national minded and respectful of states' rights. While his veto message made it clear that he was killing the bill because it was a state matter, it also recognized the larger interests of the nation as a whole. Avoiding spending on local projects like the Maysville Road, he indicated, saved money and opened up the prospect of a debt-free nation. As he declared, "How gratifying the effect of presenting to the world the sublime spectacle of a Republic of more than 12,000,000 happy people, in the fifty-fourth year of her existence, . . . free from debt and all her immense resources unfettered!" Paying off the national debt was one of Jackson's goals from the beginning, a goal he managed to reach. Indeed, time proved that he was the *only* president to pay off the national debt.

* * * *

IN HIS ANNUAL MESSAGE to Congress in December 1830 Jackson announced, "Toward the aborigines of this country no one has a more kindly feeling than I do, and no one would go farther to save them from their wandering ways and make them a happy, prosperous people." This

is not how we normally think of the ex-Indian fighter whose policies as president resulted in the deaths of thousands of Indians forced to emigrate west on the Trail of Tears.

We could dismiss his statement as an early example of White House doublespeak if it weren't sincere. In Jackson's view, he was doing everyone a favor with his aggressive policy of Indian removal. History, he said, proved that close contact between natives and whites was destructive to both sides. Indians picked up bad habits from whites, who in turn developed a desire for the Indians' property, as in 1829 when gold was discovered on the Creeks' territory. Bloody violence followed.

Close proximity between natives and whites meant war. And usually it was the whites who caused the conflict. "Every war we had with the Indians," he said, "was brought on by frontier ruffians, who stole their horses, oppressed, or defrauded, or persecuted the Indians. This caused them to unbury the hatchet, and their massacres of the whites plunged innocent people in all the horrors and cruelties of war."

Other tensions arose as well, since Indians refused to observe the laws of the states in which they lived. Removing the Indians to lands west of the Mississippi, Jackson argued, preserved peace by solving the problem of tribes that claimed status as independent nations. For whites, it made available millions of acres of nearby land once the Indians had moved. At the same time, it permitted the natives to develop on their own, enabling them, as he put it, "to cast off their savage habits and become an interesting, civilized, and christian community."

Was it painful for the natives to leave the land of their fathers? Certainly, said Jackson, just as it was for foreigners who emigrated to America or for easterners who left for the frontier. But the Indians had an advantage, since the American government would pay for their exodus and even give them short-term subsistence in their new homes.

President Jackson felt he was the Great Father of the Indians. In 1813, he and Rachel had adopted an orphaned Creek boy, Lyncoya, and had cared for him until his premature death at sixteen. The same paternalism that governed his treatment of Lyncoya—and his slaves—characterized

his feelings toward the natives. Like Jefferson before him and Lincoln after him, he at times exhibited the racial prejudices of the day. But it's misleading to call Jackson an early Hitler guilty of genocide, as some have done. He *was* guilty, however, of an overeager commitment to his removal policies that resulted in fraud, betrayal, and needless cruelty—hence the horrors that resulted.

The removal bill, considered by Congress in early 1830, offered large tracts of western territory as well as funds for transportation and settlement to Indians who chose to surrender their eastern lands. Jackson knew there was powerful resistance to Indian removal, especially among politicians associated with Christian groups, and he needed the support of key allies. The House and Senate committees on Indian Affairs were headed by two Tennessee friends, John Bell and Hugh Lawson White. The speaker of the House, Andrew Stevenson of Virginia, could be counted on to break tie votes—which he did three times, keeping the bill alive.

The debate was intense. Theodore Frelinghuysen, a senator from New Jersey, led the antiremoval forces, giving long speeches in which he pointed out that Indians' refusal to give up their lands could lead to avoidable bloodshed. The Georgia congressman Wilson Lumpkin was among those who echoed Jackson's point that removal would greatly benefit both natives and whites. After many impassioned exchanges, the bill passed the Senate and the House in close votes. On May 28, 1830, Jackson signed the Indian Removal Act into law.

He wasted no time in putting the law into effect. He sent emissaries and soldiers to the various states where most Indians lived. The first two tribes to emigrate were the Choctaws, who occupied parts of Mississippi, and the Chickasaws, who were spread over four Lower South states. After battling U.S. troops, the Choctaws agreed to the Removal Act by signing the Treaty of Dancing Rabbit Creek in September 1830. Since emigration was supposedly voluntary, only two thirds of the some twenty thousand Choctaws went west in the next six years, while the others stayed behind. Soon, though, many of these also left, as the War

Department made only feeble efforts to protect them against land-hungry whites who made their lives miserable. Chickasaws, a tribe of five thousand that owned over a thousand black slaves, accepted a similar treaty in 1832 and several years later began an exodus that took over a decade to complete.

The Creek Indians in Alabama signed a treaty by which they could either own individual land lots and observe state laws or receive federal money and move west. Many of the Creeks chose to remain on their land. But squatters and land speculators cheated the natives, who retaliated with violence. In 1836 the secretary of war, Lewis Cass, sent a force under General Winfield Scott to subdue the Indians and force them to leave. By 1838 over fifteen thousand Creeks had moved beyond the Mississippi.

The Cherokees of Georgia and Alabama put off their removal by launching legal battles that reached the Supreme Court. In one, the Cherokees argued that they were an independent foreign nation that had the right to self-government under the constitution they had adopted in 1827. Chief Justice John Marshall rejected this view in his March 1831 ruling in *Cherokee Nation v. State of Georgia*, which called the Cherokees a "domestic dependent nation" whose territory was part of the United States. A year later Marshall ruled in *Worcester v. Georgia* that the Cherokee Nation was exempt from state laws.

Although the latter decision seemed to be a blow to the removal project, Jackson did not let it stop him. It was long said that he declared defiantly, "John Marshall has made his decision; now let him enforce it!" This is a myth, but he did call the ruling "still born" and unenforceable. At any rate, neither he nor Georgia had any plan to heed Marshall. Through tactful diplomacy, Jackson untangled the dispute that had caused the court battle and set about forcing the Cherokees to emigrate.

Of the so-called Five Civilized Tribes, the Cherokees came the closest to adopting the ways of white America. They had farms, stores, schools, and churches. Some ran plantations; the Cherokees, who numbered 21,500, owned two thousand black slaves. The Cherokees had

their own newspaper and a constitution similar to that of the United States. Led by Chief John Ross, who was one-eighth Cherokee, they put up a fierce resistance to removal. In December 1835, federal agents lured a Cherokee splinter group into signing an accord at New Echota, Georgia, by which the Indians would cede their lands and move west soon in exchange for $4.5 million. The treaty was a fraud. Almost all the Cherokees opposed it, calling it the Christmas Trick of New Echota. Led by Ross, the natives sent a protest to Washington. But Jackson raised enough support in Congress so that the illegitimate treaty was ratified, by a single vote, in May 1836.

Other tribes that felt the hard hand of the American government were the Sauks, the Foxes, and the Seminoles. The Sauks and Foxes of Illinois had already moved west of the Mississippi, but then in 1832 they returned to reclaim their former land. The Illinois militia (among them was the young Captain Abraham Lincoln) and federal forces under Winfield Scott fought to drive them west again. The natives, under Chief Black Hawk, put up a spirited resistance in a short but bloody war. Twice, Black Hawk raised the white flag of surrender, but the flag was fired on, and the natives were defeated and forced west.

The Seminoles in Florida proved the most difficult of all the major tribes to uproot. In 1832 some Seminoles agreed to removal, but thousands of others did not and fled into the Florida swamps. The Second Seminole War began when federal troops under Thomas Jesup and Zachary Taylor followed Jackson's orders to remove the Indians by force. Along with the fugitive slaves who lived among them, the Seminoles fought a guerrilla war that continued for seven years, resulting in the deaths of some 1,500 federal soldiers and an untold number of natives and blacks. Finally, the U.S. army vanquished the Seminoles, many of whom went by ship to New Orleans and then overland to the western territory. In the 1850s, the Third Seminole War would reduce the number of Indians remaining in Florida to one hundred to two hundred.

Altogether, over forty-five thousand Indians moved west under Jackson's policies—with a similar number designated for later removal—at

the expense of $68 million of public funds and perhaps around thirteen thousand deaths among the natives. The thirty-two million acres of western land allotted to the natives was identified as Indian Territory, much of which later became Oklahoma. The natives had left behind one hundred million acres, mainly in the Deep South, opening up new land for slavery. In going west, the displaced Indians joined the some two hundred thousand natives who already had lived west of the Mississippi. In the east, only small pockets of tribes remained.

Upon passage of the Indian Removal Act, Jackson had announced: "It gives me great pleasure to announce to Congress that the benevolent policy of the government, steadily pursued for nearly thirty years, in relation with the removal of the Indians beyond the white settlements is approaching to a happy consummation."

Happy, however, is not the word that springs to mind when one thinks of Indian removal.

* * * *

HAPPY DID APPLY TO Jackson's private life. Or at least happier: He never got over Rachel's death and wore from his hat a black ribbon called a weeper. His niece Emily Donelson, who had moved to Tennessee in anger over the Eaton affair, returned to the White House in September 1831 to resume hostess duties, since Eaton was now abroad as minister to Spain. The president's adopted son, Andrew Jackson Jr., previously unlucky in his relationships with women, married Sarah Yorke, the gracious, good-tempered daughter of an important Philadelphia family. Sarah proved a great source of love and support to President Jackson for the rest of his life. Although there was rarely a day when Jackson was without discomfort from various illnesses, in January 1832 he was relieved of some pain in his left shoulder when a bullet from an early street brawl migrated close enough to the skin to be surgically removed.

Under Jackson, the White House took on the appearance it has today. Jackson installed the north portico—the magnificent Greek

Revival colonnade—to complement the south one. He assigned his old friend William B. Lewis, a Kitchen Cabinet member who lived in the White House, to beautifying the cavernous East Room. Lewis created a grand room, installing yellow wallpaper, three tremendous crystal chandeliers, a massive Brussels carpet, black marble mantels, mirrors, and twenty-four gold stars over the arched doorway that symbolized the states. Lewis included many spittoons for tobacco chewers (especially the president). Jackson had the White House grounds graded, and he added fencing and graveled walkways. He planted elms, maples, and sycamores. In memory of Rachel, he planted the southern magnolia tree that later appeared on the $20 bill and that has survived to this day, though it almost died in 1993 when a small plane crashed into it. He was the first to bring running water into the White House. Most Americans still got water from street pumps; only hotels and mansions had running water. Jackson had an engineer purchase a nearby spring and construct pipes of hollowed-out logs (soon replaced with iron) that carried water into the executive mansion.

Jackson transformed the White House in far more important ways than physically: he changed the very nature of the American presidency. He made the Executive Office powerful in ways never before conceived. Much of that change occurred during the last year of his first term, 1832, the year he challenged the Bank of the United States, won reelection handily, and stood up to the nullifiers in South Carolina.

Jackson viewed the BUS as a fountainhead of the evils that he thought came from aristocratic privilege and centralized government. His political enemies, Henry Clay and the National Republicans, knew of his hatred of the bank and wanted to use it against him in the forthcoming presidential election. For them, the BUS was a proven stabilizer of the American economy, necessary for economic health. For Jackson, the bank, which had twenty-nine branches and controlled a third of the nation's bank deposits, stole money from average Americans and handed it over to wealthy stockholders, a large percentage of whom were north-

easterners or foreigners. The National Republicans, with an eye on the election, persuaded the bank's president, Nicholas Biddle, to request recharter of the BUS four years before the current charter was due to expire. In January 1832, a memorial to recharter was introduced to Congress. Although antibank spokesmen such as Thomas Hart Benton and Francis Blair forcefully opposed the bill, it passed in the Senate on June 11, 1832, and in the House nearly a month later.

It was hardly a secret what Jackson would do next. The day after the measure was passed, the president declared to Van Buren, just back from England: "The bank, Mr. Van Buren, is trying to kill me, *but I will kill it!*" He couldn't kill it immediately, but he took a large step toward that goal. He vetoed the recharter bill.

With the aid of Kendall, Blair, and others—and, as always, in control himself—he wrote a veto message that he sent to Congress on July 10. It was a dazzling performance. Jackson presented the bank as a benefactor to the wealthy and to foreigners at the expense of ordinary Americans. He made no mention of the nation's recent prosperity, which the bank may have stimulated. He was less concerned with the bank's past performance than the future dangers it posed. More than a fourth of the bank's stock, he pointed out, was held by foreigners and the remainder by a few hundred rich Americans. To think that the bank forced Americans to send abroad millions of dollars annually in hard currency just to pay the dividends of foreign stockholders! What would happen should we go to war against a country that controlled a large share of our stock? Biddle and others had pointed out that the Supreme Court had supported the bank in *McCulloch v. Maryland*. Actually, said Jackson, over the years the court had shifted, twice supporting the bank and twice opposing it. Besides, the court did not have final say: "The opinion of the judges has no more authority over Congress than the opinion of Congress has over the judges, and on that point the President is independent of both." The fact was, Jackson continued, the Constitution did not authorize long-term monopolies like the BUS. The bank exemplified the ugly reality that "the rich and powerful too

often bend the acts of government to their selfish purposes." It created "artificial distinctions," making "the rich richer and the potent more powerful" while leaving out "the humble members of society—the farmers, mechanics, and laborers—who have neither the time nor the means of securing like favors to themselves."

Through his rhetoric, Jackson presented the bank as aristocratic and oppressive. A newspaper friendly to Jackson announced that the veto represented "the cause of democracy and the people, against a corrupt and abandoned aristocracy." Immediately, the bank's supporters turned this kind of language against Jackson himself. The two leading probank senators, Henry Clay and Daniel Webster, thundered that Jackson, not the BUS, was oppressive. All previous presidents, Clay insisted, had understood that the veto power was designed only for "instances of precipitate legislation, in unguarded moments." Jackson, in contrast, used the veto whenever he disagreed with a bill, behaving more like a European monarch than a democratic president. What a spectacle, Clay declared: "The president independent both of Congress and the Supreme Court!" Such action could only "end in the absolute subversion of the government."

Webster seconded the point. The bank, Webster said, supported "great public objects," whereas Jackson was guilty of "pure despotism," claiming absolute power as had Louis XIV when he announced, "I am the State." By overriding both Congress and the Supreme Court, Webster continued, Jackson destroyed the rule of law and replaced it with a dictatorship. This view of Jackson as a despot was memorably captured in an anonymously published cartoon depicting Jackson as "King Andrew the First," crowned and richly robed as he stood with a scepter in one hand and the bank veto in the other, his feet trampling the U.S. Constitution.

The bank veto gave Jackson's opponents the ammunition they thought they needed for the presidential campaign. The Antimasonic Party had held America's first national nominating convention in Baltimore in September 1831, selecting the former attorney general

William Wirt as their presidential nominee and the Pennsylvania lawyer Amos Ellmaker as his running mate. In December the National Republicans also met in Baltimore, nominating Henry Clay for president and congressman John Sergeant of Pennsylvania for vice president. The Democrats held their convention in May 1832, when they, too, met in Baltimore. They felt they didn't have to nominate Jackson officially but instead concentrated on the vice presidential choice, which, unsurprisingly, was Martin Van Buren.

The election became largely a referendum on the Bank of the United States. The Jacksonians portrayed the BUS as a hydra-headed monster of corruption, while the National Republicans described it as the basis of a sound economy, calling Jackson a tyrant irresponsibly trying to destroy it. The bank's president, Nicholas Biddle, confidently entered the fray, attacking Jackson and even distributing thousands of copies of the bank veto as though it were self-evidently ludicrous—an ill-advised

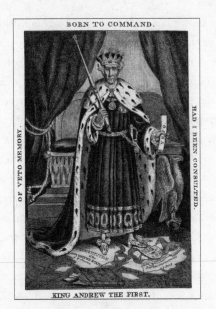

"King Andrew the First"

move, since most Americans sided with Jackson on the issue. As Van Buren noted, "the Veto is popular beyond my most sanguine expectations." A Jackson resolution said the contest was "between the Aristocracy and the People—he stands by the People." The president's followers arranged rallies, parades, barbecues, and newspaper extras that outdid even the hoopla of the 1828 campaign.

Old Hickory won the election easily, taking over 700,000 popular votes to Clay's 329,000 and Wirt's 255,000. Early in his presidency, Jackson had tried to abolish the electoral college, which he believed misrepresented the American people. But he had no reason for concern about the 1832 electoral vote, which went 219 for him as opposed to 60 for Clay and Wirt combined. The only states Clay won were Kentucky, Delaware, Connecticut, Rhode Island, and Massachusetts, with Jackson sweeping the rest except for Vermont, which went Antimasonic, and South Carolina, which voted for the Independent Democrat John Floyd.

Andrew Jackson, it seemed, now *was* American democracy. After the election, Clay lamented, "As to politics we have no past, no future." Wirt spoke for many when he said of Jackson, "My opinion is that he may be President for life if he chooses."

Although the election results pleased Jackson, he faced a national crisis when he returned to Washington from the Hermitage in October. South Carolina, having threatened nullification since 1828, was now taking steps toward it after the passage of the tariff of 1832. The new tariff lowered rates by half, but for South Carolina that was not enough. In an Ordinance of Nullification, the state announced its refusal to pay duties as of February 1, 1833. If the federal government tried to enforce the tariff, South Carolina would secede from the Union. In December John Calhoun resigned from the vice presidency and took over the senate seat of his fellow nullifier Robert Hayne, who became the state's new governor.

Jackson was unequivocal: nullification was treason, and secession was by definition impossible. He issued a proclamation on nullification

on December 10, written with his guidance by his secretary of state, Edward Livingston. If every state felt it could nullify federal laws at will, he pointed out, the Union would have dissolved long ago, since there had already been many divisive issues. The nation was a union before the idea of states' rights ever arose. The Constitution's chief aim, as everyone knew, was *"to form a more perfect Union."* Congress had always had the power of establishing taxes, duties, and imposts. No tax or duty had the same effect on each state: there was always some amount of inequity. But inequity was no excuse for nullification. As for secession, that defies the Constitution's statement about "One People" under a government that created the laws of the land. "To say that any State may at pleasure secede from the Union," Jackson declared, "is to say that the United States are not a nation." Secession was equivalent to insurrection.

It was an extraordinary statement, one that has been compared to the Gettysburg Address in its assertion of essential American principles. For the first time, an American president publicly denounced secession. Jackson was ready to back up his convictions with force. He agreed with someone who commented that Calhoun should be executed for treason if he caused nullification, which, Jackson added, would be provocation enough to send ten thousand troops to "crush and hang" all traitors in the state.

In January 1833 he worked on several fronts to defuse the crisis. He instructed his secretary of war, Cass, to make troop preparations to protect federal bases against takeover attempts by the nullifiers. He asked Congress to pass a Force Bill that would allow him strengthen duty collection in South Carolina and send in the military should the state announce secession. He negotiated with important Carolinians who were still loyal to the Union. A supporter in the House, the New York congressman Gulian C. Verplanck, proposed a reduced tariff that in two years would lower rates to their 1816 level. These reductions were too steep for tariff supporters, but they set the stage for a compromise tariff forged by Henry Clay and passed by Congress in February.

The Tariff of 1833 called for steady reductions over the next decade to a 20 percent ad valorem rate.

South Carolina accepted the compromise tariff and annulled its Ordinance of Nullification. Congress approved the Force Bill, but it was now irrelevant. Jackson's combined muscle-flexing and diplomacy had worked.

Resolving the nullification crisis was one of the great achievements of Jackson's presidency. He established the principle that America was not a compact of loosely bound *states* but an enduring union of *people*. Lincoln adopted the same principle when eleven southern states separated from the Union in 1860–61. For both Jackson and Lincoln, *secession* and *the United States* were opposite concepts; the latter made the former meaningless.

* * * *

IT WAS A GOOD time for the sixty-six-year-old Jackson to celebrate the Union by seeing face-to-face those he felt he had just saved: the American people. In the late spring of 1833, he decided to take a tour of the northeastern states. Two previous presidents, Washington and Monroe, had taken such tours but had mixed success because of their wooden personalities. With Jackson, it proved otherwise. He wasn't just the president. Many Americans worshipped him—not as a god, but as one of them. He was Everyman writ large. The crowds didn't just clap or cheer for him. They screamed at the top of their lungs. They mobbed him, they tried to touch him and shake his hand.

Or, in one case, pull his nose. On May 6 Jackson was reading a newspaper on a steamboat in Virginia when Robert B. Randolph, a former Navy lieutenant angry over losing his job, approached the seated president and grasped his face, apparently trying to tug his nose—in that era a gross personal insult. Jackson sprang up to retaliate, but he was trapped behind a table. Randolph was later caught and brought to trial. But the president, who suffered minor injuries, had no interest in pursuing the matter. Only his pride was wounded. "No villain," he de-

clared, "has ever escaped me before; and he would not, had it not been for my confined situation."

His tour began on Thursday, June 6, when he left Washington for Baltimore. The last leg of the day's journey thrilled him, since he took the railroad for the first time in his life. The first American-built steam engine, Peter Cooper's "Tom Thumb," had been introduced three years earlier on the Baltimore and Ohio Railroad. At first slow, locomotives soon attained the then-breathtaking speed of twenty miles an hour, though the primitive coaches they pulled were uncomfortable, with hard benches and showers of sparks, soot, and smoke that rained constantly on the passengers. But Jackson enjoyed the Steam Carrs, as he called them, and doubtless he added liberally to the streams of tobacco juice on the coach floors.

Jackson's three days in Baltimore provoked continuous delirium, as did his tours of other cities as he went north. Baltimore was in a special state of excitement because Black Hawk, the Indian chief the president's forces had recently defeated, was there too. After his failed effort to retake lands in Illinois, Black Hawk had been captured, shipped east, and held there before being released. Now he was a minor celebrity, like one of P. T. Barnum's curiosities. Few white Easterners had ever seen an Indian, except in pictures. He was now about to be paraded from city to city, admired by many for his courage in the face of overwhelming odds.

A short man with dark, beady eyes and a prominent nose, Black Hawk arrived at Jackson's hotel with his son and other members of his tribe. A newspaper reported that Jackson, addressing the Indians as "My children," excoriated them for massacring whites and warned them to never return to their lands at the risk of overpowering retaliation. *"My father,"* Black Hawk allegedly replied, "My ears are open to your words . . . I did not behave well last summer. I ought not to have taken up the tomahawk. But my people have suffered a great deal. When I get back, I will remember your words. I won't go to war again. I will live in peace. I shall hold you by the hand." When Jackson and Black Hawk

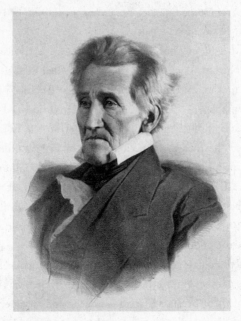

Andrew Jackson

both attended a play at the Front Street Theater, the fascinated specta-tors gawked at them.

At his next major stop, Philadelphia, Jackson consulted a famous doctor, Philip Syng Physick, about the terrible suffering he endured periodically from the abscess caused by the bullet lodged near his heart. Jackson said he was more than willing to follow the doctor's orders but added, "There are only two things I can't give up: one is coffee, and the other is tobacco." Although Dr. Physick offered no remedy but the cus-tomary one of cupping (draining blood from capillaries), he comforted Jackson by assuring him that his heart was not in danger from the ill-ness.

Jackson's arrival in New York on June 12 was greeted by near bed-lam. The wharf at Castle Garden overflowed with tens of thousands of people who went wild when he disembarked from a steamboat. The

mobbing was so excessive that a bridge to the Battery collapsed under the weight of the president's party and its onlookers; Jackson barely escaped a dousing in the shallow water, but many other dignitaries did not. The president was so impressed by the speeches, parades, and flag-waving along Broadway that he said to a friend, *"Nullification will never take root* Here."

He visited a number of cities and towns in Connecticut and Rhode Island to similarly enthusiastic greetings. But the trip took its toll. By the time he reached Boston, his hemorrhaging and coughing were so bad that he spent two days in bed. A doctor bled him twice, and he rallied enough strength to appear at Harvard to receive an honorary degree of Doctor of Laws (much to the disgust of John Quincy Adams, who privately dismissed him as an illiterate barbarian). The president pressed westward through several Massachusetts towns to Lowell, where crowds of factory girls welcomed him. The factories were closed in his honor, but he requested them to be reopened so that he could tour them. He was amazed by their machinery and felt that they promised a bright future for America.

Shortly after Lowell, he felt so weak that he canceled the rest of his scheduled tour and returned to Washington, arriving there on July 4. Gaunt and pallid, he nonetheless got back to business. The main thing on his mind was the Bank of the United States. He had prevented its recharter, but it still had more than two years left on its current charter. This monster of oppression, he believed, must be slain. The bank now held around half of the government's money. Why couldn't this money be removed and redistributed to local banks in various sections of the country?

He dispatched Amos Kendall to seek out possible banks that might be available to receive public deposits. To qualify, a bank had to have a clear record and a commitment to Jackson. By the fall, Kendall had found seven banks. The president, driven by his hatred of centralized finance, began the process of transferring funds from the BUS to the deposit banks, soon derogated by his opponents as "pet banks." Since

the treasury secretary alone had the authority to make such a transfer, Jackson dismissed his current one, William J. Duane, who questioned the legality of transferring federal funds from the BUS to state banks, and nominated in his place Roger Taney, who directed the money transfers while continuing as attorney general.

Jackson had said he would proceed cautiously, but he began with a bold move. On October 4 he ordered that $2.3 million be removed from the central bank. The brilliant, haughty Nicholas Biddle was not to be outdone by a man he regarded as an economic neophyte. "The worthy president," Biddle declared, "thinks that because he has scalped Indians and imprisoned Judges, he is to have his way with the Bank. He is mistaken." Biddle retaliated against Jackson's opening maneuver by reducing the BUS's loans and discounts by $5.8 million. He knew that the contraction might damage the economy, but, as he put it, "Nothing but the evidence of suffering abroad will produce any effect. . . . A steady course of firm restriction will lead to . . . the re-charter of the Bank." He thought that Congress, alerted to the president's shenanigans and hoping to restore credit, would stop Jackson in his tracks and come to the bank's rescue.

A mild downturn followed, with some business closures, unemployment, and collapsing prices. At first many blamed Jackson's removal of BUS funds for the Panic of 1833–34. Groups of businessmen approached him begging him to restore deposits to the central bank. Jackson was intransigent. When one delegation came to him, he worked himself up to a frenzied rage, exclaiming that "the name of Andrew Jackson would never be signed to a bill or resolution to place the Public money in the Bank of the United States or renew the Charter of that Bank." After most of his visitors left in stunned silence, he grinned at a remaining one and said with a laugh, "Didn't I manage them well?" Naturally hot-tempered, he knew how to *feign* tantrums as well.

But this was no laughing matter. He would cut off his right hand, he declared, before he restored the bank's deposits. He reported that he was "receiving two or three anonymous letters every day, threatening me with assassination if I don't restore the deposits and re-charter the

bank—the abominable institution—the monster, that has grown up out of circumstances, and has attempted to control the government." He added firmly, "I've got my foot upon it, and I'll crush it."

Crush it he did, but not without a fight. Petitions from all over the country flooded Congress, most of them demanding restoration of the BUS's deposits. In an unprecedented act, the Senate passed a formal censure of Jackson. Introduced by Clay, the censure cited the president's dismissal of Duane and his tampering with the bank as evidence that the president "has assumed upon himself authority and power not conferred by the constitution and laws, but in derogation of both." After three months of wrangling, the Senate passed the censure resolution. Jackson fired back with a protest in which he asserted that he as president represented the American people and was directly responsible to them. The Senate debated this extraordinary statement before ruling that it was unconstitutional. The whole matter had wasted five months of the Senate's time.

Meanwhile, the Treasury Department and Nicholas Biddle had been playing tit-for-tat with public money. By January 1834 the Treasury had withdrawn $9.36 million from the BUS, while Biddle continued to contract the bank's loans. Only when real signs of recession appeared did Biddle relent and restore credit to previous levels. The Treasury continued the dispersal of federal monies into the pet banks. The deposits reached $22 million by the end of 1834, peaking at over $45 million in November 1836, by which time there were over ninety pet banks throughout the nation.

At first widely lambasted, the pet-bank scheme won increasing favor. In April 1834 the House gave Jackson a vote of confidence by passing a four-point resolution approving his removal of funds from the BUS and transferring them to the deposit banks. Although Congress did not approve his first choice for the Treasury Department, Taney, it confirmed his second, the eminently capable Levi Woodbury of New Hampshire. As secretary of the treasury, Woodbury proved to be a judicious administrator of the pet-bank system.

This system got an unexpected boost when Biddle committed another blunder. Although he had made up for his first mistake by relaxing credit, Biddle churlishly refused to cooperate with the House when it tried to investigate the records of the BUS. There is no evidence that Biddle had anything illegal to hide. But he gave the impression of a cover-up when congressional representatives arrived in Philadelphia only to find him stubbornly insisting that the bank's books would remain closed to the inspectors.

As Biddle and his bank declined, the pet banks prospered along with the American economy. Foreign investments in America and a favorable trade balance fueled a robust recovery. The cash supply jumped 50 percent between 1834 and February 1837. The announcement in January 1835 of the paying off of the national debt preceded a period of surplus and speculation in lands opened up by Indian removal. Sales of public lands, which amounted to $6 million in 1834, quadrupled by 1836.

Squabbling arose over how to handle new public monies that came from the surplus, the tariff, and land sales. A bipartisan committee forged a program by which these monies went to pet banks in proportion to the number of representatives each state had in Congress. This program became law in June 1836 with the passage of the Deposit Act, which distributed about $37 million to state banks according to population. As a result, the number of deposit banks rose from thirty-five to over ninety. The act came with stipulations about the proportions of government deposits and specie (gold or silver) each bank must have. Any bank that suspended specie payments to its customers would cease to be a depository. Despite these restrictions, the Deposit Act fed the speculative fever by dispersing great amounts of federal money throughout the country. Some of the newly created banks were run by Jackson's enemies, and a significant proportion of the funds went toward the kind of internal improvements he had considered local in nature.

To restrain an economy he thought was spinning out of control, Jackson in July 1836 issued an order known as the Specie Circular, by

which public lands could be purchased by speculators only with hard currency (though settlers could still buy smaller plots with paper money). Jackson's hatred of paper money matched his mistrust of a central bank. His economic philosophy was similar to that of William B. Gouge's popular book of 1833, *A Short History of Paper Money and Banking in the United States*. A neo-Jeffersonian who believed that America's growing corporations fostered a corrupt aristocracy of money, Gouge expressed alarm over banks that issued increasing amounts of paper money unsupported by specie. This "rag money," Gouge argued, victimized average working people, since it made speculation too easy in boom times and lost value during downturns. Jackson thought the Specie Circular would put a brake on the inflationary land boom. Congress later rescinded the Specie Circular, but Jackson, typically, used a pocket veto to save it.

What effect did Jackson's economic policies have? From a financial standpoint, perhaps smaller than either Jackson or his critics believed. Jackson boasted that the bank scheme was so successful that "the condition of public finances was never more flattering than at the present period." His opponents argued that the devastating panic of 1837 resulted from Jackson's disruptions of the economy.

The truth seems to lie in the middle. The proliferation of pet banks did feed expansion, while the Specie Circular played at least some role in the bank failures of 1837, since it caused specie to drain from eastern banks as it was transferred west. But many other economic factors influenced both the boom and the bust—so much so that one historian says that the effects of the Specie Circular were "dramatic but innocuous." The surge in land sales came partly from the simple fact that while the price of many commodities rose sharply, most public land by law cost only $1.25 per acre. And just as foreign investment spurred growth, so economic disruptions abroad—especially an unfavorable trade balance that caused England to demand specie from American banks—contributed to the 1837 collapse. It's quite possible that the panic and the subsequent depression would have come even without the pet banks or the Specie

Circular. The economic historian Peter Temin uses statistical analysis to argue that "the Panic of 1837 was not caused by Jackson's actions."

But Jackson's economic program did have major repercussions, some direct, others indirect. For one thing, it helped stimulate a rebirth of the labor movement in the 1830s. Jacksonian rhetoric about virtuous workers pitted against the grasping monster of corporate America found intensified expression in the speeches and writings of labor organizers such as Ely Moore and John Commerford of New York, William English and John Ferral of Philadelphia, and Boston's Seth Luther. A number of working-class papers arose, using vigorous rhetoric about the rich versus the working poor. Rising prices and stagnant wages fueled widespread unrest. Workers in major cities formed trade unions that struck for such benefits as a ten-hour workday and higher wages. In 1833 came New York's General Trades' Union, followed by unions in Philadelphia, Baltimore, and then a dozen more cities, as far west as Louisville. Many of the local strikes were successful. A National Trades' Union formed in 1834 and held three conventions over the next three years. In 1835 came the first national labor strike, which prompted retaliatory crackdowns by employers and violence against scabs.

Working-class protest caused a renewal of the Workie parties. Left-wing factions split from the mainstream Democratic Party in New York, Philadelphia, and Boston. In New York, members of the Equal Rights Democracy, having separated from the regular Democrats associated with Tammany Hall, got their nickname Locofocos (Spanish for "crazy lights") when they lit candles with matches of that name at a workers' rally in a hall where their conservative opponents had turned off the gaslights. Soon the Locofocos were a powerful force in New York politics. A Locofoco leader, the journalist William Leggett, eloquently attacked all corporations, including banks, which he believed interfered with laissez-faire and the rights of individuals, especially the poor. A favorite of the reform-minded authors Walt Whitman, William Cullen Bryant, and John Greenleaf Whittier, Leggett called for free access to economic progress by average workers, who, he insisted,

must organize to be heard. Departing from many other labor activists, he also encouraged antislavery protest.

The Jacksonian economic revolution provoked not only the Workies, a strong *third*-party movement, but more importantly, the Whigs, arguably the first major *second* party in American history. Walt Whitman would say that America's "powerfulest scene and show" was not Niagara nor Yosemite but "America's choosing day," the "swordless conflict, . . . / more than all Rome's wars of old, or modern Napoleon's: the peaceful choice of all"—that is, the choice between the two great parties on election day. Whitman was pointing up a special factor in American democracy: the electoral process as repeatedly played out in the ongoing war between two established parties. The final consolidation of the two-party system would not come until the 1850s, with the rise of the Republicans. But the Whig Party, which emerged in the early 1830s as the adversary of Jackson and the Democrats, was a major step toward this system.

The Whig Party was a motley mix of National Republicans, Antimasons, nullifiers, supporters of the BUS, states' righters, tariff promoters, and advocates of internal improvements. The spirit that initially held this diverse group together was hostility to Andrew Jackson. During the winter of 1833–34 resistance to what was seen as Jackson's imperial presidency crystallized in response to the pet-bank scheme. The term Whig, which Henry Clay used in a speech of April 1834, harked back to opponents of a strong monarchy in England and to Americans who had revolted against George III.

The Whig Party launched a rebellion against the president it regarded as an unprincipled despot. One Whig typically saw in Jackson "an unbridled lust of power that attacked the very foundation of our free institutions." A Whig, explained a Richmond journalist, "means one who prefers liberty to tyranny—who supports privilege against prerogative." In the Senate, Clay blasted Jackson's assault on the BUS as an "open, palpable, and daring usurpation." Clay asked, "Are we not governed now, and have we not been for some time past, pretty much by

the will of one man?" Worse, Clay added, this man was "ignorant, passionate, hypocritical, corrupt, and easily swayed by the base men who surround him."

Although the Whig Party was never tightly unified—indeed, internal divisions eventually destroyed it—for a while it did have enough coherence to appeal to a large bloc of voters. In the nearly two decades of its existence, the party elected two presidents (William Henry Harrison and Zachary Taylor) and many congressmen, state governors, and local officials. In certain elections, the Whigs overwhelmed the Democrats. For instance, in 1840 they won not only the presidency but almost two thirds of Congress and over four fifths of the nation's governorships.

In general, the Whigs supported Henry Clay's American System, including a national bank, high tariffs, and federal funding of internal improvements. Less likely than Democrats to impugn the rich and material luxuries, they believed that economic progress could come through the kinds of corporate structures the Democrats held suspect. Appalled by what they considered Jackson's breaches of the Constitution through presidential fiat, they greatly emphasized legislative action and rule by laws rather than rule by men. The Whigs appealed to middle- and upper-class folk in relatively prosperous rural areas, towns, and cities, and to some portions of the urban working class. They put a high priority on self-improvement through moral and religious groups—temperance associations, Bible societies, Sunday school unions, and so on.

While poor immigrants, many of them Roman Catholic, gravitated toward the Democrats, ultra-Protestant nativists tended to be Whigs, who were not above criticizing the Jacksonians as ignorant rabble. The Whigs believed that many social problems could be solved though appeals to the individual Christian conscience. Anything that threatened moral freedom—for example, Catholic priests, alcohol, slavery, or party machinery—was anathema to many Whigs. For this reason, loyalty to party was less important to Whigs than to Democrats. Antipartyism was so strong that several leaders who supported the Whigs, including

Calhoun, Webster, and John Quincy Adams, did not like to call themselves party members.

* * * *

IN THE MIDST OF his political battles, Jackson faced two severe personal challenges. In October 1834 the Hermitage suffered major damage from a fire. Three months later, Jackson's life was threatened in the first attempted assassination of an American president.

Jackson was in Washington when the fire at his Tennessee home occurred on October 13. Living there at the time were Andrew Jr., his wife, Sarah, and their two young children. The fire started when sparks from a defective chimney ignited the roof. There were no injuries, but the fire raged for hours and ruined most of the interior except the dining room. Jackson took the news stoically and resolved to repair the Hermitage. Over the next year and a half he spent around $10,000 restoring and improving the mansion. In the end, the Hermitage was more magnificent than before, with raised ceilings, enlarged windows, and a tall columned portico extending high up the front of the house.

The president responded bravely to the attempt on his life. On January 30, 1835, Jackson, having attended the funeral of a congressman in the House chamber, was exiting onto the east porch of the Capitol with others when a bearded man leapt from behind a pillar and pointed a pistol at the president's heart. He pulled the trigger when he was within two yards of Jackson and probably would have killed him, but the gun fired without discharging a bullet. Apparently the misty weather had dampened its powder.

Jackson once said he never felt frightened in any situation, and he certainly was not now. He lifted his cane and charged his assailant. Dropping the pistol, the man pulled out another, aimed, and fired. Again the gun failed. Others wrestled the gunman to the ground. Jackson calmly continued his day, remarking that he "was not *born* to be shot by an assassin." But his life had been spared by mere chance. The attacker turned out to be an unemployed English housepainter, Richard

Lawrence. Evidently psychotic, Lawrence later said that Jackson had prevented him from becoming the king of England and had killed his father. A court found Lawrence not guilty of attempted murder by reason of insanity and ordered his confinement in an asylum.

Between the Hermitage fire and the assassination attempt came another dramatic event: Jackson's announcement in his sixth annual message to Congress that America might have to take military action against France.

Jackson's dealings with France reflected his overall foreign policy. He could be tactful and patient but also violent in his defense of America's interests. France owed the United States $4.6 million in previous spoliation claims for damages to American ships during the Napoleonic wars. In 1831 France signed a treaty agreeing to pay the amount in installments. But it put off payment again and again. During the delay, Jackson exhibited admirable forbearance. But when the French Chamber of Deputies in March 1834 voted not to pay the debt at all, Jackson was furious.

In December 1834, he told Congress that according to international law America had the right to seize French property. The House passed a fortifications bill that promised emergency war funds to the president should France retaliate. Although the Senate rejected the bill, war fever swept Washington. Jackson broke off diplomatic relations with France. It was, as Roger Taney said, the most dangerous moment in his presidency.

The danger did not abate when France responded that it would pay the debt only if Jackson apologized for his threat of war. Jackson did not apologize. He explained to Amos Kendall, "It is high time that this arrogance of France should be put down, and . . . we will not permit France or any, or *all* the European Governments to interfere with our domestic policy, or dictate to the President what language he shall use in his message to Congress." In his next message to Congress, however, he moderated his tone, saying he had never intended to menace or insult France. This restrained comment proved sufficient for England to step

in and serve as a mediator. In February 1836, France agreed to pay its indemnity and did so within three months.

Not all of Jackson's foreign dealings ended this happily, but a good number did. Recent historians have given Jackson above-average marks for his governance of foreign affairs. Old Hickory kept up John Quincy Adams's firm, pragmatic approach and in some ways outdid him. Adams had not been able to collect the French claim or the $10 million that other nations owed America for damages inflicted under Napoléon's decrees or the South American wars of independence. Through deft negotiation, Jackson's diplomats collected debts from Russia, Portugal, Spain, Denmark, and Brazil. The Kingdom of the Two Sicilies was less forthcoming, but Jackson flexed his muscles, sending several warships to the Mediterranean. As a result, Naples made a payment of $1.7 million. All told, Jackson collected more than half of the total of America's $14 million in spoliation claims.

He also strengthened commercial ties with foreign nations. American exports had peaked in 1804 at $124 million but then had suffered severely from embargoes and wars, sinking to $62 million when Jackson took office. In 1830 Jackson reopened the British West Indies trade, which had been slowed by England during the War of 1812 and cut off completely in 1826. With practical diplomacy he traded the rights of American ships in the West Indies for rights of British ships in American waters. He opened up new areas of global commerce by working out commercial treaties with Russia, Turkey, Siam, Muscat, Mexico, Colombia, Chile, Venezuela, the Peru-Bolivia Federation, and Morocco. Because of his trade agreements, both exports and imports more than doubled during his two terms in office.

When threats to American trade arose, Jackson was prepared to make a military response. In 1831 Malay pirates attacked a Salem trading schooner off Quallah Battoo, Sumatra, killing three Americans and pillaging the ship. In response, Jackson sent the fifty-gun frigate *Potomac* to Sumatra, instructing its captain, John Downes, to use force only

if negotiation failed. Downes went beyond his orders, destroying Quallah Battoo and killing a hundred natives. Although Jackson resented Downes's insubordination, he did not order a court-martial. In this case, he agreed, there was justification for violence.

Force was also involved in a crisis that arose in the Falkland Islands, off Cape Horn. For years, control of these desolate islands had shifted between England, Spain, France, and Argentina. Throughout, America had had fishing rights near the islands. When in 1829 the dictator Juan Rosas took control of Argentina, he claimed supremacy over the Falklands. His governor in the islands banned American ships from the area and in the summer of 1831 seized three American fishing vessels. Jackson's consul to Argentina, George Slacum, made feeble efforts at negotiation before ordering an attack on Argentine outposts on the Falklands—a fumbling military move with no positive results. The situation deteriorated over the next two years, with neither Jackson nor his ministers exhibiting skill or passion in negotiating a settlement. England finally outmaneuvered America, taking control of the Falklands. Bungled diplomacy and ill-timed force had spoiled America's position with Argentina, although at least Jackson could rest assured that England would not interfere with American fishing.

Jackson's failed diplomacy in Argentina extended to several other nations in the southern hemisphere. Old Hickory's Latin American ministers tended to be party hacks with little sympathy for Hispanic culture or religion. They performed poorly in Brazil and Colombia, where England again outfinessed them. Nor did Jackson's representatives succeed in persuading Spain to reduce tonnage duties for American ships trading with Cuba and the Spanish West Indies.

Jackson's biggest foreign-policy frustration related to the Tejas portion of the Mexican state of Coahuila y Tejas. Jackson deeply regretted that America had not won Texas from Spain in the Transcontinental Treaty of 1819. The United States had made several failed efforts to procure Texas after Mexico won independence from Spain in 1821. More and more Americans, mainly Southerners, moved into Texas.

Jackson wanted to acquire Texas, and in 1829 he appointed the Kentucky lawyer Anthony Butler as his chargé d'affaires in Mexico to accomplish this goal. An old friend of Jackson and a fellow Mason, Butler had served in the War of 1812 and had briefly held a seat in the Kentucky state legislature.

Butler was on a par with Samuel Swartout, Jackson's larcenous collector for the Port of New York. Unprincipled and arrogant, Butler was familiar with Texas but not with Spanish or the art of diplomacy. He managed to work out a commercial treaty and a boundary agreement with Mexico, but these were his sole achievements. Jackson instructed him to offer Mexico $5 million for Texas, but even with that large sum, Butler could do nothing. For seven years, he kept Jackson on edge with promises of a breakthrough that never came. Bullying and bribery were Butler's tactics. He once challenged a Mexican administrator to a duel, and he offered bribes of several hundred thousand dollars to officials who served under General Antonio de Santa Anna. Jackson threw in an additional half-million dollars to offer to Santa Anna for northern California. But the corrupt, swashbuckling Butler succeeded only in enraging Mexico.

Jackson came to regard Butler as a venal scamp and replaced him in 1836. But by that time, Texas was moving on its own toward separation from Mexico, which had cracked down on rebellious states. War in Texas broke out in October 1835 and continued sporadically for six months. The ex–Tennessee governor Sam Houston rallied a tough force of around two thousand that stood up to Santa Anna's army, more than three times that size. Although the Mexicans won bloody victories at the Alamo Mission in San Antonio and at Goliad, the bravery of the vastly outnumbered Texans proved inspirational. Cries of "Remember the Alamo!" and "Remember Goliad!" filled the air as the Texans battled Santa Anna near the San Jacinto River in April 1836. The Texans won this crucial encounter and captured Santa Anna as he tried to escape. Texas announced its independence. It now wished to become part of the United States.

Jackson wanted to satisfy this wish. Annexation of Texas had long been his goal. But he had hoped to achieve it quietly, with money rather than war. The Texas Revolution spoiled his plans because it further complicated relations with Mexico and attracted international attention to what could be interpreted as an aggressive move by America, which had promised to remain neutral in Mexico's hostilities. Jackson wanted at least to give the appearance of neutrality. This was difficult, since the Texas Revolution had become a cause célèbre in some parts of America, prompting rallies, contributions, and volunteers who went west to support the rebels. Jackson withheld open support of the revolutionaries until the spring of 1836, when he sent troops to protect the border with Mexico.

He stalled on officially recognizing Texas's independence. He knew that abolitionists vehemently opposed admitting Texas into the Union. The Quaker reformer Benjamin Lundy, for instance, said that the battle for Texas showed "a settled design, among the slave-holders of this country . . . to wrest the large and valuable territory of Texas from the Mexican Republic, in order to re-establish the SYSTEM OF SLAVERY; to open a vast and profitable SLAVE MARKET therein; and, ultimately, to annex it to the United States." A presidential election was approaching, and Jackson did not want to sacrifice northern votes for Van Buren by championing Texas overzealously. Also, he wanted to avoid fostering an alliance between England and Mexico, which had both recently abolished slavery.

Jackson remained cagey throughout the fall, though he did send a representative to Texas, who reported that the Lone Star Republic had a strong army and a solid government led by Sam Houston. He left the final say about Texas to Congress. On February 28, 1837, the House formally recognized the independence of Texas, and the Senate soon followed suit. The question of annexation, however, remained open and proved to be a major flash point between the North and the South over the next decade.

Another flash point was delivery of antislavery material in the U.S. mail. Like Texas, this issue came to a head in the last year of Jackson's

presidency. Since 1831, when William Lloyd Garrison and others had formed the American Anti-Slavery Society, abolitionism had spread quickly. But its opponents far outnumbered its adherents, even in the North. In 1835 a Boston mob seized Garrison and dragged him by a rope through the streets. Other abolitionists were imprisoned for expressing their views.

The mail controversy arose when on July 29, 1835, a steamboat entered the Charleston, South Carolina, harbor carrying abolitionist publications sent by the American Anti-Slavery Society to leading southern citizens. Instead of delivering the material, the Charleston postmaster, Alfred Huger, held it and locked it up. When word got out about the controversial writings, a proslavery mob broke into the post office, seized them, and destroyed them in a bonfire along with effigies of Garrison and other antislavery leaders. Huger appealed to Jackson's newly appointed postmaster general, Amos Kendall, for advice on how to handle abolitionist mail. Kendall, a slaveholder, was noncommittal. Technically, Kendall indicated, all mail must be delivered to whom it is addressed, but it was up to Huger to decide what to do with "inflammatory and incendiary" papers like antislavery publications.

Jackson chose a middle way on the mail-delivery question. Like presidents before and after him, he wished to dampen controversy over slavery. Both antislavery and proslavery mobs appalled him. "This spirit of mob-law," he declared, "is becoming too common and must be checked, or ere long it will become as great an evil as a servile war." His proposed solution to the mail problem was that "inflammatory" publications should be delivered only to people who subscribed to them. He offered the idea to Congress in December 1836, but Calhoun and other southerners found it too weak, calling for a complete ban of abolitionist mail wherever local law forbade it.

As it turned out, Calhoun did not get his way, but he might just as well have. A new postal law was passed in July 1836 stipulating that all mail must be delivered to whom it is addressed. Although apparently a victory for abolitionists, the Postal Act of 1836 became virtually a dead

letter. Abolitionist mail continued to be halted in many areas of the South. Neither Kendall nor Jackson blinked an eye over the pervasive disregard of the Postal Act. It was left to the discretion of individual postmasters whether a particular kind of mail should reach its destination. There can be only one excuse for Jackson's failure to enforce the postal law. He wanted above all to prevent conflict over slavery.

The slavery issue had pushed the ordinarily firm Jackson toward moral compromise. Of course, his enfeebled physical condition must be taken into account. In the last few months of his second term, there was rarely a day when he was out of his sickbed. All the conflicts of his presidency had worsened his already precarious health. He was not about to get overheated about slavery.

Ironically, the man he had sent to ignominious defeat in 1828, John Quincy Adams, was getting noticed for doing just that. Now a congressman from Massachusetts, Adams earned his reputation as Old Man Eloquent through his stirring pronouncements against proslavery efforts to table petitions to Congress concerning slavery. When Congress, led by the Southerners James Henry Hammond and Henry Pinckney, ruled against discussing such petitions, Adams stood up and cried, "Am I gagged or not?" He went on to become the most vocal opponent of the many so-called gag rules that Congress would issue over the next several years. He once cleverly trapped his opponents by putting on the table a petition about slavery that they automatically banned. The petition, it turned out, had allegedly been sent by twelve emancipated blacks who were asking to be reenslaved.

Overall, what was the significance of Andrew Jackson's presidency? Jackson powerfully influenced politics and culture. He strengthened the executive office. He frequently exercised the veto power. He decisively replaced government officials. He stood firm during the nullification crisis and the bank war. He did not cower, whether facing a hostile Congress or the commanding Nicholas Biddle or a would-be assassin who fired at him twice from point-blank range.

Jackson improved America's infrastructure. Although advances in

transportation and communication were an essential and distinguish-ing component of the Whigs' vision of progress, it is worth noting that the Democrat Jackson was actually, by far, the era's most active president in providing federal funds for commercial development. As president, he approved more than $10 million in federal aid to inter-nal improvements—roads, canals, lighthouses, and dredging rivers and harbors. This amount was more than all of his predecessors *com-bined*, and considerably more, on an annual average basis, than any of his Whig successors except Millard Fillmore.

He was the quintessential rugged individualist. He ushered onto the public stage a new kind of self-confidence, soon to find echoes in Emer-son's self-reliance, in Whitman's self-singing, and in the determined outlook of a whole range of Americans convinced they had the answers and could make a difference. Jackson was also a new kind of democrat. He stood for both the single self and the collective self, both the indi-vidual and, in Whitman's phrase, America "en masse." He was *the peo-ple's* president to a degree that few other presidents have been. He not only provided a fresh spirit and language for average workers, he also made them feel more truly American than those they increasingly re-garded as the idle rich.

Along with self-confidence went a stubbornness that was visible, for instance, in his defense of Peggy Eaton. Some of his appointments, es-pecially early on, were ill-advised. Jackson was also intractable on the Native American issue. He was convinced to the core that he was doing right by removing Indians from the East, where he thought their prox-imity to whites meant needless bloodshed, and so he provided what he saw as a haven for them in the West. He resorted to chicanery, remov-ing many against their will. That his policy resulted in great suffering is one of the tragedies of American history.

His actions against the Native Americans reflected his racism. He believed that whites were endowed by nature with gifts superior to those of other races. But he was hardly alone: virtually all white Americans felt the same way. To single out him or his fellow Democrats for racism, as

some have done, is misleading. One has to look long and hard—among a tiny group of avid abolitionists and other progressives—to find Americans who completely rejected the racial prejudice of the day. Jackson's backward attitude on race was, alas, the rule rather than the exception, as was his condescending pose as the caring father of blacks and natives.

On slavery as a national policy, Jackson established the middling course that his immediate successors would also adopt. Despising both proslavery fire-eaters and rabble-rousing abolitionists, whom he saw as equally threatening to the Union, he took whatever steps he could to quiet this inflammatory issue. His positions on Texas and the mails may strike some as indecisive, but they were, in fact, pragmatic compromises reached after weighing the violent results that more extreme positions might create.

An inveterate believer in rule by majority, Jackson strove to represent as many Americans as possible. It can be said that he did manage to represent *many* Americans always and *most* Americans often.

4

God's Many Kingdoms

On July 15, 1838, just over a year after he left office, Andrew Jackson joined the Presbyterian Church. He had previously been a churchgoer but not a church member. He had told his pious wife Rachel that he would wait to become one until he had put politics behind him, as he did not want to be accused of doing it only "*for political effect.*"

His conversion, as he called it, reportedly came during a sermon given by the dynamic Nashville minister John Todd Edgar at the Hermitage Church, which Jackson had built on his property for Rachel. The Rev. Edgar, having long hoped that Jackson would publicly accept religion, wrote the sermon specifically for him. To show how God protects humans, Edgar described a hypothetical man who had faced death many times—from Indians, war, a would-be assassin, and severe illness—and yet who survived. How do we explain the miracle? Edgar asked. Only by recognizing the power of divine providence.

The ex-president pondered the message. Now was the time to accept God fully into his life. He informed Dr. Edgar that he wanted to join the Presbyterian Church, the church of his mother and his wife. Edgar asked him if he were willing to forgive all of his enemies. Only his political ones, Jackson declared, not those who had questioned his military record. That was not enough, replied the minister. Christian forgiveness was total. Jackson paused. Yes, he decided, he would forgive everyone. Within days he stood in the crowded Hermitage Church,

tears streaming down his seamed face, as the rites of the church were administered.

For the seven remaining years of his life, Jackson was just as devout as Rachel had been. He constantly read the Bible, hymns, and religious commentaries. Each night he read prayers aloud to his family and servants in the Hermitage. In his will, he indicated that he wanted to be buried next to Rachel and stated that he was "hoping for a happy immortality through the atoning merits of our Lord Jesus Christ, the Savior of the world."

Legend has it that after Jackson's death one of his slaves was asked if he thought the General had made it to heaven. The man responded, "If General Jackson wants to go to Heaven, who's to stop him?"

The story may be apocryphal, but it is fitting. Along with other reports of Jackson's religious experiences, it makes Old Hickory seem representative of developments in American religion in the early nineteenth century. Jackson's embrace of the church reflected an overall tendency: Americans were joining churches in droves. The percentage of Americans who joined Protestant churches increased sixfold between 1800 and 1860, and would nearly double again by the 1920s. The French visitor Alexis de Tocqueville noted in 1835, "America is . . . the place where the Christian religion has kept the greatest real power over men's souls." He emphasized that "the religious atmosphere of the country was the first thing that struck me on arrival in the United States." President Jackson's conversion, his emotional acceptance of church rites, his Bible reading and public praying—all reflected religious practices that swept America in the aftermath of the Second Great Awakening.

As for willing himself into heaven, that too was typical. If no one could stop the General from having a happy immortality, the same could be said of anyone intensely devoted to Christ, according to the increasingly optimistic religion of the day. During Jackson's lifetime, most American Protestants put aside the gloomy Calvinist tenet of predestination and turned to the belief that through constant prayer, soul-changing conversion, ceaseless good works, and faithful reading of the Bible and religious literature, one could earn a blissful afterlife.

But to call Jackson—or anyone else—typical of early-nineteenth-century American religion is deceptive. There was a religious mainstream, which included the Presbyterian, Congregational, Baptist, Methodist, Lutheran, and Episcopal churches, to mention the major ones. But within this mainstream, there was a spectrum of beliefs and practices, as well as division and conflict. This period also saw the dramatic growth of the Catholic Church, due increasingly to immigration.

What was really distinctive about the American religious scene was its variety. Disparate European sects—the Rappites, the Amish, the Shakers, to name a few—found homes in America, often prospering on its soil. America's religious toleration also bred homegrown faiths that ranged from the original to the bizarre. Protestantism by definition posits a personal relation to God unmediated by priests or excessive ritual. This doctrine of the priesthood of all believers was liberated in the democratic atmosphere of a nation where official religion had recently been disestablished in many states. Emerson caught the free religious spirit of America when he wrote: "The Protestant has his pew, which of course is only the first step to a church for every individual citizen—a church apiece."

The decades after 1812 saw a surge of self-styled prophets claiming special revelations from God, including Isaac Bullard (the so-called Prophet Elijah), whose Pilgrims re-created primitive Christianity by rejecting material goods; Robert Matthews (aka Matthias), who walked the streets of New York proclaiming that he was God and had written the Bible; Joseph Smith, the Palmyra, New York, farmer who received from an angel a new bible that become the Book of Mormon; John Humphrey Noyes, who under divine inspiration established the Oneida community, where communal marriage was practiced; and William Miller, who attracted national attention by announcing the imminent end of the world.

For foreigners, the numerous religious groups in America could seem bewildering. Tocqueville noted, "In the United States there are an infinite variety of ceaselessly changing Christian sects." Another foreigner

wondered, "How can I live in a country where they found a new church every day?" The famous British tourist Frances Trollope wrote: "The whole people appear to be divided into an almost endless variety of religious factions Besides the broad and well-known distinctions . . . there are innumerable others springing out of these, each of which assumes a church government of its own; of this, the most intriguing and factious individual is invariably the head."

The dazzling variety of American faiths resulted not only from First Amendment freedoms but also from the emotionalism and democracy of the Second Great Awakening, the outbreak of religious revivals that began in the 1790s and lasted until the mid-1840s, continuing to flare up sporadically after that. There were two main strands of revivalism that at first were separate but in the end intertwined. One started in the frontier of Kentucky and Tennessee and was disseminated by circuit-riding preachers who led camp meetings at which countless conversions took place. The other originated in the elite colleges of the Northeast, especially Yale, and spread west with the New England diaspora.

Revivalism, which offered a simple Christianity of the heart that promised salvation to all who repented, caused a sea change in the membership of the leading denominations. Evangelical churches that promoted hopeful, emotional religion through revivals grew rapidly. In contrast, churches that resisted revivalism or stuck to old-fashioned theology saw their membership decline.

Before the American Revolution, the Congregational and Presbyterian churches were the largest denominations in America. Together, they attracted nearly a third of all religious adherents in the colonies. The other denominations didn't approach their numbers. By 1850, memberships had shifted enormously. The Congregational Church, which had led in 1776 with 20 percent of total adherents, had sunk to a mere 4 percent. The Presbyterians held ground, but the Episcopalians, damaged by Anglophobia during the wars with England, fell dramatically. Notable gains occurred among the Baptists, the Catholics, and espe-

cially the Methodists, who went from under 3 percent of religious adherents in 1776 to over 34 percent in 1850.

Founded in England in the 1740s by the ex-Anglican minister John Wesley, Methodism spread to America. It began modestly. At the first Methodist conference, held in Baltimore in 1784, there were sixty ministers present, only a third of them of American birth. A century later, there were more than twenty-five thousand native-born Methodist preachers in America. Methodism grew everywhere and made especially dramatic inroads into the Old Southwest.

The early spread of Methodism came through itinerant revivalists who addressed the feelings rather than the intellect. Emotion had been at the center of American religion since the 1730s, when the Presbyterian Jonathan Edwards spearheaded a wave of revivals in Massachusetts by declaring that conversion was signaled by a total change in feelings, or what he called affections. This First Great Awakening became a national phenomenon when the visiting British revivalist George Whitefield traversed America delivering emotional sermons to crowds as large as thirty thousand. As orthodox Calvinists, Edwards and Whitefield believed that humans were totally depraved and that God predestined a certain few, known as the elect or saints, to go to heaven. The remainder—the large majority—were reserved for hell.

The Wesleyan Methodists, in contrast, believed that heaven was open for all those who turned sincerely to God. Although humans could not earn salvation through good works, God offered grace freely, and humans could choose to accept it or not. Methodism fit the democratic spirit of the nation after the American Revolution. If politics was embracing average people, so salvation was no longer reserved for a chosen elect. Anyone could attain it.

And virtually anyone could preach. A major innovation of the Methodists and Baptists was their democratization of the ministry. The Congregationalists and Presbyterians had put a premium on higher education for clergymen. Nearly all the Congregational ministers in the

New England colonies had been college educated, mainly at Harvard or Yale.

For the Methodists, preachers did not have to know Greek or Latin or even theology beyond the basics, since religion had nothing to do with creeds. Most Methodist revivalists had little education. Of the founders of Methodism in America, only Thomas Coke was college educated. His more influential associate, Francis Asbury, was a simple, unlearned man, as were many others who followed. The itinerant Elijah R. Sabine had not gone to school beyond the age of eight. Another preacher, Orange Scott, had had only a year of schooling but became one of Methodism's most effective promoters. The celebrated Peter Cartwright had been, in his own words, a "wild, wicked boy [who] delighted in horse-racing, card-playing, and dancing" and had "made but small progress" in his education.

These circuit riders liked to boast that they were graduates of "Brush College" or "Swamp University." They developed their talents during long, grueling treks on horseback that took them far and wide. Asbury, for instance, traveled an average of six thousand miles every year for forty-five years—the equivalent of eleven times around the earth—delivering some twenty thousand sermons between 1771 and his death in 1816.

Gifted with a crude eloquence adapted to their largely frontier listeners, the Methodists enjoyed using earthy humor. The German-born Jacob Gruber told jokes in the pulpit and acted out homely Bible stories "in a manner so ludicrous that the audience could scarcely restrain their laughter." During the War of 1812 he prayed aloud, "O lord have mercy on the sovereigns of Europe—convert their souls—give them short lives and happy deaths—take them to heaven—and let us have no more of them." Another preacher, Billy Hibbard, attacked Calvinism so strongly that a Presbyterian approached him and said his feelings were hurt. Hibbard replied, "O, I'm sorry you took that,—I meant that for the Devil, and you have stepped in and taken the blow. Don't get between me and the Devil, brother, and then you won't get hurt." When

the revivalist Jesse Lee was asked by two lawyers if he ever misquoted the Bible in his unscripted sermons and had to correct himself, Lee admitted he often made a mistake but did not correct it "if it involves nothing essential." He gave a pointed example: "The other day I tried to repeat the passage where it says the Devil 'is a liar, and the father of them'; I got it, 'The Devil is a lawyer, and the father of them'; but I hardly thought it necessary to rectify so unimportant an error."

Humor did not interfere with the serious goal of converting sinners. The circuit riders held huge outdoor camp meetings in which they whipped their audiences to frenzy through their terrifying descriptions of hell and enticing accounts of heaven. Shortly after the Revolution, a wave of revivals spread through the backcountry of North Carolina, Maryland, and Virginia and then westward to Kentucky and Tennessee. Typically between eight thousand and twelve thousand—sometimes many more—gathered in the open air or in large tents to hear the passionate revivalists. Often at these camp meetings more than one sermon was going on at once. The famous one at Cane Ridge, Kentucky, in August 1801, organized by the Presbyterian Barton Stone, was dominated by numerous Methodist and Baptist preachers who addressed twenty thousand people over the course of four days. There were three meetings a day, including a torchlight service in the evening.

Revivals peaked between 1801 and 1805, subsided, and then returned in full force around 1815, lasting until the early 1830s. To call these early revivals emotional orgies is an understatement. Wailing, singing, and speaking in tongues were common. It was thought that believers took God directly into their hearts as they battled against Satan. Conversion was therefore a shattering experience, signaled by "exercises," or bodily movements. In the falling exercise, a person dropped as though dead. An observer of one revival noted, "Bold, brazen-fronted blasphemers were literally cut down by 'the sword of the spirit.' . . . Under the preaching of the gospel, men would drop to the ground, as suddenly as if they had been smitten by the lightning of Heaven." At Cane Ridge, a convert witnessed five hundred "swept down in a moment, as if

a battery of a thousand guns had been opened upon them." Many lay like corpses and had to be dragged aside. Another exercise, the jerks, affected either a part of the body or the entire frame; when the head was affected, it jerked backward and forward or side to side. The jerks often led to the dancing exercise, with uncontrollable movements of the feet and hands. The barking exercise referred to the jerks along with barking or grunting as the head moved. Frequently, afflicted persons would get on all fours as they barked, running toward trees as if they were dogs chasing opossums; this was known as treeing the devil. There was also the melodious singing exercise and the loud, piercing laughing exercise, producing sounds said to be "truly indescribable" and *"sui generis."*

Frances Trollope witnessed a revival with mingled fascination and disgust. She watched as a hundred people near the preacher, mainly women, uttered "howlings and groans, so terrible that I shall never cease to shudder when I recall them." They made "convulsive movements" and soon were all lying in various positions on the ground: "They threw about their limbs with such incessant and violent motions, that I was every instant expecting some serious accident to occur." The sounds they made were beyond description: "Hysterical sobbings, convulsive groans, shrieks and screams the most appalling, burst forth on all sides. I felt sick with horror. As if their hoarse and over strained voices failed to make noise enough, they soon began to clap their hands violently." As the preacher continued, "the convulsive movements of the poor maniacs only became more violent. At length the atrocious wickedness of this horrible scene increased to a degree of grossness, that it drove us from our station."

As Trollope's account suggests, camp meetings provided excitement and frolic for the normally isolated farmers and frontiersmen who attended them. They were the Woodstocks of yesteryear. "Take away the worship," one commentator wrote, "and there would remain sufficient gratifications to allure most young people." On the outskirts of the crowd, vendors sold alcohol, to the outrage of the preachers. This prob-

lem became so common that several states passed laws banning the sale of liquor in the proximity of camp meetings. Men and women took the occasion to mingle without restraint. A common saying had it that as many souls were conceived at revivals as were saved.

It was such excesses that the other major strand of religious revivalism—the one that emerged in New England—resisted and tried to overcome. After having died down with Whitefield's return to England, the New England revival resumed when Timothy Dwight, the grandson of Jonathan Edwards, became the president of Yale in 1795. Unlike the bumpkins who dominated the Methodist pulpit, Dwight was immensely learned. Having mastered Greek and Latin at eleven, he entered Yale, from which he graduated at thirteen; later he received honorary degrees from Harvard and Princeton.

At the time he assumed control of Yale, the college was a hotbed of religious nonconformity; most of the students were deists, Unitarians, or outright skeptics. Within several years, Dwight brought about a near-total change of heart among the students. Having written treatises that challenged deism and defended the Bible, he caused a religious revival. By 1801 most Yale students were committed Christians. Over the following decades, many revivals swept the campus. While Harvard after 1805 became the center of Unitarianism and Princeton of orthodox Calvinism, Yale promoted a modified Calvinism that made room for human agency without surrendering Trinitarian beliefs.

One of Dwight's students, Lyman Beecher, became the chief disseminator of this liberalized Calvinism over the next several decades. Born in New Haven, Beecher graduated from Yale in 1797 and went on to become a leading evangelist of Presbyterianism. Because he believed that humans could prepare for salvation by correcting their everyday lives, Beecher advocated many moral reforms. He and his allies were largely responsible for creating reform organizations such as the American Board of Foreign Missions (1810), the American Bible Society (1816), the American Colonization Society (1817), the American Sunday School Union (1824), the American Tract Society (1825), the

American Education Society (1826), the American Society for the Promotion of Temperance (1826), and the American Home Missionary Society (1826). These and similar organizations formed the so-called Benevolent Empire (or the Evangelical United Front), the powerful network of reform groups that brought moral uplift and behavioral change to millions.

Having begun preaching on eastern Long Island, Beecher moved to Litchfield, Connecticut, and then Boston. In 1832 he took his family to live in Cincinnati, Ohio, where he became president of Lane Theological Seminary. By training ministers there, he hoped to save the West from the evils of nonconformity and Roman Catholicism. As he wrote to his daughter Catharine, "If we gain the West, all is safe; if we lose it, all is lost."

Whether or not he saved the West, Beecher certainly had a deep impact on America, not the least through the children he sired. Besides Catharine, who became a noted educator and author on domestic reform, his daughters included Harriet Beecher Stowe, the author of the antislavery best seller *Uncle Tom's Cabin*, and Isabella Beecher Hooker, a leading suffragist. His sons included Henry Ward Beecher, the immensely popular Presbyterian preacher, and the Abolitionist ministers Charles Beecher and Edward Beecher. Taken collectively, the Beechers were the single most influential family in nineteenth-century America.

Lyman Beecher was ambivalent about the use of revivals to win converts. On the one hand, he was one of the few who urged the Presbyterian clergy to use emotional revival techniques. He sent out circuit riders to conduct revivals. At the same time, he shrank from what he saw as the vulgarity of the revivals of the Methodists and Baptists, as well as their mingling of men and women in worship and their crude appeals to the lower classes. Revivals, he declared in 1828, threatened to become "one of the greatest evils which is likely to befall the cause of Christ," throwing the nation "back in civilization, science, and religion, at least a whole century." He offered improved, purified revivals, full of emotion yet free of what he regarded as potentially offensive elements.

Another famous Presbyterian, Charles Grandison Finney, emerged as Beecher's chief rival for winning souls and reforming America. An ex-lawyer who was converted to Christianity in 1821, Finney became a traveling evangelist who had none of Beecher's qualms about revivals. Finney intentionally tried to copy popular revivalists. He commented, "Many ministers are finding it out already, that a Methodist preacher, without the advantages of a liberal education, will draw a congregation around him which a Presbyterian minister, with perhaps ten times as much learning, cannot equal, because he has not the earnest manner of the other, and does not pour out fire upon his hearers when he preaches."

"Pour out fire" was the main point. Finney poured it out so effectively that he turned upstate New York into the so-called Burned-over District between 1826 and 1831. In Utica and Rome, then in many other towns along the Erie Canal, most notably Rochester, Finney ignited a Christian conflagration that startled the nation and contributed to politics, since it helped catalyze the Antimasons and later the Whig Party. When in 1827 Finney showed signs of taking his revivals into New England, Lyman Beecher, protective of his territory, declared half-humorously, "If you attempt it, as the Lord liveth, I'll meet you at the State line, and call out all the artillery-men, and fight every inch of the way to Boston, and I'll fight you there." Such genial bluster did not prevent Finney from preaching far and wide: in Delaware, Pennsylvania, New York City, and even in Beecher's Boston.

Of middle height, with a cragged face and a balding dome, Finney hypnotized audiences with his intense light-blue eyes and his powerful sermons delivered with much writhing and gesturing. In his attitude toward revivals, Finney was at the opposite end of the spectrum from the originator of the First Great Awakening, Jonathan Edwards. For Edwards, revivals were miraculous interventions of God in human affairs. For Finney, they were man-made events, utterly in the hands of people who organized them to bring sinners to Christ. The father of modern revivalism, Finney anticipated many later preachers—from Dwight Moody and Billy Sunday through Billy Graham and

televangelists—whose mass spectacles came about through human planning.

In the pulpit, Finney made liberal use of the theatrics that had brought success to the Methodists. His so-called new measures shocked some of his more staid contemporaries. One critic described "his distorted countenance," his habit of gazing at hearers "with the most horrible and ghastly stare imaginable," "his violent gesticulation, and . . . the varied horrific intonations of his voice." Another saw in his sermons "a studied vulgarity, . . . alike unbecoming in the orator, and indecent in the preacher, . . . [with] language which is banished from the parlour, and is not tolerated in good society."

His most famous innovations were protracted religious services and his use of what the Methodists called the anxious bench. As though salvation could come by attrition, he held revivals that continued for many days, sometimes weeks. Near the pulpit those anxious for their souls congregated to feel the full force of his sermons and to undergo the throes of conversion. Frances Trollope bore vivid witness to the passions of the anxious bench: "The sobs and groans increased to a frightful excess. . . . Young creatures, with features pale and distorted, fell on their knees on the pavement, and soon sunk forward on their faces; the most violent cries and shrieks followed, while from time to time a voice was heard in convulsive accents, exclaiming, 'Oh Lord!' 'Oh Lord Jesus!' 'Help me, Jesus!' and the like."

Finney moved farther away from orthodox Calvinism than had Lyman Beecher. Hell was a terrifying reality for Finney, but it could be avoided by admitting one's sins and embracing Christ. Conversion guaranteed both a blissful afterlife and the capacity to act virtuously in this life. Promoting what was called perfectionism, Finney argued that the converted individual was morally enabled to be free of sin in this world.

Morally enabled and, in Finney's view, obligated to try to improve society. Finney helped found reform groups aimed at wiping out a variety of social ills, including intemperance, prostitution, war, and slavery.

He also promoted phrenology and the Graham diet and campaigned against Masonry. His preaching took him to the major eastern cities, where he won the backing of influential citizens, most notably the New York silk importers Arthur and Lewis Tappan. Avid supporters of reform movements, the wealthy Tappans rented for him a theater he turned into a church. In 1835 they funded a professorship for him at Oberlin College in Ohio. Finney taught theology there and later became president of the college. Largely as a result of his evangelical reforms, Oberlin became the most progressive college in the nation—the first to institute coeducation and one of the first to admit African Americans.

* * * *

THREE PHENOMENA THAT FOUND expression in Finney—revivalistic fervor, perfectionism, and social reform—invigorated American religion but at the same time disrupted it. Schisms occurred in several denominations, and large new churches were formed.

The Presbyterians maintained strong influence through their learned ministry and their reform work. Still, they suffered from division. In 1801 they had established with the Congregationalists a Plan of Union by which the two churches could share clergymen and administrators. The same year, they signaled their retreat from popular evangelism by expelling Barton W. Stone, the organizer of the Cane Ridge revival. Over the following decades, conservatives in the church grew increasingly uncomfortable with the vehemence and the doctrinal laxity of popular clergymen. A schism developed between the Old Lights, who demanded pulpit restraint and a return to orthodox Calvinism, and the New Lights, who adopted mass-oriented techniques and promoted a modified Calvinism. Finney's "new measures" created so much controversy that in 1832 he left the Presbyterians and opened a Free Congregational Church in New York. Lyman Beecher also moved over to Congregationalism after the Presbyterians tried him in 1835 for heresy on the charge that he had departed from the Calvinistic Westminster Catechism. The Plan of Union clearly was not working. In 1837 the

Old Lights, having taken control of the Presbyterian Church, canceled the Plan of Union and threw out those they believed were not strictly orthodox. In all, they expelled 533 churches with one hundred thousand members.

Renegade Presbyterians went to other churches or created new ones. Barton Stone, after his expulsion from the church, formed the Christians, one of the first American sects that called for a return to primitive Christianity free of Calvinistic creeds and church rituals. In time, the Stonites merged with another Presbyterian offshoot, called the Campbellites after their leader Alexander Campbell.

The son of a Presbyterian preacher who had emigrated to America from Scotland, Campbell grew dissatisfied with what he saw as the Presbyterian Church's rigidity. Campbell wanted to simplify Christianity and spread it to the masses without falling into the hyperemotionalism of the Methodists and the Baptists. In 1809 he split from the Presbyterians and soon formed a church that adopted the Baptist rite of immersion while fusing it with a hopeful, pietistic faith based on redemption through Christ as announced in the New Testament. For over a decade Campbell's church held an uneasy alliance with the Baptists until going on its own in 1827. Soon it became known as the Disciples of Christ. The Disciples grew rapidly, largely as a result of the missionary efforts of Campbell's successor, Walter Scott, who was unafraid of using revival techniques. Membership in the church surpassed hundred thousand by 1850 and six hundred thousand by 1890, with especially vigorous growth in the South and the West. The Disciples reserved baptism for believers and held that it freed one from sin and merged the soul with Christ. Other distinctive aspects of the Disciples included the avoidance of musical instruments in services, weekly communion open to all, individual interpretation of the Bible, interdenominational outreach, and a "bottom-up" church hierarchy based on the belief in the equality of ministers and the laity.

Another faction that left the Presbyterian mainstream was a group in Cumberland, Kentucky, with anti-Calvinist leanings and relaxed

standards for ministerial training. Expelled from the church in 1810, the Cumberland Presbyterians organized as an independent body three years later. The Cumberland Presbyterian Church used camp meetings to attract those who were flocking to the Methodists. By 1829 the Cumberland Church had its own general assembly as well as presbyteries in eight states, mainly in the South. Enjoying lively growth during the nineteenth century, the church became the first Presbyterian body to ordain women as ministers and one of the first to admit African Americans. By the 1870s, blacks, who made up a fifth of the some one hundred thousand members of the church, formed their own church.

The Disciples and the Cumberland group were the largest churches that came from divisions within the main Presbyterian Church, but they were hardly alone. In the two decades after the Old and New Lights separated from each other, there developed several separate bodies that used the name "Presbyterian." In order of descending size, there were the Old School Presbyterians, followed by the New School, the Associate and United, the Reformed, the Associate Reformed, and the Free Presbyterians. Among American denominations, only the Baptists had such variety. There were the Primitive Baptists, the Freewill Baptists, Hard- and Soft-Shell Baptists, the Particular Baptists, General Baptists, Six-Principle Baptists, Anti-Mission Baptists, Two-Seed-in-the-Spirit Baptists, and German Seventh-Day Baptists.

The rise of democratic, evangelical Christianity affected even the most traditional denomination in America, the Episcopal Church. Before the American Revolution, the Anglicans were strong in the colonies, especially in the South, where they had virtually a first-place tie with the Baptists, with nearly a third of all religious adherents. The war against England shattered the American church. The rebuilding process began in 1789 with the formation of an independent American Episcopal Church that recognized republican principles such as church voting by laity and separation of church and state.

The church languished, however, until 1811, when both the evangelical Low Church and the orthodox High Church gained fresh

energy. The ordination that year of Bishop Alexander Viets Griswold in New England began the rapid expansion of the church in the Northeast, where the number of Episcopal priests and parishes more than quadrupled before his death in 1843. A militant evangelical, Griswold deemphasized sacraments and rituals. He removed the singing of the Agnus Dei and even used some revivalistic touches in his services. The churches built in the Northeast often had the simplicity of other New England churches, without many icons or architectural ornaments. A similar democratic outreach was made in the South and the West, where evangelicals like Bishop Richard C. Moore of Virginia and Bishop Philander Chase led an Episcopal resurgence.

One might not expect the High Church to have made headway in a time of popular evangelizing, but it did under the leadership of New York's John Henry Hobart, who became an assistant bishop in 1811 and bishop a few years later. Among the most important figures in the history of the American Episcopal Church, Hobart launched a spirited revival of High Church rituals without losing touch with average American churchgoers. His preaching was even sometimes attacked as Methodistic. In the Chelsea area of Manhattan, Hobart helped establish the intellectually vibrant General Seminary, known as "a little Oxford on this side of the Atlantic." In upstate New York, he founded Geneva College (later renamed Hobart College in his honor), which trained Episcopal clergy and had two firsts: it was the first American college to establish a three-year "English course" of study and the first to train a woman doctor, Elizabeth Blackwell.

Bishops in several other states joined in the High Church revival. Especially surprising, given growing nativist sentiment in this period, was the rise of a Tractarian movement in America. Among those who led this highly conservative trend were bishops George Washington Doane of New Jersey, John Henry Hopkins of Vermont, and the brothers Benjamin T. Onderdonk of New York and Henry Ustick Onderdonk of Philadelphia. The Tractarian cause, however, was tarnished in the

1840s when the Onderdonk brothers were both defrocked—Benjamin for unchastity and Henry for drunkenness and drug addiction—and Doane was investigated for financial corruption. But the High Church saved face through the noble work of Bishop William Augustus Muhlenberg. Serving first in Flushing, New York, and then at the Church of the Holy Communion in Manhattan, Muhlenberg combined a dedication to conservative Anglicanism with democratic outreach to the poor and to other religions.

The Episcopalians were in the anomalous position of shrinking relative to other denominations while maintaining strong cultural influence. Another denomination that combined small numbers and large impact were the Unitarians. A holdover of eighteenth-century rationalism, Unitarianism appealed to the well-heeled intelligentsia of America's cities, especially Boston. Forms of Unitarianism harked back to the early Protestant Reformation, but in America the movement did not take off until 1785, when the Reverend James Freeman introduced this liberal religion in Boston's King's Chapel. Soon enough, other Boston churches followed suit, so that by the turn of the century almost all of the city's churches had gone over to Unitarianism.

The main churches that suffered membership losses to the Unitarians were the Congregationalists and Presbyterians. As these denominations became divided over revivalism and Calvinism, a growing number of their members decided to turn away from intense emotion and Calvinism altogether. Was Jesus part of the Holy Trinity, as Calvinism said? Did a wrathful God send most people to hell? Was human nature totally depraved? Was the Bible the inerrant Word of God? Was feverish passion a sign of true faith?

Absolutely not, said the Unitarians. God was One, not Three. Jesus was a good human being, not God. He set an example of moral perfectibility that all people could follow. God was loving, not angry and unforgiving. The Bible was a human book written by human beings. It is best understood through the lens of reason, not in the throes of passion.

This position was laid out most eloquently by the dean of American

Unitarianism, William Ellery Channing. Born in Newport, Rhode Island, and educated at Harvard, Channing served as the pastor of Boston's Federal Street Church from 1803 until his death in 1842. As a member of the board of Harvard College, he was chiefly responsible for creating the Harvard Divinity School in the Unitarian mold in 1816. Nine years later he helped found the American Unitarian Association, which distributed books and tracts and established churches nationwide. He wrote many books and sermons defending Unitarianism. Among the most famous was his 1819 sermon "Unitarian Christianity," in which he laid out the central tenets of the faith: God's benevolence and oneness, man's capacity for virtue, and the need to use reason in evaluating the Bible. He dismissed the stormy conversions at revivals with an apt metaphor: "We do not judge of the bent of men's minds by their raptures, any more than we judge of the natural direction of a tree during a storm. We rather suspect loud profession, for we have observed, that deep feeling is generally noiseless, and least seeks display."

Such arguments swayed many intellectuals and helped give rise to Concord Transcendentalism, America's leading philosophical movement. But Unitarianism never caught on with the masses. Even at its height, around 1850, the Unitarians had only a fraction of the membership of the Baptists and Methodists.

An allied liberal religion, Universalism, delivered an evangelical version of Unitarianism to the general public. By the end of the Civil War, there were three times as many Universalists as Unitarians. Brought to America by the ex-Methodist British clergyman John Murray in 1770, Universalism in America found its chief promoter in the New Hampshire native Hosea Ballou. Having been a Baptist and then a Congregationalist, Ballou adopted Universalism and divided his time between itinerant preaching and serving at the Boston's Second Universalist Church, where he was pastor from 1817 until his death in 1852. He founded the *Universalist Magazine* in 1819 and published treatises, hymns, and poems to advance his views.

Ballou and his fellow Universalists preached that God had sent

Jesus to save all humankind, not a select few. There was no such thing as punishment after death. All retribution came in this life. No matter how we behave in this world, we will all be blissful angels in the next life. The Universalists delivered this positive message mainly to humble, rural folk in sermons that steered a middle course between the rationalism of the Unitarians and the intensity of the Methodists.

If some of the runoff from larger churches went to the Unitarians and Univeralists, much more of it went to the so-called Christian Connection. At least three major sources can be identified for this very popular denomination: Methodists in North Carolina and Virginia who rebelled against that church's hierarchy; Baptists in northern New England who sought to simplify religion; and Presbyterians, some of them followers of Barton Stone, who left their church after the Cane Ridge revival. Together, these groups called themselves the Christian Connection, or just Christians. In the early 1830s, some followed Stone into Campbell's Disciples of Christ, but most did not. By then, the Christian Connection had around seven hundred ministers, one thousand churches, and seventy-five thousand to one hundred thousand members. These numbers had more than doubled by the time of the Civil War.

The Connection tried to resurrect primitive Christianity by dismissing all creeds, forms, and rituals. Ultra-Protestant, it believed that religion consisted solely in the relationship between the individual and the Bible. Presumably, there was no absolute authority for interpreting the scriptures. All people must interpret it for themselves.

In fact, however, certain core beliefs held the Christian Connection together. Most members of the group had an Arian view of Jesus, whom they considered neither wholly divine nor wholly human. They rejected baptismal sprinkling, preferring immersion. They welcomed people of all faiths to their open communion. They thought that one's destiny in the afterlife depended on one's deeds in this life. Repelled by the institutional structure of established churches, they kept their congregations largely independent of each other. But they did form many state conferences as well as a United States General Conference to coordinate the

separate churches. By the late 1860s, there were over a half million members of the Christian Connection. In the mid-twentieth century, the church merged with three others to form the United Church of Christ, which later formed a close alliance with the Disciples of Christ.

Another group that moved dramatically away from church and creed was the Society of Friends, or the Quakers. Once a sect persecuted by the Puritans, the Quakers by the nineteenth century had proven themselves a respectable and philanthropic—if somewhat insular—society that lived mainly in the Philadelphia area. The Quakers believed that Christ was revealed in every individual through a gift known as the inward light. Revelation came not from listening to sermons or prayers but from opening one's eyes to "that of God" within. Religious services, called meetings, in churches, or meetinghouses, consisted of spontaneous testimonies of the inner light by those present, sometimes under the guidance of a pastor. Most meetings were unprogrammed. Members sat silently until they were moved to rise, voice a revelation, and then sit down.

As unorthodox as Quakers seemed to traditional Christians, they were even more so after the innovations of the Long Island Quaker Elias Hicks. Born in 1748 in Rockaway, New York, Hicks joined the Society of Friends when he was twenty and became a traveling preacher noted for his speaking talents. He became increasingly dissatisfied with the Quakers' insistence on the divinity of Jesus and the holiness of the Bible. By the early 1820s, Hicks, then in his seventies, argued vehemently that the inner light, not Jesus or the Bible, was the true authority for all people. He insisted that one could be a Hindu or a pagan, with no knowledge of the Bible, and still receive God's illuminations by looking within. The Bible was a moving record of holiness, he said, but it was not the sacrosanct Word of God. Nor was Jesus divine; he simply heeded the inner light more than did most people.

Hicks was controversial not only for these heterodox views but also because of his fervent abolitionism and his declarations that human passions, including sexual ones, were natural and God-given. He was

roundly criticized but attracted a large following. In 1828 the Society of Friends split into two factions. Traditional Quakers, known as Orthodox, maintained a belief in the sanctity of the Bible and Jesus. The so-called Hicksites denied it, putting heavy emphasis on the inner light. Over time, the Hicksites grew in numbers, though they never caught up to the traditional Quakers. By the late 1860s, about a third of the nation's Quakers were Hicksites.

The democratization of American religion affected even one of the most traditional Protestant denominations, the Lutheran Church. Early in the century, the New York Ministerium changed the language of its services from German to English. Notable church leaders established the principles for an American Lutheran Church that adapted to the current social and religious climate. These leaders included Samuel S. Schmucker, who in 1826 founded the Gettysburg Seminary in Pennsylvania; Samuel Sprecher, who founded Wittenberg College and Seminary in Ohio in 1845; and Benjamin Kurtz of Baltimore. Lambasting what Schmucker called "ultra Lutherans" who wanted "to roll back the wheels of time about three hundred years, and to bring the Lutheran church to the standpoint of the 16th century," he and others called for modernization of the church. This meant not only deemphasizing the German language and culture but also dismantling the orthodox Lutheran platform that included the mass, private confession, exorcism of evil spirits, the Real Presence in the Eucharist, and divinity of the Sabbath.

Americanization, however, met stiff resistance and ultimately faltered. The forces for tradition were overpowering. Some 600,000 German emigrants arrived in America between 1820 and 1850, another 950,000 in the 1850s. To be sure, not all were Lutherans, but many were, and they resisted shedding their language and rituals. Just as important, the Lutheran Awakening that caused a conservative reaction in Germany had strong repercussions in America. Orthodoxy made a comeback. Intellectually, it was solidified by the work of the hugely influential Gettysburg theologian Charles Philip Krauth, who built a case

for Real Presence and other Lutheran tenets. By the time of the Civil War, more than two thirds of the Lutherans in the United States were of the traditional variety.

* * * *

EVANGELICAL FERMENT PRODUCED CHARISMATIC seers who said they were divine. It was a short step from saying one was *possessed* by God, as often happened in revivals, to claiming one was *appointed* by God. Groups grew around these supposed prophets. Some of the groups, such as the Vermont Pilgrims and the followers of Matthias, were small and short-lived. Others lasted longer, while one, the Mormons, became a powerful church. The beliefs and practices of these groups proved shocking to many Americans.

One of the first homespun prophets of the period was a woman, Jemima Wilkinson. She had a small but intense following until her death in 1819. The Rhode Island–born Wilkinson had been deeply moved by George Whitefield's sermons and by the illuminatory experiences of the New Light Baptists. When she was twenty-four, she had a near-death experience during an illness. After recovering, she claimed that she had actually died and her body had been taken over by a divine spirit, perhaps the Messiah. She donned long robes and rode throughout New England and Pennsylvania announcing herself as the "Universal Publick Friend." She held well-attended open-air revivals in which she claimed powers of revelation and healing. A tall, graceful woman with dark hair and eyes, she won many converts, not only among rural folk but also among merchants, lawyers, and artisans. Her most devout believers were certain that she was indeed the Messiah. Although she did not confirm this belief, she did not deny it either.

Like Mother Ann Lee of the Shakers, a prophetess who had evidently inspired her, Wilkinson demanded celibacy. Predictably, this demand did not sit well with many who refused to join their spouses in the faith. Also, the claims of divinity led to Wilkinson being tried for blasphemy. In Philadelphia, she was stoned. At last she established with

some three hundred followers a community, New Jerusalem, in the Seneca Indian region of the western New York frontier. Although the community's belief in the Universal Friend lasted until 1819, it did not survive her death, because she did not fulfill her promise that she would survive on earth for a thousand years as the Holy Spirit.

Other early cults that arose around American prophets were the Halcyon Church, the Osgoodites, the Cochranites, and the Vermont Pilgrims. The Halcyon Church was founded by Abel Morgan Sargent, a Baptist-turned-Universalist who in 1801 proclaimed that he was God's new messenger of the pure, ancient theology. He insisted that he alone held the keys to the arcanum, the Urim and Thummim, and the Jewish Kabbalah. The thousand-year return of Christ had now begun, he announced. "Columbia" (the United States) was the new Holy Land. Surrounded by twelve women disciples, he traversed New York and Ohio, attracting several hundred followers. Sargent reported that he conversed daily with angels and had the power to raise the dead. He and his followers fasted for as long as forty days at a time. But the cult fell into disrepute and in 1815 was absorbed into the Universalist Church.

Another divine messenger, Jacob Osgood, converted many in the region of his native South Hampton, New Hampshire, by announcing that God had told him to warn sinners to flee the wrath to come. He had joined the Congregationalists and then the Freewill Baptists, but these churches dismissed him, and he founded his own cult, which became prominent around 1814. Osgood rejected doctors and healed the sick with a laying on of hands. He claimed he could control natural phenomena, such as the weather and insects. His group had no churches, meeting in houses and having verbal free-for-alls in place of normal services. Though never a large group, the Osgoodites lasted until the 1840s.

In the same mold as Osgood, but more controversial, was another New Hampshirite, Jacob Cochran. Born in 1782, Cochran lived in the White Mountains until he moved to Saco, Maine. Like Osgood, he was a Freewill Baptist who had received an illumination during a revival. Around 1815, he spread the word that he was the Holy Ghost, with

powers to heal the sick, raise the dead, and cast out devils. A surprising number of people in Maine's Oxford, York, and Cumberland counties believed him. By 1818 his Society of Free Brethren claimed two thousand members. Cochran announced that he expected "to have the United States, in the present season, under his control" and that he would soon hold "universal dominion" over the whole world.

Since Cochran said he was divine, the revivals he led had a special intensity, often verging on bedlam. Cochran administered the so-called Baptism of the Holy Ghost by putting one hand on the head of a convert, pointing his other hand in the opposite direction, and screaming about damnation and the Day of Judgment. The convert went into uncontrollable convulsions and licked the ground at Cochran's feet. Asserting that he alone had the key to heaven, Cochran twisted his hand violently as if opening the celestial gates. This ritual led to a total release from sin. Once converted, a person was supposedly perfect and shared Cochran's miraculous powers. During revivals, converts grew deliriously joyful. They danced, twisted their bodies, and threw their arms wildly. Periodically they let loose a united roar that was heard far throughout the countryside.

Cochran was one of the first of many American seers who combined religious inspiration with sexual experimentation. Regularly during his revivals, his followers shed their clothing. Although Cochran was married and had children, he took many "spiritual wives" among his female converts, for whom sex with Cochran was literally unification with God. He lived with twelve wives in a dilapidated mansion in Saco—a kind of early version of David Koresh at Waco. Each of his male followers was permitted to have as many as seven wives. During his services, Cochran regularly took a woman follower into an adjoining room, fornicated, and then returned to the main area with her, asking if she did not now see the world completely differently.

A contemporary noted that if Cochran "did but touch the hand or neck of a female, his power over her person and reason was complete,"

and "he seduced great numbers of females, married and unmarried, under the pretext of raising up a holy race of men."

Predictably, this behavior got Cochran into legal trouble. In May 1819, he was brought to trial on five counts of "open and gross lewdness, lascivious behaviour, and adultery." He pleaded not guilty but was convicted and sentenced to prison. Four years of incarceration had no effect on his later actions. Certain of his divinity, Cochran resumed his ministry after his release from jail, though his flock was greatly reduced. Some of his followers settled in Allegany County in New York, where they apparently helped inspire the Mormons, who similarly yoked polygamy and divinity. He stayed in northern New England, continuing to have many spiritual wives until his death in 1836.

Not far from Cochran's home base, there gathered another small sect, the Vermont Pilgrims, under the red-bearded Isaac Bullard, who styled himself the Prophet Elijah. In 1816 Bullard left Lower Canada with his wife, their son (whom they called Second Christ), and a tiny group of followers. They settled in Woodstock, Vermont. Bullard declared that he possessed greater authority than any other power, human or divine. He rejected not only creeds and churches but also the Bible, since he believed his orders came straight from God. He and his group insisted that God did not want humans to bathe or change clothes. Bullard himself did not change his clothing for seven years; nor did he wash himself or cut his beard. Trying to resurrect primitive religion, the group wore bearskins. Believing that salvation came through penance, they held long fasts and otherwise tortured themselves—for example, by standing still for several days without sleeping or sitting down. They ate simply, without forks or spoons, typically sucking milk and mush or flour and broth through quills from a common bowl. Women in the group prayed by writhing facedown in the dirt. Communal marriage was practiced; believers slept indiscriminately with each other.

The Pilgrims gained national attention between 1817 and 1820, as they trekked southwestward from Vermont. Bullard called his group

the lost tribe of Judah in search of the Holy Land. At one point the Pilgrims split, one portion heading through New Jersey and Pennsylvania to Ohio while the larger number, under Bullard, proceeded through western New York. They became a kind of traveling freak show, gawked at everywhere and reported in local newspapers. Disgustingly dirty and vermin-ridden, the Pilgrims chanted, "Oh-a! Ho-a! Oh-a! Ho-a! My God! My God!" They cursed all outsiders, whom they saw as satanic. When news of their sexual practices leaked, they provoked outrage.

The two parties of Pilgrims reconvened near Cincinnati, where they gathered more recruits. Shedding their bearskins, they wore multicolored rags. The group now numbered between two hundred and three hundred, but as it journeyed, it was ravaged by disease. By the time the Pilgrims reached Missouri, they were dying at an alarming rate. Corpses were left unburied to rot in the sun. A few disillusioned survivors begged their way back to Vermont. True believers continued on the quest for the Holy Land, which turned out to be a snake- and alligator-infested place near Helena, Arkansas. Bullard apparently died. All that was left of the Pilgrims were his wife and another woman, who lived in a shack.

The prophet parade continued with Michael Hull Barton. A native of New York State who was excommunicated by the Quakers, Barton in 1823 announced himself as the angel Michael of the Bible, reporting that he got this information from "visions of divine light, in a miraculous manner." He joined Jacob Cochran and later the Mormons before traveling around the country accumulating converts of his own. Most of his converts were young married women whom he persuaded to leave their husbands and join his growing body of spiritual wives. His cult lasted into the 1840s, when he claimed to have traveled "70 or 80,000 miles, and perhaps 10,000 of it on foot, to preach the gospel without money and without price." But word spread of his sexual escapades. He was publicly charged in 1844 with using religion merely for "the gratification of his own lust and licentiousness." Disgraced, he disappeared from public view.

Scandal also surrounded the colorful Robert Matthews, aka Matthias. Born in Washington County, New York, in 1778, Matthews was raised as a Calvinistic Presbyterian. At first a farmer, he became a storekeeper and then a carpenter. He married in 1813. Within three years, he went bankrupt after a failed building speculation. Soon he was in Albany, where he joined the Dutch Reformed Church. He also tried out Methodism and Judaism. In the 1820s, he began attending religious revivals. After one conducted by Charles Finney, he reportedly "came home in a state bordering on phrenzy." He took up street preaching, and in 1831 had a revelation in which God commanded him to take over the world in the name of Jesus Christ. Soon he went by the name Matthias, the New Testament apostle chosen to replace Judas Iscariot.

Just as Matthias was discovering his divinity, so was Elijah Pierson, a Manhattan merchant. In 1825 Pierson had joined the Retrenchment Society, a group of wealthy New Yorkers who claimed to be directly in touch with God. Established under a different name by a Presbyterian woman, the society had regular meetings at the home of the affluent hardware merchant Benjamin Folger and his wife, Anne. At these meetings, members described their conversations with God. Pierson announced that he was the prophet Elijah the Tishbite. Among those who came within his circle was Isabella Van Wagener (who later called herself Sojourner Truth), a deeply religious ex-slave who became Pierson's housekeeper in 1829. Pierson was convinced he had miraculous powers and thus grew despondent when his wife died and he was unable to raise her from the dead.

Enter Matthias. Having drifted through Washington and Pennsylvania, Robert Matthews ended up in Manhattan and showed up one day at Pierson's doorstep. He was greeted by the pious, impressionable Isabella, who instantly linked the bearded Matthias with Jesus Christ. When Pierson met Matthias, he, too, accepted him as divine. Matthias said that Jesus's spirit had inhabited his body and that he was now God the Father, with the power to do all things, including forgive sins and

communicate the Holy Ghost to those who believed in him. Thereafter, Pierson was John the Baptist to Matthias's Christ.

Matthias played his role by wearing symbolic clothes: an olive robe trimmed with gold and lined with pink-plaid silk, an overcoat decorated with silver stars, and a black cocked hat emblazoned with a golden symbol of glory. He wore an expensive watch and a two-edged sword with a gold sheath and an ivory handle. He carried a large key for unlocking the gates of heaven and a six-foot ruler with which he planned to measure the circumference of the New Jerusalem. In bed he wore a nightcap that read "Jesus Matthias."

Meanwhile, Matthias had made successful advances on some other upper-crust New Yorkers, notably the Folgers. In August 1833, Matthias moved into the Folgers' mansion in Westchester County and soon convinced them to sign over the estate to him. Elijah Pierson and his maid, Isabella, also moved in, forming a kind of religious commune. Pierson also donated his possessions to Matthias. Within a year, Pierson mysteriously died. Had he been poisoned by the conniving Matthias and his devoted sidekick, Isabella? That's what the Manhattan authorities thought. Matthias and Isabella were tried as conspirators in the murder of Pierson, but the case was dropped for lack of evidence.

Matthias conducted baptism by having believers stand naked in a circle while he sponged them in a rite he called the Fountain of Eden. Endorsing spiritual marriage, he had several wives. He had his eye on Anne Folger. He wished to plant the holy seed in her through "a divine union." She became pregnant by him. Her husband was promised that he could produce another holy child by cohabiting with Matthias's eighteen-year-old daughter, but the daughter put up fierce resistance.

Before long, the Folgers recognized Matthias as an impostor and cast him off. He went west to Ohio, where, now calling himself Joshua the Jewish Minister, he met the Mormon leader Joseph Smith. The two felt a spiritual kinship but parted ways after Matthias claimed to be God. Matthias holds an important place in Mormon history, because in 1835

Smith told him of having had visions of celestial beings. Reportedly, Smith said that fourteen years earlier he had seen two personages (presumably God and Jesus) along with many angels. This was one of the several divine testimonies by Smith on which Mormonism rests.

Mormonism remains the most important outcome of illuminatory religion in early-nineteenth-century America. The Church of Jesus Christ of Latter-day Saints began as a tiny cabal of six members in 1830, but it grew rapidly. Within four decades, it had sixty thousand members. In time it became a megachurch, claiming a worldwide membership of over twelve million by the early twenty-first century.

The Mormon Church is both typical and atypical of the period's prophetic impulse. Its founder, Joseph Smith Jr., emerged out of the same region as several other prophets. Born in Vermont in 1805, he moved in 1816 with his family, struggling farmers, to Palmyra, New York, a religiously diverse town that boiled with revivals. His parents, Joseph Sr. and Lucy, had long been on spiritual quests: The former had passed through Universalism, Methodism, and skepticism, reportedly having celestial visions along the way; the latter was deeply devout but unchurched. Their arrival in Palmyra coincided with a major revival there. Soon Lucy joined the Presbyterian Church.

Another revival swept the area in 1820, the year the fourteen-year-old Joseph Jr. had his first divine vision. Ill-educated, Joseph had been something of a ne'er-do-well as a youth. A Palmyra neighbor called him "the most ragged, lazy fellow in the place, and that is saying a good deal." He became active as a treasure hunter, seeking buried money with forked sticks and stones that were supposedly magic. Like his parents, he was profoundly curious about religion. Revivals made him feel close to God but also distressed him with their jarring frenzy. He saw in them "great zeal" and "great love" followed by "great confusion and bad feelings" when the excitement was over. Joseph yearned for union with God that was both joyous and tranquil.

In the spring of 1820, he saw a glorious divine being (or beings) who

told him that all existing churches were wrong and that his own sins were forgiven. Three years later, he saw an angel named Moroni, who told him of golden plates on which were inscribed truths of the Gospel. Moroni said God had chosen Smith to prepare the world for the return of Christ. Under Moroni's direction, Smith went to a nearby hill, dug up the plates, and found them covered with Egyptian hieroglyphs. Moroni gave him special glasses to read the symbols but told him to delay the translation. Shortly thereafter, Smith married, settling with his wife in Harmony, Pennsylvania. In 1827 he began a three-year process of translating the plates. Sitting behind a curtain, he read from the plates as others transcribed his words.

The result was the Book of Mormon, published in 1830, a long volume, much of its language borrowed from the Bible. It recounted the wanderings and wars of three peoples in pre-Columbian America. The one truly Christian people, the Nephi, had been nearly killed off, leaving just two survivors, Mormon and his son Moroni, who buried the Nephi chronicles, to be exhumed later by a prophet who would resur-

Joseph Smith *Brigham Young*

rect the Nephi faith in preparation for the Second Coming of Christ. That prophet was Joseph Smith (or Joseph, as historians often call him after the Mormon custom of using their leaders' first names). As the king of the Kingdom of God, Joseph had the mission to spread the holy Christian principles of Nephi and create a new body of saints.

To demonstrate the authenticity of the gold plates, Joseph printed in the Book of Mormon brief testimonies by eleven witnesses, friends of his who allegedly had seen them. One witness later confessed he saw the plates not normally but "with the eyes of faith . . . though at the time they were covered with a cloth." Others insisted they had actually handled the plates, which the angel Moroni had then taken away.

The seed of the church was planted. Able people helped establish it. One convert, Sidney Rigdon, an ex-Campbellite preacher, organized the church's move in 1830 to Kirtland, Ohio, where Joseph and others created a tightly governed community that held property in common. Joseph reported having divine visions and performing miracles, such as healing diseases, walking on water, and raising the dead. Another group of Mormons settled in Missouri.

In 1838 financial troubles and internal bickering led Joseph and many of the other Ohio Mormons to join the community in Missouri, where new problems arose. Outsiders had little tolerance for these self-proclaimed saints who warned that they alone would survive the fast-approaching Day of Judgment. Also, rumors swirled of polygamy among the Mormons. A power struggle broke out when Joseph announced that God had designated a large part of the state as the New Jerusalem. Armed conflict erupted as the state militia attacked the Mormons, who fled across the Mississippi to Illinois. There they established the town of Nauvoo, where they built a new temple and a university and had their own militia. Joseph was elected mayor of the town. Signs of progress were so strong that Joseph in 1844 offered himself as a candidate for president of the United States. Once again, though, conflict broke out. Mayor Joseph Smith's violent suppression of a Nauvoo newspaper hostile to Mormon practices, especially polygamy, led to the arrest

of him and others. Joseph was put in a weakly guarded jail that was overwhelmed by an angry mob. In the melee Joseph was killed.

One of Joseph's dynamic associates, Brigham Young, took over the church. Realizing that the Saints needed to find a place of their own, he led them over a thousand miles due west to the Great Salt Lake Basin, then still part of Mexico. There the Church of Jesus Christ of Latter-day Saints prospered, growing exponentially over the years.

Theologically, Mormonism believed in faith, repentance, and baptism. It departed from Calvinism by emphasizing freedom of the will. It humanized God by holding that the Trinity consisted of three separate persons, who were really just glorified human beings. It held that all other religions were false and that the Book of Mormon was a true record of ancient history. Its view of the afterlife was benign, envisioning three realms after death, the highest to be inhabited by the saints and the lowest by sinners; but even the lowest was blissful compared with earth.

Polygamy was the church's most controversial practice. As noted above, many previous embattled American prophets had endorsed plural marriage. Joseph institutionalized it. For him, "celestial" or "patriarchal" marriage was essential preparation for the highest exaltation in the afterlife. The more wives and children a man had, the more spiritually enabled he became. Before his death, Joseph had been sealed (married) to many women—estimates of the number of his wives range from twenty-eight to thirty-three. One was only fourteen years old when he was sealed to her; at least eleven were already the wives of other men. About a fifth of the early Mormons in Utah practiced polygamy. Brigham Young had an estimated twenty-seven wives and fifty-six children. He kept many of his wives in long buildings, the Lion House and the Beehive, with a bedroom and a parlor assigned to each wife.

Some Americans responded to Mormon polygamy with amused titillation—the bawdy magazine *Venus's Miscellany,* for instance, joked that Brigham Young ruled not "with a rod of iron" but "by a pole of flesh! It is *hard,* no doubt, but not fatal." The most characteristic response, how-

ever, was outrage. The federal government pressured Young's followers to ban polygamy. The mainstream church officially did so in 1890. But plural marriage was so important to Mormon doctrine and culture that some church leaders practiced it covertly, while others formed a fundamentalist church to maintain it. Some thirty thousand to fifty thousand polygamist fundamentalists live in Utah and its environs today.

One of the underpinnings of the Mormon faith—the Second Coming of Jesus Christ—became the defining feature of the sect that developed around William Miller, a Massachusetts native who divided his adulthood between Vermont and upstate New York. Although Miller did not found a church, his prophecy that Christ was about to return created an unprecedented stir throughout the Northeast.

Most Christian churches took the postmillennial view that Christ's return would come *after* a thousand years of heaven on earth. Some, like Miller, held the premillennial position that Christ's Advent would occur *before* the millennium. Although premillennialism had been around for centuries, rarely did it attract such attention as when Miller offered alleged biblical proof that in 1843 Christ would reappear and pass judgment on all humans, sending the saints to heaven and the sinners to hell.

Born into a Baptist family in 1782, Miller shifted to deism but returned to the Baptist fold during the War of 1812, in which he served as a captain. Zealously devout, he wanted to prove Christianity logically. He spent many years carefully perusing the Bible. After close inspection, the Bible made perfect sense to him. More than that, it contained for him a historical fact both alarming and exhilarating: Jesus Christ was about to come back to earth. The Book of Daniel says "the sanctuary [will] be cleansed" in 2,300 days. Using the day-year principle, by which one Old Testament day equals one modern year, Miller figured out that Christ would return sometime between March 1, 1843, and March 1, 1844. He began lecturing publicly about this prophecy in the early 1830s, when he was ordained a Baptist minister.

For over a decade, he tirelessly crisscrossed the Northeast, giving countless sermons about the Coming. Ministers of virtually all denominations jumped on the Adventist juggernaut. Joshua V. Himes of Boston's Chardon Street Chapel was an especially effective publicist, organizing Millerite revivals that attracted thousands. Millerite magazines sprouted. Opponents ridiculed Miller, but that only fanned curiosity about him.

When 1843 came, millennial fever reached epidemic proportions. All that year, traveling preachers announced the imminent Day of Judgment at huge camp meetings. By the end of the year, over fifty thousand Americans firmly believed that the end was near. Perhaps as many as a million others were expectant, if dubious.

March 1, 1844, came and went. The appointed year was over, but the excitement did not die. Miller said that his math was wrong. Now he insisted that October 22, 1844, was the day. Anticipation mounted. Most believers remained surprisingly calm. Legends later grew about masses of people donning white ascension robes, gathering on hillsides or in graveyards, going insane, or indulging in licentiousness. Historians have disproved these colorful tales. But people did prepare, usually by getting rid of property they considered unnecessary. One Philadelphia tailor hung a sign: This Shop is closed in honor of the King of Kings, who will appear about the 23rd of October. Get ready, friends, to crown him Lord of all.

October 22 arrived and brought . . . the Great Disappointment. That was what Millerites called the day. One said, "Our fondest hopes and expectations were blasted, and such a spirit of weeping came over us as I never experienced before. . . . We wept, and wept, till the day dawned." Some attempted yet more revision of the biblical numbers; Miller himself set a new date for the millennium: spring 1845. Others dropped the idea of an exact date altogether. Many more abandoned Millerism and returned to traditional churches. William Miller diminished his preaching, fell ill, and died in 1849. He had, however, given impetus to Adventism, destined to be a powerful strain in American religion, carried

on by large movements such as the Seventh-day Adventists and the Jehovah's Witnesses.

$$\star \quad \star \quad \star \quad \star$$

"WE ARE ALL A little wild here with numberless projects of social reform," Ralph Waldo Emerson wrote Thomas Carlyle in 1840, "not a reading man but has a draft of a new community in his waistcoat pocket."

Around sixty utopian communities were founded in nineteenth-century America, with total membership approaching one hundred thousand. The groups tried to create alternative, improved lifestyles among like-minded people who clustered together, often in remote or rural places. Until the 1840s, when the ideas of the French utopian socialist Charles Fourier became known in America, most of the communities were religious, designed to resurrect the principles of authentic Christianity. The religious groups tended to last longer than the secular ones, mainly because they were defined by powerful beliefs and culture-specific practices that strengthened their isolation from mainstream America. By considering a few of the more important communities, we get a sense of the adventurousness of the era's utopian spirit.

A prime example of a strong, lasting religious community was the Amish, one of three main sects of Mennonites, Anabaptists who fled in droves to America after suffering persecution in Europe. Followers of the Dutch Protestant reformer Menno Simons, the Mennonites settled in Pennsylvania and Ohio, then spread to many other states between 1810 and 1850. The Amish, conservative Mennonites who emphasized separation from the outside world, were founded in 1693 by the ex-Mennonite preacher Jacob Amman. Like other Mennonites, the Amish expanded during the antebellum period, establishing a pattern of growth that continued through the early twenty-first century, by which time there were around two hundred thousand Amish living in more than twenty states and in Canada.

Inspired by Bible passages like "Be not yoked with unbelievers" (II Corinthians 6:14) and "Be ye not conformed to this world" (Romans

12:2), the Amish distanced themselves from American society and tailored their lives in accordance with what they saw as primitive Christianity. Since the Amish lived differently in different parts of the country, generalizations about them are difficult. Still, large numbers of them held certain customs in common. They resisted modern technology, which they thought linked them with the outside world and encouraged vanity or competition. (Hence their rejection today of electricity, telephones, cars, and photographs.) Amish women wore bonnets, tight-fitting dresses (often blue or brown), white aprons, and scarves folded across their breasts. Men wore broad-brimmed hats and coarse woolen pants and vests. Instead of buttons, which were seen as signs of vanity, the Amish fastened their clothes with hooks and eyes, giving rise to their nickname Hooker Mennonites.

Religious meetings, led successively by different members of the community, were held in houses or barns, with men and women sitting apart from each other. The Amish refused to take oaths, serve in the military, bring lawsuits, or hold public office. They rejected assistance from the government and are now exempt from federal taxes, since they do not collect social security. To maintain their distance from the "English" or "Yankees," they spoke a version of German known as Pennsylvania Dutch. Sticking to an agrarian way of life, they focused on farming and discouraged education beyond the eighth grade.

Averaging seven children per family, the Amish counted on procreation for survival. In this sense, they were worlds apart from another group that prospered in early-nineteenth-century America, the Shakers, who practiced celibacy. This sect originated in France and spread to England, where it took on the name of the Shaking Quakers because of its adherents' spasmodic movements during worship. In 1770 one of the group's British members, the fair-complexioned, blue-eyed Ann Lee, had a revelation that led her to announce that she was the female part of the dual Father-Mother God. The illiterate daughter of a Manchester blacksmith, Ann was married but had lost four children, a tragedy that prompted her to turn to celibacy. Persecuted in England, "Mother"

Ann in 1774 moved with eight fellow Shakers to New York and established a small community near Albany. Mother Ann died at forty-nine in 1784, but Shaker villages started appearing throughout the Northeast and elsewhere. The sect peaked between 1830 and 1840, when there were nineteen Shaker societies in seven states with some six thousand members. Shaker villages became common tourist spots, visited by celebrities like Charles Dickens, Harriet Martineau, and Nathaniel Hawthorne.

The bulwarks of Shakerism were celibacy, communism, and equality of the sexes. Officially known as the Millennial Church or the United Society of Believers in Christ's Second Appearing, the Shakers divided history into four phases anticipating the millennium. Ann Lee, they believed, had ushered in the fourth phase, initiating Christ's return to earth. They thought that since the world was about to end, continuance of the human race was unnecessary. Believers should band together and lead chaste, humble lives to prepare for spirituality. In Shaker communities, private property and the nuclear family were discouraged. Marriage, though not banned, was labeled unchristian. Men and women lived separately in large dormitories. They dressed simply and ate apart in dining halls where silence was maintained. They abstained from alcohol and frowned upon eating meat. The little child rearing that was needed was communal. Workdays were long and grueling. The normal day included twelve hours of work followed by supper, a religious service, and early bedtime. Although work was divided along gender lines, women enjoyed equality with men, assuming leading roles in the community. Shaker products such as furniture, seeds, herbs, and woolen goods sold well.

The bodily convulsions that gave the Shakers their name were incorporated into their services. Shakers sang fervently and danced wildly when celebrating their faith. They became famous for their dance, in which men and women lined up on opposite sides and advanced toward each other, elbows to their sides with hands outstretched in a movement that witnesses compared to that of trained dogs on their

hind feet. The dancers broke into a patterned trot in which they flapped their hands up and down or back and forth. During a period of Shaker revival, in the early 1840s, services became so ecstatic that they were closed to outside observers. Women were especially lively. They jerked and whirled around with arms splayed, often collapsing into the arms of others. They communed with spirits and spoke in strange tongues, uttering such lines as "Hock a nick a hick nick" or "Me hab brat you lub and Wampum."

Depending for growth on outsiders who adopted their faith, the Shakers prospered during the volatile religious era before 1850 but declined thereafter. Membership fell to less than a thousand by 1900. By the mid-1940s about a hundred Shakers lived in two or three communities, and in 2006 there was just one group left, in Maine, with four members. Unlike the Amish, the Shakers had embraced technology. They invented the apple corer, the circular saw, the clothespin, the rotary harrow, and the screw propeller, among many other contrivances.

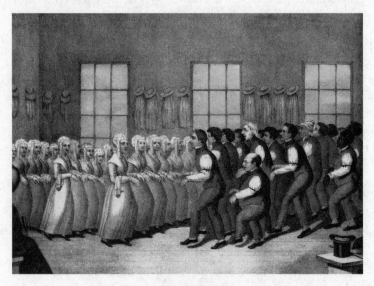

Shakers, Their Mode of Worship

But, also unlike the Amish, the Shakers had jettisoned the surest safe-guard against extinction: sex.

Similar in many respects to the Shakers was the Harmony Society, also called the Rappites after their founder, the German mystic George Rapp. Born in 1757 in southern Germany, Rapp grew dissatisfied with what he saw as the lifelessness and formalism of the Lutheran Church. Like Ann Lee, he proclaimed that God had chosen him to usher in the Second Advent of Christ. A tall, genial man, he attracted thousands of followers who believed that he indeed heralded the millennium. Viewed as heretics in Germany, some of the Rappites migrated in 1803 to the United States, where they established the community of Harmony, just north of Pittsburgh, run as a theocracy by George Rapp and his adopted son Frederick. In 1807 the group instituted celibacy in the belief that purity led to salvation. Men and women could marry but were urged to live together as "brothers and sisters in Christ." Like the Shakers, the Harmonists held all property in common, trying to create heaven on earth through Christian communism.

In 1814 they relocated to a large tract in Indiana that they called New Harmony, where they established successful farms and factories. A decade later they sold the Indiana land to Robert Owen, who established his socialist colony there, and returned to Pennsylvania, where they created the town of Economy. Hard workers like the Shakers, the Rappites combined farming and industrial skills to produce goods highly valued by outsiders: shoes, hats, cotton and silk cloth, farm implements, furniture, and—ironically, given their temperance principles—wine, whiskey, and beer. Economically successful, the Harmonists peaked between 1825 and 1850, reaching a membership of nearly a thousand. They engaged in oil drilling, invested in railroads, and founded the town of Beaver Falls. The deaths of Frederick Rapp in 1834 and of his father in 1847 stripped the community of its charismatic leaders. Schisms weakened the group, and celibacy sped its demise. The Harmony Society limped toward the millennium for another half century, dwindling until it was officially dissolved in 1906.

Some of those who had seceded from the Rappites joined another colony that formed under another German mystic, William Keil, who had emigrated to the United States in 1835. Having dabbled as a tailor, a druggist, and a doctor, Keil was converted to Methodism but left the church when he decided that he alone knew the true meaning of the Bible. He promoted his ideas in Pittsburgh and met with harsh criticism until some disenchanted Harmonists came to his side. Like the Millerites, he predicted that Christ would return in 1844. When that didn't happen, he took his followers in 1845 to live in Shelby County, Missouri, in a place they called Bethel. There they formed a communal society that took the Golden Rule as its only creed, dispensing with forms and rituals. Bethel was near the Oregon Trail, and Keil developed a strong desire to take his group to the Far West. In 1855 he started west with a long wagon train whose lead wagon contained a coffin inside of which lay his recently deceased son, pickled in whiskey. When he reached the Willamette Valley in the Oregon Territory, he established a new community, the Aurora Colony, named after his daughter. For over two decades, he assumed authoritarian control over a thriving commune with around six hundred members, which became famous for its fruit production and its textiles, furniture, tinware, and baskets. The colony, however, dissolved shortly after its leader's death in 1877.

Another religious group transplanted from Germany was the sect that formed around Joseph Bimeler (aka Bäumler), a Separatist from Württemberg in Bavaria. Bimeler and his followers aroused hostility in Germany because they would not serve in the military, take oaths, observe religious rituals, or doff their hats to anyone. In 1817 the group moved to Philadelphia, where Quakers loaned it money that Bimeler used to found a community in eastern Ohio called Zoar, after a Biblical place of refuge. Two years later, 53 men and 104 women signed a contract creating the Society of Separatists of Zoar. Communally shared property and separation from the world were the group's keystones. In 1822 celibacy was introduced and practiced for a time. The Zoarites prospered, producing many salable goods. In the late 1820s, they prof-

ited from building a section of the Ohio and Erie Canal. Their membership, however, never exceeded four hundred, and after Bimeler's death in 1853, they lost their purpose. In 1898 the few remaining Zoarites divided up the property and disbanded the society. Zoar remains as a small town with historic buildings in the old German style.

Longer lasting, because more zealous, than the Zoarites was the Amana Community. The Community of True Inspiration had arisen in eighteenth-century Germany in the belief that the spirit of Jesus Christ had reentered the world and now inhabited a chosen few, who were instruments of God. The Inspirationists grew in number but came into conflict with state authorities. In 1842 one of the group's leaders, the carpenter Christian Metz, received a command from God to take his people to a distant land. He decided on America. Metz moved with four followers to acreage near Buffalo they called Eben-Ezer. Some eight hundred more Germans joined them over the next few years, establishing factories and following rigorous moral codes. Sex was considered impure. One member of the group warned, "Fly from intercourse with women, as a very dangerous magnet and magical fire." A wedding, viewed as "a day of terror rather than of unmitigated delight," was as solemn as a funeral. Although marriage was permitted, it was not celebrated, and married couples were treated as inferior. Men and women ate, worked, worshipped, and took walks separately. Women wore black caps and drab shawls to lessen their sex appeal. Games, dinners, and feasts were avoided as sinful.

A strict work ethic fueled economic growth. The day began at 6:30 a.m. and continued, with brief breaks and four meals, until 11:30 p.m., when supper was served. Religious meetings were held every night and twice on Sunday and Wednesday. The sign of deep prayer was severe shaking caused by direct illuminations from God; Christian Metz, for example, could shake for an hour when under divine inspiration. By 1854 the community needed more land and moved to a large tract west of Davenport, Iowa, naming it Amana. Factories here soon produced textiles, lumber, and leather. Over time, Amana became perhaps the most profitable of all the communities founded in

the nineteenth century. It eventually bred Amana Refrigeration, Inc., still a leading manufacturer of home appliances.

The longevity of Amana contrasts with the brevity of Bishop Hill, a colony in Illinois founded in 1846 that lasted just fifteen years. Bishop Hill was led by Eric Janson, born and raised in Sweden. After undergoing a childhood conversion, Janson claimed messianic powers, announcing that he was God's messenger, on the level of Christ. Considering the Bible to be the only true book, he scandalized the Lutheran church by destroying other religious volumes in bonfires. Strikingly ugly, with a skull-like face and a twitching mouth, he mesmerized listeners with his oratory. Imprisoned twice, he finally fled to America with over a thousand followers, though over half died during the trip. An arduous journey from New York through the Great Lakes and Chicago brought the group to land that had been purchased for them in what is now Galesburg, Illinois. Here Janson planted the New Jerusalem. At first he enforced celibacy but soon shifted and told his followers that if they did not marry they would be damned. His illusions of divinity never flagged. He ended one argument by saying he possessed "all authority . . . in heaven and on earth" and could make his opponent "fall dead at my feet and go to hell." Once, when the weather turned bad, he warned God, "I shall depose You from your seat of omnipotence, and You shall not reign either in heaven or on earth, for You cannot reign without me."

These godly pretensions could not save Janson from the tragicomic results of infighting. When he tried to prevent a woman from eloping and leaving the community, he was gunned down in a courtroom by her fiancé. Janson's followers waited by his corpse for three days expecting their God (or Christ) to rise from the dead. He did not, and they turned to another petty tyrant, Jonas Olson, for leadership. Olson restored celibacy and guided the colony to prosperity that ended with the panic of 1857. By the Civil War, Bishop Hill was no more.

While most religious communities held sex suspect, the one that formed under the Vermont perfectionist John Humphrey Noyes consid-

ered it crucial to salvation. The shy, red-haired Noyes had experienced a conversion under Charles Finney that led to his conviction that he was totally free from sin. He gathered around him a group who also considered themselves perfect. In the 1830s, Noyes and his followers settled in Putney, Vermont, with the aim of bringing on the millennium. Within a few years, Noyes developed his distinctive sexual agenda, called complex marriage. Sex, said Noyes, should be a feast with "every dish free to every guest." He wrote to a friend, "When the will of God is done on earth as it is in heaven there will be no marriage," explaining that "my wife" is also "yours, she is Christ's, and in him she is the bride of all saints." All members of the group were considered married to each other. Variety in sex was encouraged, and monogamy was banned. Some of the "saints" had several different sex partners per week. To manifest divine grace (and prevent pregnancy), males practiced *coitus reservatus*, or sex without ejaculation. Older members of the group introduced the youngest ones to sex. Noyes specialized in initiating twelve- and thirteen-year-old girls.

Introduced in 1846, complex marriage got Noyes arrested in Putney, and so two years later he relocated to a remote spot in Oneida, New York, where this unusual sexual practice continued for over three decades. Like many other prophets of the day, Noyes took his orders from God and established a communistic enterprise that bred success. By the 1880s, Oneida had shed its religious mission and became a joint-stock company. Like Amana, it evolved into a huge corporation. By the late twentieth century, Oneida was the largest manufacturer of stainless steel tableware in the world.

Hopedale, Fruitlands, and Brook Farm were the most famous communities because they were linked to elite religious and intellectual thought. Hopedale, founded in 1841 by the Universalist minister Adin Ballou, was aimed at creating heaven on earth. Christians cleansed of sin, Ballou insisted, must group together to start the millennium. This was not a new idea, of course: Many groups were launching the millennium in the 1840s. What was unusual was the shape the millennium

took at Hopedale. In a word, it was free of racism or sexism. For years, Ballou had been an ardent social reformer, having worked with William Lloyd Garrison in the antislavery cause. Hopedale became the natural home for reformers who opposed various perceived social ills, including slavery, intemperance, unchastity, military service, capital punishment, and a meat diet. But division arose when some members wanted to embrace wholesale communism. By the early 1850s, Ballou wearied of his quest for the millennium and abandoned the community, which became the home of the Draper Company, a leading manufacturer of looms.

Smaller and shorter-lived than Hopedale was another Massachusetts community, Fruitlands, which lasted weakly from June 1843 to January 1844 and peaked in membership at eleven adults and several children. Fruitlands was founded by the Transcendentalist Bronson Alcott, who said he wanted to create "the second Eden" where man was restored "to his rightful communion with God in the Paradise of Good." In the summer of 1842, Alcott had been in England, recovering from the crushing failure of his experimental Temple School. There he met Charles Lane and Henry Gardner Wright, social reformers who ran the Alcott School, based on his progressive educational principles. Alcott felt an instant kinship with these magnetic men, who rejected all social institutions and called for free development of the individual. Alcott returned to America with Lane, who bought land in Harvard, a rural town west of Concord.

Alcott moved there with his wife and four children, including the ten-year-old Louisa May. Along with the Alcotts was Lane, soon joined by Wright. Others who came included the mystical, celibate Isaac Hecker, the farmer Joseph Palmer, the vegetarian Wood Abram, and Ann Page, who was quickly expelled because she ate a morsel of fish. The ouster of Page reflected a central idea at Fruitlands: Any use of animals by humans was cruel and sinful. Not only was meat avoided, but so was anything else from animals, including wool, honey, and manure. To avoid the use of animals, farmwork was done with spades and by hand. Potatoes and other root crops were shunned to avoid disturb-

ing worms. Alcott and his group stood opposed to the market economy and raised crops for food but not for sale—a practice that doomed the community, since neither food nor finances were stable.

Brook Farm is deservedly the best known utopian community because of the quality of minds it attracted and the intriguing phases it passed through. It began as a quasi-religious colony and quickly became an experiment in education and self-culture. At last it turned into a Fourierist phalanx.

Brook Farm was the brainchild of George Ripley, an ex-Unitarian minister who had left the church in 1840. Ripley wanted to found a new church, one that mediated between the Unitarians and those who had left the church, notably the Transcendentalists. He at first held meetings for Harvard Divinity School students in his Boston home and then in April 1841 founded the Brook Farm Institute of Agriculture and Education on two hundred acres in nearby West Roxbury. As the reformer Elizabeth Peabody explained, the original goal of Brook Farm was to realize "Christ's ideal of society" and create "the embryo of the Kingdom to come" by forming an environment favorable to "the unfolding of the individual man into every form of perfection, without let or hindrance."

Whereas many utopias were communistic dictatorships organized around a charismatic prophet, Brook Farm was a loosely organized culture club that combined work with education. Farming was the group's central occupation. A return to the land was thought to cultivate freedom of spirit. Some of the leading thinkers of the day spent time at Brook Farm: Nathaniel Hawthorne, Margaret Fuller, Thomas Wentworth Higginson, Sophia Dana Ripley, Orestes Brownson, and William Henry Channing, to name a few. These and others engaged in mundane tasks; Hawthorne later recalled attacking a manure heap with a pitchfork. Each resident paid rent, invested in the stock of the association, and was paid a dollar a day for his or her work. The agricultural enterprise never took off financially, but that didn't seem to matter. What counted at Brook Farm was the personal enrichment one got at work and at leisure. Workers debated and philosophized. As George

William Curtis wrote in *Harper's Monthly*, there was "an inevitable lack of method, and the economical failure almost a foregone conclusion. But there were never such witty potato-patches and such sparkling cornfields before or since."

The days were long at Brook Farm, starting for most at 6:00 a.m., but the work hours were reasonable. Each resident followed his or her own work schedule. Plenty of time was left for fun—card-playing, sledding, skating, costume parties—and cultural activities, such as plays, *tableaux vivants*, lectures, and musical performances. The community had an excellent school system, consisting of a kindergarten, a primary school, and a college preparatory program. Among those who attended were George Bancroft's two sons, Margaret Fuller's brother, and Charles Sumner's brother Horace. The curriculum was wide-ranging, and there was a relaxed interchange between students and teachers.

Brook Farm's fortunes began to shift in 1844, when it lost its free-flowing exuberance and embraced Fourierism. The French socialist Charles Fourier had argued that unhappiness and social inequity stemmed from suppression of natural passions by institutionalized religion and economic competition. Society must be reorganized into phalanxes, communities in which work, sex, and social relations were all based on cooperation. In the phalanxes, labor became attractive and sexual relations were based on so-called passional attraction. Fourier was both mathematical and mystical. Someday, he said, the world would consist of six million phalanxes filled with happy, productive people. Eventually, the universe itself would become a place of Edenic harmony. The editor Horace Greeley and the journalist Albert Brisbane introduced Fourierism to America, calling it Associationism and emphasizing the Frenchman's economic plan while leaving behind his unconventional sexual and cosmological speculations.

When Greeley and Brisbane brought Associationism to Brook Farm, the community stiffened into an economic arrangement, losing its vibrant cultural dimension. It was a bad omen when in 1846 a huge building called the Phalanstery burned down just as it was nearing

completion. Brook Farm fell into debt. By 1847 it had failed. As Emerson noted, Brook Farm was "the pleasantest of residences" but proved to be "a French Revolution in small, an Age of Reason in a patty-pan."

* * * *

Two FAMOUS RESIDENTS OF Brook Farm, Isaac Hecker and Orestes Brownson, shocked their free-spirited friends when in 1844 they joined the Roman Catholic Church. Hecker and Brownson were among the estimated seven hundred thousand American Protestants who turned to Catholicism in the eight decades after 1813. Besides intermarriage, there were two main reasons for most of these conversions: the fragmentation of American Protestantism, which led many to see Catholicism as solid and stable; and the Oxford Movement in England, which inspired some High Church Americans to turn Catholic.

Since the Reformation, Catholics had called Protestantism shifting and confused—so different from Catholicism, with its long history and established beliefs. This argument took on a new meaning during the Second Great Awakening, "at a period," as Catharine Sedgwick noted, "and in a country of constant mutations, were old faiths are every year dissolving, and new ones every year forming." Noting the extreme fluidity of the American religious scene, one Catholic writer lambasted Protestantism as "the prolific parent of a thousand creeds, each contradicting each; all disagreeing; none admitting anything like a tribunal to decide their controversies; all appealing to the Bible, the Bible, the Bible!" American Protestantism had created a battlefield of jarring sects, each claiming to be the true church. From the Catholic viewpoint, private interpretation had produced religious chaos; Protestant diversity had yielded relativism.

Hecker and Brownson typified Protestant seekers who leapt off the shifting sands of American religion onto the rock of the Catholic Church. Raised as a Methodist in New York, Hecker joined the Locofocos while he tested out alternate creeds. In his words, "I investigated them all, going from one of them to another—Episcopal, Congregational, Baptist,

Methodist, and all—conferring with their ministers and reading their books." His search only confused him. His immersion in Emerson's Transcendentalism frustrated him even more, as did his stays at Brook Farm and Hopedale. In August 1844, he entered the Roman Catholic Church, much to the disgust of Emerson and Thoreau. Five years later, he was ordained as a priest. He went on to become an important Catholic, known for his outreach to the poor.

Brownson similarly wandered widely before joining the church. Raised in Vermont as a Calvinist, he was first a Presbyterian. He then became, in rapid succession, a Universalist, an atheist, a Unitarian, a socialist, and a leading Transcendentalist. Finally, dismayed by the dizzying individualism of American scene, he became a Catholic shortly after Hecker had. The Transcendentalists were again appalled, but Brownson dismissed them as ultra-Protestants who worshiped only themselves. He turned into a forceful Catholic polemicist, though his elitism and irascibility alienated many in his newfound church.

The Episcopal Church yielded the most converts to Catholicism. The Oxford Movement, which produced the 1845 conversion of the Anglican leader John Henry Newman to Catholicism, affected American Episcopalians. Among the prominent figures who went over to Rome were James Roosevelt Bayley of New Jersey, Levi Silliman Ives of North Carolina, and James Alphonsus McMaster of New York.

As dramatic as such conversions were, they do not account for the amazing growth of the Roman Catholic Church in America. After all, almost as many Catholics left their church as did Protestants. In 1800 the Catholic Church was an insignificant presence on the American religious scene. By 1850 it was the third largest church in America, just behind the Methodists and Baptists. Four decades later, it had seized first place, a position it has held ever since. The main reason for Catholicism's surge was immigration, especially from Ireland. Suffering from poverty and famine, the Irish swarmed to America, especially the eastern cities. Nearly two million arrived from Ireland in the three de-

cades after 1830. At first largely Protestant, in time the Irish were almost all Catholics. Along with immigrants from other countries, such as Germany and France, they contributed to the expansion of the Catholic Church.

The Catholic invasion outraged many Protestants. Antipopery, of course, was deeply rooted in the Protestant psyche and had been powerful in America since early Puritan times. But never did it flare up with such ferocity as it did between 1815 and 1855. Confronted with the rising wave of Catholic foreigners, Protestants reacted with anger and fear. One of the few convictions that ever-diversifying Protestants had in common was their shared mistrust of Rome.

A large body of anti-Catholic literature grew. The first antipopery newspaper, the *Boston Recorder*, was begun by Presbyterians in 1816, followed shortly by the Baptist *Christian Watchman* and the *New York Observer*. These early sheets were relatively tame compared with *The Protestant*, founded by George Bourne in 1830, and William Craig Brownlee's *Protestant Vindicator*, which came four years later. Bourne and Brownlee gave a new vitriolic intensity to anti-Catholic rhetoric. The 1830s brought a torrent of scabrous writings exposing the alleged criminality and corruption of Catholics. Fictional exposés of Catholic nunneries abounded. George Bourne's lurid novel *Lorette* (1833) described Canadian nunneries as whorehouses where child murder and sexual perversion were ways of life. Rosamund Culbertson's *Rosamond* (1836) described a wild plot by priests to capture black boys, kill them, and grind them up for sausage meat. Among the other exposés were Rebecca Reed's *Six Months in a Convent* and Edith O'Groman's *Convent Life Unveiled*. Most scandalous of all was Maria Monk's *Awful Disclosures of the Hotel Dieu Nunnery of Montreal*, which appeared in January 1836. Monk reported having just escaped from a Canadian convent where priests tortured and raped nuns, whose babies were baptized, strangled, and thrown into a basement pit. Investigators discredited Monk, who eventually became a pickpocket and a prostitute. But her book went through several editions and sold some three hundred thousand copies before the Civil War.

Just as heinous as the Catholics' depravity, said Protestants, was their plan to infiltrate America and subvert its institutions. First aired by a Protestant newspaper in 1830, this charge was often repeated. Samuel F. B. Morse, the artist who later invented the telegraph, warned that the pope sent European emigrants to America with the intention of destroying American liberties. Lyman Beecher in *Plea for the West* (1835) insisted that Catholics planned to seize the Mississippi Valley. Beecher called for Protestant churches, missionaries, and schools to stop the takeover.

Inevitably, anti-Catholic violence erupted. In Charlestown, Massachusetts, Protestants unleashed their animosities by attacking the Ursuline Convent on Mount Benedict. Ursuline nuns conducted a school there whose students were mainly Unitarian girls. A rumor grew that the nuns were brainwashing their Protestant pupils and forcing them to become Catholics. In the summer of 1834, a distraught woman escaped from the convent and then returned to it but didn't come out. Was she being held against her will? A growing number of Protestants in the area thought so. Their excitement was fueled by Lyman Beecher, who preached three sermons denouncing the convent. On the evening of August 11, a mob of angry Protestants appeared at Mount Benedict. They were greeted by the mother superior, who fanned their rage by warning, "The Bishop has twenty thousand of the vilest Irishmen at his command, and you may read your riot act till your throats are sore, but you'll not quell them." Enraged by this threat, the crowd burst into the convent. Terrified pupils and their teachers fled out the back. The mob burned the convent's buildings to the ground while local firemen stood by. The nation pretended to be shocked by the destruction, but public opinion stood behind the arsonists. Thirteen were brought to trial. All were acquitted but one boy, who later was pardoned after thousands of Bostonians petitioned his release.

The issue of schooling for Catholic children created more hostility. Many poor Irish immigrants could not afford parochial schools, and most public schools were slanted toward Protestantism, using the King James Version of the Bible and incorporating Protestant teachings.

Catholic leaders, particularly Bishop John Hughes of New York and Bishop Patrick Kenrick in Philadelphia, called for public funding of Catholic schools. In 1840, New York's governor William Henry Seward expressed agreement, saying that foreigners should receive schooling that reflected their own religion and language. Immediately nativists were up in arms, charging that Catholics threatened to take over American public education. In 1842 the New York legislature passed a law favoring neutrality on the school issue—not exactly a victory for the Catholics, but enough to raise Protestant hackles. The next year, a new ultra-Protestant group, the Native Republican Party, took shape.

In Philadelphia, the school controversy led to deadly violence. Bishop Kenrick wrote a letter to the school board complaining about the use of the Protestant Bible in public classrooms. He requested that Catholic students be allowed to use their own Douay version of the Bible and to be excused from religious instruction. Nativists screamed that Catholics were trying to remove the Bible from schools. In the Irish-dominated Philadelphia suburb of Kensington, riots exploded in May 1844, spreading to south Philadelphia in early July. On several days, nativists who gathered for "Save the Bible" rallies fought against Irish groups. Nineteen people were killed, and at least forty were seriously injured. Rioting and arson resulted in the widespread destruction of property, including two Catholic churches and a convent that were burned. Even worse riots looming in New York were avoided only because Bishop Hughes stationed armed Irishmen around the city's Catholic churches to ward off Protestants.

Nativist battles lessened in the late 1840s as slavery and Texas annexation took center stage, and then flamed again with the rise of the Know Nothings in the 1850s.

By then, American religion had become like a frazzled ball of yarn with a colorful fringe. The Protestant core was the evangelical mainstream of Methodists, Baptists, Presbyterians, the Christian Connection, and others who appealed to the masses through intense emotionalism. A dazzling array of other Protestant sects and denominations—ranging

from formal High Episcopalians to expectant adventists to sexually experimental Oneidan perfectionists—departed from the core in many different directions.

Also from this core came reform movements that assumed a life of their own, offering various prescriptions for changing America.

5

Reforms, Panaceas, Inventions, Fads

In 1844 Emerson noted "the great activity of thought and experimenting" of the past twenty-five years and exclaimed, "What a fertility of projects for the salvation of the world! . . . In each of these movements emerged a good result, a tendency to the adoption of simpler methods, and an assertion of the sufficiency of the private man."

The same democratic enthusiasm that unleashed new religions also fostered reform movements bent on ridding society of various social ills, including intemperance, slavery, war, and illicit sex. Movements for oppressed or marginalized groups—criminals, orphans, the poor, the deaf and mute—also grew. (The organized battle for women's suffrage came a bit later.) In science and medicine, a few real breakthroughs were accompanied by a far greater number of pseudodiscoveries offering would-be panaceas, from patent medicines through Thomsonianism to phrenology and mesmerism.

These reforms and fads had enormous influence on American society. In some cases, such as temperance and prison reform, they led to laws aimed at eradicating particular vices. In others, such as abolitionism, they stimulated national struggles that eventually eliminated institutionalized injustice. In the case of the pseudosciences, they fostered a self-help mentality and also a mass gullibility that has lasted till this day.

The hugeness of the temperance movement mirrored the magnitude

of the problem of alcohol consumption. Up until the 1820s, America lived up to its reputation as a "nation of drunkards." Drinking was a way of life. The amount of absolute alcohol consumed annually by each American rose steadily to more than seven gallons by the mid-1820s (more than three times today's per capita consumption). Some form of liquor—eighty-proof ardent spirits, wine, beer, or hard cider—was served at virtually every social function. Alcohol, said the Methodist circuit rider James Finley, was "regarded as a necessary beverage. A house could not be raised, a field of wheat cut down, nor could there be a log rolling, a husking, a quilting, a wedding, or a funeral without the aid of alcohol."

Most employers assumed that their workers needed strong drink for stimulation: a typical workday included two bells, one rung at 11 a.m. and the other at 4 p.m., that summoned employees for alcoholic drinks. People of all backgrounds drank. "Everybody asked everybody to drink," Thomas Low Nichols wrote of his youth. "There were drunken lawyers, drunken doctors, drunken members of Congress, drunkards of all classes." Walt Whitman recalled in old age, "It is very hard for the present generation to understand the drinkingness of those years—how the 'gentlemen' of the old school used liquor: it is quite incommunicable: but I am familiar with it: saw, understood it all as a boy." In 1820 Americans spent $12 million on liquor, an amount that exceeded total expenditures by the U.S. government. Abraham Lincoln, looking back in 1842 on his childhood, said liquor was "like the Egyptian angel of death, commissioned to slay, if not the first, the fairest born in every family."

The temperance movement went through several phases. Before 1825, temperance was not an organized movement but rather a chorus of individual groups calling for moderation, not abstinence, in drinking. From 1825 to 1839, total abstinence became the battle cry for an increasing number of well-organized reformers, most of them connected with the evangelical Protestants of the Benevolent Empire. The movement declined in the late 1830s due to a division between these "ultraists" and moderates. A rebirth of temperance reform came with

the Washingtonians and similar societies that emerged from self-help groups of former alcoholics. In the mid-1840s, a fourth movement, prohibition, gained momentum, leading to the avalanche of state laws banning the sale of liquor.

A seminal document in temperance reform was *Inquiry into the Effects of Ardent Spirits on the Human Body and Mind*, a 1785 pamphlet by Dr. Benjamin Rush, a member of the Second Continental Congress who was appalled by America's dependency on drink. Rush's text went through eight editions before 1815 and became a prime piece of propaganda for the American Tract Society, which distributed it widely. Describing the ill effects of liquor on the health and on work, Rush called for an end to the practice of employers giving alcohol to their workers. A moderate, Rush called for a ban on ardent spirits but not on lighter drinks like beer, wine, and cider.

This restrained version of temperance characterized most reformers through the early 1820s. The nation's first temperance society, formed in 1808 in the upstate New York town of Moreau, consisted of some fifty citizens who pledged to avoid hard liquor (though not other alcoholic beverages) except for medical purposes or at large public functions. Similar societies appeared over the next decade, including the Massachusetts Society for the Suppression of Intemperance, founded in 1813, which discouraged excessive use of ardent spirits.

The Methodists and Quakers had long urged temperance, and other mainstream Protestant churches took up the cause. The first order of business was to rid the church itself of liquor. Lyman Beecher found that "all the various kinds of liquors then in vogue" were served at ministers' ordinations. "The drinking was apparently universal," Beecher declared. He directed a national Presbyterian conference in Boston in 1814 that called for an end to this practice and recommended other temperance measures in the church, the home, and at work.

The advent of democracy and the spread of evangelical religion gave rise to a more stringent stance on alcohol. Widening suffrage among Americans raised the question, How can the citizens of a republic vote

responsibly while under the influence of liquor? As perfectionism spread, Protestants increasingly demanded that individuals take steps to clean up their lives. Preachers used persuasion and rhetoric to convince their hearers that intemperance was a sin against God and the family.

The founding of the American Temperance Society in 1826 marked a shift toward total abstinence. Most of the society's founders were evangelical ministers. Over the next decade, temperance reform rode the wave of popular revivalism. Emotional sermons detailing the horrid wages of alcoholism yielded tens of thousands of pledges of total abstinence. In 1833 the first national temperance meeting was held in Philadelphia, with delegates from nearly all the states representing some four thousand local societies. Within two years, membership in the American Temperance Society reached 1.5 million.

Popular literature spread the temperance cause. The American Tract Society distributed millions of temperance tracts. Fiction became a favored means of advancing the cause. At first this fiction was quite tame. Works of the 1820s like *Edmund and Margaret* and *The Lottery Ticket* dramatized the ways Bible reading and domestic piety could cure alcoholism. A move to sensationalism was signaled by *Deacon Giles's Distillery*, a hugely popular story of 1836 by the Reverend George Barrell Cheever. Cheever depicted a group of devils who produced rum in barrels labeled with words revealing the grim results of drinking, including Death, Murder, Poverty, and Delirium Tremens. This so-called dark-temperance style continued into the next decade with works like *Confessions of a Reformed Inebriate* (1844), showing an alcoholic's psychological deterioration, and *The Confessions of a Rumseller* (1845), about a drunken man whose wife becomes a maniac after he murders their daughter. Eventually the genre produced Timothy Shay Arthur's best-selling *Ten Nights in a Bar-Room* (1854), which details the collapse of a community caused by a saloon and a distillery. Walt Whitman contributed to the genre in his lurid pamphlet novel of 1842, *Franklin Evans; or The Inebriate*, his most popular work, and the dark-temperance mode influenced writers like Poe, Hawthorne, and Melville.

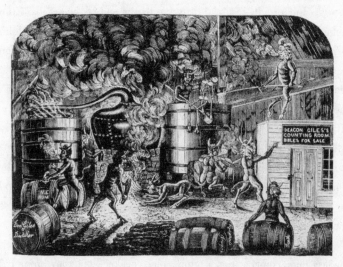

Illustration from Deacon Giles's Distillery *by George B. Cheever*

The Washingtonian Movement anchored temperance in the American masses. This movement began when some men drinking in a Baltimore tavern decided to attend a local temperance meeting as a lark. To their own surprise, the meeting inspired them to give up drinking. They evangelized on behalf of temperance. Soon they were joined by a growing army of reformed drunkards who won converts by publicizing their nightmarish experiences and by helping fellow alcoholics recover—rather like Alcoholics Anonymous today. One man they rescued, John H. W. Hawkins, spent nearly two decades traveling two hundred thousand miles delivering temperance lectures. The Washingtonians grew rapidly and spawned a number of copycat groups, including the Sons of Temperance, the Rechabites, the Cadets of Temperance, and the Good Templars.

So far, the temperance movement had focused on consumers of alcohol, using persuasion and example to lure them from vice. This approach seemed increasingly untrustworthy, however, since it often did not have lasting results. Most of those who had taken the temperance pledge in

1840 had reportedly resumed drinking by the end of the decade. Even some temperance leaders proved to be backsliders, most notoriously John Bartholomew Gough. An ex-actor who had abandoned tippling when he joined the Washingtonians, Gough became perhaps the best-known temperance orator of the day through his dramatic accounts of alcohol's ravages; he was especially effective in acting out the horrors of the d.t.'s. After lecturing on temperance across the nation for five years, Gough in 1845 disappeared for a week and was found in a New York brothel, apparently intoxicated. Although Gough insisted he had been tricked by someone who gave him drugged cherry soda, few believed the story, and he became a popular laughingstock, featured in many satirical novels as the typical "intemperate temperance lecturer."

Such slips did not halt the use of persuasion—even Gough himself made a huge comeback as a temperance speaker—but they prompted many reformers to adopt a different approach: banning the sale and distribution of alcohol by law. The prohibition movement began in 1837 in Maine, where the businessman Neal Dow tried to get a prohibition law passed. He failed at that time but succeeded in 1851, when as mayor of Portland he persuaded the legislature to pass such a law. Nationally, per capita consumption of alcohol had dipped to 1.8 gallons annually. "Maine laws" swept the nation. By 1856, eight other states had adopted prohibition. The movement had ups and downs, fading out before reviving in the late nineteenth century and leading to the passage of the Eighteenth Amendment in 1920.

* * * *

THE BATTLE AGAINST INTEMPERANCE was allied with that against slavery. Lyman Beecher in his *Six Sermons* said that drinking alcohol was "like slavery . . . sinful, impolitic, and dishonorable." Dr. Heman Humphrey, the president of Amherst College, in 1828 gave an address on "A Parallel between Intemperance and the Slave Trade," comparing the horrors of drink to those of the Middle Passage. For an increasing number of Northerners, there were analogies between thralldom to al-

cohol and chattel slavery. Lincoln looked forward to a day "when the victory shall be complete—when there shall be neither a slave nor a drunkard on the earth." Many reformers—including William Lloyd Garrison, Gerrit Smith, and Elijah Lovejoy—promoted both temperance and abolitionism.

Like temperance, the antislavery movement began moderately and then was promoted successively through religious exhortation and political action. Colonization, dominant between 1817 and 1831, called for emancipation followed by deportation of blacks. Some colonizationists believed that blacks were inferior to whites; others recognized the humanity of blacks but thought they could not be successfully integrated into American society. Some blacks backed colonization as a means of establishing independent nationhood.

A vigorous protest against colonization arose in the 1820s, leading to the abolitionist movement, which called for immediate emancipation of the slaves and their admittance into the social mainstream. Abolitionism, which began as an organized movement in 1831, found its leaders among Christians who labeled slavery sinful—a system of oppression, torture, rape, and murder. Though never numerous, the abolitionists provoked widespread reactions. When factions arose within the movement, many antislavery reformers sought a political solution to the slavery problem. The appearance of the Liberty Party in 1840, followed by the Free Soil Party in 1848, marked a turn to the electoral process that anticipated Lincoln and the Republicans.

Despite this broadening protest, slavery became ever more deeply entrenched in the South. Between 1820 and 1850, when the total U.S. population increased from 9.6 million to 23.2 million, the number of enslaved blacks rose from 1.5 million to 3.2 million. About a third of Southern white families owned slaves. Slavery was a seemingly permanent fixture on the national scene. The value of slaves rose dramatically with the growing world demand for cotton. Twelve American presidents owned slaves; the executive branch of the government was in slaveholders' hands for fifty of its first sixty-four years. A slave-owner,

John Marshall, was Chief Justice of the Supreme Court for over three decades and was succeeded by another one, Roger Taney, who held office until 1864. Speakers of the House were almost all slave-owners, as were presidents pro tem of the Senate.

Laws fixed slavery in place. The Missouri Compromise of 1820 held the North and the South in uneasy equipoise for three decades, thanks partly to congressional gag rules, but in the 1850s tensions over slavery's westward expansion produced the Fugitive Slave Act, the Kansas-Nebraska Act, and the Dred Scott decision, all of them proslavery.

The South at first considered slavery a necessary evil but increasingly saw it as beneficial for both blacks and whites. Advanced early on by John Taylor of Caroline, this argument reached dramatic expression in congressional debates over slavery. In 1837 John Calhoun declared to the Senate that slavery was not wrong but instead was "a good—a great good." Calhoun explained that "the Central African race . . . had never existed in so comfortable, so respectable, or so civilized a condition, as that which it now enjoyed in the Southern States." Similarly, James Henry Hammond of South Carolina announced on the floor of the House that slavery was "the greatest of all the great blessings which a kind Providence has bestowed upon our glorious region." He continued, "Domestic slavery, regulated as ours is, produces the highest toned, the purest, best organization of society that has ever existed on the face of the earth."

Such rationalizations covered up the horror of slaves' lives. Even two ex-slaves who said they had been relatively well treated, Frederick Douglass and Harriet Jacobs, experienced enough physical and psychological torment that their autobiographies are among the most harrowing documents in American literature. They are full of unforgettable scenes, such as Jacobs's account of seven years hiding in a rat-infested attic or Douglass's descriptions of his aunt shrieking beneath the bloody lash and a fellow slave's brains being blown out by an overseer's rifle.

Slaves who managed to escape north often used the so-called Underground Railroad, that secret network of routes and stopping places

along which fugitives made their way to freedom. Thousands thought that the possibly fatal risk of recapture was worth the try for freedom. From 1810 to 1850, between thirty thousand and one hundred thousand blacks escaped their masters and fled north. The most popular route was through Philadelphia, where abolitionists like William Still and Isaac Tatum Hopper served as "stationmasters" on the railroad. Other favored routes were along the east coast through Massachusetts, especially the Northampton area; through Ohio, a state crisscrossed with escape routes, five of which converged in Oberlin; and through Indiana, where the most active "conductor" was Levi Coffin, a Quaker mill owner who aided many fugitives, among them Eliza Harris, whose escape across the ice Harriet Beecher Stowe would make famous in *Uncle Tom's Cabin*.

A number of Northerners made repeated trips into the South to help slaves escape and guide them north. Harriet Tubman, an ex-slave who settled in Canada, made nineteen such trips and assisted in the escape of three hundred slaves. Known as Moses among blacks and as General Tubman by abolitionists, she was fearless, with no tolerance for timid souls. She carried a revolver with which she threatened fugitives who wanted to turn back. "Dead niggers tell no tales," she declared; "you go on or you die!"

Slaveholders unwittingly publicized their own cruelty in ads for runway slaves. Typical notices offered rewards for "my woman Siby, *very much scarred about the neck and ears by whipping*"; "my man Fountain—has *holes in his ears*, a *scar* on the right side of his forehead— has been *shot in the hind parts of his legs*—is marked in the back with the whip"; or a teenaged girl, Molly, "LATELY BRANDED ON THE LEFT CHEEK, THUS, R, AND A PIECE TAKEN OFF OF HER EAR ON THE SAME SIDE, THE SAME LETTER BRANDED ON THE INSIDE OF BOTH HER LEGS."

The ultimate proof of slaves' dissatisfaction with their lot was insurrection. We will almost certainly never know exactly how many slave revolts there were in the two centuries before the Civil War. Estimates

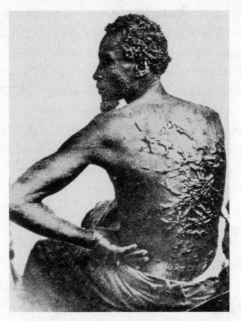

An Ex-Slave's Back

that go as high as 250 are surely inflated; but, then, most resistance took the form of day-to-day actions rather than organized revolts. Two of the largest plots, Gabriel Prosser's and Denmark Vesey's, were foiled. In 1800 the Virginia slave Gabriel Prosser and two of his brothers got oaths from over a thousand fellow slaves to follow them in taking over the state's capital, Richmond, and killing all whites except those opposed to slavery. Gabriel aimed to strike terror in the hearts of slaveholders and destabilize slavery in the state, perhaps the nation. The uprising failed when a storm delayed it and fearful slaves revealed it to their masters. Gabriel and his confederates were captured; some thirty-seven blacks went to the gallows. Two decades later Denmark Vesey, a North Carolina slave who had purchased his freedom, recruited nine thousand blacks to invade Charleston, burn the city, slaughter whites, and take

over a ship to flee to the West Indies. Once again, the plot leaked, and the slave rebels were caught. Vesey and thirty-four others were executed.

A large slave revolt broke out in southern Louisiana in January 1811. Charles Deslondes, a free mulatto from Saint Domingue, spearheaded a rebellion that started on the plantation of Manual Andry and then spread down the River Road toward New Orleans. Armed with knives, clubs, and a few guns, the rebels gathered perhaps as many as two hundred recruits as they proceeded. They killed two or three whites and burned five plantations before being quelled by federal troops and a militia. The enraged whites slaughtered sixty-six of the rebels and later executed sixteen others. As a warning to other would-be rebels, they decapitated many of the corpses and stuck their heads on spikes that lined the route between the Andry plantation and New Orleans.

The deadliest slave rebellion before the Civil War took place in Southampton, Virginia, in 1831. Nat Turner was a shy, pious slave who had visions and heard voices that he interpreted as God's directing him to lead a slave revolt. In the early morning of August 22, 1831, he and four other blacks went on a killing rampage. They moved from plantation to plantation, stabbing, clubbing, and shooting whites indiscriminately. More than fifty other blacks joined the rebels, who over the next two days killed fifty-eight whites before being subdued by the local militia. Turner escaped and hid out for weeks before being captured. He and nineteen other blacks were executed. Terror spread throughout the South. Alarmed slave-owners clamped down on their slaves and in some cases killed them as warnings to would-be rebels. Furious Southern mobs murdered hundreds of innocent blacks, sometimes torturing them first.

The Turner revolt caused momentary antislavery stirrings in some areas of the South. Slavery seemed like a powder keg about to explode. As one Virginia politician said, Southerners were now haunted by "the suspicion that a Nat Turner might be in every family,—that the same bloody deed might be acted over at any time and in any place,—that

HORRID MASSACRE IN VIRGINIA

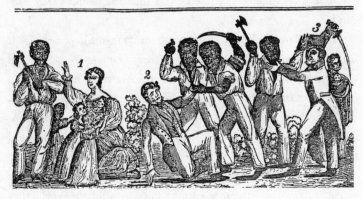

Nat Turner's Rebellion

the materials for it were spread through the land, and were always ready for a like explosion." The Virginia state legislature in January 1832 considered a bill for the gradual of abolition of slavery. The bill failed, however, and similar debates over abolition in Tennessee and Kentucky went nowhere.

Indeed, the main effect of the Nat Turner incident was to strengthen feelings *against* abolitionism, not *for* it. For most Southerners, Turner was the tool of a wicked cabal of Northern abolitionists. This charge about Turner was false, but it reflected the South's growing irritation over a very real phenomenon: the rise of a combative abolitionist movement in the Northern states.

One of the first reformers who called publicly for immediate and unconditional emancipation of the slaves was the Protestant minister George Bourne. An English emigrant who settled in Virginia and later moved to New York, Bourne in 1816 wrote *The Book and Slavery Irreconcilable*, a diatribe on the sinfulness of slavery that influenced many later abolitionists. Expelled by the Presbyterian Church for his radicalism, Bourne became a leader in the fight against popery and slavery. In the 1830s he founded the anti-Catholic newspaper *The Protestant* and helped found

the American Anti-Slavery Society. An English Quaker, Eliza Heyrick, in 1824 published *Immediate, not Gradual Abolition*, a prominent text in the movement that led to the abolition of slavery in the British Empire in 1833. Another Quaker, the New Jersey–born Benjamin Lundy, traveled throughout America and abroad campaigning against slavery in lectures, societies, and periodicals. In 1821 he founded a newspaper, the *Genius of Universal Emancipation*, in which he demanded that the federal government abolish slavery where it had jurisdiction, amend the three-fifths clause of the Constitution, ban the internal slave trade, and prevent the extension of slavery into the western territories—all central arguments for later antislavery reformers. For the slave states, he recommended gradual emancipation followed by the resettlement of blacks abroad.

A more violent brand of abolitionism came with the publication in 1829 of David Walker's *Appeal to the Coloured Citizens of the World*. Born in 1785 in North Carolina, Walker was the son of a slave father and free mother. Appalled by the conditions of Southern slaves, he moved to Boston, where in 1826 he became an agent for *Freedom's Journal*, an African American newspaper. Walker opened a secondhand clothing store but kept his mind on the slavery issue. He wrote antislavery articles that he brought together in his *Appeal*, one of the most incendiary abolitionist pamphlets ever published.

With apocalyptic imagery, Walker pronounced doom on America if it did not abolish slavery. "I tell you Americans!" he warned. "That unless you speedily alter your course, *you* and your *Country are gone!!!!!!* For God Almighty will tear up the very face of the earth!!!" Slaves, Walker wrote, were "the *most wretched, degraded* and *abject* set of beings that *ever lived* since the world began." White Americans were rampant hypocrites. Jefferson saw blacks as inferior, and Henry Clay, another slaveholder, promoted colonization, a racist program. Whites pretended to be Christian and democratic, Walker wrote, but "they brand us with hot iron—they cram bolts of hot fire down our throats—they cut us as they do horses, bulls, or hogs—they crop our ears and sometimes cut off bits of our tongues—they chain and hand-cuff us . . . [and] beat us

with cow-hides and clubs." Trapped by cruelty and ignorance, blacks must take their liberation in their own hands. If not freed, slaves must take up arms against whites.

Explosive words. Walker stitched his pamphlet into the clothes of sailors bound for the South, where he was instantly demonized. Georgia put a price of $10,000 on his head. Other states moved to suppress abolitionist publications. Three editions of the *Appeal* appeared in two years. Walker died under mysterious circumstances in June 1830.

White abolitionists backed off from Walker but were inspired by him. William Lloyd Garrison, the coeditor of Benjamin Lundy's newspaper, imitated Walker's inflammatory rhetoric while leaving behind his violent message. When Garrison came out with his own newspaper, the *Liberator*, in January 1831, he announced: "I am in earnest—I will not equivocate—I will not excuse—I will not retreat a single inch—AND I WILL BE HEARD." Like Walker, Garrison lambasted colonization, demanded immediate emancipation, and gave graphic evidence of the cruelty of slaveholders. He reprinted parts of Walker's *Appeal* in his paper. Unlike Walker, however, he leaned toward pacifism. Espousing Christian nonresistance, he believed slavery could be best challenged by moral suasion.

The son of an alcoholic drifter, Garrison grew up in Massachusetts and took up the temperance cause before focusing on slavery. Jailed in 1830 for writing a libelous article, Garrison went on to become the most controversial abolitionist of the age. Although subscriptions to his *Liberator* never exceeded three thousand, this powerfully written and well-edited newspaper made a stir nationally. Nat Turner's revolt occurred six months after the *Liberator* first appeared, and for Southerners, Garrison seemed to be a malicious instigator of insurrection.

He did not instigate violence, but he did inspire principled firmness. In the spring of 1833, Prudence Crandall, a Quaker schoolteacher in Connecticut, answered Garrison's call for education for blacks by admitting a black girl and preparing to open her school to many more blacks. Angry whites desecrated the school's property. Crandall was

William Lloyd Garrison

imprisoned and brought to trial for violating a state law against black education. The case was eventually thrown out. Prudence Crandall closed her school as a result of the controversy, but she was championed as a martyr by abolitionists.

In the summer of 1833, Garrison went to London when the Emancipation Bill, abolishing slavery in England's colonies, was passed. Moved by England's example, Garrison helped organize the American Anti-Slavery Society, which had its first meeting in Philadelphia that winter. The society, presided over by the New York merchant Arthur Tappan, claimed two hundred thousand members by the late 1830s but attracted far more opposition than support. Tappan and Garrison were viewed as criminals in the South. Even in the North, they met violent resistance. In 1834 Tappan's store was attacked by opponents of abolition, and his brother Lewis's home was sacked. The next year in Boston,

Garrison was seized by a mob, beaten, dragged by a rope, and threatened with lynching before the mayor jailed him for his own protection. Several other antislavery speakers were pelted by rocks, eggs, or sticks.

Despite unrelenting challenges, the abolitionists continued their struggle. By 1838 the American Anti-Slavery Society had two hundred local branches with a combined membership of around 250,000. Abolitionism flowered in the Old Northwest when the Tappans established in Cincinnati the Lane Theological Seminary, with Lyman Beecher as its president. The seminary attracted many antislavery students, soon known as the Lane Rebels. Among them was Theodore Dwight Weld, who had taken up the antislavery cause under the influence of Charles Grandison Finney and the British abolitionist Charles Stuart. Weld worked closely with local blacks and in 1834 organized a public symposium on slavery that divided the community. Lane's board of trustees criticized the student activists, who left en masse for nearby Oberlin College. The Tappan brothers created there a new theological division headed by Finney. The new western hub of abolitionism, Oberlin pioneered coeducation and higher education for blacks.

Weld remained active in the abolitionist movement. He lectured widely and directed the national campaign for sending antislavery petitions to Congress. This effort yielded over four hundred thousand petitions, sparking the congressional hostilities that led to the gag rules of 1835–44. Weld also edited a newspaper, the *Emancipator*, and wrote *American Slavery As It Is*, a searing exposé of Southerners' cruelty to their chattels.

Assisting him on this volume were his wife Angelina Grimké Weld and her sister Sarah Grimké, two of several prominent women abolitionists. Raised in a slaveholding family in South Carolina, the Grimké sisters early developed antislavery feelings that grew when they moved north and became Quakers. In the 1830s, both sisters spoke and wrote in support of abolition and women's rights. Angelina's antislavery article "An Appeal to the Christian Women of the South" inflamed such con-

troversy that it was burned publicly in her native state. Angelina in 1837 became the first woman to address the Massachusetts legislature.

Other path-blazing antislavery women included Maria Miller Stewart, Lydia Maria Child, and Lucretia Mott. Maria Miller, the orphan child of African-born parents, was raised in Connecticut and later settled in Boston. In 1825 she was married to James W. Stewart, who died within three years. Maria Stewart took up the antislavery cause, denouncing colonization and writing for Garrison's *Liberator*. The first black woman to speak publicly on political issues, she encouraged other African Americans to take pride in themselves and improve their lives by seeking education. Another supporter of social advancement for blacks, Lydia Maria Child, was an author of popular novels and advice books who espoused abolitionism in the wake of her husband David Lee Child, a friend of Garrison. Lydia Maria Child in 1833 wrote *An Appeal in Favor of That Class of Americans Called Africans*, which called for emancipation followed by full integration of blacks into American society. Not only should blacks be educated, Child argued, but their intermarriage with whites should be regarded as normal—a remarkably daring position for its day. Small wonder that Child was widely vilified or that she published two later abolitionist books, *Authentic Anecdotes of American Slavery* (1835) and the *Anti-Slavery Catechism* (1836), anonymously. With her husband, she edited the *National Anti-Slavery Standard* in the early 1840s.

Lucretia Mott holds a special place in abolitionism because of her forceful appeals for the involvement of women. A Hicksite Quaker, she and her husband, David Mott, refused to use any products of slavery, including cotton and cane sugar. Their Philadelphia home was a station on the Underground Railroad. Disarming with her mild manner and staid Quaker dress, Lucretia Mott organized women's antislavery societies because women were excluded from the movement. In 1840 she aggravated a growing division among male abolitionists. That year she and several other women reformers—including Elizabeth Cady

Stanton, Ann Green Phillips, and Mary Howitt—attended the World's Anti-Slavery Convention in London, expecting to participate. Instead, they were forced to sit in a curtained enclosure, barred from joining the men's discussion. This act of gender discrimination set off a correspondence between Mott and Stanton that led eight years later to the world's first women's rights convention, held in Seneca Falls, New York.

A number of men supported women's rights, among them William Lloyd Garrison. When Garrison showed up late at the World's Anti-Slavery Convention, he was so disgusted by the exclusion of the women that he sat silently with them behind their curtain for ten days. The previous month, he had created a schism at home when he helped bring about the election of a radical woman, Abigail Kelley, to the Executive Council of the American Anti-Slavery Society. When Kelley was elected, a large faction under Arthur Tappan and Theodore Weld split off and formed a separate antislavery society.

Divided over the women's issue, the Tappanites and the Garriso-

Lydia Maria Child *Lucretia Mott*

nians differed in other ways as well. The former, seeking to promote antislavery reform through politics and the church, helped found the Liberty Party, which ran James Birney for president in the election of 1840. In contrast, Garrison, utterly disillusioned with the government and with churches, became a come-outer—that is, he came out of politics and organized religion, depending on persuasion to combat slavery. Cynical about politics, Garrison in 1854 labeled the Constitution "a covenant with death and an agreement with hell" because it seemed to condone slavery. The American Union, he insisted, was a fraud, since it yoked free Northerners with slaveholding Southerners. He advocated disunion, or the secession of the North from the South. Along with the Boston reformer Wendell Phillips and others, he devoted the energies of the American Anti-Slavery Society to immediate emancipation or, barring that, disunion. Although it lost ground to antislavery political parties, the society continued its activities until the Thirteenth Amendment abolished slavery in 1865.

Neither politics not persuasion, of course, uprooted slavery. It took the extreme violence of the Civil War to do that. Most abolitionists before 1850 did not consider violence a solution to the slavery problem. One did, however: the Illinois editor Elijah Lovejoy. And when he was killed for his tough stand on slavery, he inspired another abolitionist warrior, John Brown.

Lovejoy was a Presbyterian preacher from New England who moved to St. Louis and ran a newspaper there in which he denounced alcohol, Catholicism, and slavery. At first a Garrisonian nonresistant, he took a more militant stance when a proslavery mob destroyed his printing materials. He moved across the Mississippi River to Alton, Illinois, but he was no safer in a free state than he had been in slaveholding Missouri. Two more times, mobs destroyed his press after it was learned that he wanted to start an antislavery society. Undeterred, Lovejoy planned to open yet another printing establishment, making sure that this time he was ready to answer force with force. He armed himself with a pistol, and friends gathered to help him protect the warehouse that housed his

new press. On November 7, 1837, a mob gathered outside the warehouse, hurling stones and firing shots at the building. One of Lovejoy's men answered fire, killing one of the crowd. The mob furiously rushed forward with ladders to set fire to the roof, yelling "Burn 'em out!" "Kill every d—d Abolitionist as he leaves!" In the melee, Lovejoy took a shotgun blast to the chest and died immediately.

The murder of Lovejoy brought a whole new dimension to the slavery conflict. For Lincoln, the incident was "the most important single event that ever happened in the new world." For John Quincy Adams, it sent "a shock as of an earthquake throughout this continent, which will be felt in the most distant region of the earth." Emerson wrote, "The brave Lovejoy has given his breast to the bullet for his part, and has died when it was better not to live. There are always men enough ready to die for the silliest punctilio; to die like dogs . . . but I sternly rejoice that one was found to die for humanity & the rights of free speech & opinion." Services for Lovejoy were held throughout the North.

At one service, in Hudson, Ohio, the lean, grizzled John Brown rose, held up his right hand, and declared, "Here, before God, in the presence of these witnesses, from this time, I consecrate my life to the destruction of slavery!" The message was not new, but Brown's plan for acting on it was. The Lovejoy killing made other antislavery people *recoil* from violence. Garrison commented that Lovejoy was "certainly a martyr" but "not . . . a *Christian* martyr" because he had taken up arms. "We solemnly protest," Garrison wrote, "against any of his professed followers resorting to carnal weapons under any pretext or in any extremity whatever." Garrison stuck to nonresistance, as did Wendell Phillips, who was inspired by Lovejoy to join abolitionism. Lincoln, Adams, and the Tappanites hated violence so much that they avoided radical reform altogether and turned to politics.

John Brown went in the opposite direction. He sensed that only violence would eradicate slavery. There is evidence that just after the Lovejoy event he began forming his plans to invade the South, forcibly liberate slaves, and start a chain reaction that would lead to the fall of

slavery. According to his son John, one day in the late 1830s he made family members pledge that they would help him "make war on slavery—not such war as . . . 'was equally the purpose of the nonresistant abolitionists,' but war by force and arms." Already, John Brown was headed on the violent path that would lead to Pottawatomie and Harpers Ferry.

Why did not more abolitionists follow Brown's violent example? After all, predictions of an eventual war over slavery were not uncommon. As early as 1790, a South Carolina congressman had declared that emancipation of the slaves "would never be submitted to by the South without a civil war." In 1840, after a movement for secession had begun in the South, a University of Virginia professor said, "The question of *separation* will always be a question of *war*. The *constitutional question* will be drowned in the din and tumult of arms and finally decided by the issue of the war."

The fact is, though, that threats of violence most often came from

John Brown, *daguerreotype by Augustus Washington*

the South. Both opponents and supporters of slavery knew that South-ern culture was violent. "Pistols, dirks, bowie knives, or other instru-ments of death, are generally carried throughout the slave states," wrote Theodore Weld, "and . . . deadly affrays with them, in the streets of their cities and villages, are matters of daily occurrence." Visitors sus-pected of abolitionism were common victims of Southern violence. One Virginia politician declared, "The best way to meet the abolitionist is with cold steel and Dupont's best [gunpowder]!" George Lippard's best-selling novel *The Quaker City* caricatured a typical Southerner, who bragged that he "roasted an Abolitionist the day afore I left [South Carolina], for tryin' to steal my niggers. Lynched a Yankee, the day afore that . . . Killed four or five fellers in a duel. Took 'em one after another. . . . Very low business."—the sort of Southern-based black hu-mor later immortalized in the Shepherson-Grangerford feud in Mark Twain's *Huckleberry Finn*, where rival families start shooting each other until "by and by everybody's killed off, and there ain't no more feud." Small wonder that when John Brown slaughtered five proslavery settlers in Kansas, a contemporary noted he had "brought Southern tactics to the Northern side."

But, again, why weren't there more Lovejoys or Browns—abolitionists inclined to use firearms or knives? Part of the answer lies in a trend toward nonresistance in the North.

* * * *

ORIGINALLY, OPPOSITION TO WAR had been largely the province of Quakers. In 1693 William Penn, the Quaker leader who founded Penn-sylvania, proposed the formation of an international tribunal to settle European disputes. During the American Revolution, another Phila-delphian, Anthony Benezet, led Quakers in the antiwar effort. In time, the Quakers were joined by other peace advocates. The deist Benjamin Franklin opposed war, as did another founding father, the Presbyterian Benjamin Rush, though both supported the American Revolution.

Rush recommended the formation of a Peace Office to counteract the War Department.

The Napoleonic Wars (1804–15) and the War of 1812 led some Americans to take steps to insure that wars would never again happen. This was the hopeful agenda of the New York merchant David Low Dodge, who in his book *War Inconsistent with the Christian Religion* argued that war was inhuman, unwise, and criminal. In 1815 Dodge created a peace society in New York, apparently the first of its kind. Also that year, there appeared a similar society in Boston, inspired by the liberal Congregational preacher Noah Worcester. Having become a pacifist during the War of 1812, Worcester wrote a book, *The Solemn Review of the Custom of War*, and edited a periodical, the *Friend of Peace*, in which he described war as heathenish and savage, a curse on the world. Anticipating future developments, Worcester called for an international court of justice to arbitrate between nations. His precepts were adopted by the Massachusetts Peace Society, which first met in the home of William Ellery Channing. It attracted many of the state's most respected clergymen and judges and fostered other organizations. By 1820, peace societies had sprung up in different areas of the country, many of them with branches and publications of their own.

The peace movement accelerated with the work of William Ladd. Rotund and friendly (Garrison called him "a huge and strange compound of fat, good nature, and benevolence"), Ladd graduated from Harvard and earned enough as a merchant and cotton planter to retire in 1814 to a large farm in Maine. He joined the peace movement after reading Noah Worcester. Seeing that the movement was fragmented, he undertook to combine numerous peace societies in a national organization. In 1828 he established the American Peace Society, made up of groups from six states. Ladd's call for a world court and a congress of nations helped bring about numerous international peace conferences at The Hague, beginning in 1843.

Devoted to temperance, abolition, and women's rights as well as

pacifism, Ladd brought a fresh openness to the peace movement, which, he said, must be promoted in every possible way—through religion, economics, and coordination with other reforms. He spread peace principles. A key moment came in September 1838, when he organized a four-day peace convention in Boston. Garrison was there, along with many other leading reformers. Not only were many of them won over to peace reform, but some, including Garrison, brought to it a perfectionist zeal that caused a split in the movement. Some Garrisonians carried pacifism to the extreme of forbidding defensive as well as offensive violence—a passive approach they called nonresistance. Garrison and others went on to form the New England Non-Resistance Society, while the more moderate reformers, who conceded that in some cases violence was justifiable, continued in the American Peace Society.

The list of reformers and intellectuals who espoused pacifism is remarkable. At various times, all of the following participated in the movement, with varying levels of commitment: Ralph Waldo Emerson, Henry David Thoreau, Theodore Parker, William Ellery Channing, Lydia Maria Child, Horace Greeley, Abigail Kelley, Bronson Alcott, Adin Ballou, James Freeman Clarke, Francis Parkman, James Russell Lowell, Julia Ward Howe, Elihu Burritt, Josiah Quincy, Henry C. Wright, the Tappan brothers, and Elizabeth Palmer Peabody and her sisters Mary and Sophia.

Pacifism contributed to anarchism and civil disobedience. Because Garrison and his followers rejected not only war but also "preparations for war," they refused allegiance to all human governments. This position fed into transcendentalism, which replaced social institutions with individual intuition, and anarchism, which in the hands of reformers like Nathaniel P. Rogers, Josiah Warren, and Thomas Low Nichols led to the belief in what they called individual sovereignty.

Civil disobedience became common among those influenced by the peace movement. Opposed to violent protest, many reformers between 1835 and 1850 allowed themselves to be taken to jail. Among the willingly incarcerated were the abolitionist Stephen S. Foster, imprisoned for failing to show for a military muster, and Nathaniel Allen, Erastus

Brown, and Thomas P. Beach, all of whom did prison time for inter-rupting church meetings with antislavery statements. These nonresis-tant protesters proudly assumed martyr roles. They glorified their jail sentences, declaring themselves freer and happier than those who con-tinued to live normally in a world of corrupt institutions.

The transcendentalists made civil disobedience famous. Emerson viewed war as a necessary evil but addressed the American Peace Soci-ety in 1838, declaring, "War is on its last legs; and a universal peace is as sure as is the prevalence of civilization over barbarism, of liberal gov-ernments over feudal forms." Although Emerson supported a congress of nations, he insisted that peace could be best achieved "not in a feudal Europe," with its rivalries and traditions, but "in this broad America," where "the universal cry for reform of so many inveterate abuses" allows for a new "faith and hope, intellectual and religious."

Emerson had no jail term to brag of, but some of his fellow tran-scendentalists did. One was Bronson Alcott. Stating in his diary, "I re-gard Non-Resistance as the germ of the New Church," Alcott instituted versions of nonresistance at the Temple School, where a naughty stu-dent was asked to punish the teacher, and at Fruitlands, his utopian community where pacifism was preached. In 1843 he followed the lead of others when he was jailed after protesting against slavery by refusing to pay a poll tax.

Thoreau famously withdrew from society by living for two years at Walden Pond and by refusing to pay his poll tax for six years, for which he spent a night in the Middlesex County jail in Concord. In the late 1840s, he immortalized the experience in his essay "Civil Disobedience." Virtuous people, Thoreau argued, would refuse loyalty to the American government as long as it is "the *slave's* government also." Like the previ-ous reformers, he rhapsodized about his jail sentence. "Under a govern-ment which imprisons any unjustly," he wrote, "the true place is also a prison. The proper place today, the only place which Massachusetts has provided for her freer and less desponding spirits, is in her prisons."

Peace reform flowered in the 1830s and 40s but faded after that. Only

a few reformers, such as Adin Ballou and Stephen Foster, clung to nonresistance. Ballou late in life befriended Tolstoy, who was so attracted to nonresistance that he called Ballou America's greatest writer. Tolstoy in turn became a link between American peace reform and passive protesters of the twentieth century such as Gandhi and Martin Luther King.

Stephen Foster and his wife, Abigail Kelley Foster, were among a handful of leftover pacifists so devoted to the cause that they objected to the Civil War, even though they detested slavery. But they were atypical. During the 1850s, it became clear to most reformers that only violence would end slavery. Thoreau, once the champion of passive resistance, became the strongest supporter of John Brown, the sword-wielding warrior. Many others who had sometimes flirted with pacifism—Emerson, Alcott, Parker, Wright, and Phillips—also jumped eagerly on the John Brown bandwagon. The former peace reformer Julia Ward Howe went so far as to fuse Brownian violence with America itself when she changed the words of the "John Brown Song" to produce "The Battle Hymn of the Republic," with its martial images of "the grapes of wrath" and "the fateful lightnings of His terrible swift sword."

As the Civil War showed, peace was a wonderful ideal virtually impossible to reach, let alone maintain, when a nation confronted an evil so deeply rooted as slavery.

★ ★ ★ ★

MORAL REFORM, OR THE organized battle against prostitution and other forms of illicit sex, arose in the early 1830s and was soon joined by a sexual purity movement, targeted mainly at masturbation. Whereas moral reform was a religious movement associated with the Benevolent Empire, sexual hygiene came from health reform.

Both movements must be seen against the complex background of sexual mores and attitudes of nineteenth-century America. Walt Whitman identified two main attitudes toward sex in his day: the conventional and the prurient. The first, Whitman wrote, was "the conventional one of good folks and good print everywhere," seeing sex as dirty and

suppressing any mention of it. The second—"and by far the largest," he noted—was a "merely sensual voluptuousness," visible in popular pornography and the urban sporting culture that featured promiscuity, prostitution, and "erotic stories and talk."

Whitman's generalizations have some substance. What he calls the conventional viewpoint produced the prissiness that we often associate with Victorian America. The perfectionist spirit led to a general cleaning up of everyday behavior, including sex. In polite circles, prudishness abounded. Shame of nakedness yielded some unusual customs. Frilly stockings were often put over the legs of pianos. In museums, naked statues sometimes were cloaked in dimity aprons. Undergarments were called "inexpressibles," shirts "linen," arms and legs "branches" or "limbs." Women's dresses were multilayered and billowing, allowing no view of the ankles (which were opaquely stockinged anyway), while corsets were pulled to a punishing tightness. Such puritanical mores help explain a notable decline in premarital pregnancy rates, which in the late eighteenth century had been above 30 percent among women in some sections of New England and then dropped to an estimated 20 percent nationally in the 1820s and 10 percent in the 1850s.

The economy sped the rise of the so-called cult of domesticity. With the advent of capitalism, men increasingly worked in the public arena. Woman's sphere was the home. In that realm, a woman had great power, but also certain restrictions: She was expected to be pure, pious, apolitical, and submissive to her husband. For the average wife, sex was for procreation, not enjoyment. The ideal of the passionless woman had emerged in the eighteenth century and grew as moral strictures tightened and pseudosciences preached the debilitating effects of sex.

The same economic forces that fostered sexual repression, however, simultaneously produced certain forms of sexual excess. The market economy opened many new job possibilities for men but few for women. Women who entered the workforce did not automatically escape domesticity. The Lowell factory girl, for instance, typically worked for about three years as a teenager and then went on to become a wife and

mother. Women could be teachers, seamstresses, governesses, and servants, but these jobs were low paying and onerous. By far the highest pay went to prostitutes. A woman who might earn $2 a week slaving twelve hours a day as a seamstress could earn $10 to $50 a session as a prostitute. Some prostitutes and procuresses, such as the Manhattan madams Adeline Miller and Phoebe Doty, got rich.

Prudishness fed prostitution. Not only was premarital sex discouraged, but a woman's loss of her virginity outside of marriage was considered a terrible sin. Once a woman had fallen, there was no turning back. As one journalist warned, "One step over the barrier thrown around virtue, and the gulf below is your receptacle forever." No longer pure, and with no other opportunity in sight, a woman was tempted to embrace prostitution as her only option.

Many did so. By a conservative estimate, in the 1840s between 5 percent and 10 percent of all New York women between fifteen and thirty worked for a time as prostitutes, and in hard times the percentage was higher. By the 1850s, prostitution was New York's second largest cash-value business; only tailor shops brought in more money. Unlike at a later period, when telephones and skyscrapers made prostitution more furtive, it was then very much a public phenomenon. "Fast" girls in gaudy clothes paraded the sidewalks openly and crammed into theaters, which had special galleries for them. Their clients were not only "sports" (young men who reveled in urban fun) but also more established types: lawyers, judges, businessmen, editors, and—as often reported in scandal sheets of the day—clergymen.

Popular literature reflected the split between prudishness and promiscuity in society. On the one hand, a large body of conventional literature—ladies' magazines, domestic advice manuals, religious tracts, and sentimental novels—enforced the ideals of passionlessness and the cult of domesticity. On the other hand, there was a thriving industry of cheap sensational literature, some of it pornographic. At first, virtually all pornography was imported, but after 1840 various kinds of racy literature were produced by Americans. This literature ranged from bawdy

urban periodicals, such as "flash" newspapers like the *Weekly Rake*, the *Sunday Flash*, the *New York Sporting Whip*, to what now would be called soft-core porn, such as the novels of George Lippard and Henri Foster, to more explicit writings, such George Thompson's pulp novels or obscene newspapers like *Venus's Miscellany*.

Inevitably, this emerging culture of eroticism collided with the puritanical codes of evangelical Christianity. The result was a movement called moral reform, a Protestant effort to halt prostitution and pornography.

Moral reform got off to a controversial start with the efforts of the Reverend John R. McDowall. Born in Canada in 1801, McDowall moved to Rhode Island in his teens and then relocated to New York in 1830. An ordained Presbyterian minister, he joined the Tappans' evangelical army. He toured the seamier sides of New York. Astounded by the extent of prostitution, he founded the Female Benevolent Society. His sensational pamphlet *Magdalen Facts* and his weekly newspaper *McDowall's Journal* gave graphic reports of whoredom, abortion, child murder, assignation houses, and obscene books. Believing that the best cure for sin was to expose it openly, he gave many explicit details about his findings.

This candid approach opened him to criticism. Major newspapers in New York and Boston charged him with describing illicit sex for titillation, not reform. One lambasted "that infamous bawdy chronicle called McDowall's Journal," whose editor disseminated "among our virtuous females, pamphlets and papers containing details calculated to poison their imagination, and make them adepts in all the mysteries of human corruption!" Another called *McDowall's Journal* "the most foul and loathsome journal that ever suffused the face of modesty, . . . a sort of Directory of Iniquity—a brothel companion," which "under the pretence of reforming mankind, excites the imagination of youth by the most glowing pictures of sensual debauchery." In 1834 a New York grand jury ruled that McDowall's paper was "calculated to promote lewdness," and McDowall was forced to suspend publication. In 1835

the Third Presbytery of New York convicted McDowall of corrupting public morals, illegally using funds donated to his cause, and other "scandalous things, too bad to name" (he was rumored to be sleeping with one of the prostitutes under his care). Although supported by evangelical heavyweights like Lyman Beecher and Charles Grandison Finney, McDowall was defrocked and driven to isolation and early death.

McDowall's downfall changed the moral reform movement, which thereafter was left largely to women. The New-York Female Moral Reform Society formed in 1834 to combat "the sin of LICENTIOUSNESS," which "has woven itself into all fibres of society, shaping its opinions, modifying its customs, and . . . spreading an atmosphere of corruption and death throughout the entire community." To accomplish "the *rescue* and salvation of those who have *already fallen*," the society opened a shelter for penitent prostitutes. The society also distributed tracts and newspapers describing common tricks of seducers and warning readers against admitting into polite circles people known for their licentious habits. By 1841, renamed the American Female Moral Reform Society, it claimed that it had forty thousand members and had published more than thirteen million pages of newspapers, tracts, and leaflets—the equivalent of nearly forty thousand fat volumes!

This written material was staid. One commentator recalled that previous moral reform publications were "calculated rather to outrage delicacy and good taste than to correct vicious propensities," and emphasized: "But no more of that—The entire direction of these efforts has passed into other hands, guided by wiser heads."

That was only part of the story. True, moral reform cleaned up its act. But the titillating treatment of sex did not disappear. To the contrary, it became more widespread than before when it fell into the hands of penny newspapers and pulp novelists. The transition to a new kind of erotic popular literature came in 1836 with newspaper reports of the murder of Helen Jewett, a beautiful New York prostitute. Jewett was bludgeoned to death and her body was burned in a brothel run by the

famous procuress Rosina Townsend. The alleged killer, Richard Robinson, had been one of Jewett's clients and was a typical "sport," a young clerk who enjoyed the city's pleasures. When Robinson was acquitted for lack of evidence, the city was divided between his supporters and Jewett's. This imbroglio was natural fodder for the emerging penny press. In particular, James Gordon Bennett nearly doubled the circulation of his *New York Herald* by harping on the case, paying special attention to Helen Jewett's beauty, in life and as a corpse. Thereafter, penny papers feasted on sensational news, often with a sexual twist. The 1840s and 1850s brought the hugely popular erotic novels of George Lippard, George Thompson, and others, most of them written with the supposed intent of exposing vice only to cure it.

With graphic exposure of sex taken over by popular writers, moral reform emphasized conventional language. For instance, when the reformers mentioned Jewett, they did so to preach morality, as when one reform meeting warned parents to "look at the lovely jewel by their side" and "tremble lest, amidst the corruption of the times, that jewel should become another Helen Jewett."

Helen Jewett

Moral reform groups multiplied. The American Seventh Commandment Society, founded in 1833, soon changed its name to the American Moral Reform Society. By 1847 it claimed to have published more than a million pages of tracts. Among the many other moral reform organizations were a national association of blacks, begun in Philadelphia in 1835 by Samuel E. Cornish and Robert Purvis; a female society founded in Oberlin in 1836; and the New-England Golden Rule Society (1838), run by Protestant women. Antislavery leaders joined the moral reform effort. Garrison noted "the prevalence of lewdness" in the North, which made it similar to the South, where slavery, "a system of incest, pollution, and adultery," was enforced by slaveholders, who were "whoremongers and adulterers." In the *Liberator*, Garrison strongly endorsed several moral reform societies. The seducer, he wrote, "is a viper in society. Let him be avoided as a despicable felon."

Moral reform had two main goals: rescuing prostitutes and eradicating the causes of prostitution, especially seduction. Most major cities had shelters in which former prostitutes received vocational training and religious instruction. Several moral reform groups pushed for state laws against seduction. The first such law, passed in New York in 1848, made the seduction of a previously chaste woman under the age of twenty-five punishable by a fine of up to $1,000 and a maximum of five years in prison. Other states passed similar laws. By the end of the nineteenth century most states had antiseduction laws.

While evangelicals focused on licentiousness and prostitution, health reformers emphasized masturbation, the so-called solitary vice. In the late eighteenth century, the French physician Simon André Tissot had warned that the ejaculation of one ounce of semen equaled the loss of forty ounces of blood. The rise of pseudoscience in America fanned an interest in health reform, which nurtured a phobia of masturbation.

Sylvester Graham brought masturbation to the forefront of cultural consciousness with his book *Lectures to Young Men on Chastity* (1834). A Presbyterian minister active in the temperance cause, Graham in the

early 1830s studied anatomy and physiology. He concluded that many things were dangerous to the health, including alcohol, coffee, tea, tobacco, and meat. Objecting to the chemical additives in commercial baked goods, he invented a natural, whole-grain flour for bread and crackers. Besides fathering what later became the graham cracker, he was a leading vegetarian, giving lectures that sometimes attracted thousands. He also came out strongly against excessive sexual intercourse and masturbation. If a husband and wife had sex more than once a week, he argued, they endangered their lives; he advised that intercourse be limited to twelve times a year. (Some of his disciples recommended just once a year.) Masturbation, Graham insisted, swept "with the tremendous force of a tornado" through the body, which was "tortured into a shocking state of debility." It was, he said, the single greatest cause of insanity. "Among the hapless inmates of the lunatic asylum," he wrote, "none is more incorrigible, nor incurable, than the wretched victim of this odious vice."

For Graham and his followers, there was barely a disease that masturbation did not cause. Masturbation "blights and destroys like the breath of the sirocco," wrote the Massachusetts doctor Alfred Hitchcock. "The manly frame totters and decays beneath its undermining power, while the social, moral, and intellectual man is wrecked or annihilated in ruin!" Samuel B. Woodward, the head of a lunatic asylum, gave a grim list of illnesses the solitary vice spawned: "Consumptions, spinal distortions, weak and painful eyes, weak stomach, nervous headaches, . . . insanity and idiotism, [and] a host of other diseases."

Whereas Graham stressed masturbation among young men, others noted that it was common among women as well. "Self-pollution," wrote one doctor, "is as common among females as among males," and it "exists among all classes," even proper female churchgoers. Medical journals were filled with admonitory stories: of a sixteen-year-old girl who masturbated fifteen to twenty times a night for six months and became bedridden with severe pain and fever; of another teenager who developed an uncontrollable hiccup because "she had long been in the

habit of masturbation, that, too, in no limited extent—ordinarily producing orgasm four or five times daily, and that for a period of two years"; of "a young child, scarcely 12 years of age, [who] abandoned herself to the practice of masturbation, of which she was guilty several times in the course of the day, and that in the most open and undisguised manner"—a "fatal passion" that so dominated her that she "became an object of horror to her parents and friends," until she was confined to a nunnery, where she soon died of "compression of the brain." The medical reformer Orson Fowler said girls were "dying by the thousands" from masturbation.

Although called the solitary vice, masturbation was thought to be contagious when practiced communally. It was commonly charged that boys trained other boys or girls other girls in group sessions. A physician told of twenty-four recent cases of female patients who had congregated with others to masturbate en masse: "The reason for this is to be found in the fact that the gratification is heightened by the manipulation upon each other . . . One female may thus spread the habit among hundreds." Sylvester Graham estimated that nearly three quarters of twelve- and thirteen-year-old boys masturbated, with some going to what Graham called "the still more loathsome and criminal extent of an unnatural commerce with each other!"

One might think that reports like this would prompt an outcry over homosexuality, but it did not. Today's sexual categories—hetero, homo, and bi—were then unknown. The word *homosexual* did not appear in English until 1892 and was not widely used until the 1920s. Earlier on, same-sex affection was not considered unconventional. Men regularly slept with men, and women with women, with no eyebrows raised. People of the same sex hugged, kissed, and even, on occasion, had sex with each other without being considered a different sexual type. Prudish censors left virtually untouched Walt Whitman's Calamus poems, about same-sex affection, while they expurgated many sections of his Children of Adam poems, about heterosexual eroticism. Criminal prosecution for sodomy was rare.

For moral reformers and sex hygienists, there was plenty to complain about without worrying about sexual inversion, as sex between people of the same gender was then called. Prostitution, seduction, pornography, and masturbation—these were, as one reformer said, the "sins" that threatened to make America "one vast Sodom, engulfing the innocent and unwary in the vortex of destruction."

Meanwhile, there were signs of future attitudes toward sex. Even as moralists cried out against sin, scientists introduced facts about reproduction. In 1827 the existence of the human egg—the ovum—was discovered, and soon it was found that conception came when a man's sperm enters the egg, though there was a widespread, mistaken belief that each sperm contained a tiny human being. Scientific publishing houses like Fowlers and Wells, which first issued Whitman's sexually candid poetry, made available books and pamphlets on the physiology of sex. Although urbanization fanned prostitution, it also brought professionalization, which in turn helped produce the so-called companionate marriage of later times. Couples had fewer and fewer children; the average number of children per family, just over seven in 1800, dropped by half in the course of the century. Contraception devices appeared. The 1830s brought a primitive douche, a cervical cap (anticipating the diaphragm), and vulcanized rubber, used for condoms and other birth-control devices. When contraception failed, women increasingly sought abortions. The number of abortions went from one in twenty-five to thirty live births in 1830 to one in five to six live births in the 1850s—it was not until the post–Civil War years that a strong antiabortion movement took shape. Among the many utopian communities of the day, there were a few that advocated free love, insisting that love should be based on passional attraction.

Already, behind the raging moral battles, there were small indications of the sexually savvy, pleasure-oriented America of the future.

* * * *

THE SPIRIT OF REFORM bred the humanitarian treatment of criminals, aimed at transforming them into productive citizens. American

prisons became world famous. Tocqueville originally came to America to see its prisons, which were favorite stops for many other touring celebrities, from Harriet Martineau through Charles Dickens.

In colonial times, criminals usually received physical punishments such as whipping, branding, mutilation, or time in stocks. After America adopted the stiff English penal code in 1718, many crimes were punishable by death. In Virginia and Kentucky, for instance, the death penalty was inflicted for an astonishing twenty-seven crimes. As late as 1789, three states gave death sentences for ten different crimes.

The overuse of capital punishment dissolved with Enlightenment rationalism. The Italian philosopher Cesare Beccaria made a powerful case against the death penalty and torture in his widely read treatise *On Crimes and Punishment* (1764). Pennsylvania in 1776 made only one crime punishable by death. Soon other states reduced their sentences as well. A complete change of approaches to imprisonment followed the surge of evangelical religion during the Second Great Awakening. It was now widely thought that all but the most depraved offenders could improve through discipline, sobriety, and religious instruction.

Two kinds of prisons arose to fulfill this belief: the Auburn system and the Pennsylvania system. Both were based on the idea that criminals must be cut off from the outside world in order to meditate on their sins and change morally and spiritually. The two systems took different roads toward this end. In the Auburn plan, prisoners spent much of their time with each other, working and having meals together, though not talking with each other. The Pennsylvania plan, in contrast, demanded solitary confinement for every prisoner. Although both plans were considered humanitarian alternatives to harsh prisons of the past, each had rigors of its own. Tocqueville and his traveling companion de Beaumont concluded that "the penitentiary system in America is severe. Whilst society in the United States gives the example of the most extended liberty, the prisons of the same country offer the spectacle of the most complete despotism."

The prison that opened in Auburn, New York, in 1819 operated on the

theory that profitability and reform of criminals could be achieved simultaneously. The New York officials believed that isolating inmates led to despair and insanity, while ignoring their work capabilities cut off a viable source of income. Auburn tried to be economically self-sufficient. In many years, it succeeded in doing so. Prisoners typically worked around eleven hours a day. They grew their own vegetables, butchered their own meat, and sewed their own clothing. They made products—shoes, carpets, cloth, combs, and so forth—that were sold to outsiders. They worked and ate together, then retired at night to solitary cells. Each cell was around seven feet long, three feet wide, and six feet seven inches high—sufficient for sleeping, but cramped on Sundays, when prisoners stayed in them all day.

Prisoners worked side by side in large rooms, but they were forbidden to talk. Guards whipped those who did. The silence spooked visitors. "We felt as if we traversed catacombs," Tocqueville and de Beaumont reported; "there were a thousand living beings, and yet it was a desert solitude." Prisoners wore prison uniforms with horizontal stripes. When going to their workplace, they were chained together and forced to walk in lockstep, a broken shuffle in which they held one another's shoulders as they turned their heads right and stared down at the ground—a reminder of their shame and depravity. Their only reading was the Bible. Many prisoners became so familiar with the Bible that they memorized long portions of it. Sunday schools and religious services kept alive the Christian spirit.

Many American jails were built on the Auburn system in the three decades after 1819. Among the most famous were the one in Wethersfield, Connecticut, which opened in 1827, and the one at Sing Sing, thirty miles north of New York City, which started the next year. The Auburn plan made economic sense, not only because of the prisoners' work but also because cells were tiny and common areas large, reducing construction costs. In 1825 Boston reformers led by Louis Dwight formed the Prison Discipline Society, which founded numerous Auburn-style prisons in different states. The Prison Discipline Society,

which ran until Dwight's death in 1854, monitored American prisons to see that inmates lived in safe, wholesome conditions.

Despite this worthy goal, the society could not prevent the widespread abuse of prisoners, who were not only kept silent but also flogged for the least offense, sometimes savagely. A warden at Auburn was fired for wounding and starving his prisoners, and an inmate there died after receiving over four hundred lashes with the cat-o'-nine-tails. Every prison had its own harsh forms of punishment. Sing Sing, for example, was infamous for "bucking," or suspending prisoners upside down on a bar fastened between the arms and the legs, and the "bath," in which a metal shield was placed around the face into which water was poured that nearly drowned the victim.

The Pennsylvania system was more expensive than the Auburn one, and in certain ways even harsher. The Eastern Penitentiary, which opened in Cherry Hill, Pennsylvania, in 1829, was, at over $700,000, the costliest building ever constructed in America to that time. A massive granite structure whose grounds covered ten acres, it had a central hub from which seven wings of cells radiated like spokes. The wall around the prison was thirty feet high and eight feet thick. Huge towers with turrets and Gothic windows made it look like a medieval fortress. Each cell was comparatively large—twelve feet long and over seven feet wide—and well appointed, with modern plumbing and heating. A thin beam of sunlight, called "the eye of God," streamed from a high circular window. Every cell had its own small yard, surrounded by an eleven-foot wall.

Prisoners at Cherry Hill faced a formidable challenge: isolation. Unlike Auburn, the Pennsylvania plan allowed no contact whatsoever among the inmates, who stayed at all times in their cells wearing black hoods. They had just an hour a day of exercise in their private yards. Years passed, and they did not see other prisoners. Nor did they hear them, because of the thick walls and double-doored cells. The idea behind the Pennsylvania plan was that lone reflection could yield moral regeneration. The prisoners got periodic visits from schoolmasters and

Eastern State Penitentiary at Cherry Hill

charity workers who guided them through religious books, and on Sundays clergymen came to their cells. In the early years, work was disallowed, but in the mid-1830s it was decided that prisoners should work to earn their own keep. But they worked alone, always in their cells.

Which was the most successful prison system, Auburn or Pennsylvania? Tocqueville and de Beaumont commented that the former produced "more obedient citizens," the latter "more honest men," but this assessment seems overly optimistic about each. Excessive physical punishment was all too common in the Auburn-style prisons, and the silence could be unbearable. Equally painful was the bleak isolation enforced by the Pennsylvania plan: Dickens, for instance, found that the "rigid, strict, and hopeless solitary confinement" at Cherry Hill was "immeasurably worse than any torture of the body."

The two prison systems were part of a larger movement toward what Michel Foucault calls the carceral, or the merging of prison discipline and other social institutions. In *Discipline and Punish*, Foucault connects

the movement from the public, physical punishment of early times to the nineteenth century's prisons with the spread of accepted norms of discipline and power. Over time, prison routine becomes similar to that in other modern institutions, such as factories, schools, hospitals, and the military. Prisons of both the Auburn and Pennsylvania types were designed not only to deprive people of liberty but to create mini societies in which bourgeois norms of work and religion were enforced by constant surveillance and strict regulation of prisoners' lives. De Beaumont's and Tocqueville's comments on American prisons, taken together, are telling: These prisons tried to produce "honest men" and "obedient citizens" through "complete despotism." Punishment and discipline came from the state, which used its power to reform criminals.

For juveniles who committed minor crimes, there emerged the house of refuge. The Society for the Prevention of Pauperism, formed in 1816, aided orphans and vagrants for a decade and led to the founding in 1825 of the New York House of Refuge for Juvenile Delinquents, the first institution of its kind in the nation. Admitting boys and girls guilty of small offenses like petty theft or vagrancy, the House of Refuge combined education, vocational training, and religious instruction. The sexes were kept separate, and the inmates had individual cells. Much of the day was spent at work. The boys produced shoes, brushes, nails, and shoes, while the girls made uniforms and did laundry and other domestic tasks. Several hours a day were reserved for schooling in basic subjects. Prayers were said in the morning and the evening, and on Sundays there were two religious services as well as Sunday school. Inmates were segregated according to their conduct.

The next year a house of refuge was established in Boston under the Reverend E. M. P. Wells. The Boston house offered a relaxed approach to juvenile reform, allotting time for play. Recreation hours were from six to seven in the morning and late in the afternoon, just before supper. Still, Wells retained the routines of work, school, and worship, as well as the merit system, of the New York reformatory. Inmates helped enforce discipline on one another under the guidance of adult officers. In court sessions,

rewards went to those who had behaved well, demerits to those who had broken rules. Offenders suffered penalties such as silence, a bread-and-water diet, and, in extreme cases, whipping or cold shower-baths. Those who were deemed reformed were indentured out as workers, with boys usually sent to farms or to sea, girls to homes where they served as maids.

More houses of refuge soon arrived: two more in Massachusetts and several others in states from Maine to Louisiana. By the mid-1850s, there were fifteen such institutions in the United States, including one for blacks in Philadelphia. Built at an aggregate cost of around $2 million, the reformatories apparently succeeded in converting many potential criminals into useful citizens. "It is impossible to estimate the amount of evil prevented by the rearing of these establishments," one journalist wrote. The reformatories kept close tabs on the rates of former inmates successfully employed, which came to about 70 percent.

* * * *

ADVANCES MADE IN REFORMING juvenile delinquents matched those in educating the deaf, the blind, and the mentally ill. The key figures in these areas, respectively, were the Connecticut clergyman Thomas Gallaudet, the Boston doctor Samuel Gridley Howe, and the Worcester teacher Dorothea Dix.

Born in Philadelphia in 1787, Gallaudet as a child moved with his family to Connecticut and later attended Yale and Andover Theological Seminary. His pity for Alice Cogswell, a deaf playmate of his younger sisters, made him aware of the plight of deaf-mutes, as they were then called, of which there were four hundred in New England and five times that number in the nation. He joined a group of Congregationalists led by Alice's father, the Hartford physician Mason F. Cogswell, who raised money for him to go abroad to learn the latest approaches to educating the deaf. In 1815 Gallaudet went to Scotland, England, and France. In Paris he studied with the path-blazing educator Abbé Sicard, skilled in both sign language and oral methods. Accompanied by one of Sicard's students, Laurent Clerc, Gallaudet returned to America

and in 1817 founded the American Asylum, a school for the deaf that taught sign language and lipreading along with manual training and reading, writing, geography, and history. As a minister, Gallaudet also put high priority on Bible instruction.

At first funded by charity, the American Asylum got a boost when a congressional committee under Henry Clay donated twenty-three thousand acres of public land to the school. Proceeds from the sale of the land supported the asylum. Similar state-funded institutions soon appeared in New Hampshire and Vermont and, by 1850, in eleven other states as well. Gallaudet directed the American Asylum until 1830, when ill health forced him to step down, but he continued to write prolifically. He married one of his students, Sophia Fowler; their son, Edward M. Gallaudet, carried on the cause, directing the asylum and later founding a college for those who suffered from deafness and consequent speech difficulties.

What the Gallaudets were for the deaf, Samuel Gridley Howe was for the blind. A graduate of Brown University and Harvard Medical School, Howe was a forward-thinking doctor and social reformer—eventually he joined the Secret Six, a group that helped to finance John Brown—who in the 1820s went to Greece, where he fought in that country's war for independence. He toured Europe and discovered modern techniques for teaching the blind, an area that had long interested him. He had ample opportunity to use these techniques when his friend Dr. John Dix Fisher asked him to direct a school for the blind in Boston that soon was funded by Thomas H. Perkins, a shipping magnate who was visually challenged.

As the head of the Perkins Institute for the Blind between 1833 and his death in 1876, Howe built a broad curriculum that allowed blind students to learn not only regular subjects but also more sophisticated ones like algebra and astronomy. He went to great lengths, such as gluing thick twine on boards to form geometric figures. Devoutly religious, he got the Bible and *Pilgrim's Progress* printed in Braille and was responsible for the publication of other books for the blind. He helped found

many of the other institutes for the blind throughout the nation. He also established a school for the mentally challenged, as well as the State Board of Charities of Massachusetts.

He became world famous for his treatment of Laura Bridgman, a New Hampshire girl who was seven when she arrived at his school in 1837. Struck by scarlet fever at the age of two, Laura could not see, hear, speak, taste, or smell. Howe taught her the alphabet by having her touch objects and then corresponding letters in raised type. She soon could answer simple sentences with her hands. In her teens, she learned how to write with the aid of a tin on which letters and numbers were formed by grooves. Despite her disability, she had a cheerful temperament and an impish sense of humor. She grew into a sociable woman, interested in the world around her and visited by scores of celebrities. Howe wrote regular reports of her progress for newspapers. By 1850 a journalist could say of her: "Perhaps there are not three living women whose names are more widely known than hers; and there is not one who has excited so much sympathy and interest." It was Charles Dickens's moving account of her in *American Notes* that inspired Kate Keller to enroll her daughter Helen in the Perkins Institute in 1888.

Treatment of the mentally ill also progressed during this period, though not as dramatically as its main proponent, Dorothea Dix, initially hoped. Dix followed in the wake of a number of European and American reformers who were appalled by the maltreatment of the mentally ill. Historically, those suffering from severe mental afflictions were regularly thrown into cells, sometimes indiscriminately with felons, or chained to walls and left to wallow in their own filth. The late eighteenth century brought a movement toward humanitarian treatment of the mentally ill. Philippe Pinel, the director of L'Hôpital Général of Paris, declared that "the insane are, after all, human. They are not animals." At his hospital, Pinel created a salubrious environment for his mental patients. Without knowing of Pinel's work, the English Quaker William Tuke did the same in York, where he founded a retreat that he promoted in a widely read book.

America joined the movement for reformed treatment of the mentally ill. The first hospital designed chiefly for mental patients was established in Philadelphia in 1752. Dr. Benjamin Rush, sometimes called the father of American psychology, experimented with different remedies for insanity, including bleeding, behavioral therapy, and, in severe cases, shock treatment. His 1812 book, *Medical Inquiries and Observations upon the Diseases of the Mind*, had a strong influence on later approaches to mental illness with its emphasis on practicality and humanity in the approach to those judged insane.

The four decades after 1815 witnessed the establishment of many asylums for the mentally ill in the United States. By 1848 there were twenty public asylums and several that were privately run. Among the most famous were the Worcester Lunatic Asylum, directed by Samuel B. Woodward; the Bloomingdale Asylum in New York, run by the Quaker Thomas Eddy and his chief physician, the famous Dr. Pliny Earle; and the McLean Asylum in Massachusetts and the Retreat in Hartford, both built on the Tuke system. The asylums offered rest, exercise, games, work, and religious services. One commentator heralded "an entire and happy revolution in the manner of treating insanity," pointing to the new institutions as evidence of "the grand experiment . . . of treating the insane not as something below brute animals in the scale of intelligence, but as rational beings in a deranged state of health."

The asylums brought optimism. Victims of mental illness, formerly neglected or brutalized, were now commonly regarded as curable. Virtually all the asylums reported high cure rates. Usually around 60 percent of all formerly ill patients were listed as either cured or relieved, with rates sometimes approaching 90 percent. "Not only is insanity a curable disease," wrote a doctor, "but a very large proportion of lunatics, under a proper system of management, recover."

In reality, however, the situation was not so bright. Understanding of mental illness was then primitive. Among the leading causes of insanity commonly mentioned were masturbation, religious anxiety, in-

temperance, disappointment in love, loss of property, excessive study, fear of fires, disappointed ambition, and abuse of snuff or tobacco. Common classifications of lunacy included vague terms like mania, melancholia, monomania, and idiocy. Worst of all, only a fraction of America's mentally ill entered asylums. Most were still either kept at home or confined in cells, exposed to the same wretched conditions the insane had always known. It was for this reason that Dorothea Dix began her one-woman campaign on behalf of the mentally ill.

A slight woman with a gentle voice and calm eyes, Dix had a soul of iron. Raised as a Calvinist in Massachusetts, she adopted the Unitarianism of William Ellery Channing. She became a schoolteacher and writer of children's books. While teaching Sunday school in a prison in 1841, she found her true cause: working on behalf of America's mentally ill, especially among the poor. She began an eight-year inspection of conditions of the mentally ill that took her to every state but Florida and Texas. She was appalled by the great number of mental patients who were still confined in almshouses, jails, and cages. In 1848 she told Congress she had witnessed "*more than nine thousand idiots, epileptics, and insane, in the United State, destitute of appropriate care and protection.*" The majority of America's mentally ill, she noted, still suffered in squalid poorhouses or jails, each of which had its "'crazy cells,' 'crazy dungeons,' or 'crazy hall.'" In a typical poorhouse, she met deranged people who looked like "hideous objects" with "matted locks, unshorn beards, and wild, wan countenances," often "in a state of nudity, save the irritating incrustations derived from dungeons, reeking with filth," without light or air, "forlorn, abject, and disgusting."

Because of Dix's work, new asylums arose around the county, and existing ones were improved. But she felt that the real solution lay with the federal government. She demanded 12.5 million acres of public land for asylums that would allow mentally ill Americans to be removed from prisons and poorhouses. In 1854 Congress approved a land bill, but President Franklin Pierce vetoed it. Dorothea Dix continued her lonely battle in Europe, where she worked to improve treatment of the mentally

ill in fourteen countries. Returning to America, she directed nurses during the Civil War, and then resumed her work for the mentally ill. But America's asylums, strained by immigration, had become in many cases as bad as the jails they had replaced. Dix grew bitter over public apathy. Toward the end of her life, she was so cynical over lack of progress in her cause that she refused even to discuss it when questioned.

The problem of governmental support for the mentally ill did not disappear. As recently as April 2007, the *New York Times* announced, "Maltreatment of mentally ill prisoners is a national shame," citing high numbers of suicide attempts and self-mutilations among mentally disturbed inmates. Although mental illness is now better understood than ever, its ravages are still widely felt, especially among the poor.

* * * *

AMERICANS BELIEVED THAT SOCIETY progressed along with science. Timothy Dwight, the president of Yale, declared in 1814: "Improvements are advancing on so large a scale, as to outrun every thing which had been known before. . . . Knowledge will increase, and great improvements will still be made." In an age before Darwin, there was little fear of a collision between science and religion. As the celebrated scientist Benjamin Silliman affirmed, "The whole circle of physical science . . . every where demonstrates both supreme intelligence, and harmony and beneficence of design in THE CREATOR."

This period saw significant discoveries in the fields of botany, geology, mineralogy, and ornithology, to name a few fields. It also produced a number of inventions, such as the reaper and the telegraph, that proved to have immense impact.

But overconfidence in science had drawbacks. Half-truths were widely accepted as facts. Mainstream medicine was often wrong about both the causes and remedies of disease. Alternative approaches to disease were equally misguided, as evidenced by the popularity of patent medicines. Self-help fads and pseudosciences proliferated.

Reflecting the Enlightenment, American science of the late-

eighteenth and early-nineteenth centuries was broad-ranging and democratic. From Benjamin Franklin, Benjamin Rush, and Thomas Jefferson through Benjamin Silliman, Amos Eaton, and Louis Agassiz, Americans involved in science were polymaths, achieving expertise in various fields. Typical was Constantine S. Rafinesque, the European-born naturalist who moved to America in his teens and between 1812 and his death in 1840 wrote over two hundred works—from scientific treatises on animals, plants, shells, astronomy, chemistry, electricity, and geology to writings on Indians, architecture, psychology, archaeology, navigation, poetry, history, and religion.

Some impressive results came from American scientific research. The South Carolina physician William Charles Wells in 1818 anticipated Darwin by theorizing about evolution and natural selection. Wells was not sufficiently well known to influence Darwin, but in the fourth edition of *The Origin of Species*, Darwin acknowledged Wells's work. American pioneers also appeared in botany (Jacob Bigelow and Asa Gray), geology (Amos Eaton), entomology and conchology (Thomas Say), herpetology (John E. Holbrook), and ornithology (John James Audubon).

The nationalist pride of the post–War of 1812 era fused with science. If conquering the frontier fed into Manifest Destiny, it also fueled the scientific study of the nation's plants, animals, and geological formations. The terms "America" or "the United States" appeared in the titles of major scientific works. The country's plants were classified in Bigelow's *American Medical Botany* (1817–20) and Gray's *Manual of the Botany of the Northern United States* (1848); its insects and shells in Say's *Entomology, or Descriptions of the Insects of North America* (1824–28) and *American Conchology, or Descriptions of the Shells of North America* (1830–34); its birds in Audubon's *Birds of America* (1827–38); its geology in Eaton's *A Geological Nomenclature for North America* (1828); and its reptiles in Holbrook's *North American Herpetology* (1842).

Much of the information for these and similar volumes came from scientific surveys and expeditions, often backed by state or federal funds.

Between 1820 and 1840, eighteen states commissioned geological surveys for agriculture and commerce that yielded valuable scientific information. What geologists call the Eaton era was begun when New York's Central Board of Agriculture funded Amos Eaton's survey of the Erie Canal area—the basis for Eaton's path-blazing books and his founding of Rensselaer School (now Rensselaer Polytechnic Institute). In 1819–20 President Monroe supported an expedition through the Louisiana Purchase territory led by the engineer Stephen H. Long. Accompanied by scientists, including Thomas Say, Long explored the Great Plains and the Rockies on a geological fact-finding tour, initiating a career of expeditions that eventually took him twenty-six thousand miles. The famous Boatload of Knowledge that went to Robert Owen's New Harmony in 1826 included Say as well as other notables, such as the geologist William Maclure and the naturalist Charles Alexandre Lesueur.

Even Andrew Jackson caught the science bug. Reversing his earlier stance on government funding for science, President Jackson in 1836 signed a bill authorizing the United States Exploring Expedition. This project led to Charles Wilkes's celebrated venture to the South Seas and Antarctica in 1838–42, which provided enough specimens from around the world to justify the founding of the Smithsonian Institution in 1846.

The Smithsonian followed in the wake of other distinguished American centers of scientific learning. In the eighteenth century, the American Philosophical Society in Philadelphia and the American Academy of Arts and Sciences in Boston were established. Two other Philadelphia institutions, the Academy of Natural Sciences and the Franklin Institute, came in 1812 and 1824, respectively. The Lyceum of Natural History in New York, chartered in 1818, led to the founding of New York University in 1831. The Lyceum later became the New York Academy of Sciences, which had over twenty thousand members by the early twenty-first century. Together, these institutes and the journals several of them produced made America a vibrant center of intellectual activity, especially in the natural sciences.

Most of these centers were research-oriented, though some of them, like the Franklin Institute and the Smithsonian, soon became popular museums. They joined a growing number of American museums whose aim was to introduce science to the masses. The spread of scientific knowledge was thought to promote American freedoms. At the opening ceremony of the Franklin Institute, a speaker typically urged Americans "to encourage institutions *calculated to diffuse knowledge among the people* It will insure to us *religious, political and personal freedom*; and will, sooner or later, by our example, lead to the emancipation of the world."

From the start, American museums tried to appeal to average people. When the scientist and painter Charles Willson Peale opened his museum in Philadelphia in 1786, he designed it specifically for the general public, in contrast to Europeans, who typically expected museums to appeal only to the social elite. Along with the usual specimens of natural history, Peale introduced the mastodon, the first large animal skeleton exhibited in America. By the early 1820s, the Peale family had also opened museums in Baltimore and New York, with the former specializing in animals and the latter in oddities like a live cannibal, Siamese twins, a five-legged cow with two tails, and a musician who could play twelve instruments (six at a time).

Such curiosities increasingly filled American museums. Although nature itself produced wondrous animals, plants, and minerals that museums continued to feature, the American public, hungry for the kind of thrills provided by the era's sensational penny papers, also enjoyed other fare. Wax figures of celebrities from President Jackson to notorious criminals were sure draws, as were the *cosmorama* (a box with a lens that magnified images), the *zoetrope* or wheel of life (in which scenes mounted on a rotating wheel seemed to move when viewed through a slit), and the *diorama* (at the time meaning a tremendous painting on rollers that also gave a sense of motion). Joseph Dorfeuille's Western Museum in Cincinnati was filled with waxworks, freaks, and other diversions—most notably a panorama of hell in a cavernous room filled

with lakes of fire, walking skeletons, people-eating snakes, and humans with animals' heads.

The leading purveyor of museum curiosities was Phineas T. Barnum. A former newspaper editor and failed businessman, Barnum noted Americans' fascination with sensational spectacles. In 1836 he began a three-year tour exhibiting Joice Heth, a blind, paralytic black women who he said was 161 years old and had been George Washington's nanny. Although it was revealed on her death that she had been only around 75, Barnum went forward eagerly with his project of hoodwinking the public.

He was encouraged by the presidential election of 1840, in which image trumped substance. "Humbug," he declared, "is an astonishingly wide-spread phenomenon—in fact almost universal." It filled politics, religion, newspapers, and society. Why not make a living from it? In 1841 Barnum bought a New York museum and opened it the next year as Barnum's American Museum. The museum offered the usual items—plants, shells, animals, wax figures, cosmoramas, and so on—but also displayed many living oddities, such as the North Carolina Fat Boy, a seven-year-old who weighed two hundred pounds; Mr. and Mrs. Randall, billed as "the largest giant and giantess in the world"; the half-woman, half-fish Fiji Mermaid; a seven-year-old "whiskered child" who had "a large and bushy pair of Natural Whiskers"; and an array of midgets, two-headed animals, and other rarities. His most famous spectacle was Henry Stratton (aka General Tom Thumb), a boy twenty-five inches tall and fifteen pounds in weight. Luckily for Barnum, Stratton stayed small; at twenty, he was just two feet nine inches tall. Barnum trained Stratton to sing, dance, and crack jokes and toured with him throughout the United States and Europe. By the mid-1850s, Barnum's finances were strained, but after the Civil War he became a circus impresario, establishing a name that continues to resonate today.

If Barnum showed how science could mingle with show business, a string of inventors proved that it could be practical. Inventions, whether

produced abroad or indigenously, got instant attention, though not all were immediately available for general use. A German visitor said of the United States: "Anything new is quickly introduced here, and all the latest inventions. There is no clinging to old ways; the moment an American hears the word 'invention' he pricks up his ears."

Inventions came fast upon each other. In 1826 the New Jersey engineer John Stevens introduced the steam-powered passenger train, leading in 1830 to the first operating railroad, the Baltimore and Ohio. Within a decade, there were over four hundred locomotives running on three thousand miles of track in America—though railroads did not have a large economic impact until the 1850s. John Walker of England invented friction matches in 1827. Two years later from Michigan came William Austin Burt's typographer, an early version of the typewriter, another machine whose heyday was in the future. A Frenchman, Barthélemy Thimmonier, introduced in 1830 a sewing machine using a

P. T. Barnum and General Tom Thumb

hooked needle, replaced in 1834 by the eye-pointed needle invented by the New Yorker William Hunt, who in the 1850s was succeeded by the Bostonian Isaac Singer and others, who produced the wildly popular foot-pedal machines that reigned for decades. The Virginian Cyrus McCormick introduced the first practical reaper in 1831, followed six years later by the steel plow, created by the Illinois blacksmith John Deere. But it took time for these inventions to take hold; the era of widespread mechanical farming arrived after the Civil War. The bicycle was invented in 1839, the stapler in 1841, and the vulcanized rubber pneumatic tire in 1845. During this period, the Massachusetts shoe-maker Arial Bragg demonstrated how shoes could be mass-produced rather than made individually.

Three especially significant inventions of the 1830s were the re-volver, the daguerreotype, and the telegraph. In 1836 the Hartford in-ventor Samuel Colt patented his revolving gun, which became the first widely used repeating firearm. Photography, introduced in France in August 1839 by Louis-Jacques-Mandé Daguerre and in New York later that year by D. W. Seager, soon achieved a popularity in America un-matched abroad. By the early 1850s, there were more daguerreotype galleries in Manhattan alone than in all of England, and more on Broadway than in London.

The telegraph was the outgrowth of the electromagnet, invented in England in 1825 and first used for long-distance communication by an American, Joseph Henry, in 1830. Some fifty inventors were at work on the telegraph when the New York artist and professor Samuel F. B. Morse in 1838 demonstrated an electromagnet that efficiently sent sig-nals over a wire. Five years later Congress funded the first long-distance telegraph, which stretched forty miles from Washington to Baltimore, delivering words in the code of dots and dashes that Morse had created. Appropriately, one of the first sentences sent over the telegraph, chosen by the daughter of one of Morse's friends, was a Bible verse: "What hath God wrought." Soon several eastern cities were linked by tele-graph, which spread to other parts of the country in the 1850s.

The cumulative effect of inventions and other advances was to foster a boundless faith in scientific progress among some Americans. A magazine writer predicted that the telegraph would "be the means of extending civilization, republicanism, and Christianity over the earth," so that "Wars will cease from the earth. . . . Then shall come to pass the millennium." The *New York Herald* announced, "Steam and electricity, with the natural impulses of a free people, have made, and are making, this country the greatest, the most original, the most wonderful the sun ever shone upon." The mixing of technology with providence into a mark of human progress, which originated with the likes of John Quincy Adams, became a definably Whig concept, blossoming in the 1830s and 1840s. Daniel Webster rhapsodized, "It is an extraordinary era in which we live. It is altogether new. The world has seen nothing like it before. . . . The age is remarkable for scientific research into the heavens, the earth, and what is beneath the earth; and perhaps more remarkable still for the application of this scientific research into the pursuits of life . . . The progress of the age has almost outstripped human belief; the future is known only to Omniscience."

What Webster did not mention was science's tremendous failure in one key area: human health. In 1850, after many so-called scientific advances had taken hold, Americans' life expectancy at birth was still low: 38.3 years for men, 40.5 for women. A third of America's white children and more than half of its black children did not live to adulthood. In an age before antibiotics, doctors administered few effective treatments and in fact often sped death. The most commonly prescribed remedies were painful and often dangerous. Nor did alternative medicine or pseudoscience have lasting results.

American doctors in the first half of the nineteenth century remained under the imposing influence of Dr. Benjamin Rush, the eighteenth-century medical titan who had championed so-called heroic medicine. Rush believed that most diseases were aggravated by congestion of bodily fluids. Relief and possible cure supposedly came from a release of blood, vomit, sweat, pus, or other fluids. Rush advocated

techniques toward these ends: bleeding, blistering, purging, vomiting, and so on.

Physicians after Rush used these techniques with a confidence that verged on abandon. Bleeding typically involved cutting open a vein and allowing blood to flow freely into a receptacle, often regulated by a tourniquet. It was not uncommon for large amounts of blood to be taken—eight to ten ounces for mild illnesses, twenty to thirty for more serious ones, and more than six hundred ounces over several weeks in dire cases (the average human body contains two hundred ounces of blood). Cupping referred to piercing capillaries and covering them with a cup that caught the blood. Blistering resulted when caustic substances like cantharides (powdered Spanish flies) were applied to the skin, creating second-degree burns that discharged pus and other fluids. Bloodsucking leeches facilitated the removal of blood. Frequently leeches were placed all over the body—even on sensitive areas like the face or private parts—in the belief that they helped the healing process. Bottles full of live leeches were commonly featured in the windows of apothecary shops.

It is difficult for many today to understand the devotion that Americans of an earlier era had to bleeding. A typical doctor said he had had "great success" treating pneumonia with a simple regimen: "Bleed freely—vomit freely—and blister early." Shortly after Andrew Jackson's wife Rachel had passed into unconsciousness from her final heart attack, Old Hickory commanded her doctor, "Bleed her!" The doctor obediently cut open a vein but got only a tiny drop; his patient had already died. For Rachel, the medical technique of bleeding was gratuitous. For others before and after her, it was fatal. George Washington's death evidently was hastened by the bleeding and blistering prescribed for his pneumonia. Other presidents whose deaths were reportedly sped by such methods were William Henry Harrison and Zachary Taylor.

Medicines were rarely more effective than bleeding. Since vomiting was a commonly prescribed remedy, emetics like lobelia, ipecac, and tobacco were given for many illnesses. Sweat, saliva, and other bodily fluids were forced out with plasters like hot mustard. The favorite medicine

of the era was calomel, a mercury compound used along with laxatives for purging. Whereas Americans in recent times have received warnings against mercury, small amounts of which sometimes appear in deep-sea fish, doctors then recommended the ingestion of vast amounts of the substance, which is now known to damage the gums, the brain, and the endocrine system; eventually it can cause death.

Alternatives to mainstream drugs were easy to come by. Patent medicines, made of secret ingredients that were usually quite simple, included some harmless, even useful products, such as cough syrup and castor oil, but also many chimeras peddled for a profit. Patent medicines often consisted of alcohol, opium, and/or coca leaf extract mixed with an herbal concoction and other materials like soap or camphor. Some medicines were designed for specific diseases. For syphilis there were The Unfortunate's Friend and Levison's Red Drops; the latter was billed as "the only absolute Specific that had ever been discovered for the cure of the most dangerous disease bad company is the cause of." Women with unwanted pregnancies could take abortifacients like Dr. Relfe's Aromatic Pills.

Panaceas were part of everyday life, readily available and universally applicable. Goelick's Matchless Sanative promised to cure consumption (tuberculosis), palsy, gout, leprosy, and spinal disease. Dr. Leidy's Vegetable Febrile Elixir was promoted as a panacea, as was the tremendously popular Brandreth's Vegetable Universal Pills. These pills, first advertised in 1834 by Dr. Benjamin Brandreth, claimed to be "indeed a Universal Remedy . . . all powerful for the removal of diseases, whether chronic or recent, infectious or otherwise." There were many efforts among regular doctors to stamp out patent medicines, but to no avail. These nostrums became ever more popular and in fact did not peak in influence until the late nineteenth century, the age of the allegedly all-curing snake oil.

The causes of illness were understood no better than their treatment. It was commonly assumed that diseases of all kinds originated from earth gases, night air, or even the position of stars or comets.

Actually, most Americans lived in unsanitary conditions that bred disease. They could not know that they were surrounded by germs and viruses, for germ theory was decades away. Since water came from public pumps, baths were infrequent. In rural areas, a once-weekly sponge-down from a washtub, without soap, was considered a luxury—once or twice yearly was closer to the average. In cities, many streets remained wide dirt paths that in bad weather became muck stinking of animal feces. In the absence of professional garbage collection, the most capable disposers of waste were hogs, geese, and other animals, which rooted in the garbage that was universally deposited on the streets.

Small wonder that epidemics repeatedly broke out. Although smallpox had been successfully combated through vaccination, Americans stood defenseless against other fast-spreading diseases, most notably cholera. Terror arose in the fall of 1832 when a great cholera epidemic besieged the nation. Having spread from Europe and down the east coast from Canada, the cholera had an especially devastating impact on city dwellers. Soon it spread west to St. Louis and then down to the Gulf. All the usual remedies, from bloodletting and emetics to plasters and purgatives, were not only ineffective but cruel, since the disease by itself drained the body of fluids. Nothing could prevent thousands of American deaths that year. Nor could much be done about another cholera epidemic that came in 1849 or the regular outbreaks of yellow fever that happened every two or three years throughout the period.

If you couldn't fight illness, you joined it. That was approach of homeopathy, which was based on the notion that disease could be combated by introducing into the body substances that mimicked the disease's symptoms. Introduced in Germany by the physician Samuel Hahnemann, homeopathy became a popular treatment in America. With molecular biology and its information about antibodies still things of the future, homeopathy was a hit-and-miss approach and has been dismissed by modern science, though it remains a popular form of alternative medicine. By the 1840s, it had temporarity lost some ground to another German import, hydropathy, or the water cure. Developed by the Prussian

farmer Vincent Priessnitz in 1829, hydropathy was a modern version of the ancient belief that water cured many diseases. American proponents of Priessnitz's theories utilized numerous forms of water therapy, including hot and cold baths, douches, spitz baths, swims, and gargles. Although unorthodox, water therapy had links to the medical mainstream, since those who used it often wrapped themselves tightly in damp blankets that eventually created pus-oozing boils (analogous to the blisters of heroic medicine) that were thought to rid the body of impurities.

The water cure achieved great popularity in the two decades after 1840, when hydropathic homes like those in Brattleboro, Vermont, and in Long Island's Oyster Bay were established. Along with the full range of hydropathic treatments, these centers offered a strict regimen of diet, exercise, and sleep. Harriet Beecher Stowe, Horace Greeley, Julia Ward Howe, and the popular journalist Fanny Fern were among the many who spent months living at hydropathic retreats seeking relief from physical or mental ills. For the faithful, hydropathy was a cure-all. As one believer wrote, "The Water Cure is applicable to all classes and kinds of diseases." And it offered more than just physical therapy. It promised, in the words of the *Water-Cure Journal,* to "hasten the advent of UNIVERSAL HEALTH, VIRTUE, AND HAPPINESS."

Botanic medicine took off under the New Hampshire–born Samuel Thomson, who believed that illness came from cold. Thomson advised treatments that increased the body's heat, such as steam baths. Thomsonianism became a major fad. A national convention met in 1832, and many supportive books and magazines appeared. Thomson mixed botanical medicines in different strengths that he numbered from one to six. He used seventeen herbs, mainly cayenne peppers and the patent-medicine emetic lobelia (aka pukeweed or vomitwort). Through thousands of agents he sold patents. By 1840 he claimed that three million people owned rights to his products. After his death in 1843, the craze merged with the herbal movement known as eclectic medicine.

When herbal remedies came up short, Americans could try the more mystical approaches offered by mesmerism and phrenology. The

late-eighteenth-century Viennese physician Franz Anton Mesmer had posited a universal electrical fluid that permeated the universe and connected all humans. Certain people, called operators, used their electrical "odic force" to perform marvels and control others. By the 1830s, mesmerism (or animal magnetism) swept America when Charles Poyen of France and England's Robert Collyer toured the nation giving demonstrations of their mesmeric abilities. Soon they were outdone by American mesmerists like Charles Bovee Dods and Andrew Jackson Davis, who stunned large audiences illustrating their apparently miraculous powers. When in a mesmeric trance, Davis, the so-called Poughkeepsie Seer, could see through walls, scan distant countries, travel through time, and gaze into people's bodies to spot diseases. He was one of many mesmerists who claimed the ability to heal. The British author Harriet Martineau and Nathaniel Hawthorne's wife Sophia were among those who regularly consulted mesmeric healers. (Hawthorne, skeptical of fads, retaliated with his negative portrait of the satanically magnetic pseudoscientist Roger Chillingworth in *The Scarlet Letter*.) By the 1840s, mesmerists hung out signs in American cities, inviting patients with promises of MESMERIC EXAMINATIONS, DISEASES EXAMINED BY A CLAIRVOYANT HERE, and DISEASES CURED BY MESMERISM HERE.

Phrenology was the pop psychology of the day. Modern neuroscience identifies areas of the brain that control specific functions and emotions. Phrenology did so too, but with a precision that was misleading. Having originated in 1800 in the "cranioscopy" of the Austrian anatomist Franz Josef Gall, phrenology held that there were thirty-seven so-called brain organs, each of which governed a trait or impulse, such as amativeness (sexual desire), adhesiveness (comradely affection), ideality (the religious instinct), combativeness, self-esteem, benevolence, and so on. The size of each organ was supposedly registered on the contours of the skull, creating bumps that revealed character. A large bump of amativeness, for instance, indicated an especially strong sex drive. A particular organ could become inflamed, or unduly excited, creating psychological imbalance. The phrenologist claimed the ability to read a

person's character by feeling the skull and assigning numbers from one to seven to each bump, according to its size. Therefore, someone with sevens in ideality and benevolence combined with a two in combativeness was likely to be a gentle, intensely religious person. Besides throwing light on the character, phrenology was designed for healing mental illness. If one knew that a particular bump was too large or inflamed, he or she could use willpower to suppress the corresponding impulse. For instance, when Walt Whitman, who published Lorenzo Fowler's reading of his skull several times, found that his adhesiveness was "diseased, feverish, disproportionate," he warned himself to "Depress the adhesive nature" in order to gain "a superb calm character."

Whitman's close friends, the New York brothers Orson and Lorenzo Fowler, were chiefly responsible for popularizing phrenology in America. The nation had grown excited in 1832 when Gall's pupil Johannes Gaspar Spurzheim toured the United States demonstrating phrenology. As Harriet Martineau reported, "When Spurzheim was in America, the great mass of society became phrenologists in a day, wherever he appeared." Four months into the tour he died, but he was followed by the Scottish phrenologist George Combe, who visited America in 1838–40. Meanwhile, the cause was taken up fervently by the Fowlers. Lorenzo Fowler lectured widely, examined thousands of skulls, and in 1836 opened his famous Phrenological Cabinet in Manhattan, where he exhibited the plaster heads of famous and unknown people. Orson wrote prolifically. The brothers joined with the businessman Samuel R. Wells to form a publishing firm, Fowlers and Wells, which issued scores of books promoting all the fads and reforms of the day. Among their many volumes were the first two editions of Walt Whitman's *Leaves of Grass*, containing poetry full of images from these crazes.

The interest of the Fowlers and Whitman in bringing together the various crazes shows a general melding of previously distinct reforms. In the 1840s, phrenology merged with mesmerism in phreno-magnetism, which in turn fed into a popular cosmology known as Harmonialism. In 1848 came spiritualism, which fostered a generation of séances and

Phrenological Map of the Head

spirit-rappers. The eclecticism of the reform scene is revealed by typical titles of popular books issued by Fowlers and Wells in the decade after 1842: *Elementary Principles of Mesmerism or Animal Magnetism; Phrenology Proved, Illustrated, and Applied; Hydropathy for the People; The Philosophy of Electrical Psychology; Water and Vegetable Diet; The Great Harmonia; Cholera Conquered; Intemperance and Tight Lacing;* and *The Water-Cure in Chronic Diseases.*

The popular "isms" cultivated a self-help instinct that persisted in the American psyche through the late nineteenth century, with the New Thought movement, on through the twentieth century, with its phases of occultism, astrology, and transcendental meditation, to the vitamin shops and many types of alternative medicine today.

A less desirable result of the pre–Civil War pseudosciences was the racism they reinforced. Racial prejudice was already deeply embedded in the

North as well as in the South. Phrenology and one of its heirs, ethnological science, supplied alleged physical evidence that existing racial stereotypes were accurate. Popular periodicals often juxtaposed phrenological pictures of allegedly typical skulls of Caucasians, Asians, Native Americans, and Africans, along with descriptions of the traits each skull exhibited. Inevitably, the Caucasian head was said to manifest positive qualities like intelligence and refinement, while the African supposedly showed brutishness and stupidity. Ethnographers were soon predicting the eventual disappearance of so-called inferior races because of their inherent weaknesses. Even the otherwise democratic Whitman, who accepted this ethnographic view, declared, "The nigger, like the Injun, will be eliminated: it is the law of races, history, what-not: always so far inexorable—always to be." In the Age of Jackson, such pseudoscientific views were used to justify slavery and the maltreatment of Native Americans.

Despite such pernicious attitudes, the pseudosciences were part of the fertile mix that produced this period's cultural renaissance. The imaginative vigor that marked the Age of Jackson, sometimes misdirected in the pseudosciences, found positive expression among writers, artists, and performers.

6

Rebellion and Renaissance

The years from 1815 to 1848 produced American masterpieces, many of which had a worldwide impact. In literature, this period witnessed the greatest writings of Washington Irving, James Fenimore Cooper, Edgar Allan Poe, Ralph Waldo Emerson, Margaret Fuller, and Frederick Douglass. The Fireside Poets—William Cullen Bryant, John Greenleaf Whittier, James Russell Lowell, Henry Wadsworth Longfellow, and Oliver Wendell Holmes Sr.—established themselves as the nation's most popular writers of verse. Many others—among them Henry David Thoreau, Nathaniel Hawthorne, Herman Melville, Walt Whitman, and Harriet Beecher Stowe—served literary apprenticeships, preparing for that concentrated moment of literary expression (1850 to 1855) that the critic F. O. Matthiessen called the American Renaissance. In art, America reached indigenous expression in the early Hudson River School and genre painting. Performance culture saw the rise of characteristically American styles in music and theater. Culturally, these years were among the richest in American history.

American literature in the decades just before the Civil War is traditionally divided between so-called light or optimistic authors—such as Emerson, Thoreau, and Whitman—and dark or gloomy ones, including Poe, Hawthorne, and Melville. Emily Dickinson, who was shaped during this period, occupies a middle ground, shifting between the light and the dark. Optimistic themes included nature's miraculous beauty,

spiritual truths behind the physical world, and the potential divinity of each individual. Pessimistic ones included haunted minds, perverse or criminal impulses, doubt, and ambiguity. Americans probed these themes with special intensity, largely because of the nation's Puritan heritage. Calvinist preachers from John Cotton through Jonathan Edwards had devoted their lives to probing ultimate questions about death, God, and human nature. When this metaphysical impulse collided with nineteenth-century skepticism and secularism, the result was literature that ranged from the exhilarating to the profoundly disturbing, from Emerson's *Nature* to the gloomy fiction of Hawthorne and Melville.

The light/dark division, though generally accurate, inadequately describes American literature. After all, European Romanticism saw a similar divide between optimism and pessimism. What was distinctive about the American literary scene?

Cultural flowering reflects larger forces in society and politics. "Great geniuses," Melville wrote, "are parts of the times; they themselves are the times, and possess a correspondent coloring." The poet, Walt Whitman argued, is "the age transfigured." Emerson pointed out in *Representative Men*: "The ideas of the time are in the air, and infect all who breathe them. . . . We learn of our contemporaries what they know without effort, and almost through the pores of our skin." History is the crucible that produces masterpieces.

Jacksonian America brimmed with populist forces that were also present in Europe but that gained special potency when unleashed in the rapidly burgeoning democracy. Andrew Jackson set off cultural waves that rippled right up to the Civil War and beyond. In popular culture, his raw spirit helped nurture the radical democracy of the penny press, the brashness of frontier humor, and the volcanically subversive bestsellers of George Lippard and others. For the era's creative geniuses, Jackson was an intriguing amalgam of qualities. The great literature and art of the day—from Emerson's essays through Melville's *Moby-Dick* and Whitman's *Leaves of Grass* to the paintings of Cole and Durand—resonated with the powerful energies that Jackson helped

fuel. In fact, this period can arguably be divided culturally into the pre-Jacksonian and Jacksonian phases. The dividing point between the two phases occurs around 1828, the year Jackson was first elected president and became a truly symbolic, and controversial, hero of the people.

Before then appeared several of the best works by Irving and Cooper. After then came writings by authors destined to make a greater mark on the world scene. Poe produced two volumes of poems in the late 1820s, followed by another in 1831, the novel *Narrative of Arthur Gordon Pym* in 1838 and *Tales of the Grotesque and Arabesque* in 1840, then *Prose Romances* (1843), *The Raven and Other Poems* (1845), and *Eureka* (1848). Emerson spearheaded the Transcendentalist movement in New England with the 1836 publication of his pamphlet *Nature*, followed by his *Essays: First Series* (1841), *Essays: Second Series* (1844), and *Poems* (1846). Emerson's friend Thoreau lived for two years at Walden Pond in the 1840s and began giving lectures on his experience in 1847. Hawthorne's first novel, *Fanshawe*, appeared in 1828. He then wrote tales for periodicals that were collected in *Twice-Told Tales* (1837) and came out with a second short-story volume, *Mosses from an Old Manse*, in 1846, preparatory to his phase of major novels that began in 1850 with *The Scarlet Letter*.

Before 1828, American writers, although they often experimented with American themes and characters, still wrote in a style that typically showed a strong European influence. This transnational influence never died away—indeed, American writers after 1828 were *more* responsive to it than the earlier ones had been—but it mingled with the styles and idioms of an emerging popular culture that was distinctively American. After 1828, with the increasingly sharp divide between the Jacksonians and their opponents, writers were confronted with the choice between competing styles: one pointing to democratic passions, average Americans, and working-class sympathies, and the other to a more elitist conception of culture, which meant sustaining subtle European techniques while shying away from the so-called vulgar emotionalism and unleashed imaginativeness associated with Jacksonianism.

In popular culture, the conflict between the two approaches culminated in 1849 in the Astor Place Riots, in which opposing acting styles—the flamboyant one of the American actor Edwin Forrest and the restrained, subtle one of the British visitor William Charles Macready—sparked deadly class conflict. Long before Astor Place, America felt the building tension between what were seen as the Democratic and the Whig styles. This tension contributed to the richness of American literature of this period.

Stirrings of the tension appeared in the careers of two Americans who first established themselves in the pre-Jacksonian phase, Irving and Cooper. With the 1820 publication of *The Sketch Book of Geoffrey Crayon, Gent.*, which contained his stories "Rip Van Winkle" and "The Legend of Sleepy Hollow," Irving became a literary celebrity at home and abroad. Also in the 1820s, Cooper made his first mark on the world literary scene. Having read a novel by the British writer Jane Austen, he casually bet his wife that he could write an even better one. He published *Precaution* in 1820 and went on to publish several more novels in the decade, including *The Pioneers* and *The Last of the Mohicans*.

Both Irving and Cooper left America for Europe during the pre-Jacksonian period, spent a long time abroad, and returned during the Jacksonian phase, discovering profound cultural changes. The America they had left was, in their view, stable, structured, and agrarian, harking back to the traditional world of the founding fathers. The America they found upon returning in the 1830s was, they thought, crass, materialistic, unstable, ever-shifting, and characterized by the passions of mobs. Both authors protested against these changes.

Irving in his classic story "Rip Van Winkle" had anticipated the tensions that both he and Cooper felt when confronted with the transformation of American society. In the story, a shiftless farmer in the era before the American Revolution goes hunting and falls asleep in the woods. When he awakes, he discovers that two decades have passed. He returns to his village to find that "The very character of the people seemed changed. There was a busy, bustling, disputatious tone about it,

instead of the accustomed phlegm and drowsy tranquillity." The old Rip feels out of place in this new world, which seems like bedlam to him, though he settles into it, becoming a reminder of an older, quieter time.

Irving himself became America's chief literary reminder of an older time. In his anti-Jefferson satires in *Salmagundi* (1807–08) and *A History of New-York . . . by Diedrich Knickerbocker* he had proved himself "the arch-Federalist in American literature," as Henry Seidel Canby puts it. In *The Sketch-Book* (1820) and *Bracebridge Hall* (1822), he praised the stable institutions, hoary ruins, and embedded customs of England. As *Fraser's Magazine* said, "The literary labours of Washington Irving will always find a ready way to the understandings and hearts of Englishmen." He was so attracted to Europe that he went to live there for seventeen years. When he returned home in the 1830s, he found America very different from when he left it. Now there was party conflict, political demagoguery, newspapers filled with racy news—all confusing and disconcerting to Irving. He became employed as an emissary abroad, serving as chargé d'affaires to London under Jackson and minister to Spain under Tyler. He wrote histories of the American and European past. Believing in an aristocratic society based on settled institutions, he had trouble coping with industrialism and capitalism. Late in life he said he would love to build European chateaux in America, "but I would first blow up all the cotton mills . . . and make picturesque ruins of them; and I would utterly destroy the railroad; and all the cotton lords would live in baronial castles."

Cooper in his five Leatherstocking novels tried to impose order and morality on the American frontier experience. His frontier hero, Leatherstocking (or Natty Bumppo), embodies decency and common sense. He contrasts with a variety of less rational characters, ranging from the impulsive Hurry Harry of *The Deerslayer* to money-grubbing settlers with wasteful ways. Cooper highlights the innate intelligence and morality of some Native Americans, although he never was able to shed the racist view that Indians, like blacks, were fundamentally inferior to whites. Cooper's model is Judge Marmaduke Temple, who appears in

The Pioneers (1823). The just, wise ruler of the town of Templeton who is respected by others, he is based on Cooper's Federalist father, William Cooper, the landowner who founded Cooperstown, New York.

Like Irving, James Fenimore Cooper experienced a jolt on returning home from a foreign tour. When after seven years in Europe he came back to America in 1833, he found a society devoted to money, political partisanship, and democratic leveling. For the remaining eighteen years of his life, he tried to resurrect the agrarian-republican world of his patriarchal father by writing novels and nonfiction in which he satirized contemporary America and praised laws and customs based on the traditions of the propertied elite. He was a Democrat but was not fully satisfied with either party. He defended slavery and opposed universal manhood suffrage. He criticized those in upstate New York who were resisting new demands made on them by property owners to pay rent on lands they had long enjoyed for little or no money. In his anti-rent trilogy of 1845–46—*Satanstoe*, *The Chainbearer*, and *The Redskins*—he ridiculed democratic mobs and praised conservative property owners as prudent and ethical. America, he declared, was fast becoming a "country with no principles, but party, no God, but money, and this too with very little sentiment, taste, breeding, or knowledge." What was needed, he thought, was a return to the old republican notion of the gentleman-leader, who was "the natural repository of the manners, tastes, tone, and . . . principles of a country."

Whereas Irving and Cooper tried to resist the cultural changes brought by Jacksonian democracy, other writers embraced them. The 1830s not only witnessed the rise of conflicting political parties, the Democrats and the Whigs. They also saw changes in both popular culture and elite culture in America. On the popular level, the decade brought the penny newspapers, which caused a revolution in reading for the masses. It also brought show business, in the person of P. T. Barnum, as well as popular reform movements and pseudosciences. On the elite level, the decade brought Hawthorne's cryptic tales, Poe's well-crafted poetry and fiction, and the philosophical essays and lectures of the Con-

cord Transcendentalists. Popular and elite culture interpenetrated and fed off each other. This was an era before cultural stratification—before the separation between what later would be called lowbrow and highbrow. The celebrated writers of the American Renaissance combined the popular and the elite, as they did the visions of the Democrats and the Whigs.

Popular culture came into its own in the 1830s, taking on dimensions that have lasted until this day. A signal event was the establishment of penny newspapers in 1833. Horatio David Smith's *New York Morning Post* and Benjamin H. Day's *New York Sun*, founded that year, were the first of the penny papers. Soon every major American city had one or more of them. Previously, the typical American newspaper had sold for the relatively high price of six cents and had confined itself to political news. Changes in printing technology permitted rapid production of cheaper newspapers designed for the masses. The steam-powered press, the cylinder press, and the rotary press allowed enterprising American publishers to satisfy the public's demand for news that was often racy and sensational.

A MYSTERIOUS DISAPPEARANCE, a DOUBLE SUICIDE, INCEST BY A CLERGYMAN, or an AWFUL ACCIDENT—anything zestful or intriguing was considered fit to print. James Gordon Bennett, the editor of the leading penny paper, the *New York Herald*, found that Americans "were more ready to seek six columns of the details of a brutal murder, or the testimony of a divorce case, or the trial of a divine for improprieties of conduct, than the same amount of words poured forth by the genius of the noblest author of our times." Emerson commented that many Americans spent their time "reading all day murders & railroad accidents" in the penny newspapers. Whitman, who was weaned in New York journalism, noted that foreign papers had a superior tone to American ones and confessed, "Scurrility—the truth may as well be told—is a sin of the American newspaper press."

The popularization of the press brought about a surge in newspaper production. In 1828 there were 861 American newspapers; by mid-century, the number had tripled. Newspaper circulation leapt from

68 million in 1828 to nearly 150 million a dozen years later. Poe claimed that the influence of the penny papers was "probably beyond all calculation."

The newspaper world was rough-and-tumble, to say the least. Editors lambasted each other and often came to blows. When in 1835 James Gordon Bennett, editor of the *Herald*, charged Benjamin Day of the *Sun* with being an infidel, Day replied that Bennett's "only chance of dying an upright man will be that of hanging perpendicularly upon a rope." In January 1836, another editor, James Watson Webb, thrashed Bennett for twenty minutes with a cowhide whip on Wall Street as crowds cheered. Benjamin Day rubbed in the disgrace by saying that had Webb chosen a dog, a polecat, "or any other decent animal" to punish, he would understand, but he couldn't comprehend how Webb could "have so far descended from himself to come into public contact with the veriest reptile that ever defiled the paths of decency." When Webb again assaulted Bennett shortly thereafter, Day wrote gleefully: "Upon calculating the number of public floggings which that miserable scribbler, Bennett, has received, we have pretty accurately ascertained that there is not a square inch of his body which has not been lacerated somewhere about fifteen times. In fact, he has become flogging property; and Webb has announced his intention to cowskin him every Monday morning until the Fourth of July, when he will give him a holiday."

In September 1838, Webb challenged a Democratic politician, Jonathan Cilley, to a duel. When Cilley refused, Webb sent a representative who succeeded in getting a duel, killing Cilley on the third shot. Webb was again in the shooting mood in 1842, when he fought a duel with a Kentucky congressman and was wounded, imprisoned, and later pardoned. Even the relatively mild-mannered *Evening Post* editor William Cullen Bryant was driven to violence; he once swung a cow whip at the *Commercial Advertiser*'s William Leete Stone in front of City Hall. Stone grabbed the whip and began thrashing Bryant until he was pulled away by spectators.

The penny papers feasted on such quarrels. Bennett actually courted

insults, since he knew they gained publicity. There was a standing joke that if you horsewhipped Bennett he would "bend his back to the lash and thank you; for every blow is worth so many dollars." And there were plenty of other sensational stories for the penny papers to report, including the Maria Monk scandal, involving the alleged ex-nun who reported whoredom and infanticide in a Montreal nunnery; the great New York fire of December 1835, which destroyed twenty blocks of buildings in the city's downtown area; the trial of Richard Robinson for the murder of the prostitute Helen Jewett; and the diverting case of the hot-tempered teacher John C. Colt, who in September 1841 axed to death the printer Samuel Adams and then stuffed the corpse into a crate later found in the hold of a New Orleans–bound ship. By the 1840s, many urban writers— among them George Lippard, A. J. H. Duganne, George Thompson, and E. Z. C. Judson (aka Ned Buntline)—were producing sensational novels, embellishing penny-press stories in urban-gothic thrillers about the so-called mysteries of American cities.

When juicy stories were lacking, the penny papers invented them. The most famous example was the moon hoax, a story that ran in the *Sun* in the summer of 1835 and was widely reprinted. Capitalizing on the public's growing interest in curiosities, the reporter Richard Adams Locke wrote as fact the story of a powerful telescope through which a scientist, Sir John Herschel, could see society on the moon, featuring talking man-bats, a golden temple, blue unicorns, biped beavers, and odd birds and trees. Locke reported the daily activities of the man-bats, who were winged, red-haired creatures with arms, legs, and monkey-like yet intelligent faces. The public gobbled up this fantastic story, sustaining interest in it even after it was revealed as false. Poe called the moon hoax "decidedly the greatest *hit* in the way of *sensation*—of merely popular sensation—ever made by any similar fiction either in America or Europe."

Poe's wording here—Locke's story was a "merely popular sensation"— speaks volumes about Poe, the one American of the period who produced sensational writings with lasting appeal.

Poe lived in the cut-and-thrust world of popular journalism. He once challenged a rival, William Lummis, to a duel, and he got into a fistfight with the poet Thomas Dunn English, who pummeled him so badly that Poe spent several days in bed. As an author or editor who worked for several magazines and newspapers in major American cities, Poe knew well the public's thirst for the sensational. He published several hoaxes, like his April 1844 "Balloon Hoax" for the *Sun*, which under the title "Astounding Intelligence . . . The Atlantic Ocean Crossed in Three Days!!" described the alleged transatlantic voyage of a gas balloon that flew from London to South Carolina in three days. Poe felt that "it is . . . the excitable, undisciplined and childlike popular mind which most keenly feels the original." His tales teem with bizarre or macabre images: live burial, bloody murder, sadism, necrophilia, and so forth. Many of them were originally published in the popular press.

But Poe was a sensational writer with a difference. He avoided what

Edgar Allan Poe

he dismissed as "merely popular sensation." It is useful to compare him to his Philadelphia friend George Lippard, the era's most popular author of sensational novels. Lippard's best seller *The Quaker City; or, The Monks of Monk Hall*, the most popular American novel of the 1840s, brims with violence and demonism. Its labyrinthine plot contains as many perverse moments as a score of Poe's tales. Poe admired Lippard's fiction but found it undisciplined. Regarding another of Lippard's blood-soaked thrillers, *The Ladye Annabel*, Poe said it was "indicative of *genius*" but caviled, "You seem to have been in too desperate a hurry to give due attention to details."

As a reviewer, Poe commented on all sorts of fiction and poetry, from the sensational to the moralistic. Popular literature of the day was divided between conventional, sentimental-domestic literature and adventurous or sensational fiction. Poe attacked works on both extremes. He denounced what he called "the heresy of *The Didactic*." Imaginative literature must not preach; that was the province of nonfictional writing. At the same time, Poe criticized what he regarded as the excesses of popular sensational fiction. He had no toleration for the common character type of the likable or justified criminal—the evildoer shown in a positive light. For instance, he wrote that his "principal objection" to Joseph Holt Ingraham's *Lafitte: the Pirate of the Gulf*, was that its hero was "a weak, a vaccillating [*sic*] villain, a fratricide, a cowardly cut-throat, . . . Yet he is never mentioned but with evident respect." Nor did he approve of fiction that harped at length on gore or physical suffering. He charged the novelist William Gilmore Simms with "villainously bad taste" for describing the "minutest details of a murder committed by a maniac" who suffocates his victim in mud, an act "dwelt upon by Mr. Simms with that species of delight with which we have seen many a ragged urchin spin a cockchafer [i.e., a may bug] on a needle." Simms, wrote Poe, shows "a certain fondness for the purely disgusting or repulsive, where the intention was or should have been merely the horrible."

Poe's own tales are uniquely horrific but removed from "the purely

disgusting or repulsive." The narrators of his murder stories are so clearly insane or deluded, as in "The Black Cat" or "The Cask of Amontillado," that they thrill us without winning our sympathy. The sadism and perversity of which they are guilty is communicated not through extensive descriptions of blood but through portraits of their diseased psychology. Unlike Lippard or Simms, Poe at his best brings order and control to the horrific or sensational. He carefully sculpts terror, using controlling devices such as the first-person narrator, understatement, and singleness of effect. His invention of the detective genre stems from his effort to apply logic and intuitive reason to crimes of the sort that were commonly reported in the penny press. In poetry, his careful regulation of rhyme, meter, and other techniques, famously described in "The Philosophy of Composition," structures emotion even in poems of wild passion like "The Raven." Another controlling device is geographical distancing, by which he chooses foreign cities as settings even for sensational events based directly on reports in the American penny papers—as in "The Mystery of Marie Roget," his Parisian take on the widely reported murder of the New York cigar saleswoman Mary C. Rogers. His fascination with codes, cryptograms, puns, and the like show his overriding concern with various kinds of logic.

His response to excessive sensationalism parallels his politics. Orphaned at an early age, he was raised in luxury by the Virginia merchant John Allan. Poe's erratic lifestyle caused a falling out with Allan, but Poe never lost the sense that he had an aristocratic heritage. He became a Southern Whig, and he stood opposed to what he saw as the flattening effect of Jacksonian democracy. In "Mellonta Tauta" he described "a fellow by the name of *Mob*" as a horrible despot, "a giant in stature—insolent, rapacious, filthy; had the gall of a bullock with the heart of an hyena and the brains of a peacock." "Democracy," he writes, "is a very admirable form of government—for dogs." "The queerest idea conceivable," Poe writes, is that "all men are born free and equal—this in the very teeth of the laws of *gradation* so visibly pressed upon all things both in the moral

and physical universe." According to these laws of gradation, certain individuals naturally separate themselves from the crowd. Just as certain races were superior to others, in Poe's view, so genius towered above mediocrity.

To this extent, he stood opposed to the populist impulses of Jacksonian democracy. Mobs and crowds in Poe's stories are negative symbols. In "The Man of the Crowd" a bustling city crowd made up of all social classes becomes a symbol of depressing anonymity and anomie; Poe's narrator spends a day following around a thin old man who find it impossible to separate himself from the crowd—Poe calls him "the type and the genius of deep crime. He refuses to be alone." The man is, in a sense, the typical Jacksonian, absorbed into the masses. For Poe, he is a terrifying example of the loss of individuality threatened by the rise of the modern masses.

Poe, then, was in the ambivalent position of a writer completely immersed in the popular culture of Jacksonian America and yet in some ways repelled by it. His relation to popular culture paralleled his relation to alcohol: he was dependent on it, yet he struggled to separate himself from it. Several times he joined temperance groups and had periods of sobriety, but he regularly backslid, and his habit contributed to the downward spiral that led to his death at forty, possibly after an alcoholic binge. In his writings, he swung between vilifying popular tastes and catering to them. He was simultaneously the alienated genius and the panderer to the mass audience. As magazine editor, fiction writer, and poet, he knew he had to emphasize the sensational themes that captivated popular readers. He borrowed freely: "The Cask of Amontillado," for instance, was indebted to "A Man Built in a Wall," a grisly magazine tale by Joel Tyler Headley. Poe declared that "the truest and surest test of *originality* is the manner of handling a hackneyed subject." He hated popular themes when they were handled ineptly, without control. By asserting such control in his own works, he produced enduring literary art.

Two other writers who had a complex relationship to Jacksonian America were Emerson and Thoreau. Like Poe, they felt in some ways distanced from the masses. But also like him they were extremely re-

sponsive to many strands in popular culture. If he was especially attentive to sensationalism, they had a particularly close eye on popular humor and reform movements.

The Boston-born Emerson, the son of a Unitarian minister, had attended Harvard, where he graduated in the middle of his class in 1821. He taught school for a time, then studied theology. In 1826 he entered the Unitarian ministry, earning a pastorship at Boston's Second Church three years later. He absorbed the optimistic spirit of Unitarianism, with its belief in human perfectibility and God's fairness. But he mistrusted Unitarian rationalism, and he could not accept Christian rituals literally. In 1832, because of his doubts about the Lord's Supper, he left the ministry.

His extraordinary maturation in the 1830s is usually linked to his tour through Europe, where he met many of the leading Romantics, and to his reading of foreign literature. Indeed, his essays and lectures are full of foreign-based concepts. His distinction between reason (the creative imagination) and understanding (intellect) comes from Coleridge. His system of correspondences, which sees the physical as a symbol of the spiritual, derives from the Swedish thinker Emanuel Swedenborg. His interest in idealism and subjectivity was influenced by Kant, his idea of heroic individualism by Carlyle, his devotion to figurative language by European poetry, his mysticism by Asian religions, and so on. In September 1836, he joined around a dozen others, mainly Unitarian ministers, in the founding of the Transcendental Club, which met for a number of years for free-flowing discussions. The group came to include Frederick Henry Hedge, Bronson Alcott, Convers Francis, Orestes Brownson, Theodore Parker, Margaret Fuller, George Ripley, James Freeman Clarke, and others. Although no topic was excluded, the conversations— or, in the cases of Alcott and Fuller, the monologues—centered largely on Romantic philosophy and literature. Emerson was stimulated by this ongoing exposure to world philosophy. His own writings are profoundly transnational.

But they are also indelibly American. In fact, Emerson distin-

guished himself from the others by his special sensitivity to the American scene. Like Poe, he was both repelled and attracted by Jacksonian America. Emerson associated Jackson with filth, the common crowd. "[W]e shall all feel dirty if Jackson is reelected," he wrote in 1832. His antipathy toward Jackson came out in a journal entry on "ANIMALS" in which he wrote, "The favorite word & emblem of the Jackson Party is a Hog." The urban masses, many of them newly arrived immigrants courted by the Democrats, had little appeal for him. His journals contain slurs on indigent Irish as well as snide outbursts like this: "Masses! the calamity is the masses!" He said of America, "'Tis a wild democracy; the riot of mediocrities and dishonesties and fudges." In a sour moment in the 1840s, he wrote, *Manifest Destiny, Democracy, Freedom*, fine names for an ugly thing. They call it otto of rose and lavender,—I call it bilge-water."

For Emerson, "Jacksonism" was associated with common people, average life, wildness, and expansiveness, while the Whig Party suggested culture, control, refinement, and eloquence. The Democrats were "low," the Whigs were "the Best." But that didn't make the Whigs a more valuable example for American writers. "Good is promoted by the worst," he wrote; he compared Andrew Jackson to low things like "an insect that fertilizes the soil with worm casts" and a "scavenger buzzard that removes carrion," performing "a beneficence they know not of." Elsewhere Emerson commented, "The Best are never demoniacal or magnetic but all brutes are. The Democratic party in this country is more magnetic than the Whig. Andrew Jackson is an eminent example of it. . . . The lowest angel is better. It is the height of the animal."

The lowest angel is better. That made Andrew Jackson "better" than the Whigs Emerson often praised, such as Daniel Webster, William Ellery Channing, Edward Everett, and so on. Or, rather, what Jackson stood for was better than what they stood for. Of "the two great parties" in America, Emerson wrote, "I should say, that, one [the Democratic] has the best cause, and the other [the Whig] contains the best men."

The Democrats had the best cause because they seemed closer to the

people and more truly American than the Whigs. In 1834 Emerson complained that American writers were Anglophile. "We all lean on England," he wrote; "scarce a verse, a page, a newspaper but is writ in imitation of English forms." He found relief in Jackson's forceful rhetoric: "I suppose the evil may be cured by this rank rabble party, the Jacksonism of the country, heedless of English & of all literature—a stone cut out of the ground without hands—they may root out the hollow dilettantism of our cultivation in the coarsest way & the new-born age may begin again to frame their own world with greater advantage."

Emerson was inviting American writers to mine common, everyday language the way that Jackson represented average people. Despite his complaints about the masses, in his rides around Boston he liked to frequent the rough North End areas of Ann Street, Charter Street, and Prince Street, where he could observe the unrestrained behavior of common workers, so different from the stiff elegance of Washington and Tremont Streets. Just as Vladimir Nabokov, to prepare for *Lolita*, spent hours on upstate New York buses listening to the slang-filled chatter of teenagers, so Emerson thought that the American writer's best school was the street. "If you would learn to write," he said, "'tis on the street you must learn it. Both for the vehicle and for the aims of fine arts you must frequent the public square."

Not only slang but also swearing held an attraction for him: "I confess to some pleasure in the stinging rhetoric of a rattling oath in the mouths of truckmen & teamsters. How laconic & brisk it is by the side of a page from the North American Review . . . Always this profane swearing & barroom wit has salt & fire in it." He thought that genteel American writers lacked such street-generated vigor. He insisted that writers like Irving, Bryant, and Webster "all lack nerve & dagger."

He opened himself to the lively idioms of American popular culture. Tocqueville noted that Americans "often mix their styles in an odd way," as "the continual restlessness of democracy leads to endless change of language," producing what I have called the American subversive style, characterized by weird juxtapositions of images and by

rapid shifts in time, place, or perspective. Emerson got a lesson in creative style, for example, from the Methodist preacher Edward Thompson Taylor of the Seamen's Bethel Church in Boston. A flamboyant evangelical performer with a salty sense of humor, Taylor epitomized the imaginative sermon style of the Second Great Awakening. "Taylor's muse," Emerson wrote, was "a panorama of images from all nature & art." Calling him "the Shakespeare of the sailor & the poor," Emerson commented that Taylor "rolls the world into a ball & tosses it from hand to hand." He loved in Taylor "the ridicule of all method, the bright chaos come again of his bewildering oratory" and "the wonderful laughing life of his illustrations," making his sermons "a perfect Punch & Judy affair."

Emerson also admired the energy and originality of frontier humor. The decades when Emerson discovered himself were also the time that brought humorous publications featuring the "screamer" or "ring-tailed roarer," the loud backwoods braggart who spouted streams of strange metaphors. In popular writings, the legendary frontier roarer Mike Fink was introduced in 1821, followed in 1830 by Davy Crockett, Nimrod Wildfire, and Jack Downing, by Mark Forrester in 1834, by Horse-Shoe Robinson in 1835, and by Roaring Ralph Stackpole in 1837. This was also the time when backwoods humorists like James H. Hackett and George Handel Hill made goodly sums from telling tall tales to lecture audiences nationwide. Beginning in 1835, some fifty issues of yellow-covered pamphlets called the Crockett almanacs were published, each enjoying a lively sale.

Emerson saw such humor as a source of style. Giving examples of lively imagery from the popular humor character Jack Downing, he declared, "It is this which gives that piquancy to the conversation of a strong natured farmer or backwoodsman which all men relish. It is the salt of those semisavages, . . . who bring out of the woods into the tameness of refined circles a native way of seeing things, and there speak in metaphors." He described the future of American letters: "Our eyes will be turned westward, and a new and stronger tone in our litera-

ture will be the result. The Kentucky stump-oratory, the exploits of [Daniel] Boone and David Crockett, the journals of the western pioneers, agriculturalists, and socialists, and the letters of Jack Downing, are genuine growths, which are sought with avidity in Europe, where our European-like books are of no value."

Frontier humor and Emerson's writings were different products of exaggerated American individualism. In the hyperbolic democracy of frontier humor, all aspects of reality are dissolved and recombined at will by the imagination that reduces all things to the same level: Davy Crockett, for instance, can ride a streak of lightning or squeeze a bear's blood over the sun with the ease of squeezing dry a washcloth. The images in the Crockett almanacs are shifting and kaleidoscopic, as when a frontiersman is described as "half horse, half alligator, and a touch of the steam boat, . . . and always wolfish about the head."

Emerson's own writings are peppered with lively, sometimes bizarre expressions and metaphors. His pamphlet *Nature* begins with his inspirational yet grotesque image of the seer as "a transparent eye-ball," which the artist Christopher Pearse Cranch caricatured in a funny picture of a spindly-legged eyeball in a top hat and suit. Elsewhere in *Nature*, Emerson talks of travelers trying to roast eggs on the cinder of a volcano, the poet's ability to toss creation like a toy from hand to hand, the imaginative person's ability to visit the most distant regions of time and space, and humans as broken and in heaps. In his lecture "The American Scholar," he refers to humans in society as "so many walking monsters—a good finger, a neck, a stomach, an elbow, but never a man." He also says that "men in the world of to-day are bugs, are spawn," the poor "are content to be brushed like flies from the path of a great person," and that "we are lined with eyes; we see with our feet."

These weird, often violent images continue in the Divinity School Address, where Emerson says that man has become "an appendage, a nuisance," that anything which "shows God out of me, makes me a wart and a wen," and that the Christian notion of miracle "is Monster. It is not one with the blowing clover and the falling rain." In "Self Reliance"

he asks, "Why drag around this corpse of your memory[?]" and de-clares, "A foolish consistency is the hobgoblin of little minds."

Even one of Emerson's most sophisticated ideas, symbolism, relates to Jacksonian America. In "The Poet," to show how symbolic perception is universal, Emerson notes that all people love badges and emblems. He uses Whig and Democratic campaign images to argue that it is not just poets or artists who love symbols: "See the great ball which they roll from Baltimore to Bunker hill! In the political processions, Lowell goes in a loom, and Lynn in a shoe, and Salem in a ship. Witness the cider-barrel, the log-cabin, the hickory-stick, the palmetto, and all the cognizances of party. See the power of national emblems. . . . The peo-ple fancy they hate poetry, and they are all poets and mystics!"

It was partly because of his popular-inspired style that Emerson became a crowd-pleasing speaker. With our interest in Emerson as a philosopher, we sometimes forget that he was a popular lecturer. He and the other Transcendentalists profited from the growth of the lyceum movement. Founded in Millbury, Massachusetts, by the Yale-educated teacher Josiah Holbrook in 1826, the lyceum was an organized network of lectures and seminars that provided diversion and instruc-tion for the masses. The movement arose in the middle of the adminis-tration of John Quincy Adams and flowered under Andrew Jackson and his three presidential successors. Almost every topic imaginable in sci-ence, literature, philosophy, and the arts was covered by the hundreds of speakers who traveled on the lyceum circuit. By the mid-1830s there were some three thousand local lyceum societies, with fifteen statewide organizations and a national lyceum convention.

Emerson became a lyceum star. By the 1850s he was second only to the reformer Wendell Phillips in the lecture fees he could demand. "It is a singular fact," noted the *Atlantic Monthly*, "that Mr. Emerson is the most singularly attractive lecturer in America. . . . Mr. Emerson always draws." The *Springfield Republican* pronounced Emerson "the most widely known, the greatest, and the most attractive of all the present lecturers."

One reason Emerson was more successful on the lyceum circuit than many of his contemporaries was that he enlivened his lectures with native humor. His pungent, ever-shifting images distinguished him from others. His witty, often racy style set him apart from the rarefied prose of Bronson Alcott, the rather stilted wording of Margaret Fuller, the smoothness of Longfellow, or the workmanlike directness of Unitarians like William Ellery Channing and William Ware. Alcott, for instance, admitted, "My thoughts do not easily flow out in popular terms," because he had "little communication with the popular mind"; he envied Emerson's ability to use "pictures of vulgar life, . . . the under as well as the upper vulgar" and to slide easily between the "refined, elegant" and images of "beast, vermin, the rabid mob, the courtesan." Alcott said that in Emerson, "the burlesque is, in a twinkling, transformed into the serious."

As a speaker, Emerson often drove audiences to laughter with his odd images. One reviewer noted, "Mr. Emerson is an inveterate humorist. . . . He gathers up the widest analogies by the armful, and evokes at will the most striking illustrations from nature and history." Another commented on Emerson's "well-known wit, running not infrequently into grotesque conceits" and producing "an irresistible smile, or a shouting peal of laughter."

Humor, of course, was a means rather than an end for Emerson, who gave philosophical depth to images that in popular texts were often merely entertaining. He affirmed creativity, mental independence, idealism, respect for the present hour and the miracle of everyday life, often using weird American imagery but uplifting it and deepening it.

Not only the images but the structure of Emerson's lectures reflected the American experience. Although the typical Emerson lecture has an overall structure, its paragraphs and sentences move fluidly in different directions. Carlyle famously called Emerson's style a "*bag of duck-shot* held together by canvas"; for Lowell it was "a chaos of shooting stars." Even Emerson admitted that he could write "with the most fragmentary result: paragraphs incompressible, each sentence an infinitely repellent particle."

This loose form had cultural meaning. In Emerson's eyes, America itself was teeming, unstructured. In his journal he called America "the ungirt, the diffuse, the profuse, procumbent, one wide ground juniper, . . . formless." Tocqueville noted that in democratic literature "the style will often be strange, incorrect, overburdened, and loose, and almost always strong and bold. . . . There will be a rude and untutored vigor of thought with great variety and singular fecundity."

It was Emerson's specifically American vision that called for a poet who would survey "with tyrannous eye" the overflowing multiplicity of America—"Our logrolling, our stumps and their politics, our fisheries, our Negroes, and Indians, our boasts, and our repudiations, the wrath of rogues, and the pusillanimity of honest men, the northern trade, the southern planting, the western clearing, Oregon, and Texas"—in organic poetry that "has an architecture of its own" without following rules of prosody. When the young Brooklyn carpenter Walt Whitman read these words, he was inspired to write a new kind of American poetry that dispensed with ordinary form and embraced the total range of the American experience. Emerson, in turn, found in Whitman the poet he had called for. He praised Whitman's poetry volume *Leaves of Grass* as "the most extraordinary piece of wit and wisdom that America has yet contributed."

Emerson also responded powerfully to the reform impulse of the day. His notion that each person must follow the inner law, the voice of private intuition, instead of established laws and customs carried to an antinomian extreme the spirit of reform that swept through America. Andrew Jackson, we have seen, promised reform by battling against intrusive governmental and commercial institutions that he thought interfered with the interests of the people. The motto of the pro-Jackson newspaper the *Washington Globe* was the Jeffersonian statement "That government is best which governs least," a conviction Martin Van Buren carried forward by defending limited government.

For Emerson, the Democrats' assault on the government was thrilling.

It re-created the American Revolution, fostering a mood of universal rebellion. He declared:

> In politics . . . it is easy to see the progress of dissent. The country is full of rebellion; the country is full of kings. Hands off! let there be no control and no interference in the administration of the affairs of this kingdom of me. . . . I confess, the motto of the Globe newspaper is so attractive to me, that I can seldom find much appetite to read what is below it in its columns, "The world is governed too much."

Emerson absorbed elements of not only Jacksonian reform but also many other reforms of the day. This radical openness to reform movements distinguished him from Poe, who called reformers *"Believers in everything Odd,"* bonded only by "Credulity:—let us call it Insanity at once, and be done with it." Although Emerson put complete faith in no single political or reform movement, he surveyed many different reforms and caught from them a spirit of rebellion that lay behind his commitment to nonconformity. To elaborate on what he meant by America being full of rebellion, he pointed to many reform movements. He saw healthy questioning in "temperance and non-resistance societies, in movements of abolitionists and of socialists, and in very significant assemblies, called Sabbath and Bible Conventions,—composed of ultraists, of seekers, of all the soul of the soldiery of dissent, and meeting to call in question the authority of the Sabbath, of the priesthood, and of the church."

This widespread devotion to dissent and change underscored for Emerson the power of the individual conscience, which he saw as more powerful than any government. In his words,

> So the country is frequently affording solitary examples of resistance to the government, solitary nullifiers, who throw themselves on their reserved rights; nay, who have reserved all their rights; who reply to the assessor, and to the clerk of court, that they do not know the State; and embarrass the courts of law, by non-juring, and the commander-in-chief of the militia, by non-resistance.

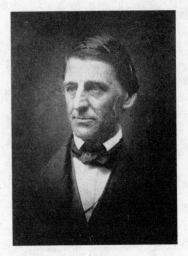

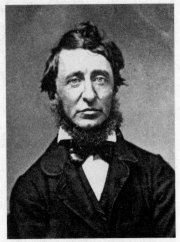

Ralph Waldo Emerson *Henry David Thoreau*

Foremost among the "solitary nullifiers" Emerson praised was his protégé, Henry David Thoreau. Through his individual rebellion, Thoreau resisted both materialism and slavery. The son of a Concord pencil manufacturer, Thoreau attended Harvard in the 1830s and then successively taught school, tutored Emerson's children, and worked in his father's factory, where he helped develop an improved pencil. Although he continued to be affiliated sporadically with the family business, he was uninterested in advancing in it. As he explained, he "tried trade" but "found that it would take ten years to get under way in that, and that then I should probably be on my way to the devil." Convinced that "the ways by which you may get money almost without exception lead downward," Thoreau cast his attention elsewhere and pursued a higher economy. Beginning on July 4, 1845, he lived for over two years in a small cabin by Concord's Walden Pond, an experience he would retell in *Walden* to show how people could simplify their lives by getting back to nature and abandoning superfluities.

In effect, Thoreau was trying to be a one-man plug in the dam that

held back full-fledged capitalism, which was on verge of bursting. The market economy ushered in a sensibility familiar enough today but then new: a single-minded devotion to money and the accumulation of material goods. As production moved outside the home, entrepreneurship and consumerism gripped the nation. With urbanization, what today would be called blue-collar and white-collar jobs both surged. The net value of manufactured goods doubled in the 1840s. The first department store, A. T. Stewart's so-called Marble Palace, opened in New York in 1846 and was soon followed by R. H. Macy, Lord & Taylor, and B. Altman. The economy hit a pace of expansion that would continue almost uninterrupted for decades.

Foreigners who toured America noted the nation's materialism. The Frenchman Michel Chevalier wrote in 1836, "At the bottom of all that an American does is money; beneath every word, money." The British traveler Basil Hall called America "a country where all men are engaged in one and the same engrossing pursuit—namely, that of making money." Frances Trollope cited an Englishman living in America who told her "he had never overheard Americans conversing without the word DOLLAR being pronounced between them"; this created "a sordid tone of mind, and, worse still, . . . a seared and blunted conscience on all questions of probity."

Inequality also increased, producing vehement labor-protest writings, such as Orestes Brownson's 1840 essay "The Laboring Classes" and the fiction and journalism of George Lippard, along with the many utopian socialist experiments of the day. Thoreau created his own private utopian experiment at Walden. If other reformers rejected capitalism by regrouping in communities like Brook Farm and the North American Phalanx, Thoreau did so by building his own shelter and living off the land. Most Americans, he believed, had been diverted from higher goals by focusing on financial gain, often in arduous jobs that robbed them of precious time. He returned to a precapitalist, subsistence lifestyle that permitted him to reflect and write.

In doing so, he outdid other reformers. If the utopian socialists

tried to make labor attractive, he absorbed it into his other interests. If diet reformers like Sylvester Graham espoused vegetarianism, he went beyond them by eating the simplest foods, such as berries, boiled green corn, or bread without yeast. If temperance reformers advised drinking fluids other than alcohol, he kept away from any drink but water, explaining that "I did not use tea nor coffee, nor butter, nor milk, nor fresh meat, and so did not have to work to get them." If health reformers warned of the debilitating effects of sex, he repeated their warning with special emphasis: "The generative energy, which, when we are loose, dissipates and makes us unclean, when we are continent invigorates and inspires us. Chastity is the flowering of man."

Many American reformers of the day, especially peace reformers and abolitionists, enforced their convictions through nonresistance, allowing themselves to be taken to jail to protest against laws or customs they considered immoral. Thoreau did the same. To protest against slavery and the Mexican War, he refused to pay his poll tax for six years, for which he got the brief prison term that he memorably re-created in "Resistance to Civil Government," delivered as a lecture in 1848 and published the next year. In this classic piece, later known as "Civil Disobedience," Thoreau begins with the limited-government concept that Emerson had derived from the Democrats. Thoreau declared, "I heartily accept the motto,—'That government is best which governs least;' and I should like to see it acted up to more rapidly and systematically. Carried out, it finally amounts to this, which also I believe,—'That government is best which governs not at all.'"

The rest of "Civil Disobedience" took this no-government credo to a new kind of antinomianism, one that even Emerson could not have envisaged. Thoreau's message was that the ethical individual was more powerful than the corrupt state. In his words, "There will never be a really free and enlightened State, until the State comes to recognize the individual as a higher and independent power, from which all its own

power and authority are derived, and treats him accordingly." The individual conscience, he maintained, is higher than any human law that can be passed by a government that tolerates so grotesque an institution as slavery.

Although Thoreau set an example of passive resistance that inspired later peaceful protesters like Gandhi and Martin Luther King Jr., he soon realized that nonresistance was not working. Slavery strengthened in the 1850s, buttressed by a series of proslavery laws. Within a decade, Thoreau had abandoned peaceful protest and was prepared to support John Brown, the abolitionist who committed crimes in the name of a higher law. As I claim elsewhere, if it had not been for the Transcendentalist spirit of antinomian rebellion, John Brown may have well disappeared from view, since virtually all Americans except the Concord group initially rejected him. It was because of Thoreau, Emerson, Alcott, and a few others that Brown was rescued from oblivion and became a catalyzing force behind the Civil War.

Thoreau was such a nonconformist that it is hard to think of him as having been influenced by the popular culture of his day. But he *was* influenced by it. "Perhaps the value of any statement," he wrote, "may be measured in its susceptibility to be expressed in the popular language." Sometimes he actually charged himself with overusing popular expressions. In his journal, he admitted that one of his "faults" was "Using current phrases and maxims, when I should speak for myself."

Like Poe and Emerson, he used popular techniques in an individual way. He knew he had to appeal to a public that feasted on sensational newspapers. "We do not care for the Bible," he wrote, "but we do care for the newspaper. . . . The newspaper is a Bible which we read every morning and every afternoon, standing and sitting, riding and walking." He recognized the popularity of sensational news. He spoke of "the startling and monstrous events as fill the daily papers" and compared reading the average newspaper to rooting in a sewer. He knew that America, with its crime-filled penny papers, frontier slang, Bar-

numesque freaks, and yellow-covered pulp novels, was known world-wide as a culture of sensationalism, and he wanted to coin literary capital from its perceived wildness. "In literature it is only the wild that attracts us," he wrote. "Dullness is only another word for tameness." British literature, he stressed, had no "wild strain. It is an essentially tame and civilized literature. . . . There was a need for America." He declared, "America is the she-wolf of to-day." Elsewhere he wrote, "We must look to the west for a new literature," predicting that popular expressions "which now look so raw slang-like and colloquial when printed another generation will cherish and affect as genuine and American and standard."

Thoreau developed his mature writing style in response to an American popular culture that feasted on sensations and hungered for curiosities. Thoreau, the hermit who lived on the simplest foods, was perceived by some as one more American oddity. One magazine compared him with P. T. Barnum in a piece called "Town and Rural Humbugs." Another writer said of Thoreau's style, "Sometimes strikingly original, sometimes merely eccentric and odd, it is always racy and original." James Russell Lowell charged that Thoreau "seeks, at all risks, for perversity of thought. . . . It is not so much the True that he loves as the Out- of-the-Way. As the Brazen Age shows itself in other men by exaggeration of phrase, so in him by exaggeration of statement."

Reviewers caviled, but it was precisely the sensational or bizarre elements that attracted the popular audience. His idea for *Walden* came from a lyceum appearance where his audiences were curious about the details of his solitary life in the woods. When he began to lecture about his Walden experience, it was the strange, diverting moments of his talks that were the most popular. His biting "Economy" lecture, commented one magazine, was "sufficiently queer to keep the audience in almost constant mirth. . . . The performance has created 'quite a sensation' among Lyceum goers." By contrast, a tamer lecture, which became a less spicy chapter in *Walden*, was called "less successful than the former one in pleasing all" because it was "rather too allegorical for the popular

audience." When selecting passages from his writings to reprint, periodicals of the day most often chose the freakish or wild passages, such as "I grow savager and savager every day, as if fed on raw meat" or "There is in my nature, methinks, a singular yearning toward all wildness."

As Thoreau revised *Walden* for publication in the seven years after 1847, he heightened the sensational qualities of his prose. He added shocking images that might fit into the penny press: tortured people suspended over fire or chained for life to a tree; the battle of the ants; the taunting loon; the eerie owl hoots; and the passage about wanting to eat a woodchuck raw. He also invited us to laugh at the freakish or theatrical, as when he writes, "We know but few men, a great many coats and breeches," or "The head monkey at Paris puts on a traveller's cap, and all the monkeys in America do the same," or, about the transatlantic telegraph, "perchance the first news that will leak through into the broad, flapping American ear will be that the Princess Adelaide has the whooping cough." When *Walden* appeared, several reviewers noted its popular techniques. One stated flatly, "He coveted readers, and believed that he should have them." Another explained that he wrote *Walden* to satisfy "an inquiring public" and that "in the whole course of the book he keeps this audience in mind, goes out to meet it, and by a most conspicuously popular style adapts himself to it." And to some degree Thoreau satisfied this popular audience. Although *Walden* was not a best seller, it originally sold over two thousand copies—then a strong sale for a nonfiction volume—and proved popular over time, staying alive for future generations through its prose that absorbed popular images.

If the Transcendentalists carried the Democratic ideology toward radical individualism, Hawthorne followed it into metaphysical ambiguity. Born in 1804 in Salem, Massachusetts, Hawthorne was bookish child and went on to attend Bowdoin College from 1823 to 1827. He then entered what he famously called the "dismal chamber" period of literary productivity—a statement that has wrongly led some to say that he was an isolated genius, distanced from his times. He was in fact every bit as responsive to contemporary culture as the other major writers.

His first novel, *Fanshawe* (1828), was a Gothic thriller reminiscent of the dark novels of Horace Walpole, Ann Radcliffe, and Charles Brockden Brown. He went on to produce two collections of tales over the next two decades, *Twice Told Tales* and *Mosses from an Old Manse*, followed in 1850 by his novel *The Scarlet Letter*.

Hawthorne became close to the Democratic Party. He admired Andrew Jackson, whom he called "surely . . . the greatest man we ever had," with a "power of presenting his own views of a subject, with irresistible force, to the mind of his auditor." Hawthorne denounced Whigs like Daniel Webster, whom he labeled "altogether a disreputable character" who "drinks, and is notoriously immoral." Hawthorne published more than twenty tales and sketches in the *Democratic Review*, whose editor, John L. O'Sullivan, he hailed as "one of the truest and best men in the world." When Hawthorne was struggling financially in the 1840s, he needed a political job, and he received help from his Democratic friends in Washington, including the New Hampshire senator Franklin Pierce, his close friend from college. Through the Democrats he got the position of surveyor of customs at Salem, a job he held for over two years. After he lost the office when the Whigs under Zachary Taylor came to power, he made literary capital out of the political change in the preface to his most famous novel, *The Scarlet Letter*, in which he humorously called himself "the Locofoco Surveyor" who had been "decapitated" on the "political guillotine," so that his novel could "be considered as the POSTHUMOUS PAPERS OF A DECAPITATED SURVEYOR." In the 1852 presidential race, Hawthorne wrote a campaign biography of Pierce, who rewarded him with him the consulship to Liverpool.

As a conservative Democrat, Hawthorne had no tolerance for abolitionism. Nor was he attracted to labor reform or Fourierism. Despite his brief stay at Brook Farm in 1842, he decided, "A man's soul may be buried and perish under a dung-heap or in a furrow in the field, just as well as under a pile of money," and he went on to lampoon Brook Farm in *The Blithedale Romance*. He was traditional on slavery and women's rights.

Despite Hawthorne's affinities with the Democratic Party, more

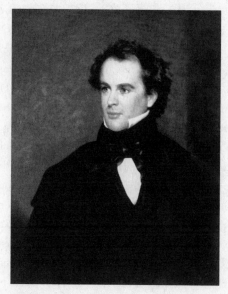

Nathaniel Hawthorne, *portrait by Charles Osgood*

significant for his fiction was his openness to the energetic, sometimes wild forces of popular culture that emerged from 1828 onward. Hawthorne was sensitive to the full range of cultural movements of his day, and this sensitivity deepened his imagination and influenced his fiction.

One story in which Hawthorne comments on his contemporary society, "The Celestial Rail-road" (1843), suggests why he was not inclined to Emerson's and Thoreau's example of improving on liberal or radical tendencies of the age. A revised version of John Bunyan's classic allegory *The Pilgrim's Progress*, "The Celestial Rail-road" shows Hawthorne's dissatisfaction with the optimistic religion and philosophy of his day. In Bunyan's original allegory, Christian's journey from the City of Destruction (the earth) to the Celestial City (heaven) is full of terrors and seemingly insuperable obstacles. In Hawthorne's satirical update, the trip is comfortable and easy.

Accompanied by the genial Mr. Smooth-it-away, the narrator rides a

train that speeds toward the Celestial City. Once-difficult parts of the trip are now trouble free. There is a bridge over the Slough of Despond built on a foundation of "some editions of books of morality, volumes of French philosophy and German rationalism, tracts, sermons, and essays of modern clergymen, extracts from Plato, Confucius, and various Hindoo sages, together with a few ingenious commentaries upon texts of Scripture—all of which, by some scientific process, have been converted into a mass of granite." The train proceeds over the Valley of Humiliation, through a tunnel under Hill Difficulty, and across the gaslit Valley of the Shadow of Death. At one point, it comes to the mouth of hell, but Mr. Smooth-it-away "took occasion to prove that Tophet [hell] has not even a metaphorical existence." It passes a cavern where Bunyan had put the giants Pope and Pagan, who have now been replaced by a Giant Transcendentalist, "German by birth, . . . but as to his form, his features, and his substance generally, it is the chief peculiarity of this huge miscreant, that neither he for himself, nor anybody for him, has ever been able to describe them." He is a heap of fog and duskiness, and he utters strange language.

The train arrives at Vanity Fair, where the speaker stays for a long time enjoying the bustling city. In Vanity Fair, there is a church on nearly every street, and religion is universally respected. Among the famous clergymen are the Rev. Mr. Shallow-deep, the Rev. Mr. Clog-the-spirit, and the Rev. This-to-day, to be replaced soon by Mr. That-to-morrow. The sermons of these ministers are "aided by those of innumerable lecturers, who diffuse such a various profundity, in all subjects of human or celestial science, that any man might acquire an omnigenous erudition, without the trouble of even learning to read." Vanity Fair is a commercial marketplace governed by capitalist bargaining, with many residents selling their consciences at low prices and politicians buying votes.

Most in Vanity Fair never leave it, because they love it, but periodically a person will disappear like a burst soap bubble. At the end, the speaker is taken to a river, on the other side of which is the Celestial City. There he is abandoned without being able to cross the river. Smooth-it-away leaves, snorting smoke and fire like a demon.

Hawthorne's message was that Americans had lost touch with dark truths and ultimate issues. The nation's increasing optimism about God and humanity had made it seem all too easy to gain heaven or personal morality through good behavior. In effect, hell no longer existed, nor did human depravity. Clergymen had become shallow and worldly. Religious sects were ever shifting. Lyceums lowered the educational process. Transcendentalism, the main philosophical alternative to Christianity, was fuzzy and mystifying. Capitalist materialism had invaded every aspect of the American experience, including religion.

Despite his complaint about optimistic liberalism, Hawthorne was a professional writer with an eye on the popular readership, one segment of which, he knew, was attracted to pious, hopeful literature. The literary marketplace, he would later complain, was taken over by "a d——d mob of scribbling women" who produced sentimental domestic fiction. One group of his short stories shared the preachiness and optimism of conventional literature. For instance, "Sights from the Steeple," "The Gentle Boy," "Little Annie's Ramble," "The Vision of the Fountain," and "The Village Uncle"—all first published in popular gift books or magazines—used conventional images such as simple piety, angelic visions, domestic bliss, and childhood purity. Hawthorne even wrote a temperance tale, "A Rill from the Town-Pump" (1835), in which he had a water pump call himself "the grand reformer of the age" and vow to wipe out the many ills that came from alcohol.

But Hawthorne was also profoundly aware of the contrasting strain in American culture, associated with darkness and subversiveness. Much of his interest in gloomy themes came from his guilt-ridden preoccupation with the Puritan past. He counted among his ancestors two Puritan leaders, William Hathorne, who persecuted Quakers, and John Hathorne, a judge in the Salem witch trials. Hawthorne probed the harshness of Puritans in his fiction, and their Calvinistic faith provided the basis for his preoccupation with human sin. As Melville put it, "this great power of blackness" in Hawthorne "derives its force from its appeals to that Calvinistic sense of Innate Depravity and Original

Sin, from whose visitations, in some shape or other, no deeply thinking mind is always and wholly free." If "The Celestial Rail-road" showed Hawthorne's dissatisfaction with the complacent religion of his day, much of his other fiction—from early short stories like "Young Goodman Brown" and "The Minister's Black Veil" through the novels of his major phase, like *The Scarlet Letter* and *The Marble Faun*—dramatizes human frailty with an intensity that harks back to early Calvinism.

Still, Hawthorne was neither a Puritan nor a Calvinist. Instead, he frequently imported into Puritan settings motifs from nineteenth-century sensational writings. He was what he called a voracious reader of "all sort of good and good-for-nothing books." He loved Gothic novels and crime narratives. One of his favorite childhood books was an old crime anthology which his son Julian called "the forerunner of the yellow literature . . . so signally popular these days," a "medieval Police Gazette" whose gory plots "would be a godsend to the criminal-fiction school of today." Julian admitted his father had a "pathetic craving" for these kinds of murder stories. This interest in the sensational lasted until old age, when Hawthorne pored over popular trial reports. Also, he loved reading popular periodicals so much that, as Julian recalled, he read novels for pleasure "but if study were his object, he would resort to the newspapers and magazines." In 1830 he had been taken up by the famous Salem Murder, in which a wealthy retiree had been brutally killed by a criminal hired by two brothers from a respectable family. He knew the 1833 volume *The Record of Crimes in the United States*, containing the lives of twenty-three American criminals with accounts of their perverse crimes, and he proposed to write a tale about "A Show of wax-figures, consisting almost wholly of murderers and their victims," listing many of the pirates, seducers, and killers of the day. Although he never wrote the story, much of his major fiction contains themes or images from popular sensational writing, including scaffold confessions, adultery, persons outside the law, and foes of mainstream society.

The Scarlet Letter showed Hawthorne's fascination with the seamy side of Jacksonian popular culture. The characters he chose for the

novel were common in sensational literature. Hawthorne knew of actual scandals in Puritan history, such as that of a Maine minister's wife, Mary Bachelor, who was branded with the letter *A* for having adulterous relations with one George Rogers. Hawthorne must also have been aware of popular fiction along these lines, such as "The Magdalen," an 1833 tale in the *Salem Gazette* about a sinful woman who lives alone in an isolated cottage and penitently works for a nearby village, or Sylvester Judd's 1845 novel *Margaret,* which has a subplot about a woman forced to live alone with "a significant red letter" sewed on her clothes.

Hawthorne followed in the wake of popular sensational novelists who used subversive characters to puncture pious pretensions of supposedly respectable people. George Lippard's best seller *The Quaker City* was one of many city-mysteries novels of the 1840s that dramatized the alleged hypocrisy and corruption of the ruling class. Among the favorite character types in the Lippardian vein were the reverend rake, or the minister who seduced female parishioners; the fallen, adulterous woman who used sex to climb socially; the vindictive cuckold who went to devilish extremes to avenge his wife's infidelity; and the magnetic pseudoscientist who exploited mesmerism and other powers to control others. Another common character was the wayward child, typified by Jack the Prig in George Thompson's 1849 novel *City Crimes,* who refused to learn the Christian catechism and engaged in other naughty behavior (the proudly wicked Topsy of Stowe's *Uncle Tom's Cabin* was another example of the bad-child figure).

Hawthorne used similar characters in his tale of an adulterous woman who was involved with a clergyman and who had a misbehaving child and a vindictive husband with the powers of a demonic pseudoscientist. Hawthorne's novel was similar enough to popular sensational literature that a prudish reviewer, Arthur Cleveland Coxe, wrote that Hawthorne's tale of "the nauseous amour of a Puritan pastor" was a book "made for the market," smelling "strongly of incipient putrefaction" and belonging to the "Brothel Library" along with other American imitations of racy French novels.

But there were notable differences between *The Scarlet Letter* and popular novels. Hawthorne put stereotypical characters in a fully realized early New England setting. He invested these characters, who were portrayed with lip-smacking prurience in popular fiction, with new resonance and depth. Arthur Dimmesdale possesses both the illicit passions of the reverend rake and the conscience of the sincere Puritan preacher. A hypocrite, he is nonetheless truly tormented and humanly believable. Hester Prynne is the adulterous wife but much more as well: she is a charity worker, a skilled seamstress, a bold thinker, and, above all, a woman committed to her lover. Her wayward daughter, Pearl, and her betrayed husband, Roger Chillingworth, come close to being stock characters, but they, too, have dimensions unseen in popular stereotypes. Pearl is not just the undisciplined rebel who refuses to recite her catechism; she is also a force for honesty, since she constantly demands that her mother and her paramour publicly confess their love. Even Chillingworth, an unsavory combination of the vengeful cuckold and the satanic pseudoscientist, serves a moral function by helping keep alive a sense of sin within Arthur Dimmesdale.

By placing subversive nineteenth-century characters in the moral context of bygone Puritan culture, Hawthorne creates a masterpiece of irony, symbolism, and psychological complexity.

Hawthorne's contemporaries Walt Whitman and Herman Melville were, like him, Democrats. Whitman published *Leaves of Grass* in 1855, but he had been writing for nearly two decades before this innovative poetry volume appeared. In the early 1840s, the Long Island–born Whitman, who divided his time between his Brooklyn home and nearby Manhattan, had written conventional rhymed poetry, popular fiction, and essays on political and social topics. A Democratic journalist, in 1846 he began a two-year stint as the editor of one of the era's leading Democratic newspapers, the *Brooklyn Daily Eagle*. He served for a time as a Democratic ward politician.

Utterly devoted to the American union, Whitman was alarmed by the rising sectional tensions that flared during the Mexican War over

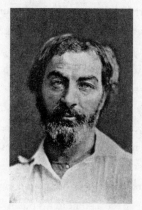

Walt Whitman

the issue of extending slavery into the western territories. Although he was a free-soiler who wanted to stop slavery's spread, his main purpose was to answer threats of disunion that came from both sides of the slavery divide. He denounced both Southern fire-eaters and Northern abolitionists, since each group called for the separation of America into two independent countries.

In his private journals he made a startling discovery. Through *poetry* he could imaginatively bind the fractured segments of his nation. In manuscript drafts dating from the late 1840s or early 1850s, he wrote experimental verses in the style of his later rhythmic prose-poetry. His earliest scribblings were about slavery:

> I am the poet of slaves,
> and of ^{the} masters of slaves [. . .]
> ~~The~~ ^{I go with} the slaves ^{of the earth} ~~are mine and~~
> ~~The~~ ^{equally with the} masters ~~are equally~~ ^[illegible]
> And I will stand between
> the masters and the slaves,
> ~~And I~~ Entering into both, ~~and~~
> so that both shall understand
> me alike.

Here Whitman creates a loving "I" who assumes simultaneously a Northern and a Southern perspective, embracing both slaves and their owners. The "I" defuses the slavery crisis by promising to "stand between" slaves and their masters, by "entering into both" in a gesture of healing and reconciliation.

Whitman continued this poetic balancing act in the famous first edition of *Leaves of Grass*. In the preface he assured his readers that the American poet shall "not be for the eastern states more than the western or the northern states more than the southern." Since Whitman knew that Southerners and Northerners were virtually at each other's throats over slavery, he made a point in his poems constantly to link the opposing groups. He proclaimed himself "A southerner soon as a northerner, a planter nonchalant and hospitable [. . .] At home on the hills of Vermont or in the woods of Maine or the Texan ranch." In an unprecedented gesture of brotherhood, he encompassed not only the nation's conflicting sections but virtually all social phenomena as well as people of every race, religion, and class. The result is the most expansive poetry America has produced.

Another all-absorptive work shaped by the contemporary scene was Melville's *Moby-Dick*. Published in 1851, Melville's novel was formed in the crucible of the political and cultural changes of the 1840s. Having returned in 1844 from five years at sea, Melville set out to record some of his experiences in his adventurous early novels *Typee* (1846) and *Omoo* (1847). Featuring cannibalism, hairbreadth escapes, exotic settings, and eroticism, these novels fit into the sensational-adventure mode that was then popular—they were, as Melville said of *Typee*, "calculated for the popular reading, or for none at all." They leaned toward a Democratic perspective in their common-man protagonists and anti-establishment themes.

As such, they showed the effects of so-called Young America, which at the time was a dual literary and political movement. In 1839 the New York novelist Cornelius Mathews and the editor Evert Duyckinck had founded the Young America literary group, with the intensely national-

Herman Melville

istic agenda of establishing an indigenous American literature free of foreign (especially British) influence. At the time, this literary current was closely allied with the emerging Young America political movement, which was Democratic, expansionist, and jingoistic.

Melville was directly involved in both literary and political Young America: he was close to Mathews and Duyckinck, and his brother Gansevoort was a fiery Jacksonian politician and orator. In time, though, the Young America movement became divided. Its literary sector became more elitist than its political one. Duyckinck, separating from political Young America, declared that American literature should be "immune from democratic enthusiasms, and from the wildness of American life." Mathews similarly asked for "nationality in its purest, highest, broadest sense," far above the din of brawlers and political orators.

Melville questioned political Young America in his allegorical novel *Mardi* (1849) by satirizing American expansionism and the European revolutions. Meanwhile, he married into the family of the staunch Whig Lemuel Shaw, the Massachusetts chief justice who became notorious for enforcing the Fugitive Slave Law. Already distanced from the Democrats,

Melville was also skeptical of the Whigs, whose then-leader, President Zachary Taylor, he lampooned in "Authentic Anecdotes of 'Old Zack.'"

By the time he wrote *Moby-Dick*, Melville was liberated from any single political or literary vantage point. On the one hand, he could express nationalistic Young America attitudes, as when he wrote that the American author "is bound to carry republican progressiveness into Literature, as well as into Life." On the other, he adopted a patrician view, as when he denigrated the mass readership in his letters to Hawthorne.

In *Moby-Dick* he moved flexibly between radical democracy and intellectual aristocracy, between Americanism and transnationalism, between the local and the universal. Like Hawthorne, he used popular sources. The 1820 sinking of the whaleship *Essex* after being rammed by an angry whale was well known to him. Many other stories about destructive whales circulated, too, from J. N. Reynolds's magazine tale "Mocha Dick: or the White Whale of the Pacific" through "Whaling in the Pacific: Encounter with a White Whale" in the Boston story weekly *Uncle Sam* to Harry Halyard's pulp novel *Wharton the Whale Killer!*, in which a vicious whale attacks a ship that is chasing it. Onto this sensational plot of the ill-fated whale hunt Melville grafted central themes of his period.

Written just after the Age of Jackson, *Moby-Dick* was the period's culminating statement in fiction. Melville captured the paradox of Old Hickory—as both everyman and King Andrew—when he had his narrator, Ishmael, praise the "great democratic God" who picks up Andrew Jackson "from the pebbles," thundering him "higher than a throne" and choosing the "selectest champions from the kingly commons." Ishmael explains that he wants to show "high qualities" in the "meanest mariners, and renegades and castaways." *Moby-Dick* mingles the lowly and the lordly, roistering common folk and meditative isolates, offering fresh, provocative variations on the conflicting political imagery of the Democrats and Whigs.

Melville's all-encompassing novel got little response in the short run.

Although *Moby-Dick* got some politely positive reviews, it was widely attacked and had a poor sale. Melville took out his frustrations in his bitter autobiographical novel *Pierre,* in which the author-hero joins "Young America in Literature" and promises to write a popular novel but enrages his publisher when he produces a dark philosophical one instead. In the remaining few years of his prolific period, before his literary hiatus began in 1858, Melville produced bleak portraits of passivity and blankness ("Bartleby, the Scrivener"), complex race relations ("Benito Cereno"), and human greed and deception (*The Confidence-Man*). As time passed, Melville left behind the certainties and exuberance of Young America. In doing so, he carried the contradictory impulses of Jacksonian America toward modernism.

* * * *

JUST BEFORE THE CIVIL War, the Reverend Henry Ward Beecher, the genial Brooklyn preacher who was called "the most famous man in America," explained American art by saying that it reflected a democratic spirit unshackled by governmental interference. European art, he declared, revealed the effects of monarchy. "In all the Italian schools," Beecher declared, "not a picture had ever probably been painted that carried a welcome to the common people." He continued, "There were angels endless, and Madonnas and Holy Families without numbers," and monkish legends and heathen divinities, but "nothing that served the common people." Beecher concluded, "In art, as in literature, government, *government*, GOVERNMENT, was all, and *people* nothing! I know not that the Romanic world of art ever produced a democratic picture." American art, in contrast, was all about democracy.

This comment is only partly true. European art was *not* all about angels or "GOVERNMENT," nor was American art all about the common people. Still, Beecher's statement reflected America's quest for a democratic artistic style. If anyone felt what Harold Bloom calls the anxiety of influence, it was American artists of the early nineteenth century. American artists were thoroughly familiar with the Old

Masters. A good number spent time in Europe, studying classic paint-
ing and sculpture. Commonly Americans dealt with themes and sub-
jects that had been already treated abroad.

How, then, could America forge an art of its own?

Part of the answer was exaggeration. An American journalist noted,
"Hyperbole and exaggeration are the universal religion, from church to
state, from Capitol to the closet, and the Impossible is the only god of
popular idolatry." Democracy *did* make a difference. Tocqueville wrote
that creative people in America "inflate their imaginations and swell
them out beyond bounds, so that they achieve gigantism."

He was bringing attention to the "-est factor" in Jacksonian Amer-
ica. The exuberance and brashness of the young republic created a fas-
cination with the largest, the smallest, the thinnest, the fattest, the
most outrageous, and so forth. The -est factor was everywhere: in the
frontier screamer character, who boasted that he could outwrestle, out-
swim, outshoot, outdrink, and outlove anyone; in Poe, who strained to
write the weirdest of the world's Gothic fictions; in Thoreau, who ad-
vertised his lifestyle as the simplest and his language as the boldest,
stating, "I desire to speak somewhere *without* bounds . . . ; for I am con-
vinced that I cannot exaggerate enough even to lay the foundation of a
true expression." America's literary classics of the 1850s would feature
the world's largest animal and maddest captain (in Melville's *Moby-
Dick*); its most painful love triangle (in Hawthorne's *The Scarlet Letter*);
its most meaningful grass, mouse, and armpit odor (in Whitman's
Leaves of Grass); and later its oddest, most creative spinster in Emily
Dickinson, the so-called Woman in White or The Myth of Amherst.

On the most basic level, the -est factor made a difference in size. An
example of America's love of size was its taste for tremendous paintings
called panoramas—oversize renderings of a scene. There were many
subcategories: the cyclorama, a 360-degree canvas displayed in a ro-
tunda; the diorama, paintings that faded into each other as they moved
behind linen panels and the light was shifted; the myiorama, or moving
panorama, which rolled before the viewer's eyes; and other variations

with names like cosmorama, noctorama, georama, caricaturama, and paleorama. Panoramas were first displayed by the Irish artist Robert Barker, who in 1787 presented in Edinburgh a cyclorama of the Scottish countryside. The Frenchman Louis-Jacques-Mandé Daguerre introduced the diorama in Paris in 1822, presaging his coinvention of photography fifteen years later.

Americans had a fascination with especially large and exotic panoramas. In the fall of 1817, there was exhibited in New York's Washington Hall a 300-foot-long painting of "the Sea Serpent, a Monster of uncommon size, who has paid a long visit to our eastern coast, and excited the admiration of scientific men, . . . [and] has been *accurately painted* by an artist of the first talents." The next year came a 2,440-foot canvas showing the Battle of Waterloo. In the 1830s, two New York brothers, William J. and Henry Hanington, began displaying popular panoramas. In 1836 they exhibited a tremendous image of a Texas battle, "General Houston's Glorious Victory." Three years later came their Grand Moving Dioramas, illustrating Noah and the flood, a scene in India, a moonlit sea, and a Fairy Grotto.

The vastness of the American frontier inspired the largest panorama, painted by the Western artist John Banvard. Born in New York in 1815, Banvard moved to Kentucky, where he painted portraits and landscapes. Bitter about the frequent complaint that America had "no artists commensurate with the grandeur and extent of her scenery," he set out to produce what he called *"the largest painting in the world!"* In 1840 he began going up and down the Mississippi River on a skiff, sketching as he went and returning periodically to his Louisville studio to work on a panorama of the river. In its early phase, the panorama was twelve feet high and 1,300 feet long. By 1846, it had expanded to around half a mile of canvas that was slowly unfurled before viewers as Banvard lectured about the various scenes depicted, including shipping, Indians, raftsmen, and harvesting. As though the painting were not large enough, it was advertised as being three miles long. Since Banvard wanted it to be "a homegrown production throughout," he used cotton

produced in the South and spun into canvas in Lowell factories. He displayed this myiorama throughout America and Europe, earning enough money to build a mansion on Long Island in imitation of Windsor Castle, later derided as Banvard's Folly.

Americans counted among art works *tableaux vivants* (aka living statues or model artists): actual men and women, posing stationary in various stages of undress, depicting scenes from classical literature and art. The craze for model artists began in 1838 and peaked in 1847–48, continuing for a decade after that. Every major city had exhibition halls, such as the Broadway Odeon and the Apollo Rooms in New York, offering live classical scenes for a price. Exhibitions included *Venus Coming out of the Bath*, *Adam's First Sight of Eve*, *Diana on the Chase*, *Arab Girls in Pyramid*, and *Venus Stealing Cupid's Bow*. The living statues were a kind of polite pornography. Typical ads promised views of "six handsome women and four well-shaped men" in *Amazonian Triumph*, "twenty-three of the most beautifully formed women in the world" in *The Rape of the Sabines*, and Hiram Powers's nude statue *The Greek Slave* impersonated "by a young lady of faultless form." Police raids on model artist exhibitions were common. But many, including Walt Whitman, who would bring the undraped body into poetry, regarded the *tableaux vivants* as genuine art. Denouncing those who said "the sight of such things is *indecent*," he wrote: "If that be so, the sight of nearly all the great works of painting and sculpture—pronounced by the united voice of critics of all nations to be master-pieces of genius—is, likewise, indecent. It is a sickly prudishness that bars all appreciation of the divine beauty evidenced in Nature's cunningest work—the human frame, form and face."

When we survey mainstream American art of the 1815–48 period, we find that the division between light and dark themes of literature was paralleled in paintings of the day. On the light side, we find paintings emphasizing pastoral beauty, blissful rural life, individualism, and a distinctly American form of light that bred what is now called the luminist style of the 1850s. On the dark side, we find a preoccupation with death,

decay, madness, rupture, and violence, drawing off the Gothic mode that in literature ran from Charles Brockden Brown through Poe and Hawthorne. The optimistic themes reflected the expansive, hopeful impulse of Jacksonian democracy. The negative ones were aggravated by disruptive factors such as urbanization, mob violence, and racial tensions.

The first major American artist of the period, Washington Allston, represents the Eurocentric, pre-Jacksonian vision that we saw in Washington Irving. Born in 1779 on a South Carolina plantation, Allston had a dark, mystical streak that came partly from supernatural tales told him by slaves. He once explained that his "love for the wild and marvelous" originated in childhood, when "I delighted in being terrified by the tales of witches and hags, which the negroes used to tell me." At eight, he moved to Newport, Rhode Island. From 1796 to 1800, he attended Harvard, where he loved reading Gothic novels. His attraction to gloomy themes resulted in his 1800 painting *Tragic Figure in Chains*, a terrifying rendering of a shackled, nearly naked madman against a shadowy background.

Politically, Allston was a conservative Federalist and later a Whig. He had strong leanings toward Europe. After college he spent seven years in England and on the Continent. There he befriended Washington Irving, who called him "a young gentleman of much taste and a good education." In 1808 he returned to Boston and was soon married to Ann Channing, the sister of the Unitarian leader William Ellery Channing. In 1811 he went for another seven-year stay abroad. After the War of 1812, he said, "Next to my own country, I love England, the land of my ancestors. I should, indeed, be ungrateful if I did not love a country from which I have never received other than kindness; in which, during the late war, I was never made to feel that I was a foreigner."

Most of his paintings of the period displayed his affiliation with European tradition. True, shortly after returning to Boston in 1818, he produced the stunning *Moonlit Landscape*, which in some respects

anticipates the American luminists with its idealistic use of light. But, as Barbara Novak notes, this and Allston's other landscapes use light in a hazy, coloristic way, closer in spirit to the European masters than to the American luminists, with their crystalline clarity and emphasis on tangible fact.

Allston's more characteristic paintings deal with historical or religious subjects with roots in European art. His oil painting *Jacob's Dream* (1817) shows the sleeping Jacob surrounded by angels who direct him upward to a gleaming heaven where we see a winged divine creature. His other paintings of the time—such as *Angel Releasing St. Peter from Prison* (1814–16), *Belshazzar's Feast* (begun in 1817), *Elijah Fed by the Ravens* (1818), *The Flight of Florimell* (1819), *Saul and the Witch of Endor* (1820–21), and *Miriam the Prophetess* (1821)—reveal his interest in biblical themes and in the dramatic color contrasts that made Allston known as the American Titian.

Allston often achieved the sublime effects associated with dark Romanticism. "His genius," commented a contemporary journalist, "may be characterized by one word—sublimity. He delights in the terrible, the gorgeous, the magnificent, the mystic." Like Poe, Allston created dark, Gothicized art partly in response to a changing America in which he felt increasingly uncomfortable. Dissatisfied with what he saw as the anarchic rabble of Jacksonian democracy, he became a Whig and an Episcopalian. He once complained that the "courtesies, deferences, & graces" of genteel society were disappearing and that if America continued on its current course, "In thirty years there will not be a *gentleman* left in the country."

Some of his paintings reflected his political fears. Like many other Whigs, he had a nativist streak associated with anti-Catholicism. His painting *Spalatro's Vision of the Bloody Hand* (1831), which appeared just as anti-Catholic sentiment began to sweep the nation, depicted a priest in company with a hired assassin. The conscience-stricken assassin, Spalatro, is terrified by the vision of a bloody hand, but the priest, Schedoni, is remorseless and wants to go ahead with the murder of his pa-

tron's wife. Another Allston painting of the time, *The Death of King John* (1837), was based on an old Protestant legend about a king who stood up to the pope and was poisoned by evil monks. Allston portrays the dying John surrounded by four monks, one of whom looks truly sinister.

If these works suited a decade that also produced Maria Monk and George Bourne, a more famous Allston painting, *Belshazzar's Feast*, appears to have reflected larger fears about Jacksonian America. Allston worked on this painting for years but left it unfinished at his death in 1843. His inability to complete the picture may have been related to his disenchantment with Jacksonian society. The painting treats a common subject among artists: the prophet Daniel's translating of words on a wall that warn Belshazzar, the wicked ruler of Babylon, of the impending destruction of his nation (hence the common saying about the writing on the wall). When Allston began to work on the painting in 1817, he evidently intended it to comment on the autocratic rule of Napoléon. But as time passed, Allston reportedly changed his goal, aiming the painting against Andrew Jackson, who was commonly seen by Whigs as a Napoleonic tyrant. Allston blotted out the original Belshazzar—to make him more Jackson-like, perhaps?—and, as some contemporaries noted, revised Daniel to make him look more like Daniel Webster, Jackson's archrival.

Allston also seems to have been haunted by guilt over his slaveholding past. Allston lived partly off the money he had gained in 1809 when he sold his family's South Carolina plantation with its twenty-four slaves, and later he put up for sale another sixteen slaves left to him by his mother. Perhaps there is ominous meaning in the fact that the one figure in *Belshazzar's Feast* who looks hopefully at the words warning of the nation's destruction is a slave woman, who seems to sense that violence is the only way her race will be freed from bondage.

Allston's contemporary Thomas Cole also projected into his paintings his worries over social problems. Cole divided his efforts between allegories and landscapes. His allegorical cycles—the five-part *Course of*

Empire (1834–36), the companion pieces *The Past* and *The Present* (1838), the four-part *The Voyage of Life* (1840–42), and the five-part *The Cross and the World* (1846–47)—suggest his sense of personal suffering and national collapse. His landscapes offered a more peaceful, optimistic vision that looks forward to the Hudson River School, though even they sometimes have surprisingly negative elements.

Cole was born in Lancashire, England, in 1801 and at eighteen emigrated with his family to Philadelphia, where he worked as an engraver and then as an art teacher. In 1826 he helped found the National Academy of Design in New York, an organization of artists supported by wealthy patrons. Although he became a naturalized citizen in 1834, he felt like a cultural outsider. For a time, he had to support his impoverished family, enduring anxieties felt in his 1828 sketches *Hope Deferred Maketh the Heart Sick* and *Shipwreck Scene*, which show a marooned man stranded on a rock in midocean during a storm as another ship disappears in the distance. In the 1830s, marriage brought periods of happiness but also a sense of disconnectedness, as Cole lived in a home owned and inhabited by his wife's family. He said, "I often think that the dark view of life is the true one." One of the paintings this angst produced was *Manhood* of the famous *Voyage of Life* cycle, in which a man standing on a boat prays as he drifts toward boiling rapids in a threatening landscape of dark crags, blasted trees, and storm clouds.

Cole's fears were linked with his profound abhorrence of the social changes he thought were caused by Jacksonianism. He sourly noted that "every newspaper" brought news of turbulence and lawbreaking, and he lamented "all the ignorance, the flippancy, the slang, the falsehood, that is daily vomited by the press, to feed the sickly & diseased appetite of the multitude." He anticipated what he called "the downfall of this republican government" resulting from "tyranny & wrong, blood & oppression." In a futuristic prose piece, he predicted that the twentieth century would bring a "fearful season in the history of man," with America taken over by "vice, profligacy, irreligion and anarchy" and good people being forced to flee to the mountains.

He dramatized his doubts about his nation in a number of paintings. He was preoccupied with transience and social collapse. *The Course of Empire*, painted during Jackson's second term in office, traces the rise and fall of what looks in the paintings like the Roman Empire but which hints of America as viewed from Cole's bitter perspective. The first three paintings trace the rise of an empire from the savage state through the pastoral state to *Consummation*, which portrays a Roman city in a time of peace and prosperity. The fourth painting, *Destruction*, shows the city falling apart as masses of people rush about in turmoil. The final one, *Desolation*, pictures lifeless ruins framed by a dead, pallid landscape.

Cole's fears of the Jacksonian masses are reflected in these *Empire* paintings. In the early ones, the masses don't exist, for there are only scattered people in the primitive settings. In *Consummation* the city is full of people, almost to the bursting point. In *Destruction* a torrent of people heaves about in chaos, as though the city is disintegrating from the strain of human beings in frenzied disorder. In the right foreground of *Destruction* towers the statue of warrior missing his head and a hand

Thomas Cole, The Course of Empire: Consummation

Thomas Cole, The Course of Empire: Destruction

and taking a huge stride, perhaps symbolizing what some saw as the mindless, "go-ahead" American spirit—the spirit that prompted the conservative Whig Philip Hone to lament in 1837, "We have become the most careless, reckless, headlong people on the face of the earth. 'Go ahead' is our maxim and pass-word, and we do go ahead with a vengeance, regardless of consequences and indifferent about the value of human life." In the final painting, *Desolation*, all human life has disappeared. Humanity has brought about its own destruction.

If the masses were the problem, Cole thought there was a solution. Why not forget people altogether? Nature seemed to be a peaceful alternative to the mayhem of American society. Cole became a founder of the Hudson River School largely because he was the first American painter to consistently capture nature devoid of humans, or with only faint suggestions of them. Reflecting the nation's fascination with the frontier, Cole wanted to represent what he called its "primeval forests, virgin lakes and waterfalls."

The starting date of the Hudson River School is commonly said to be 1825, when Cole produced three landscapes of the wilderness near

Catskill, New York. The art patron Philip Hone bought two of the paintings. The newly constructed Erie Canal made the Hudson River America's most important waterway, and paintings that depicted the region were praised with jingoistic pride. As Hone declared, "I think that every American is bound to prove his love of country by admiring Cole." Without surrendering his interest in allegorical cycles, Cole at the same time produced landscapes of the Hudson River and other areas. Among his better known are *Sunny Morning on the Hudson* (1827), *The Oxbow* (1836), *Schroon Mountain* (1838), *The Hunter's Return* (1845), and *Catskill Creek* (1845). In the mid-1830s Cole set up a rural studio in Catskill.

He believed that nature paintings had both religious and patriotic meaning. But he did not idealize rural settings. To the contrary, many of his landscapes have negative or agitated elements. *Lake with Dead Trees* is downright harrowing in its portrayal of lifeless trees that stand skeleton-like around water so still that it seems like a river of death. Blasted or stunted trees appear even in several of Cole's otherwise green landscapes such as *Sunrise in the Catskills*, *Landscape with Tree Trunks*, and *Crossing the Stream*. These images of death remind us that transience was never far from Cole's mind.

They also make an ecological statement. Cole knew the harm inflicted by America's expansion. In his 1835 "Essay on American Scenery," he said that although he loved painting American landscapes, he was saddened "that the beauty of such landscapes are quickly passing away—the ravages of the axe are daily increasing—the most noble scenes are made desolate, and oftentimes with a wantonness and barbarism scarcely credible in a civilized nation." He continued: "The way-side is becoming shadeless, and another generation will behold spots, now rife with beauty, desecrated by what is called improvement; which, as yet, generally destroys Nature's beauty without substituting that of Art." He was aware that his own paintings caught a beauty that was being threatened by civilization. His ambivalence about expansion came out in a work like *The Hunter's Return*, in which a frontier cabin is surrounded by

beautiful mountains but also by logs and tree trunks, the signs of man's ravages.

Cole's only pupil, Frederic Edwin Church, would show little of this ambivalence, perhaps because he came of age in the 1840s, the decade of Manifest Destiny. Church first exhibited a painting in 1844, when he was eighteen. Since his major works—epic vistas of Niagara Falls, the Andes, icebergs, and so on—appeared in the 1850s and 1860s, he lies outside the purview of this book. But worth mentioning here are some of Church's early works: *Hooker and Company Journeying through the Wilderness from Plymouth to Hartford, in 1636* and *Moses Viewing the Promised Land* (both 1846), in which brilliant light illuminates faraway landscapes, promising spiritual and worldly reward to people journeying toward new territories; *Sunset, Hudson River* (1847), which finds both peace and ruggedness in the American landscape; and *View near Stockbridge, Mass.* (also 1847), a farm scene with rolling hills that gives a sense of America's expansiveness and fertility.

When Thomas Cole died in 1848, a journalist compared him with a fellow Hudson River artist, Asher B. Durand. "It is now generally conceded," the writer noted, "that Cole and Durand are the two most prominent landscape painters in this country.—They are indeed artists of superior ability, and will undoubtedly hereafter be looked upon as the founders of two American schools." The two American schools were actually different versions of the Hudson River style Cole had defined. While Cole emphasized sublime effects in nature, Durand stressed the pastoral and domestic.

Born in Springfield, New Jersey, in 1796, Durand at fifteen went to Manhattan and worked for an engraver. He produced many engravings of famous Americans and classical scenes. In the early 1830s, he made allegorical images for paper currency. His works on canvas began with traditional historical subjects, as in paintings like *Mary Magdalen at the Sepulchre*, *Hagar in the Wilderness*, and *Samson and Delilah*. In 1830 he and the nature poet William Cullen Bryant collaborated on a project

called The American Landscape, intended to be a serial publication of engravings of American locales by native artists. Although the project failed, Durand produced four landscapes, one of which was exhibited in 1832.

Anticipating Church and others, he introduced a new kind of landscape artistry that explored fully the optimistic potential of America's rural settings. From Claude Lorrain and other eighteenth-century landscapists, he derived an interest in soft colors and soothing light. He applied the Claudian technique to accentuate the virginal freshness and fecundity of America. His landscapes were as ideal as was his 1836 portrait of President Andrew Jackson, which Durand painted under a commission by the New York merchant Luman Reed. In the portrait, Jackson's rough edges are removed. The president is firm-faced and determined-looking, with a swept-back mane of gray hair and a dignified black coat and cravat. His furrowed brow and creased forehead are deemphasized by glowing light, betraying no more anxiety than the ruffles on his white shirt. Durand produced an image of Jackson that was at once strikingly realistic and subtly idealized.

He did the same for the American wilderness. In his 1830 oil painting *Catskills Mountains*, he showed cows grazing on a hill that rolls down to a river with a plain in the distance backed by hazy mountains. *The Beeches* creates a kind of American arcadia, with a large tree on the right framing a sloped dirt path on which advance a shepherd and his sheep toward a lake, behind which is a soft landscape of fields, mountains, and muted pastel skies. Similarly comforting are *Mountain Stream*, showing a deer on a rock amid rolling hills and lush trees, and *Dover Plains, Dutchess County, New York*, depicting a mother and two children on rocks looking at cattle grazing below her and distant fields that stretch toward mountains beneath fair skies. In the famous *Kindred Spirits*, Durand pays homage to Bryant and Cole both in subject and style. He renders the poet and the artist standing together on a high ledge over a ravine, with mountains on the horizon. Cole-like sublime

Asher B. Durand, Andrew Jackson

effects like the cliff and foregrounded dead trees combine nicely with Bryant- and Durand-like emphasis on nature's gently consoling beauty in the distance.

Durand was one of the first American plein-air artists, who painted outside, directly from nature. Later in the century, the plein-air technique freed the French impressionists, inspiring them to play with effects of light and color instead of worrying about realism. In America, plein air also opened up experiments with light, but without sacrificing palpable fact. Some of Durand's paintings anticipated luminism, the landscape style that dominated American art in the 1850s. Luminism featured gleaming light that pointed to the ideal in closely rendered nature scenes that also captured the miraculous detail of the real. A special Durand painting in this regard is *Indian Vespers* (1847), in which a worshipping Indian stands with arms outstretched beside a tree and rocks before a beautiful lake over which a setting sun shines. Durand here shows an appreciation of Native American religion, based on one-

Asher B. Durand, Kindred Spirits

ness with nature. If, as several have suggested, luminism reflected the idealistic vision of Transcendentalism, it also owed something to another indigenous source: the faith of Native Americans.

To mention Native Americans in art is to bring up the name of George Catlin. Durand's *Indian Vespers* pays tribute to Native American culture only indirectly; we see an Indian from rear view against a vast landscape that makes him seem minuscule. In Catlin's paintings, in contrast, Indians are typically the sole subjects, seen up close in frontal portraits. Catlin also painted landscapes related directly to Indian culture, focusing on the prairies, buffaloes, and rock formations in tribal areas.

Catlin's paintings of Indians were an artistic reaction to Jacksonian democracy. Born in Wilkes-Barre, Pennsylvania, in 1796, Catlin was the son of a conservative Federalist politician-farmer. When Catlin was twenty-one, he went to Connecticut to study law, which he disliked. In 1821 he moved to Philadelphia and took up painting. He joined art groups and tried his hand at portraits. Relocating to New York in 1827, he saw there a visiting delegation of Indians and became interested in

trying to capture them in art. He moved to St. Louis, which became his base for exploring Indian territory.

Andrew Jackson's Indian removal policy, proposed in December 1829, gave Catlin a sense of urgency to preserve in art native cultures that he believed would soon be destroyed. Between 1830 and 1836, he made several long excursions on the Missouri River deep into Indian territory, aiming to catch the "primitive looks and customs" of many tribes. He found that the tribes nearest white settlements "have been blasted and destroyed by the contaminating vices and dissipations of *civilized* society." As one went farther away from civilization, he reported, one "gradually rises again into the proud and heroic elegance of a savage society, in a state of pure and original nature, beyond the reach of civilized contamination."

Catlin was the first to represent effectively this pride and elegance of the natives. He had a special interest in relatively uncorrupted, pure tribes such as the Blackfeet, Mandan, and Arikara. By 1837 he had created an Indian Gallery, consisting of 474 works, three hundred of which were individual portraits and the remainder paintings of Indian pastimes, ceremonies, and rural areas. He displayed his collection in New York and then took it on tour in Europe, where he spent the next thirty-two years. His record as a traveling showman is pitiable. At first he was an informative lecturer, carefully explaining his paintings to his audience. Unable to profit from his exhibitions, he resorted to sensationalism, displaying live Indians engaged in war dances, scalping ceremonies, and so on. Eventually he went bankrupt and lost his Indian Gallery to creditors. His wife and son died, and his three daughters were sent back to America because he could not support them. He returned to the United States in 1871 and died in Jersey City the next year, a broken man.

Catlin's efforts to profit from his Indian Gallery colored later generations' views of him. He became widely seen, as one museum director says, as "an emblematic exploiter of native peoples, . . . a cultural P. T. Barnum, a crass huckster trading on other people's lives and lifeways."

True, he was an entrepreneur whose tactics were suspect. But he produced remarkably sympathetic portrayals of Native American culture. His paintings put the lie to the racist assumptions of his era. The natives in his characteristic portraits do not look ignorant, backward, or brutal. Instead, they have calm nobility; their faces radiate courage, solidity, and wisdom. Their tribal costumes, jewelry, and weapons are depicted with compassion. Catlin's 1838 portrait of Osceola, the betrayed Seminole chief, is one of the great portraits of the day, showing both pain and majesty in the face of a man who became the chief symbol of the tragic consequences of Indian removal.

If Catlin brought dignity to Native Americans, another genre painter, William Sidney Mount, featured average rural folk—black and white—in ennobling paintings. Mount was born in Setauket, a country village in northeastern Long Island. In his teens, he went to Manhattan, where he illustrated signs. By the late 1820s, he was producing historical paintings like *Christ Raising the Daughter of Jairus* and *Saul and the Witch of Endor*. In 1830 his genre painting *Rustic Dance after a*

George Catlin, Osceola

Sleigh Ride won a New York art competition. This painting portrayed country types in rough clothes gathered for a dance. Mount had found his niche. Over the next two decades, he produced many other genre pieces with descriptive titles like *Dancing on the Barn Floor*, *Haying Scene*, *Raffling for the Goose*, *Catching Rabbits*, and *Dance of the Haymakers*. Although indebted to foreign genre painters like Sir David Wilkie and William Hogarth, Mount chose American subjects and came to be known as a distinctly native artist. "The paintings of W. S. Mount," commented one reviewer, ". . . are of a strictly national character; the pride and boast, not only of his native Long Island, nor yet of the state of New York, but of the whole country."

A committed Democrat, Mount reflected the populist side of the Jacksonianism. His goal, he said, was to "paint for the many, not the few." He explained, "I must paint such pictures as speak at once to the spectator, scenes that are most popular, that will be understood on the instant." Even before Durand, he painted outdoors, inventing a portable studio for mobility. With a democratic openness to all experience, he declared, "A painter's studio should be everywhere; wherever he finds a scene for a picture indoors or out"—in the blacksmith's shop, at camp meetings or horse races, in a church or at a theater, in dens of poverty, "wherever you may happen to be thrown."

As a Democrat, Mount disliked abolitionism and tolerated slavery. When the antislavery Republican Party arose, he dismissed its members as "Lincolnpoops." Nonetheless, Mount stands out among his contemporaries for his sympathetic portrayal of African Americans. "His heads of Negroes," remarked a reviewer, ". . . are the finest Ethiopian portraits ever put upon canvas." Several of Mount's paintings imagine a rural utopia of racial bonding. In *Dance of the Haymakers*, a black boy beats a barn door with sticks as two white farmers dance happily, with a black woman smiling down from a hayloft. *The Power of Music* includes a large, handsome black man listening gleefully as a white farmer plays a fiddle in a barn, with two other whites also listening. In *Farmers Nooning*, a huge black man sleeps on a haystack as four others, three white men and a

white boy, relax around him in the shade of a tree. *Eel Spearing at Setauket* is remarkable not only for its luminist translucence but also for its portrait of racial harmony. It shows a black woman standing large on a skiff steadied by a white boy in the stern, with a simple, lovely landscape in the background. The tans and browns associated with the woman meld with the colors of nature, creating a sense of unity enhanced by the perfect mirroring of the hills and trees in the water.

To be sure, Mount's racial utopias ignore the horrors of slavery and prejudice in America. But, like *Uncle Tom's Cabin* or Walt Whitman's poetry, they explore the common humanity of blacks and whites and thus make a political statement of their own.

The Jackson devotee Mount was not the only American who produced important genre paintings of American folk life. A Missouri Whig, George Caleb Bingham, did so as well. Born in Virginia in 1811, Bingham moved with his family to Franklin, Missouri, when he

William Sidney Mount, Eel Spearing at Setauket

was seven. His father, a tobacco farmer, owned slaves. Bingham later turned against slavery and became a free-soil Whig. He apprenticed as a sign painter and cabinetmaker before earning a living by painting portraits of his Missouri neighbors, most of them from leading families. By the early 1830s, he had earned enough to go on the road. He toured eastern cities like Philadelphia and Washington, where he honed his artistic talents and also grew disgusted by what he called the "mobcratic influence" of Jacksonian democracy. Like Cole, he saw Jackson as a tyrant who had destroyed liberty and had unleashed the ignorant masses. Bingham campaigned for Harrison in 1840 and painted election banners for Clay in 1844. Bingham ran for the Missouri state congress, losing in the election of 1846 but winning two years later. As a politician, he fought against Democrats and against slavery extension.

Just as the Whigs during Harrison's Log Cabin campaign had co-opted Jackson's common-man appeal, so Bingham in the 1840s shared the spotlight with the Democrat Mount as a painter of rural folk. Tired of painting portraits, Bingham became intrigued by Mount's style and decided to portray Missouri raftsmen, traders, and trappers in their native habitats and daily activities. Between 1844 and 1848, he painted *Fur Traders Descending the Missouri*, *The Jolly Flatboatmen*, *Raftsmen Playing Cards*, and many other genre paintings that established him as the Artist of the West or the American Artist. The New York Art-Union, a lottery that distributed paintings and prints to its ten thousand members, buttressed Bingham's fame by selecting a total of twenty of his paintings for nationwide circulation before its demise in 1852. Like Mount, Bingham brought an egalitarian freshness to genre painting, capturing the frolic and camaraderie of common people in the Missouri River Valley. In a typical work, *The Jolly Flatboatmen*, Bingham creates a colorful pyramid of boatmen, one of whom dances joyously with arms raised as two comrades play fiddles and five others relax and watch. Experimenting with luminist effects, Bingham often coupled sharply detailed foregrounds with soft, light-filled backgrounds, showing reverence for both the real and the ideal.

George Caleb Bingham, The Jolly Flatboatmen

Whereas Mount and Bingham created refreshing rural scenes, another major genre painter, John Quidor, reveled in the dark and grotesque. Based in New York City, Quidor was closer to the turbulent urban streets than were the other genre painters. While he was in his twenties, he opened a studio in the squalid Five Points area of Manhattan. An alcoholic, he eked out a living by painting designs for stagecoaches and fire engines. He was surrounded by b'hoys, tough types who brawled and chased fire engines. He befriended John Browere, the muscular, streetwise sculptor who snubbed the Whig art establishment. Quidor himself tried without much success to gain inroads into that establishment. In the early 1840s, he spent several years in Quincy, Illinois, and then returned to New York, where he died, indigent and unappreciated, in 1881.

Quidor produced some thirty-five paintings, about half of which

were based on the writings of Washington Irving. Quidor found bizarre, grotesque potential in many scenes that Irving had handled moderately. In *Ichabod Crane Flying from the Headless Horseman* (1828) he portrays a terrified horse and rider flying through a Gothicized landscape of broken trees, massive rocks, and eerie moonlight. His *The Money Diggers* (1832), based on an Irving tale in which three men searching for buried treasure are frightened by a pirate's ghost, highlights terror through weird body positions and stark contrasts of light and dark. *Anthony Van Corlear Brought into the Presence of Peter Stuyvesant* (1839) features bulging bodies in odd postures; its brutish excess is accented by a howling dog and a grimacing black man.

Besides giving a Dark Romantic answer to Enlightenment rationalism, Quidor channeled into art some of the wilder energies of the era. These energies are even more explosively felt in some of the popular art of the day, particularly in illustrations for frontier humor and city-mysteries novels. Some of these illustrations are so bizarre as to be called presurreal. Lippard's *The Quaker City* has several wacky woodcuts, including one of a man seated in a coffin with hair streaming as he floats down a river. The Crockett almanacs abound in pictures with a distorted, nightmarish quality. One shows a huge fly, wearing a hat and a fishing bag; the fly is fishing and has caught a tiny human being, who is frantically swimming at the end of the hook. Another features an ax-wielding hog and two standing fish with human heads surrounding a man on a chopping block. In another, the frontier screamer's voice is pictured as a jagged geometrical object extending from his mouth. This mixture of different realities shows a presurrealistic style surging from the heart of Jacksonian popular culture.

* * * *

THESE BIZARRE ILLUSTRATIONS WERE part of Americans' interest in the freakish, the weird, or the bombastic. Popular performances, from exhibitions of oddities through minstrel shows and even high theater, emphasized the curious and the exaggerated.

Freaks held a special allure for Americans. P. T. Barnum, who emerged in the mid-1830s, was an outgrowth of hucksters who for years had earned countless dimes and quarters by exhibiting oddities. In 1818 Scudder's Museum in New York presented a Mammoth Child, a four-year-old boy who weighed 122 pounds and stood three foot three—outdone the next year by the so-called American Lambert, age two, who weighed 125 and was sixteen inches around the calf and forty-three inches around the waist. Other spectacles included the Clarke Dwarves, a twenty-year-old girl and her younger brother who both were only thirty-six inches tall, and "the largest elephant ever seen," allegedly weighing four tons. In the 1820s, came Calvin Edson, the celebrated Living Skeleton, who was in his forties and stood five feet two and weighed sixty pounds but could lift over two hundred pounds. In 1832 there appeared at the American Museum a Monsieur Chabert, who could walk into a large oven heated to four hundred degrees, stay inside until he had finished cooking a pan of steaks, and emerge unscathed. He could also swallow boiling oil, inhale arsenic and other poisons, and stand unharmed for several minutes in a Temple of Fire, engulfed in flame.

Barnum made the -est factor an institution by expanding the scope of curiosities. He offered not only the usual odd fare—dwarves, giants, a mermaid, an armless man skilled with his toes, gigantic elephants and snakes, a man who was supposedly half human and half monkey—but also unusual artifacts or people with different customs. He had wax figures illustrating the dangers of intemperance and a working model of Niagara Falls. In 1846 came his immensely popular display "Santa Anna's Wooden Leg, taken by the American Army in Mexico!" Barnum also exhibited three Shaker women whirling in their ecstatic dance. Other regulars at his museum were "Snow White Negroes from Brazil" and Indians performing war games or tribal dances. He also had a theater and a lecture room. Eventually he had some six hundred thousand displays.

Two types of theatrical spectacles Barnum featured, melodramas

and minstrel shows, had a strong popular life of their own. Melodramas had formulaic plots and interchangeable dialogues involving a beleaguered heroine, a noble, imprisoned lover, a pursuing villain, and helpful servants. In 1815 the Park Theatre in New York began the long-running melodrama *Aladdin, or, the Wonderful Lamp*. Other melodramas followed over the next decades, with titles like *Zembuca, or, the Net-Maker and His Wife*, *The Maid and the Magpie*, and *The Carib Chief; and The Mountain Torrent*. Providing a heady mixture of sentiment and adventure, melodramas competed for an audience increasingly attracted by sensationalism. Popular titles included: *The Idiot Witness: A Tale of Blood*; *Blood Will Have Blood, or, the Battle of the Bridges*; *The Cannibals, or, Massacre Island, A Tale of Blood*; and *The Monk! The Mask!! The Murderer!!!* In 1836 a New York newspaper complained:

> We live in times of such intense excitement, that the publick taste is in a measure perverted . . . The legitimate drama is hardly tolerated . . . This is the true cause of the all-absorbing interest now felt in the melo-drama. It is of no importance how extravagance and unnatural a dramatick spectacle may be; the more so the better.

Like melodrama, minstrel shows—humorous performances in blackface—had sensational appeal, though of a different sort. Whereas melodramas developed an adventurous plot, minstrel shows were free-form comedies in which action and dialogue came spontaneously from the shifting relationships between performers and their audiences. Minstrel shows have been called "the only genuinely indigenous form of American drama." They amused nineteenth-century Americans while reflecting their attitudes toward race relations.

Although white performers in blackface had appeared since the eighteenth century, it was not until after the War of 1812 that the dialect and habits of American blacks were consistently mimicked onstage. In 1822 the British actor Charles Mathews attended an all-black play in New York at the African Theater and was struck when the audience

demanded that the Hamlet of the evening stop reciting Shakespeare and sing instead a popular song, "Possum Up a Gum Tree." Russell incorporated this song into his own act, "Trip to America." By the end of the 1820s, a number of white actors had begun to smear their faces with burnt cork, don curly black wigs and ragged clothes, and give acts in purportedly "Negro" dialect. One performer, Thomas Dartmouth Rice, in 1828 saw on the street an old black man who had a high shoulder, a twisted arthritic leg, and a shuffling walk. Imitating the man, Rice gave his first blackface performance as Jim Crow, contorting his body and dancing with a strange hop as he sang: "Turn about an' wheel about an' do jis so, / An' ebery time I turn about, I jump Jim Crow." Within a few years, Rice was internationally famous as Jim Crow.

Minstrel shows arose when several blackface performers came together in a single comic act. The first major group, Dan Emmett's Virginia Minstrels (none of them from Virginia or even the South), performed in New York in February 1843. They were so popular that soon many imitators appeared, including the Kentucky Minstrels, the Ethiopian Serenaders, and the Sable Minstrels. Popular in the eastern cities, especially New York, minstrel acts soon spread nationwide. Professional groups prospered along the Mississippi River and, by the late 1840s, as far away as California. Among the American presidents known to have enjoyed minstrel shows were Tyler, Polk, Fillmore, Pierce, and Lincoln. The minstrel groups billed themselves as representing life among American blacks, both South and North. The Virginia Minstrels typically advertised an evening of "oddities, peculiarities, eccentricities, and comicalities of that Sable Genus of Humanity." Another time they promised "sports and pastimes of the Virginia Colored Race, through the medium of Songs, Refrains, and Ditties as sung by Southern slaves."

The minstrel show featured a so-called interlocutor, a straight man who soberly asked questions or gave directions to the other actors, whose farcical answers punctured his pretensions. The endmen, often called Brudder Tambo and Brudder Bones after the instruments they played, kept the audience laughing. They occupied the first act with

puns, jokes, riddles, and chatter. A tenor sang songs that ranged from the nonsensical to the mawkish. The second act, or olio, brought dances and a comical stump speech. Minstrelsy bred many songwriters, including Stephen Foster, who wrote ditties like "Oh! Susanna," "My Old Kentucky Home," "Camptown Races," and "Old Folks at Home," which became national standards.

The minstrel phenomenon grew in an atmosphere of racial prejudice. Tocqueville noted the prevalence of racial prejudice in America. The black reformer William J. Watkins insisted that "prejudice at the North is much more virulent than at the South," an observation seconded by William Lloyd Garrison, who declared, "The prejudices of the north are stronger than those of the south." The word "nigger" was widely used. As one journalist noted, "Nigger lips, nigger shins, and nigger heels, are phrases universally common."

Minstrel shows promoted, and sometimes celebrated, the common view that African Americans were inferior to whites. A main source of humor in them was the supposedly absurd efforts by black characters to copy the habits or social interests of whites. An attempt by a black man to wear expensive clothes and go to "De Colored Fancy Ball" was considered hilarious, as was his giving a lecture on Transcendentalism or "frenologism." The minstrel actors caricatured black people physically, appearing with wide eyes, gaping mouths, protruding lower lips, stiff woolly hair, and oversized feet.

Still, it's misleading to dismiss minstrels as merely racist. There are many examples in America of the performing arts—later to include jazz, the blues, rock, and rap—being defined by African American culture. Certain aspects of minstrel shows came from actual black experience. Many of the early blackface performers, including Billy Whitlock, Ben Cotton, and Dave Reed, went south and picked up from enslaved blacks dances or songs that they used onstage, revised for comic effect.

Minstrel songs were among the few popular genres that emphasized the humanity of blacks. Slavery and racial prejudice were built on the

spurious notion that blacks were fundamentally different from whites—physically, mentally, and morally. Some Americans accepted the theory of polygenesis, which claimed that whites and blacks were actually of different *species*. Minstrels showed that, far from being subhuman, blacks possessed the same feelings and motivations that whites did. Particularly in the hands of Stephen Foster, the era's most popular songwriter, minstrel songs dramatized a whole range of emotions among blacks, as in such famous Foster compositions as "Oh! Susanna," "Nelly Was a Lady," "Swanee River," "My Old Kentucky Home," "Camptown Races," and "Old Folks at Home."

Also, minstrel shows sometimes expressed subversive political ideas. True, some minstrels gave the message that Southern plantations were happy homes for blacks, who were cared for by protective masters. But this romantic vision of plantations became especially prominent in the 1850s, after tensions over slavery had become so intense that any rebellious suggestions were considered dangerous. Earlier, in the 1840s, the picture that minstrels projected of slavery was decidedly mixed. Enslaved blacks were often shown chafing at the restrictions of slavery. Both the Nat Turner rebellion and the *Amistad* revolt were positively presented in minstrel shows.

The sexual exploitation of female slaves by their masters was a target of minstrel songs, such as one that said, "White man come to take my wife / I up and stick em with a big Jack knife." Minstrels also sometimes protested against the separation of slave families, as in a scene in which an old slave fondly recalls "A happier day of sweeter joys" when he was with his wife and eight children, before his master sold him because, "I'se gitten old." Fantasies of violence against slave-owners sometimes entered the early minstrels' songs. In one song, a black man describes his master being devoured whole by an elephant-sized fly: "Poor mass did scream, de fly didn't care / He eat till de shoe alone war dere." Also, the empowerment of blacks was imagined in Crockett-like skits in which black roarers boasted of supernatural strength. One braggart proclaimed: "My mammy was a wolf, my daddy was a tiger / I'm what you call de ole Virginia

nigger; / Half fire, half smoke, a little touch of thunder / I'm what dey call de eighth wonder."

Other popular music brought militant abolitionism to the musical stage. The Hutchinsons, a family of talented brothers and sisters from New Hampshire, spread abolitionism and many other reforms in rousing songs. The most popular singing group before the Civil War, the Hutchinsons provided an American alternative to the European music that flooded the nation in the 1840s, a transitional time in American musical history. The New York Philharmonic Society was founded in 1842, and the next year the nation went into frenzy over the European superstars who began to arrive. American theaters were recovering from the economic doldrums of 1837–43, and the rapid progress of the transatlantic steamship made travel to America far easier than before. There arrived Ole Bull, the tall, elegant Norwegian violinist; the great Belgian violinist Henri Vieuxtemps; the Irish violinist and piano master William Vincent Wallace; the Swedish soprano Jenny Lind, known as the Swedish Nightingale; and opera stars like the Italian contralto Rosina Pico and the Scottish tenor John Templeton.

The Hutchinsons were inspired by a family singing group from Austria, the Rainers, who with their Alpine costumes and songs initiated a craze for family singing groups. Despite the foreign inspiration, the Hutchinsons tried to carve out a specifically American sound. They avoided singing European airs. Nor did they perform minstrel songs, which they considered proslavery. They wrote much of their own music, focusing on indigenous themes and social issues. The Hutchinsons consisted of three brothers—Judson, John, and Asa—and their younger sister Abby, part of a talented family of thirteen boys and girls from Milford, New Hampshire. Their first New York appearance was in May 1843. With some family members leaving the group along the way and others joining it, they remained popular for nearly four decades, becoming international celebrities, playing to packed houses and befriending notables like William Lloyd Garrison, Frederick Douglass, and, eventually, Lincoln. They had many imitators, most notably the Cheneys

and the Barton family. Walt Whitman called the Hutchinsons and other singing families "simple, fresh, and beautiful," the "starting point from which to mould something new and true in American music."

The Hutchinsons' popularity came not only from their vocal talents but also from the popular appeal of their song lyrics. Their music is an index of antebellum popular culture. The division that we saw in popular literature between the sensational and the sentimental was reflected in their songs, which ranged from thrillers like "The Maniac" and "The Vulture of the Alps" to pious effusions like "My Mother's Bible" and "The Cot Where We Were Born." They also used music to promote popular reforms, as in their temperance ditty "King Alcohol."

Their stirring entrance into the antislavery scene came in 1843 when they sang an abolitionist tune at an antislavery rally led by Garrison and Douglass. Soon they were regulars on the abolitionist circuit. Their pounding antislavery song "Get off the Track!"—about the locomotive Liberty hurtling through America and heralding emancipation—had an astounding effect on audiences. At a typical rally, the response to the song was called "absolutely indescribable," with listeners jumping, waving their arms, and bellowing out the lyrics along with the singers. After the women's-rights movement began in 1848, the Hutchinsons promoted women's suffrage in song. They became the unofficial songsters of the antislavery Republican Party and aided Lincoln by singing at his campaign rallies in 1860.

The enthusiastic crowd reaction to the family singers typified the boisterousness of antebellum audiences in general. In a time of urban mobs and Southern violence—what one historian calls "the turbulent era," referring to scores of riots—the typical theater was clamorous and unruly. For plays, there was a tripartite seating arrangement, with upper-class patrons occupying box seats, middle-class ones on wooden benches in the so-called pit in front of the stage, and working-class types, along with many prostitutes, in the cheaper rear seats, known as the gallery. Those seated in the pit or the gallery smoked, drank liquor, and chewed peanuts, disposing of the shells on the floor (hence the

phrase "peanut gallery"). Tobacco juice flowed, with the floor used as a spittoon. A journalist who listed mock rules for theatergoers said it was de rigueur to "spit all over the floor" and try to "spit so a lake will form at your feet."

There was constant interchange between the actors and the audience. Disapproval of an actor's performance was greeted by hisses, jeers, or objects hurled onstage. Not only was there a lively exchange between the players and the spectators, but there was great variety in each theatrical program. Later generations would bring cultural separation, with one theater presenting mainly classical fare, another musical comedy, and others plays or rock concerts or jazz, and so on. In the pre-1850 period, many genres were typically juxtaposed on the same bill. On a single evening, a Shakespeare play could be preceded by a farcical skit, with song-and-dance routines between acts and a short melodrama or comic act afterward.

New York led the way in the theatrical renaissance—naissance, really—that occurred in this era. The elite Park Theatre, opposite City Hall Park on Chatham Street, originally opened in 1798 and was rebuilt after being ruined by fires in 1820 and 1848. The Bowery Theatre, which appealed to a plebeian crowd, opened in 1825 and gained real popularity when in 1830 the thunder-voiced actor Thomas S. Hamblin took it over. It, too, was reconstructed after burning down four times between 1828 and 1845, after which it survived for eighty years. Other New York theaters included the Chatham, the Broadway, and the National. There were fewer successful theaters in Boston, where Puritan prejudice against plays lingered. Cities with prominent theaters included Philadelphia, Baltimore, Washington, Cincinnati, Louisville, and New Orleans.

A stream of important British actors began coming to America around 1815. At the same time, American actors arose, reflecting the nationalistic spirit of the era. The two most important were Junius Brutus Booth and Edwin Forrest. Booth, a short, wild-eyed Marylander whose sons included the actor Edwin Booth and John Wilkes Booth,

Lincoln's assassin, was a brilliant method actor famous for his complete identification with the characters he played. "When he was in a passion," Walt Whitman commented, "face, neck, hands, would be suffused, his eye frightful—his whole mien enough to scare audience, actors—often the actors *were* afraid of him." Alcoholic and neurotic—THE MAD TRA- GEDIAN HAS COME TO OUR CITY, headlines announced—he sometimes got so carried away onstage that he forgot he was acting. As Othello, he could come so close to actually suffocating Desdemona that other actors had to pull him away, and often as the sword-wielding Richard III he chased Richmond out of the theater and into the streets, once into a nearby tavern where he had to be disarmed.

Edwin Forrest earned his nicknames the Mastodon of the Drama and the Ferocious Tragedian by raising emotional intensity and forceful gesturing to the highest pitch. A thickset man who made his stage de- but in Philadelphia in 1820 and then starred as a blackface performer, he excelled in plays from Shakespeare to cheap melodrama, doubling as a Jacksonian orator. Although he turned down an offer to run for the House of Representatives, he remained close to Locofoco leaders and hoped for "the downfall" of the Whig Party, "whose chief desire," he declared, "seems to be to benefit the few at the expense of the many."

Forrest became the center of a conflict involving international rela- tions and party politics. We have seen that in various cultural areas there was a dichotomy between a conservative, Anglophile tendency, sometimes associated with the Whig Party, and a populist, jingoisti- cally American one, often linked with the Democrats. Increasingly, this division was enhanced by class conflict, with the "upper ten" (wealthy, Whiggish conservatives) pitted against the "lower million." In New York, the latter consisted partly of the b'hoys, or Bowery Boys. Typically the b'hoy was a butcher or other worker who spent after- noons running to fires with the fire engines, going on target excur- sions, or promenading on the Bowery with his g'hal. A subgenre of American plays emerged around the b'hoy. Onstage, the b'hoy was a larger-than-life figure like Paul Bunyan and Davy Crockett. The b'hoy

character was introduced in the 1834 melodrama *Beulah Spa; or Two of the B'hoys*. The b'hoy craze took off in 1848 with Benjamin A. Baker's play *A Glance at New York*, followed by many similar plays, like *Mose in a Muss* and *Mose in California*, many of them with the versatile actor Frank S. Chanfrau in the b'hoy role.

The b'hoys affected not only the content but also the performance of plays. The arrival of leading British actors elicited a mixed response from American theatergoers. There developed a contrast between a restrained, elitist British style of acting, which in its most conservative form featured an actor standing with one hand on a hip while making circular motions with the other, and an American style, linked with ardor and democracy. Whitman described the "American style of acting" as "the loud mouthed ranting style—the tearing of everything to shivers." The b'hoys and others in the working class sided with the American style, cheering visceral actors like Forrest while hissing at the more subtle, studied performers from abroad. An explicitly anti-American remark from a foreign actor provoked outrage among working-class types. The riots that greeted the American appearances of Edmund Kean (1821 and 1825), Joshua R. Anderson (1831), and George P. Farren (1834) were among the stormiest incidents involving British actors who had reportedly criticized America and were shouted down or bombarded when they tried to perform.

These incidents were just minor rehearsals for the collision between the British tragedian William Charles Macready and the American star Edwin Forrest. Enmity between Macready and Forrest had long simmered. A subtle and controlled performer, Macready sniffed at Forrest's acting, saying it had "vehemence and rude force" but lacked "careful discipline." He explained Forrest's popularity by pointing out that "the audiences of the United States have been accustomed to exaggeration in all its forms, and have applauded what has been most extravagant." He insisted that Forrest was spoiled by "the injudicious and ignorant flattery, and facetious applause of his supporters, the 'Bowery lads.'" Forrest, for his part, hissed at Macready during a *Hamlet* per-

formance in Edinburgh in March 1846. Macready responded by de-claring, "I feel I cannot *stomach* the United States as a nation." When he toured America he said of Forrest, "*He is not an artist*. Let him be an American actor—and a great American actor—but keep him on this side of the Atlantic, and no one will gainsay his comparative excel-lence."

Macready became a despised figure among Forrest's working-class followers, who took the occasion of simultaneous *Macbeth* performances by the two actors on May 7, 1849, to show their anger. The rowdies filled the audience at the Astor Place Opera House, jeering Macready so loudly that he could not be heard and pelting him with rotten eggs, vegetables, and even chairs. A number of New York's leading citizens— among them Washington Irving and Herman Melville—signed a document expressing their disapproval of those who had come out in protest against Macready.

On May 10, the date of another scheduled appearance by Macready, a force of citizen militia was posted outside the theater. A horde of nearly twenty thousand surrounded the theater, yelling "Burn the damned den of the Aristocracy!" and "Down with Macready!" and hurling paving stones that smashed the theater's windows. The alarmed militia fired into the crowd. Some twenty-three were killed and over a hundred were wounded in the bloody fray. Macready suspended his performance and was spirited away in disguise, never to return to America again.

The Astor Place Riot was a watershed moment when the explo-sive forces of Jacksonian society collided with the restraining ones of conservative culture. The riot was a cultural manifestation of politi-cal conflicts between the Democrats and the Whigs, arch-opponents under the Second American Party System. At Astor Place, the -est factor was applied to political squabbles that had been gathering in-tensity for years.

7

Party Politics and Manifest Destiny

What is called the Second Party System had taken shape by the mid-1830s. Although neither party had a single economic base, the Democrats successfully promoted themselves as the party of the people, defending average workers against allegedly oppressive corporations like the Bank of the United States. Their opponents, the Whigs, answered that it was "King Andrew" who was oppressive; people's true interests would be served by limiting presidential power and fostering economic opportunity through the American System.

Although both the Democrats and the Whigs promoted entrepreneurship and free enterprise, the former put stronger faith in the decisions of ordinary citizens, unhampered by government or financial institutions they believed were biased in favor of the privileged, while the latter endorsed a controlled economy encouraged and guided by the federal government as well as by the states. Appealing sharply to the working classes, the Democrats also utilized rhetoric of class conflict that was anathema to the Whigs, who saw social classes as economically interdependent and harmonious, not at war with one another.

The presidential election of 1836 began to crystallize the differences between the parties. Andrew Jackson's handpicked successor was his vice president, Martin Van Buren. Balding, with gray-red mutton-chop whiskers and a prominent forehead, Van Buren had an ample paunch that made him look shorter than his five feet six inches. Charm-

ing and astute, he had outmaneuvered several opponents, especially John C. Calhoun, while retaining Old Hickory's favor. Van Buren had long dreamed of being president of the United States, and he was now perfectly positioned to fulfill the dream. The natural Democratic candidate, he was unanimously endorsed at the party's national convention, held in Baltimore in May 1835. His running mate, Richard Mentor Johnson of Kentucky, was not as obvious a choice. Although backed by Jackson for his courage as an Indian fighter, Johnson was surrounded by scandal; he had sired two children out of wedlock with a mulatto woman, and after she died, he had taken another black mistress.

Van Buren ran on the Jackson program of limited government, hard money, fiscal responsibility, and a strong but judicious foreign policy. Although he was from the North, Van Buren took care to avoid offending the South on slavery. His father had had six enslaved Africans on his New York farm, and Van Buren as a boy had owned a slave named Tom. Tom had escaped but was recaptured a decade later, and Van Buren agreed to sell him to his captor. Still, Van Buren instinctively opposed slavery, and later he would lead the Free Soil Party. He took the strict-constructionist stance, shared by all but immediate emancipationists like Garrison, that since the founders had condoned slavery where it already existed, modern Americans should do the same. As he was preparing his presidential run in 1835, he witnessed the dangerous passions slavery stirred up, evidenced by the burning of abolitionist mail in the South and the persecution of Garrison and others by northern mobs. As vice president, Van Buren had taken a middle position on slavery by helping to table hundreds of antislavery petitions in the Senate.

Van Buren's opponents could not agree on someone to run against him. The Whigs did not hold a national convention that year. Instead, candidates were chosen from three different sections. These candidates shared a mistrust of Van Buren, whom they attacked as a sly manipulator and Jackson's lackey, but in other ways they differed. Southern Whigs selected Hugh Lawson White, a proslavery, states'-rights senator from Tennessee. The West chose the Ohio politician William

Henry Harrison, who had been a military hero in the War of 1812. New England went with Daniel Webster, the Massachusetts senator legendary for his oratory. Most Whigs realized that none of these candidates would defeat Van Buren, hoping the election to end in a stalemate and be sent to the House of Representatives, where one of the Whig candidates would be chosen.

That's not what happened. Capitalizing on his strong national organization, Van Buren ran strongly in all sections of the country, while each Whig did well only in his section. Van Buren won 170 electoral votes—far ahead of Harrison's 73, White's 26, and Webster's 14. The popular race was tighter. Just over 50 percent of the popular vote went to Van Buren, which was 15 percent higher than Harrison but only 1 percent above his opponents' combined total.

Van Buren's inauguration ceremony on March 4, 1837, had a special poignancy, since it was also a public farewell for the outgoing president. Jackson had been sick in recent months, and he attended the inauguration against his doctor's wishes. Wan and stern-looking, he stood on the east portico of the Capitol near Van Buren, leaning on a cane as he waved to a screaming horde of well-wishers who had come from all over to see him a last time. Van Buren's inaugural speech was safely banal, offering to carry on the work of his "illustrious predecessor" and to remain neutral on slavery. Calling Americans "a great, happy, and flourishing people," he urged every citizen "to exert himself in perpetuating a condition of things so singularly happy!"

Van Buren's optimism reflected the economic prosperity that had buoyed Jackson's final years in office. Five weeks after the inauguration, that prosperity dissolved. The Panic of 1837 initiated the worst economic depression the country had yet known.

The downturn resulted from various international and native economic developments. In 1836 the Bank of England, fearing a run on its deposits of specie (silver and gold), sharply contracted credit. British companies curtailed their business with America. Foreign demand for American cotton plummeted, cutting cotton prices nearly in half.

Southern planters suffered, and many northern companies associated with the cotton trade failed. The Specie Circular, which mandated that speculators could purchase public land only with hard money, caused a drain of specie from eastern to western banks. In April 1837, world prices suddenly collapsed, creating a run on banks. On May 10, 1837, all banks in New York suspended specie payments; that is, they refused to redeem paper currency in silver or gold. Banks in New Orleans and other cities soon did the same. The specie suspensions caused panic, which in turn led to widespread bank failures. The New York diarist George Templeton Strong said of the banks, "So they go—smash, crash. Where in the name of wonder is to be the end of it?" All told, around 40 percent of America's 850 banks soon were out of business.

Most sectors of the economy slumped. Business failure brought unemployment. By the January 1838, half a million Americans were jobless. The economy then briefly rebounded, but another contraction abroad brought on a second panic in October 1839, leading to four more years of depression. Wholesale prices tumbled, and the nation's money supply shrank. Imports plummeted, as did property values. America would not again see such deep, prolonged economic malaise until the Great Depression of the 1930s.

Predictably, President Van Buren was blamed for the downturn. Whigs insisted that Jackson's reckless policies, carried forward by Van Buren, had wreaked havoc on the economy. What was needed, they argued, was government-sponsored stabilization of the economy through a new national bank. As the "out" party, the Whigs profited politically from the depression, gaining in state elections at moments when it was especially bad.

Van Buren had no plans to resurrect the national bank. Plausibly blaming the panic on the banks that had suspended specie payments, he called for a divorce of the federal government from private banking. In September 1837, he proposed a bill for an independent treasury system, in which public monies would be put into government vaults or

subtreasuries around the country. The second economic downturn, which began in October 1839, gave Van Buren ammunition against the bill's foes. The subtreasury plan, he argued, would free the Treasury not only from unstable banks but also from England's credit, which wavered according to the health of that nation's economy. The government, he maintained, should regulate the nation's gold and silver but not the everyday currency used in commerce. Despite strong opposition, the Senate passed the bill in January 1840. The House followed in June, and Van Buren signed the bill into law on July 4. According to the law, each subtreasury must accept only hard currency and reject any deposits from banks that had suspended specie payments.

In taking the hard-currency stance, Van Buren aligned himself with such radical Democrats as William Gouge and William Leggett. He alienated conservative Democrats and pulled mainstream Democrats toward the Locofocos, a name thereafter applied to the party as a whole. Despite his personal magnetism, Van Buren never aroused popular support of his subtreasury scheme the way Jackson had for his war on the bank. Van Buren did his political work more quietly than had Jackson, through weekly cabinet meetings and maneuvering, not through boisterous rhetoric and bold speeches. As John Randolph had remarked years earlier, Van Buren "rowed to his objective with muffled oars."

Still, in his prudent way, he made a significant impact. Having helped fashion the Democratic Party before and during the Jackson years, he maintained the party line as president, advocating principles that stimulated a lively dialogue between the parties. Though no populist rhetorician, he had average workers in mind. For instance, labor activists had long demanded a ten-hour workday; Van Buren by executive order established the ten-hour day for federal employees. His subtreasury system was abolished a year after he left office but then was revived in 1846, lasting until the Federal Reserve system came into being in 1913.

Van Buren also handled foreign affairs skillfully. Twice he avoided a possible war with Great Britain. Shortly after taking office, he faced a

developing crisis in America's neighbor to the north, Canada. First Lower Canada and then Upper Canada made stirrings for independence from England. By a treaty of 1818, America agreed to be neutral in Canadian affairs. But Van Buren had little control over U.S. citizens who for various reasons—republican zeal, economic motives, or a filibustering spirit—crossed over the boundary and lent their support to the Canadian rebels. Nor could he prevent Canadians from using sections of the northern United States as military bases. Incensed by Americans' involvement in the rebellion, England adopted a warlike tone toward the United States. In late December 1837, British forces captured and sank the *Caroline*, an American steamship on the Niagara River that was being used to transport goods to the Canadian rebels. Van Buren sent to the area General Winfield Scott, who forged a diplomatic solution to the problem. Flare-ups continued, but Van Buren temporarily quelled them by forcefully proclaiming America's neutrality.

A second quarrel broke out in northern Maine over territory that was claimed both by the United States and British North America. The Treaty of Paris in 1783 had left undecided which nation had jurisdiction over some twelve thousand square miles near the Aroostook River in the southern region of the British colony of New Brunswick. When Maine, originally part of Massachusetts, gained statehood in 1820, it continued to grant land to Americans who wished to settle in the disputed area. New Brunswick, meanwhile, claimed the territory as its own. Economic issues were involved, since the area was rich in timber. Conflicts arose over forested tracts.

Late in 1838 it appeared that Maine and New Brunswick were on the brink of a military showdown. Maine readied its militia and received a commitment of $10 million and fifty thousand federal troops from Congress. But Van Buren again sent General Scott, who defused hostilities, though the matter would not be finally settled until 1842. The so-called Aroostook War (also called the Lumberjack's War, the Pork and Beans War, or the Northeast Boundary Dispute) had ended, although some thirty-eight deaths were associated with it.

Texas annexation, a thorny issue left over from Jackson, became an immediate concern after Van Buren took office. After Jackson had recognized Texas's independence from Mexico, Texas hoped to be annexed by the United States. Southern politicians, eyeing additional territory for slavery, strongly urged annexation. But Van Buren knew that an attempted takeover of Texas would almost certainly entail a war with Mexico and would inflame sectional animosities. Shrewdly he diverted attention from annexation by focusing instead on fifty-seven monetary claims against Mexico, several of which were settled during his administration. In August 1837, he publicly announced his opposition to annexation, postponing a major problem that would beset the presidents who immediately followed him.

As with annexation, he steered a middle course on slavery. He won from England compensation for nearly two hundred enslaved Africans who had been freed in the British West Indies, where three American ships carrying them had run aground. He supported an early, mild version of the congressional gag rule that was passed in 1836. This rule meant the automatic tabling of petitions on slavery received by Congress.

If he wanted to quiet discussion of slavery, he also wished to avoid possible conflict over it, as seen in his reaction to the *Amistad* incident. In June 1839 two Spanish slave traders in Havana, José Ruiz and Pedro Montez, seized fifty-three Africans who had been recently shipped from their native land. Ruiz and Montez secured forged papers stating that the Africans were *ladinos*, or Spanish-speaking slaves. Planning to sell the Africans on plantations in eastern Cuba, the slave dealers herded the Africans onto a schooner called the *Amistad*. On the fourth day of the journey, the Africans, led by Sengbe Pieh (translated into Spanish as José Cinque), escaped from their chains and rose up in rebellion, killing the captain and the cook and, after a short battle, taking over the ship. Cinque gave orders to be taken back home to Africa. By day the Spaniards headed east, but by night they directed the ship north, hoping to reach slave territory. Finally the meandering ship was spotted

off Montauk Point on eastern Long Island. The surviving Africans (ten had died during the ordeal) were taken into custody and held in prison in New London, Connecticut, to await further action.

Van Buren was away from Washington when the incident occurred. Members of his cabinet agreed with the Spanish minister in Washington that the United States had no control over the *Amistad* blacks, who should be taken back to Cuba for trial. When Van Buren returned to the capital, he took steps to enforce this plan. Meanwhile, the imprisoned Africans had become a cause célèbre among abolitionists like the Tappan brothers, who funded legal counsel for them. On the advice of their lawyers, the Africans sued for their freedom, claiming that they had never been legally enslaved. Surprisingly, a district court agreed with them. Shocked at the court's decision, Van Buren assigned a federal attorney to argue for the return of the Africans to Cuba.

The case went to the Supreme Court, where John Quincy Adams became the chief lawyer for the *Amistad* rebels. In an eloquent defense, Adams insisted that the blacks never had been enslaved at all and that their revolt was similar in spirit to America's revolution against George III. In a major victory for abolitionists, the Court in March 1841 decided six to one in favor of the Africans, who were set free and subsequently taken back to Africa.

The Native American problem simmered through Van Buren's administration. Van Buren was subject to ongoing criticism from Whigs and humanitarians for his Indian policy, which was the same as his predecessor's. Especially controversial was the treacherous capture of Osceola, a chief of the Seminoles in Florida. Osceola had led a resistance movement against removal to the West, making his point with violent forays against whites. After the Second Seminole War had raged for two years, Osceola in October 1837 was lured to truce negotiations by the U.S. General Thomas Jesup. The peace flag meant nothing to Jesup, who ordered that Osceola be chained and imprisoned in a fort in St. Augustine. There the betrayed chief fell victim to malaria three months later. Before he died, he was visited by the painter George

Caitlin, whose sympathetic portrait of him made him a folk hero even among supporters of Indian removal.

Van Buren tried in vain to uproot the remaining Seminoles. He sent to Florida Colonel Zachary Taylor, who demonstrated the soldierly toughness that would eventually help him win the White House. In December 1837, he had tracked down and defeated a Seminole force at Lake Okeechobee. Soon Van Buren made Taylor the head of the Florida campaign. But two years of skirmishes produced no clear results, and in 1840 Taylor requested a transfer to the Indian campaign in the Southwest. The Second Seminole War sputtered on until 1842, costing the nation the then-formidable total of over $30 million. It was the longest U.S. war between the Revolution and the Vietnamese War.

For another tribe, the Cherokees, Van Buren's policies spelled tragedy. The removal of the Cherokees is one of the most heartrending stories in American history. After the fraudulent Treaty of New Echota squeezed through Congress in 1836, many Cherokees went west, but some sixteen thousand remained on their Southern lands, with two years to depart. Early in 1838 nearly the whole tribe signed a petition asking Congress to revoke the treaty. The petition was futile. Van Buren saw to it that that the May 23, 1838, deadline for Cherokee removal was enforced. He sent thousands of government troops, who rounded up the Indians at bayonet point, herded them into stockades, and looted their property. Many natives died of disease in the government camps. Then came the grueling trek west to the Indian Territory along what in Cherokee was called *Nunna daul Isunyi*—the Trail Where We Cried. Altogether, around four thousand Indians died during the ordeal.

Although Van Buren's removal policies in general received public support, some were horrified by the Cherokee tragedy. In April 1838 Ralph Waldo Emerson wrote Van Buren:

> Such a dereliction of all faith and virtue, such a denial of justice, and
> such deafness to screams for mercy were never heard of in times of
> peace and in the dealing of a nation with its own allies and wards,

since the earth was made. Sir, does this government think that the people of the United States are become savage and mad? . . . Will the American government steal? Will it lie? Will it kill?

Other aspects of the Indian program went more smoothly, though never without pain. Van Buren negotiated the removal of the Foxes, Sauks, Potawatomies, and Winnebagoes with little expense and trouble. He also kept in check tribes in the West who attacked whites and sometimes each other.

Policing the natives meant increasing the number of garrisons in the West, which in turn raised the larger issue of the size of America's armed forces. Van Buren recommended that two lines of new forts be established within and beyond the Indian Territory. He agreed with his secretary of war, Joel R. Poinsett, that the American frontier elsewhere—in the North, the East, and the South—must also be militarily strengthened. He persuaded Congress to pass an appropriations bill increasing the regular forces from around eight thousand to over twelve thousand and boosting the military in other ways as well. Even this increase did not

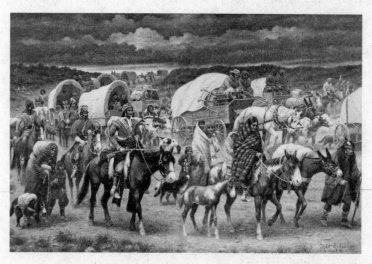

Robert Lindneux, The Trail of Tears

promise to cover the nation's military demands. Poinsett proposed a plan by which state militia throughout the nation would be trained by federal troops and then placed on reserve in the case of a national crisis. But the plan met immediate opposition because of republican fears of a large standing army under the control of the president. Realizing that the militia scheme would hurt him politically, Van Buren quietly dropped it.

Joel Poinsett typified the capable men in Van Buren's cabinet. A Southerner with varied governmental experience—as minister to Mexico he had brought home the Christmas flower that bears his name, the poinsettia—he laid the groundwork for the Smithsonian Institution by founding the National Institution for the Promotion of Science, devoted to studying some of the specimens brought back from the world tour of Charles Wilkes's United States Exploring Expedition. The expedition itself had been overseen by another able cabinet member, Secretary of the Navy James Kirke Paulding. A Knickerbocker author from Tarrytown, New York, Paulding had a long history in the naval service that reached back to the Monroe administration. He accepted Van Buren's appointment as Navy secretary after another Knickerbocker author, Washington Irving, rejected it. A proslavery Northener, Paulding tightened discipline in the Navy, directed America's five regular squadrons, and introduced the first steam frigates to the Navy. The scientific exploring expedition, preparations for which had been bungled for two years by his inept predecessor Mahlon Dickerson, successfully started under Paulding. Leaving Norfolk in August 1838, it circled the globe in four years, traveling more than eighty thousand miles and making landmark discoveries, including that of a new continent, Antarctica.

The Van Buren administration had other achievements as well. The Postal Department profited from the able direction of Amos Kendall, who increased the number of America's post offices from 12,097 in 1837 to 13,468 in 1840 and postal mileage from around twenty-six to thirty-six million miles while keeping postage rates in check. The one great exception to the overall success, of course, was the revelation of long-term corruption in the New York Custom House. Van Buren had

initially opposed Jackson's appointment of the shady Samuel Swartout as New York's Customs Collector. When Swartout disappeared to Europe after his $1.25-million defalcation came to light, Van Buren pointed out that most of Swartout's thefts had occurred under two financial systems he firmly opposed: the national bank and the pet bank system. But the president could not escape the obloquy of Whigs like the young Illinois congressman Abraham Lincoln, who declared that the Democrats' economic operations were shot through with "fraud and corruption."

Still, as the 1840 election approached, Van Buren had reason to be confident of reelection. He had consolidated the Democratic Party. He had averted war and subdued sectional tensions. He had run a tight financial ship with the assistance of generally skilled administrators. In his view, he had put the nation on a course toward economic recovery by divorcing the government from banking.

He did not seem to recognize the depth of the nation's crisis. A much later Democratic presidential candidate would heed advice that should have been shouted in Van Buren's ear: "It's the economy, stupid!" Despite the small upturn in the middle of Van Buren's term, the nation had never seen such hard times as it did under him. It was difficult for many Americans to fathom the withdrawal of the government's money from many banks at a time when money was in such short supply. The Whig arguments for an expanded currency, relaxed credit, and governmental participation in everyday finance made sense at a time when scarcity reigned.

The Democrats' largest base was among rural and urban workers. The Whigs appealed mainly to business interests in the North and plantation owners in the South, but also to some sectors of the working class. Neither party was wholly "the people's party," though the Democrats had seized this image. The Whigs believed in government control of the economy through some version of the American system. They tended to be affiliated with movements like temperance, prison reform, nativism, and antiprostitution. Their position on slavery was divided between the

abolitionism of so-called Conscience Whigs in the North and the pro-slavery Cotton Whigs of the South. Most believed in governmental noninterference with slavery.

The Whigs were such a diverse assortment of groups that it wasn't easy for them to choose a presidential candidate. Two evident choices were the legendary statesmen Daniel Webster and Henry Clay. Both had vast political experience, and both had long been the leading challengers of the Democrats. But both had liabilities. Each seemed like a sectional candidate. Webster, the New Englander, for many remained associated with Northern interests and bygone Federalism. After a vigorous early effort, he dropped out of the race when he alienated many by saying he would resist "anything that shall extend the slavery of the African race on this continent," such as the annexation of Texas.

Clay had broader appeal than Webster but also had enemies in the party. Even though he owned slaves, he was president of the American Colonization Society and was suspected of abolitionist leanings. He answered such suspicions with a speech in February 1839 in which he blasted abolitionism. Still, ardent states' rights Southerners mistrusted his nationalism. He was also opposed by some antislavery Whigs in the North, especially the powerful New York contingent of Thurlow Weed, Horace Greeley, and William Henry Seward.

Then there was the issue of the national bank. As the enthusiasm for Jackson's war on the bank had shown, most Americans had little affection for the Bank of the United States. No politician was more closely linked with a national bank than Clay, who thus was open to the charge of supporting an unpopular institution.

The Whigs needed a candidate untainted by the messy anti-Jackson squabbles of the previous decade. Two military men, Winfield Scott and William Henry Harrison, emerged as the leading contenders. The physically imposing Scott (he was six feet five and eventually weighed over three hundred pounds) had a distinguished record as an army officer reaching back to 1808. Vain, hot-tempered, and arrogant, but a superb general, he always appeared in full regalia, his heavy face fixed

in a stern scowl. His two nicknames, the Grand Old Man of the Army and Old Fuss and Feathers, summed up his contradictions.

Harrison was a more conventional figure than Scott. Genial and unassertive, he came from a distinguished Virginia family. Having attended Hampden-Sydney College and the University of Pennsylvania, he had left the study of medicine and joined the army. He fought in the Northwest Indian War and then served for twelve years as the governor of the Indiana Territory, where he negotiated the takeover of Indian territory, often plying the natives with alcohol to win land. During the War of 1812, he gained fame in a battle near Tippecanoe Creek, where he repelled a surprise attack by followers of Tenskwatawa (aka the Prophet), the brother of the rebellious Shawnee chief Tecumseh. The Battle of Tippecanoe was more a draw than a victory—Harrison suffered around 180 casualties, his opponents perhaps 130—but was symbolically important, because the Prophet, who had previously proclaimed himself invincible, fled to Canada, ending Tecumseh's dream of a great alliance of Indian tribes. In the fall of 1813, Harrison's forces defeated Tecumseh himself at the Battles of the Thames. Harrison's

William H. Harrison

exploits led to his being appointed commander of the Army of the Northwest.

In the three decades after the war, Harrison had a sporadic political career, representing Ohio in the House and the Senate before serving as a clerk in a Cincinnati court. Tall and slender, Harrison had close-set eyes, a large nose, a weak chin, and dark hair that he brushed forward.

Harrison's name became prominent in the Whigs' national convention, held in Harrisburg, Pennsylvania, in December 1839. In the initial balloting, Clay won 103 votes to Harrison's 94 and Scott's 57. Reshuffled loyalties caused large blocs to go over to Harrison, who in the end beat Clay by 58 votes and Scott by 132. Clay was deeply bitter, his dream of the presidency again in shambles. "My friends are not worth the powder and shot it would take to kill them," he grumbled. "I am the most unfortunate man in the history of parties." Soon, though, he reconciled himself to the defeat, deciding that as a senator he would wield great influence over Harrison. The Whigs' motives fed into his plans. The Whigs argued that the executive branch of the government had become despotic under Jackson and Van Buren and that the legislative branch should have greater power. In his senatorial seat, Clay believed, he could hold sway over a Whig president.

To undermine the Democrats' claims of being the party of the people, the Whigs fancifully painted Van Buren as a pampered aristocrat, insisting that he lived in decadent excess at a time when the rest of the nation faced pinching scarcity. The Pennsylvania congressman Charles Ogle gave a long speech, "The Regal Splendor of the Presidential Palace," describing the expensive furniture, massive gold-framed mirrors, gleaming silverware, precious china, and fancy dinners in the Van Buren White House. The degenerate Democrats, Ogle said, had gone so far as to create landscaped hillocks on the White House grounds in the shape of women's nipples. Tens of thousands of copies of Ogle's speech, known as the Golden Spoon Oration, circulated around the country as a campaign pamphlet.

The contrast between the allegedly dandified Van Buren and the

plain Harrison became even sharper when the Democrats unwittingly gave the Whigs a potent campaign weapon. A Baltimore newspaper wrote of Harrison, "Give him a barrel of hard cider, and settle a pension of two thousand a year on him, and my word for it, he will sit the remainder of his days in his log cabin by the side of a 'sea coal' fire, and study moral philosophy." Democratic journalists around the country gleefully reprinted the gibe, thinking they were hurting Harrison. But Harrison's followers seized the remark as a badge of honor.

The log cabin was an ideal image for the Whig Party, which struggled to escape the charge of being elitist. Log cabins sprouted as prolifically as had hickory poles during Jackson's presidential runs. Harrison's supporters often built actual log cabins at their rallies, sometimes bringing in a raccoon, a bear, or another wild animal to enhance the frontier effect. Spiked cider was frequently served. In New York, the Whig editor Horace Greeley fanned the Harrison flame in his newspaper, the *Log Cabin*. There were log cabin pins, log cabin posters, and songs with verses like this:

> In the White House, Van Buren may drink his champagne,
> And have himself toasted from Georgia to Maine,
> But we, in log cabins, with hearts warm and true,
> Drink a gourd of hard cider to Old Tippecanoe.

The Log Cabin campaign represented what would become a common phenomenon in American politics: the triumph of illusion over reality. In the twisted melodrama of the 1840 race, Van Buren, the self-made son of a humble farmer and tavern keeper, became a dissipated lord, while Harrison, scion of Virginia's ruling class, became a plain frontiersman. The son of Benjamin Harrison—a signer of the Declaration of Independence, member of the Continental Congress, and later governor of Virginia—William Henry Harrison was raised on the sprawling Berkeley Plantation, one of the grand estates of Virginia. In recent times he had lived on a three-hundred-acre farm in North Bend, Ohio. His house there had once been a log cabin, but he

had converted it into a sixteen-room mansion. He still had family at the Virginia plantation, which he visited frequently.

But in an age of hoaxes and nostrums—a time when, as one of P. T. Barnum's competitors said, "There's a sucker born every minute"—the Log Cabin was an easily swallowed distortion. It gave the Whig campaign an inevitability symbolized by huge leather balls pushed from town to town by Harrison's supporters, an activity that gave rise to the popular line "Keep the ball rolling."

Harrison's running mate, John Tyler, was an odd choice for the Whigs. Once a strong Jackson supporter, he had opposed Old Hickory's handling of the nullification crisis and the war on the Bank. Still, Tyler did not espouse several of the causes, such as the American System or evangelical reforms, that drove many other Whigs. Like Harrison, he was raised on a Virginia plantation. He attended the College of William and Mary, took up the law, then entered politics. After five years in the Virginia state legislature, he served in the House of Representatives and later in the U.S. Senate, with a term in between as governor of Virginia. Apparently the Whigs saw him as him a safe candidate, one who had supported Clay early on and could attract Southern states' rights advocates. Also, his name conveniently gave rise to the alliterative slogan "Tippecanoe and Tyler Too," reminding voters of Harrison's military background.

Campaign ditties abounded. One went:

> We will vote for Tippecanoe and Tyler too,
> Tippecanoe and Tyler too,
> And with them we will beat little Van,
> Van, Van is a used up man.

Another used fanciful rhymes to drive home the plebeian theme:

> Old Tip he wears a homespun coat
> He has no ruffled shirt-wirt-wirt.

But Mat he has a golden plate
And he's a little squirt-wirt-wirt.

Van Buren, for his part, had a vigorous campaign network. So-called Old Kinderhook Clubs arose. If the Whigs had Old Tip, the Democrats boasted of Old Kinderhook, often abbreviated as O. K., as in the slogan, "Down with the Whigs, boys, O. K." Thus another slang expression entered the language. Even though Van Buren did not campaign, he remained confident of victory. His running mate, Richard M. Johnson, remained controversial because of his affairs with black women but stole some of Harrison's military thunder because he had starred in the Battle of the Thames, where he had allegedly killed Tecumseh. "High-cockalorum rumsey dumpsey! / Colonel Johnson killed Tecumseh!" was the Democrats' reply to the Whig jingles about Tippecanoe.

A third contender in the 1840 race was James G. Birney, who represented the new Liberty Party. A Kentuckian who had also lived in Alabama, Birney had inherited from his father twenty-one slaves but freed them because he was convinced of the sinfulness of the South's peculiar institution. Birney had split with the Garrisonian abolitionists over the question of the American Union. Garrison, disdaining the Union, thought that the North should secede from the South and become a separate nation. Birney and his followers in the Liberty Party wanted to initiate a political process that would maintain the Union while eradicating slavery. In 1840 the party still dreamed of abolition. Within a few years, it moved toward the more moderate goal of containing slavery by halting its westward expansion.

The turnout on election day was exceptionally strong. Voter participation, which had stood at 58 percent of eligible voters in 1836, reached an astonishing 80 percent in 1840, setting a pattern for high turnouts that continued through the nineteenth century. Although the Log Cabin hoopla contributed to the excitement, recent historians have shown that it was the mass hunger for economic reform that brought out voters in unprecedented numbers. The Whigs surged to victory.

Harrison won 234 electoral votes to Van Buren's 60. The popular race was tighter, with 53 percent of the voters going for Harrison, 47 percent for Van Buren, and 0.3 percent for Birney, the Liberty Party candidate. But the electorate's mandate for change was certain. The Whigs triumphed in congressional races, beating the Democrats 133 to 102 in the House and 28 to 22 in the Senate.

The Whigs, however, were not destined to see a Log Cabin presidency—whatever that may have brought. Harrison, at sixty-eight the oldest American president before Ronald Reagan, died after a month in office. Harrison had defied his age. He was the first American presidential candidate who campaigned directly on his own behalf. On inauguration day, he challenged the elements. March 4, 1841, was frigid and blustery. To show soldierly grit, Harrison rode without an overcoat or gloves on a white horse down Pennsylvania Avenue, waving his hat to the thousands who had come to celebrate Old Tip. He had a military escort followed by Tippecanoe Clubs that dragged log-cabin floats decked with cider barrels, coonskins, and other frontier paraphernalia. When he reached the Capitol, he braved the northeast blast, delivering a rambling, hundred-minute oration in which he pledged to serve only one term and to limit his presidential power in order not to interfere with Congress. He then held a public reception in the White House, followed by three inaugural balls in the evening.

The festive atmosphere dissolved before the demands of the presidency. Office seekers hounded him, trying to gain from the new party in power. He had pledged to avoid patronage in making appointments. But his pure motives were difficult to observe when throngs swarmed to the White House with petitions for choice posts. His cabinet was largely suggested by Whig leaders, and he complained that he had little choice in his appointees. Daniel Webster was secretary of state; the portly, intellectual Thomas Ewing of Ohio headed the Treasury; the Tennessee congressman John Bell, an ex-Jacksonian turned Whig, led the War Department; George E. Badger, the Yale-educated North Carolinian who made up in charm what he lacked in experience, was secretary of

the Navy; the gray-haired New York politician Francis Granger was postmaster general; and John J. Crittenden, the brilliant senator from Kentucky, served as attorney general.

It was a distinguished group, but hard to control. The Whigs had planned to curb the president's power by strengthening the Congress and the cabinet. The seemingly pliable Harrison appeared to fit this scheme well. When he took office, his cabinet assumed that he would rely heavily upon its judgments. Although Harrison did consult the cabinet regularly, he chafed under its demands. When Webster, for instance, told him at a meeting that the cabinet had chosen James Wilson of New Hampshire to oversee the Iowa Territory, Harrison announced his own appointee by declaring testily, "William Henry Harrison, President of the United States, tells you, gentlemen, that by————, John Chambers shall be Governor of Iowa."

Harrison also had to deal with the disgruntled Henry Clay. Having rationalized his failure to win the presidential nomination by anticipating great power as a senator, Clay quickly made demands on President Harrison. Clay insisted that Robert C. Whitmore be appointed as collector of the port of the New York, not Edward Curtis, as several cabinet members were saying. Harrison rejected Clay's suggestion. Then Clay recommended that Harrison call a special session of Congress to discuss the economy, hoping to have a public stage for promoting a national bank. Harrison demurred. He put the special session idea up for a cabinet vote and broke a 3–3 tie by casting a negative vote. Furious, Clay felt alienated from the president he had expected to control.

Clay did not have to wait long to try out another president. About three weeks after assuming office, Harrison walked coatless in a freezing rain and caught a cold that soon worsened. On March 27, Harrison's illness was diagnosed as "bilious pleurisy, with symptoms of pneumonia and intestinal inflammation." Doctors administered heroic remedies and patent medicines. A general bloodletting was avoided because of Harrison's advanced age. But to treat his pneumonia, physicians launched the rest of their medical arsenal. Cupping, leeches, blistering, calomel, opium,

brandy, snakeweed—even a Seneca remedy that involved live snakes—
were applied, to no avail. Harrison died on April 4. Reportedly, in his
delirium he mistook his doctor for his vice president and told him at the
end, "Sir, I wish you to understand the true principles of the government.
I wish them to be carried out. I wish nothing more."

★ ★ ★ ★

IN 1841 IT REMAINED unclear, based on the Constitution, whether a
vice president who succeeded a president would fill out the deceased
man's term or just serve as a kind of temporary president until a new one
could be elected. There was considerable debate about this. But John
Tyler was adamant. He was now every bit as much the president as Har-
rison had been, and he intended to govern that way.

His opponents had harsh words about his chance rise to power. To
John Quincy Adams, Tyler was "a political sectarian, of the slave-driving,
Virginian, Jeffersonian school, . . . —with talents not above medioc-
rity"; the presidential seat was now occupied, Adams griped, by "a man
never thought of for it by anybody."

At fifty-one the youngest president up to that time, Tyler was slen-
der and long limbed, above middle height, with auburn hair that grayed
during his presidency, a prominent nose, dull close-set eyes, thin lips,
and hollow cheeks. He was a Whig in name, since he opposed Jackson
and Van Buren, but many of his basic beliefs were Democratic. He had
the courtly manners of a Virginia gentleman. A trained violinist and
wine connoisseur, he enjoyed having guests drink with him in the ex-
ecutive mansion—an expensive pastime, since Tyler received few ap-
propriations from a hostile Congress and had to pay most White House
expenses, even for heating and state functions. Continuing his planta-
tion lifestyle, he surrounded himself with enslaved blacks in the White
House. He had a studied informality that today might be called casual
chic. When Dickens on his 1842 tour met Tyler, he found the president
"mild and pleasant, and his manner was remarkably unaffected, gentle-
manly, and agreeable."

Whig congressmen, especially Henry Clay, thought that the mild-mannered Tyler would be an easily controlled tool. Time told how wrong they were. Harrison had been no pushover, and Tyler was even less of one.

On April 9, 1841, two days after Harrison's funeral, Tyler outlined his goals. He announced that he would work toward a sound currency, a stronger military, and improved relations with foreign nations and Native Americans. Unlike Harrison, he did not rule out a second term. Nor did he mention increasing the power of the cabinet or Congress. Over the next few months, his firmness contributed to a political crisis the likes of which America had not seen.

Although he kept Harrison's cabinet to ensure a smooth transition of power, he made it clear that he did not accept his predecessor's "one-among-equals" arrangement. Webster told him that Harrison made major decisions by casting a vote at cabinet meetings. Tyler rejected this procedure. He said to his cabinet, "I can never consent to be dictated to

John Tyler

as to what I shall do or not do. When you think otherwise, your resignations will be accepted."

In the summer, he sparred with Congress over two new bank measures. He disliked the financial systems of recent times—the national bank, pet banks, and the subtreasury. In July he signed a bill abolishing Van Buren's independent treasury. He knew that the Clay Whigs wanted to revive the Bank of the United States, which he opposed. With his treasury secretary, Thomas Ewing, he devised a plan for a financial institution in Washington that would be controlled by Congress in its role as the governing body of the nation's capital. Branches would be established in states that wanted them.

The latter stipulation enraged some congressional Whigs. If states could accept or reject branches at will, Clay insisted, chaos would result. The Virginia congressman John Minor Botts introduced an amendment to the bill that would make state branches mandatory except in states that specifically voted against them in their first legislative meeting. Congress adopted the Botts amendment and sent the revised measure to Tyler on August 6. For Tyler, the Botts amendment was "supremely ridiculous" and violated states' rights. Ten days later he vetoed the bill.

Clay denounced Tyler in the Senate. The election of 1840, Clay declared, had been a referendum on limiting the president's power and on creating a new national bank. Tyler was ignoring the people's will, exhibiting "pride, vanity, and egotism." His actions, Clay continued, would be considered offensive in private life and took on "the character of crimes, in the conduct of public affairs." The anti-Tyler fire grew when a letter by Botts surfaced declaring that the president was alienating both Whigs and Democrats.

Offended and hurt, Tyler saw that the Clay Whigs were using the bank issue to try to destroy him. But he did not give in. If anything, he grew more stubborn. He now even doubted the Ewing bank plan, which he had formerly supported. As he thought over the plan, he had reservations about a provision allowing state branches to discount prom-

issory notes. His attorney general, Crittenden, came up with a scheme that Congress soon modified. This system called for a central government agency, called a Fiscal Corporation, that would have branches throughout the nation and would not issue discounted notes. Tyler vetoed this bill too, objecting to its automatic creation of state branches.

Tyler said he regretted to be "compelled to differ from Congress a second time in the same session," but his enemies ignored his contrite tone. Clay had rallied forces against the president all summer, and his hostility took effect. In September, Tyler's entire cabinet, except for Webster, resigned. Within days, Tyler had chosen replacements, who were quickly confirmed by the Senate.

The new cabinet, evenly divided between Northerners and Southerners, included several former Democrats who, like Tyler, had become Whigs because they had lost faith in Jackson. Webster stayed on as secretary of state. Tyler assigned the New York politician John C. Spencer to the War Department; the states' rights Virginian Abel Parker Upshur to the Navy; Charles A. Wickliffe, the former governor of Kentucky, to the Post Office Department; the brilliant South Carolina planter-intellectual Hugh S. Legaré as attorney general; and the tariff supporter Walter Forward of Pennsylvania to the Treasury. It was an able cabinet with the exception of Forward, a procrastinator who floundered for two years before John Spencer, moving over from War, replaced him.

Although Tyler had chosen only Whigs for his cabinet, he did not placate his Whig foes in Congress. Two days after he named his cabinet, sixty Whigs adopted a manifesto denouncing him and stating that the party was no longer responsible for his actions. The document charged him with executive usurpation and reiterated the Whig campaign pledge for a national bank, a single-term presidency, and congressional supremacy. Twenty thousand copies of the manifesto were distributed nationally. Whig newspapers hurled anathemas at Tyler, calling him "His Accidency," "Executive Ass," and a man "destitute of intellect and integrity." In December Henry Clay announced his resignation from the Senate.

Tyler was a president without a party. The situation was painful, but it also permitted Tyler to make appointments without worrying about offending a faction. The Whigs liked to portray Jackson and Van Buren as singularly sleazy spoilsmen, a view endorsed by the Whigs' later admirers. In fact, federal offices changed hands at an unprecedented rate during Tyler's presidency. Taken together, Harrison and Tyler, in four years, removed nearly twice as many presidential appointees as Andrew Jackson had in eight years—more removals, indeed, than those undertaken by all the presidents from Madison through Van Buren combined. Including Harrison's appointees, the cabinet between 1841 and 1845 included five different secretaries of the navy, four secretaries of state, four secretaries of war, three attorneys general, and two postmasters general.

Tyler did not shrink from punishing foes or rewarding friends. As he told his treasury secretary, John Spencer, in 1843, "We have numberless enemies in office and they should forthwith be made to quit." Nor was Tyler afraid of possible charges of nepotism. He freely handed out political plums to family members. He gave government jobs to his sons John and Robert, to his son-in-law James Semple, to his nephews John and Floyd Waggaman, to two brothers-in-law, and to the father of his daughter-in-law.

But no matter how many friends or relatives Tyler put in office, he could not get his domestic agenda moving. Congress stymied him at every turn. Shortly after the Whigs expelled him, he had a new idea for a banking system. He and his cabinet discussed a financial institution called the Exchequer Plan, which, unlike the Bank of the United States, would not be a private corporation but rather a government agency under the control of the Treasury Department. Centered in Washington, it would have branches in commercial centers to be determined by Congress. A three-member government board would manage the Exchequer, which, in contrast to Van Buren's subtreasury, would accept both specie and notes. Though sensible, the Exchequer idea pleased neither

national bank advocates nor subtreasury supporters. After many speeches pro and con, Congress killed the plan in January 1843.

The legislative impasse was particularly alarming because it came when the nation was still in a major depression. Bank failures continued. Unemployment worsened. The Treasury had little money. Government salaries went unpaid. When Congress cut off appropriations to the president, the White House became shabby. Its drapes were in tatters and its paint was faded. The grand portico pillars were coated with tobacco juice, the sign of an era when nearly all men, including the president, spat yellowish-brown slime in all directions ("The air of heaven," Frances Trollope wrote, "is not in more general use among the men of America than chewing tobacco"). The White House furniture was in such disrepair that the *New York Herald* called it "a disgrace—a contemptible disgrace to the nation," adding: "Many of the chairs of the East Room would be kicked out of a brothel."

For one group of Americans—those who wanted to move west— conditions were promising, thanks to the Preemption Act (or Land Act), passed by Congress in September 1841. According to this law, squatters who settled on western land for at least fourteen months had a preemptive right to purchase 160 acres at the low cost of $1.25 an acre. This bill gave a great boost to westward migration, setting the tone for the 1840s, the decade that produced the phrase Manifest Destiny. Expansion fever spread. Even the hermit Thoreau, who rarely left Concord, caught the spirit, preferring to head west in his daily walks. "Eastward I go only by force," he wrote, "but westward I go free . . . We go westward as into the future, with a spirit of enterprise and adventure."

Pulled west by the Land Act and pushed by the ongoing recession, Easterners felt a double impetus to seek new lives in an imagined agrarian paradise. More and more looked not to the Great Plains, arid and treeless, but to the fertile lands of California and Oregon, two thousand miles away. In 1841 the New York teacher John Bidwell, along with the wagon master John Bartleson, pioneered migration to the Far West by

leading a wagon train across the Rocky and Sierra Mountains to settle near Stockton, California. The following year, migration to Oregon Country began. Over the next three decades, more than three hundred thousand settlers made the overland journey to the Far West.

Grueling under even the best circumstances, the trek resulted in horror for the group led by the Illinois brothers George and Jacob Donner in 1846. Trapped by blizzards in the Sierra Mountains, the Donner Party ran out of food and resorted to cannibalism to survive until help arrived. Two Indian guides were slaughtered and eaten, and an unknown number of whites were consumed after dying from exposure. The cannibalism was not as extensive as was popularly reported, as by a San Francisco journalist who wrote, "Bodies of men, women and children, with half the flesh torn from them, lay on every side. . . . The daughter was seen eating the flesh of the father—the mother that of her children—children that of father and mother." Still, the torments were real enough. Just over half of the eighty-nine travelers survived the grisly ordeal.

Politically, land preemption raised a key question: What should happen to the monies from western land sales? Most Whigs wanted these funds to be distributed to the states. Democrats opposed distribution, for they feared it would lower the federal government's revenues and therefore cause an increase in tariffs, which had been sinking thanks to the compromise tariff of 1833.

The issue came to a head in the summer of 1842, when the ten-year tariff reduction was scheduled to bottom out at a 20 percent rate. The Congressional Whigs wanted to raise tariffs while providing for the distribution of land revenues. President Tyler, though long opposed to high tariffs, saw the need for a tariff hike. But if rates went above 20 percent, he would not accept distribution, which, he argued, would draw off some of the money raised by the tariff. In June Congress passed a bill calling for both a tariff and distribution. As expected, Tyler vetoed the measure.

Talk of impeaching the president rumbled through Congress. In the

House, John Minor Botts called for the appointment of a committee to examine the grounds for impeachment—the first such action against an American president. Whigs actually wanted Tyler to continue to use the veto power so that he could be charged with criminal usurpation. From Kentucky, Clay, preparing his 1844 presidential run, wrote, "The more vetoes the better now! Assuming the measures vetoed are right."

Congress laid the veto bait again on August 5 when it sent Tyler a second tariff-distribution bill, which, of course, he vetoed. In his veto message, he explained that the tariff and distribution should be treated separately. John Quincy Adams formed a House committee of thirteen that condemned the president and called for a constitutional amendment that would lower the congressional vote needed for overriding a presidential veto from two thirds to a majority. Congress approved the committee's condemnation of Tyler but rejected the override amendment.

Tyler fanned the political fires by writing two letters similar in spirit to the protest message Jackson had sent to Congress in 1834. Tyler denied that he had acted with undue authority. He cited the balance of powers established by the Constitution. None of the three branches of government must outweigh another. As president, he refused to be reduced to a "mere cipher, . . . a piece of wax to be moulded into any shape that others pleased." Brashly, he invited Congress to impeach him so that he could defend himself publicly. As matters stood, he said, "I have been accused without evidence and condemned without a hearing."

Tyler won the game of bravado. Impeachment did not materialize. Congress reluctantly went along with the president, passing separate bills, one calling for a tariff increase to an average rate of around 35 percent, the other for disbursing land monies to the states. Tyler signed the tariff into law and killed the distribution bill with a pocket veto. The tariff had a mixed effect on the economy. Imports sank by about 20 percent. But manufacturing, newly protected by raised duties, rebounded, and federal revenues climbed, wiping out the deficit. By June

1844, the money supply had increased by 14 percent. A recovery was under way.

Economic recovery, it turned out, was not matched by recovery of harmony among the Whigs. John Calhoun, a former Whig who had returned to the Democrats, gloated that the Whigs were in "a sad state of distraction between defeats and vetoes." The Whigs fared miserably in the state elections in the fall of 1842. Whereas in the 27th Congress the Whigs had outnumbered Democrats 133 to 102 in the House of Representatives, in the incoming one they fell to 79 seats, while their opponents climbed to 142.

Rancor and spite governed the lame-duck session of 1842–43. Tyler faced charges of tyranny and venal patronage. John Minor Botts revived the impeachment issue, giving nine reasons why Tyler should be removed, including the "arbitrary, despotic, and corrupt abuse of the veto power" and "wicked and corrupt abuse of the power of appointment to office." Although Congress concluded that such charges would not stick, many doubtless agreed with the New York Whig Philip Hone, who said that Tyler should "serve out his time, and go back to Virginia, from whence the Whigs have bitter cause to lament they ever called him forth."

Even as Tyler fended off congressional attacks, he confronted two international crises involving Great Britain: the *Creole* affair and the Maine boundary dispute. Both cases exacerbated tensions over slavery.

In October 1841, the New Orleans–bound brig *Creole* set sail from Virginia with a cargo of 135 slaves who were being taken south for sale. Several days into the journey, nineteen of the blacks revolted and took over the ship. Their leader was the large, muscular Madison Washington, the ship's cook. A slave-owner and a slave were killed in the fray, and several others were wounded. Madison Washington directed the ship to Nassau Island in the Bahamas. The Bahamian authorities declared that the blacks were free according to British law. They took into custody the nineteen rebels, charging them with mutiny, but soon released them. The United States demanded the return of the mutineers

so that they could be put on trial in America. Secretary of State Webster insisted that the *Creole* was on a legal voyage and that England had wrongly seized property (the 135 slaves) that was still under American jurisdiction.

When England refused to return the blacks, the case set off a fierce dispute at home. Southerners predicted that the *Creole* revolt would spark other slave insurrections. Calhoun declared that if England could take American slaves, it could thereafter confiscate any other kind of property with impunity. In the North, the *Creole* rebellion became a cause célèbre for abolitionists. The Ohio congressman Joshua Giddings used the case to challenge the gag rule in the House when on March 21, 1842, he introduced nine resolutions about the *Creole*. The blacks, Giddings argued, had exercised their natural rights by rising up against the whites. American law no longer applied to the rebels when they were in international waters or on foreign soil.

Incensed by these antislavery resolutions, the House censured Giddings. The disgraced Giddings resigned from the House but soon returned as an antislavery hero when his Ohio district overwhelmingly reelected him. The gag rule was effectively dead, though it was not until December 1844 that it was formally rescinded. The *Creole* matter lingered until 1853, when England gave the owners of the former slaves $110,300 for the estimated amount of their loss.

Under Tyler, England and America reached a significant decision on the boundary between the United States and Canada. Van Buren had quieted the friction over the border issue but had not resolved the matter. When the Whigs took power, war with England was still a real possibility. In 1840 a Canadian sheriff, Alexander McLeod, who boasted he had been involved in the sinking of the *Caroline*, was imprisoned in New York to await a trial scheduled for October 1841. England demanded McLeod's immediate release, threatening war if he was executed. New York's governor, William Henry Seward, replied that McLeod would be tried in due course.

McLeod was eventually acquitted, but conflict with England

erupted again in Maine over the disputed land near the Aroostook River. The Maine legislature asked the state's governor to expel British settlers from the region. By early 1842, three other states joined Maine in calling upon the federal government to intervene.

The last thing the beleaguered Tyler—and the financially strained nation—needed was a war with England. Fortunately, Robert Peel's government set the stage for effective diplomacy by appointing a special emissary, the retired bank owner Robert Baring, Lord Ashburton, who arrived in Washington on April 4, 1842. Lord Ashburton was well disposed toward America. He was married to the daughter of a wealthy Philadelphian, William Bingham. Both he and his wife felt close to Tyler's secretary of state. When Webster had been in London in 1839, he had served as America's legal representative for the Baring Brothers firm, befriending Ashburton in the process. Ashburton and Webster were well positioned to have a meaningful dialogue.

Their discussion, during the long, sultry summer of 1842, led to the famous Webster-Ashburton Treaty (aka the Treaty of Washington), signed on August 9. The treaty divided the disputed Maine land, with 7,015 acres going to the United States and 5,012 to England. The treaty also settled much of the remaining U.S.-Canada boundary, extending along the 49th parallel through the Great Lakes to the Rocky Mountains. Ashburton was liberal with his concession of western lands, which included territory in what later was Minnesota that proved exceedingly rich in iron and other minerals. Oregon, the huge northwest territory claimed by both nations, was left for future negotiations.

The treaty also dealt with slavery. The United States had banned the international slave trade in 1808 and twelve years later made it a crime punishable by death. But the small American navy had difficulty enforcing the ban. Also, America warned England and other nations against searching its ships. As a result, slave traders often shipped slaves under the American flag with little fear of being stopped and searched. Webster agreed to Ashburton's call for a mutual crackdown on the illegal slave trade. The treaty stipulated that England and America would

cooperate in establishing cruising squadrons off the African coast to prevent the exportation of enslaved blacks.

Altogether, the Treaty of Washington was a successful resolution of a difficult problem. Tyler regarded it as an unqualified triumph. If his eighteen months as president had yielded nothing else, he said, the treaty deserved praise "as a set-off to the torrents of abuse so unceasingly and copiously lavished upon me." That is not the way his foes saw it. For Democrats like James Buchanan, the treaty was too soft on England, since it surrendered Maine land that was rightfully America's. For some proslavery Southerners, it was an abolitionist document because of its article about teaming up with England to combat the slave trade.

Tyler's opponents showed their displeasure at a Whig dinner in New York held for Lord Ashburton as he was about to go home. When someone raised a toast to Queen Victoria, everyone stood up in respect. When another person toasted President Tyler, the only ones who rose were Ashburton's party.

Despite the ongoing snubs, Tyler had a right to be proud of his achievements at this time—not only the boundary treaty but also his handling of the Dorr Rebellion in Rhode Island and his response to European intrusion in the Pacific.

The Harvard-educated attorney Thomas Wilson Dorr led a battle against Rhode Island's restrictive suffrage requirements, which dated back to a 1663 colonial charter by which only landowners could vote. Many working-class Rhode Islanders, whose ranks had grown due to immigration and industrialization, did not have the vote. This arrangement favored the wealthy seashore towns while hurting the larger communities. For example, only 6 percent of the population of Providence could vote. After unsuccessfully seeking change from the state legislature, Dorr in 1842 formed a separate ruling body based on his "People's Constitution," which gave the vote to all white males. In response, the regular legislature considered but rejected moderate changes in suffrage, ordering that Dorrites be arrested.

Dorr sought outside help. In May 1842, he went to New York and rallied support among the "b'hoys," urban street types who made up the so-called shirtless democracy led by the pugnacious Mike Walsh. Along with Walsh and others, Dorr returned to Rhode Island ready for battle. Dorr's small group surrounded the state arsenal, setting off two cannon that did not fire. Repelled by procharter forces, Dorr fled the state. Rhode Island's governor, Samuel Ward King, appealed to President Tyler for help.

Tyler took moderate action. He sided neither with the Whigs, who saw Dorr as an anarchic outlaw of the Fanny Wright variety, nor with the Democrats, who championed him as a working-class hero. To quiet the situation, Tyler flexed his military muscles. As the Dorr crisis reached its denouement, he took the first steps toward calling up federal troops and authorizing the governors of Massachusetts and Connecticut to send in militia.

His approach worked. The state legislature expanded suffrage rights. Rhode Island gave the vote to all males who could pay a nominal one-dollar poll tax. Dorr was sentenced to life in prison in 1844 but was released the next year because of widespread sympathy for his cause. His battle had not only extended suffrage but also had sharpened differences between Whigs and Democrats, who had responded so differently to him.

If Tyler handled the Dorr crisis adeptly, he dealt with problems in the Pacific firmly. The Monroe Doctrine demanded European nonintervention in the Americas. What came to be called the Tyler Doctrine extended this policy to the Sandwich Islands. Both England and France showed signs of wanting to annex the islands. The United States felt it had the strongest claim to Hawaii due to American settlement and commercial use of the islands. In December 1842, Tyler made a statement to Congress in which he opposed "any attempt by another power . . . to take possession of the islands, colonize them, and subvert the native Government." By bringing the Sandwich Islands under the

American sphere of influence, Tyler shaped future U.S. relations with Hawaii.

Tyler also opened trade relations with China. By means of the First Opium War of 1842, England had won most-favored-nation status from China. Tyler, to stimulate commerce with China, sent his ambassador, Caleb Cushing, there in 1844. Tyler instructed Cushing to be friendly but not submissive, and in particular to avoid the ritualistic kowtow, which involved touching the forehead to the floor in greeting. Following Tyler's directions, Cushing negotiated effectively and forged the Treaty of Wanghsia, by which China awarded the United States most-favored status and gave it five ports of entry. The treaty also ensured extraterritorality to American residents of China. Americans could now easily satisfy their craving for Chinese goods and, if they wished, live in China while remaining under American jurisdiction.

The extraordinary highs and lows Tyler experienced in office were paralleled in private vicissitudes. Tragedy struck in September 1842 when he lost Letitia, his wife of twenty-nine years. Gentle, pious, and beautiful, Letitia had stayed out of politics, preferring a domestic life. In 1839, at forty-seven, she had suffered a stroke that left her partly paralyzed. Thereafter she rarely appeared in public. When Tyler became president, Letitia moved into the White House along with five of their eight children. The crippled Letitia was confined to a second-floor bedroom until her death. Tyler entertained constantly, his charming daughter-in-law Priscilla Cooper Tyler serving as First Lady.

Several months after Letitia's death, Tyler's life took a happy turn when he met Julia Gardiner, an East Hampton socialite who was visiting Washington with her wealthy father. Three decades younger than Tyler, the twenty-two-year-old Julia had a glowing complexion, gray eyes, and black hair that she wore in buns over her ears. Five feet three, with an hourglass figure, she was wooed by a number of prominent men. Tyler joined the pursuit. Given to sentimental scribbling, he penned romantic poems about her. A talented guitar player and singer,

she set one of his poems to music, producing a song called "Sweet Lady, Awake!"

After seeing each other for a year, Julia and the president were bonded by a painful event. To strengthen the American navy, Tyler had encouraged the development of propeller-driven steam warships with huge guns. The launching of the first of the ships, the USS *Princeton*, was celebrated by a party of over four hundred, including President Tyler, the Gardiners, and many other leaders of government and business. On February 28, 1844, the excited crowd gathered on the ship, which during the day went on the Potomac to Mount Vernon and back to Washington. Amid festivities, groups gathered on deck to witness firings of the *Princeton*'s two mammoth guns, the Peacemaker and the Oregon, which had fifteen-foot barrels and enough power to send a two-hundred-pound projectile three miles.

The last firing of the Peacemaker went horribly awry. The gun's breech exploded, sending shards of scalding iron into the crowd of spectators. Eight were killed, including two members of Tyler's cabinet, one of his domestic slaves, a naval officer, a former diplomat, two seamen, and David Gardiner, Julia's father. Several of the bodies were badly mangled. Nine onlookers were wounded. Apparently, the president and Julia escaped death or injury by chance. They had started to go to the main deck to witness the firing but lingered below to hear a patriotic song when the explosion occurred.

The president comforted Julia and soon proposed to her. On June 26, 1844, the two were married in a secret service held in an Episcopal church in New York. She was a dazzling presence in the White House—the Jackie Kennedy of her day—though some objected to the age difference between her and her husband. Especially uncomfortable was Tyler's oldest daughter Mary, who was five years older than her new stepmother. Julia loved discussing all kinds of topics, from literature to politics. Despite the run-down condition of the executive mansion, she and the president hosted many parties and balls. Early in his presidency, Tyler had purchased Sherwood Forest, a 1,600-acre Virginia plantation

where they settled after he left office, raising seven children and continuing their grand lifestyle.

Even as Tyler's life changed when he met Julia, America changed as result of reforms Tyler introduced. Tyler had vowed to make the nation stronger and more efficient, and in some respects he succeeded in doing so. Despite the freak accident on the *Princeton*, the Navy had a sound record under Abel Upshur. Upshur's effort to modernize the Navy by shifting from sail to steam looked to the future. Upshur expanded the Navy Department, adding twenty-six secretaries to handle the affairs of U.S. sailors, officers, and naval bases. Congress appropriated $35,000 that went toward modernization and the construction of the U.S. Naval Observatory (later the National Observatory).

Another of Upshur's projects, the establishment of a naval academy to match the Army's West Point, got moving after a scandalous incident aboard a navy training brig, the *Somers*. Naval training had long been unregulated, left to the discretion of individual captains. Terrible abuses resulted. Flogging was such a common practice that Richard Henry Dana featured it in his 1839 best seller *Two Years Before the Mast*. The captain of the *Somers*, Alexander Mackenzie, was a typically harsh disciplinarian who used the whip freely. On a training voyage to Africa in the fall of 1842, Mackenzie caught wind of a mutiny plot hatched by sailors bitter over his severity. The leader of the alleged plot was the nineteen-year-old cadet Philip Spencer, the recalcitrant son of the secretary of war, John C. Spencer. Acting on circumstantial evidence, Mackenzie had the young Spencer and two others incarcerated and later hanged. When Spencer's father learned of the executions, he demanded that Mackenzie be court-martialed and tried for murder. Mackenzie was acquitted, and the enraged Spencer took up the matter with President Tyler. Although Tyler said that the verdict must stand, he made a point of never offering a position to Mackenzie again. The *Somers* affair highlighted the need for standardized training, which soon was provided by the U.S. Naval Academy, founded in 1845.

Important reforms also occurred in the Postal Department. The rapid expansion of the nation came with a price for postal delivery. The farther mail had to go, the higher the postage rates. By 1844, it actually cost four times as much to send a three-page letter by U.S. mail from New Orleans to St. Louis as it did to ship a barrel of flour there. Most letters were sent COD, giving rise to cheating. The recipient of a letter, for instance, would quickly read a short message written on the outside of an envelope and then refuse to accept the letter, thereby avoiding payment. Many letters went undelivered. For instance, when Zachary Taylor won the Whig nomination in 1848, he did not know of the victory for weeks, because he refused to pay COD on several official notifications sent to him, and the letters went to the Dead Letter Office in Washington instead.

The inefficiency of the U.S. Post Office became a byword among journalists. England had reduced its postal rates in 1840. America wanted to do the same, but the depression prevented any decrease of revenues. As a result, private mail companies sprang up to compete with the federal postal service. There were three main kinds of private companies: intracity firms, which delivered mail locally; intercity ones, which linked the eastern cities; and, in the west, fast-horse and carriage delivery, anticipatory of Wells Fargo and the Pony Express. Besides offering rates that were as much as 80 percent lower than government rates, the private companies brought innovations like the adhesive postage stamp, prepaid delivery, mailboxes, and home delivery.

By 1843 a senator estimated that half of all U.S. mail was delivered by private companies. For a time, it appeared the federal postal service would go out of business. However, Tyler's postmaster general, Charles Wickliffe, responded intelligently to the crisis. He took note of the practices of the private companies. He had the government buy one of the largest New York firms, the City Dispatch Post. He also helped draft the Post Office Reform Act, which reduced postal rates and instituted some of the practices of the private firms. Passed by Congress on the day before Tyler's term ended, this landmark law went into effect on July 1, 1845.

While the postal department advanced as time passed, the other departments in Tyler's ever-changing cabinet weakened because their leaders were inappropriate or partisan. In the spring of 1843, Webster resigned as secretary of state. The Clay Whigs battered Webster from the start and viewed him as an apostate from the party for sticking by Tyler when the rest of the original cabinet quit. His diplomatic successes, such as the boundary treaty, had received only grudging praise. He still felt close to Tyler but was disturbed by the president's desperate efforts to raise support for another run for office. The gifted Hugh Legaré replaced Webster ad interim while Tyler sought someone else. After Legaré died in June, Tyler moved Abel Upshur from the Navy to the State Department and gave the Navy to the unqualified Massachusetts politician David Henshaw. When Upshur died in the *Princeton* accident, his position was filled by John C. Calhoun, while the Virginia Democrat John Y. Mason took over at Navy. Tyler's cabinet, which originally had consisted of Whigs from various regions, ended up having a strongly sectional slant, as it was made up solely of Southerners, mainly Democrats.

Tyler's Southern connections bring up the question of his attitude toward slavery. Because Tyler served in the Confederate Congress shortly before his death in 1862, it is commonly thought that he was an ardent proslavery fire-eater. That is untrue. He was a nationalist and a peace advocate who earnestly supported the Union until he saw it could not be preserved, at which time he endorsed a powerful Southern Confederacy, which, he hoped, might make the North think twice about engaging in war.

He was born into a family of slaveholders, and he held slaves his entire life. Although he never freed his slaves, he discouraged use of whips and other forms of torture on his plantation. In 1832 he led an effort to stop the sale of slaves in Washington, D.C. He took the Jeffersonian view of slavery as a fundamentally wicked institution that would eventually disappear. First, he thought, it would vanish in border states of the Upper South, such as Virginia, Delaware, and Maryland. Eventually economic forces would kill it elsewhere.

He feared what would happen when blacks were emancipated. Like most people of his day, he thought they could not be successfully integrated into white society. He therefore supported the idea of shipping them out of the country once they were free. To this end, he accepted the presidency of the Virginia Colonization Society in the 1830s. Slavery, he believed, was not worth fighting over. Both fire-eaters and abolitionists were too militant. Leave slavery alone, he thought, and someday it would go away.

Like many slave-owners, he evidently took sexual advantage of his female slaves. In 1841 the abolitionist editor Joshua Leavitt in his journal *Emancipator* published an article saying that Tyler was the father of several mulatto children by slaves on his plantation. Two boys, who called themselves John Tyler and Charles Tyler, confirmed that the president was their father. Allegedly Tyler sold some of his slave children. Although this claim, which a pro-Tyler newspaper vehemently denied, has not been proved with certainty, historians have unearthed compelling circumstantial evidence that supports it.

American blacks lost legal ground under Tyler. The Supreme Court decision in *Prigg v. Pennsylvania* (1842) cracked down on slaves who tried to escape north. The Constitution contained a passage about returning any "person held to service or labor" that was widely seen as a fugitive slave provision; this was one reason the Garrisonians considered the Constitution a hellish document. The Fugitive Slave Law of 1793 had made helping fugitive slaves a federal crime. *Prigg v. Pennsylvania* specified that the federal law superseded state laws regarding escaped blacks. Therefore, all personal liberty laws in the North that favored fugitives were null and void before the national regulation. Although not as harsh as the Fugitive Slave Act of 1850, which stiffened the penalties for aiding fugitives, *Prigg v. Pennsylvania* was a proslavery decision that fueled sectional tensions over slavery, which worsened notably in the early 1840s.

Nothing fueled these tensions more dramatically than the main phenomenon of the decade: westward expansion. Tyler helped ignite the

expansionist passions that led to the Mexican War. Symbolically, the war became a struggle over slavery, endorsed by Southerners who wanted to extend their institution and opposed by Northerners who wanted to halt its spread.

But that is not how Tyler saw the matter. For him, slavery had little to do with expansion. Acquisition of Texas and California, he argued, would benefit the entire nation economically. Instead of dividing the North and South, it would be a unifying force because it would extend America's commercial empire. Climate and geography would settle the slavery matter.

Although Tyler did not make expansion a sectional issue, several members of his administration did. His last two secretaries of state, Abel Upshur and John Calhoun, saw the annexation of Texas as vital to the protection of slavery, which they viewed as a blessed institution. Others close to Tyler who took the proslavery view of annexation were the Virginia congressman Henry Wise, Postmaster General Charles A. Wickliffe of Kentucky, and the second secretary of war, William Wilkins. Between 1842 and 1844, Waddy Thompson, a rabidly pro-slavery South Carolinian, was Tyler's envoy in Mexico, sent there to negotiate a treaty. Another spokesperson of the administration, Duff Green, saw the acquisition of Texas as crucial for preventing the dismemberment of the Union that wicked abolitionists were planning.

The choice of Duff Green as, successively, an unofficial agent to France and a private representative in England was among Tyler's most curious appointments. Green, the former Jacksonian now in the Calhoun camp, was given to rash judgments and inappropriate statements. In his paranoid view, England, having abolished slavery, was plotting to do the same in the United States. It would use Texas to accomplish this dastardly goal. By claiming Texas as its own and ending slavery there, England would create an abolitionist haven to which the South's escaped slaves would flee. Northerners would applaud and perhaps aid England in the scheme. England would thus destabilize slavery and divide the American Union, reaping great benefits in the process.

Tyler pursued expansion, convinced that it would help make America a great world power. He agreed less with the proslavery partisans than with his envoy in England, the moderate Bostonian Edward Everett, or his second secretary of the navy, Thomas W. Gilmer, both of whom wanted Texas for economics and empire building. Late in 1843, Tyler had his secretary of state, Upshur, start negotiating with the Texas chargé in Washington, Isaac Van Zandt, for a treaty of annexation. Upshur was on the verge of finalizing a treaty in February 1844, when he was killed in the *Princeton* accident. Surprisingly, Tyler appointed the Southern spokesman John C. Calhoun to head the State Department. By April, Calhoun had finalized a treaty whereby Texas would be annexed by the United States as a territory, with the right to apply for statehood. On April 12, 1844, the treaty was signed and soon went to the Senate for ratification.

Congressional approval of the treaty was doubtful, given the escalating slavery controversy. It became even more unlikely when Calhoun sent a proslavery letter on April 18 to the British minister Richard Pakenham. In the Pakenham letter, Calhoun linked Texas annexation to slavery. Calhoun argued that blacks were naturally inferior to whites and were far better off as slaves than they were as free persons. Slavery, Calhoun wrote, was "essential to the peace, safety, and prosperity" of the South. By annexing Texas, the United States would strengthen the slave system.

Calhoun's letter inflamed sectional passions in the Senate, where the treaty was furiously debated for three weeks before being voted down, thirty-five to sixteen. Tyler did not give up on the treaty. On June 10 he introduced it to the House, which also failed to ratify it.

The presidential race energized the fight over annexation. Lacking support in either of the major parties, Tyler announced himself as a third-party candidate for reelection with the slogan "Tyler and Texas." Soon he saw that his support was weak, and in August he dropped out of the race. The Democratic front-runner, Van Buren, hurt his own

chances when he published a letter opposing Texas annexation because it would open up new slave territory and bring on a war with Mexico. Suddenly disillusioned with Van Buren, the Democrats sought a fervent proannexationist. They found one in James K. Polk of Tennessee. A longtime congressman who patterned himself after Andrew Jackson—hence his nickname, Young Hickory—Polk was a pragmatic politician who called for "immediate reannexation," since, he said, Texas was originally part of the Louisiana Purchase and had been unfairly lost in the Adams-Onis Treaty of 1819. At the Democratic convention in Baltimore, the Democrats moved away from Van Buren and chose the dark horse Polk on the ninth ballot, with the Pennsylvania senator George M. Dallas as his running mate. The party platform called for the annexation of Texas and of the Oregon Territory.

The Whigs chanted derisively, "Who is James K. Polk?" ignoring Polk's long record in the House of Representatives and his term as the governor of Tennessee. The Whigs felt sure of themselves because Henry Clay was their candidate. Clay, however, faltered unexpectedly. In the summer of 1844, he published two indecisive letters on annexation in an Alabama newspaper. Texas, Clay said, might indeed become part of the United States, but only if the American people made it clear that they wanted it to happen. The decision must await the outcome of the next presidential election. At any rate, the Union must not be jeopardized for Texas. A Clay biographer notes, "Clay's position was consistent throughout—a consistent straddle. No one could be sure from these letters what would be his future attitude toward annexation."

The Whigs' choice of New Jersey Senator Theodore Frelinghuysen as Clay's running mate showed how strongly the reform network called the Benevolent Empire influenced politics in the 1840s. Known as the Christian Statesman, Frelinghuysen was active in reform groups like the American Temperance Union, the American Tract Society, and the American Sunday School Union. He attracted support among nativists.

The number of immigrants in America rose from 902,000 (in a population of 17,120,000) in 1840 to 2.2 million (out of 23,261,000) in 1850, sparking the rise of political nativism, especially in the northeastern cities. Frelinghuysen appealed to Protestants alarmed by the influx of foreigners, who increasingly were Catholic. He also offset the shabby moral reputation of Clay, whom the Democrats lambasted as a debauched tippler, womanizer, gambler, and duelist.

The election was close. Although Polk handily won the electoral race, 170 to 105, he barely took the popular vote, winning 1,339,494 to Clay's 1,300,004. James Birney, running again as the Liberty Party candidate, aided Polk's victory, since he won 2.3 percent of the popular vote, attracting many potential Clay supporters. Clay lost New York by only 5,100 votes. Had he won that state, which cast 16,000 votes for the Liberty Party, he would have triumphed, with 141 electoral votes to Polk's 134. Clay lost by narrow margins in five other states as well. Near-victory was no solace to the Whigs. One of Clay's friends grumbled, "Our strongest man has been defeated by a mere John Doe." Nor did the outcome of the congressional races cheer the Whigs. The Democrats gained control of the Senate and took 143 House seats to the Whigs' 77.

With an expansionist Democrat to succeed him, Tyler felt emboldened to continue his annexation project. In the closing months of his term, he supported a proposal, introduced by the Whig congressman Milton Brown of Tennessee, for a congressional resolution announcing the annexation of Texas as a state, with its southern boundary to be determined later. Such a resolution passed the House on January 25. The Senate amended the resolution, giving the president the option either to approve it or to negotiate a new treaty with Texas. Both chambers had approved the amended resolution by March 1, 1845, three days before Tyler left office. Quickly considering his course of action, Tyler signed the resolution for immediate annexation. For the rest of his life, Tyler boasted that it was he, not Polk, who had initiated the process of

westward expansion that soon made Texas, California, and Oregon part of the United States.

* * * *

JAMES K. POLK WAS BORN in Mecklenburg County, North Carolina, in 1795. The oldest of ten children, he was of Scots-Irish Presbyterian ancestry. His father, Samuel Polk, was a slaveholding farmer who took the family to live in Middle Tennessee in 1806, when James was ten. A sickly boy, James was unfit for the rigors of a farmer's life, and his parents encouraged the development of his mind. James was fascinated with mathematics and the classics, which he studied at the University of North Carolina. He graduated first in his class in 1818 and then worked in the law before entering politics. He was elected to the House of Representatives in 1828. His six terms in Congress included two as Speaker of the House. A committed Jacksonian, he absorbed many of Old Hickory's views on banks, the tariff, Native Americans, and slavery. Along with his brother he purchased a large cotton plantation farmed by slaves. In 1839 he was elected governor of Tennessee but lost elections for the same office in 1841 and 1843. His mentor, Andrew Jackson, pushed Polk to the forefront of the presidential race in 1844 when Van Buren lost ground among the Democrats.

Short and thin, Polk had long hair that he swept back behind his ears. He admired Jackson but had little of Jackson's magnetism. Calm and unimaginative, Polk struck some people as cold—an unfair judgment, since his warmth and compassion sometimes came out, especially in his private relationships. He was an effective though not dynamic speaker. His strongest point was his methodical work ethic. "Though I occupy a very high position, I am the hardest working man in this country," he once said during his presidency, and he may have been right. He typically rose before dawn and worked all day and into the night, sometimes until midnight. He convened his cabinet twice a week, on Tuesday and Saturday mornings, demanding regular attendance. A

James K. Polk

quick learner with amazing attention to detail, he mastered the complexities of the difficult issues he faced. During his four years as president, he took few vacations, leaving Washington only four times.

His work paid off. Polk was one of the few American presidents who accomplished everything he set out to do. When he took office, he announced four goals: to lower the tariff; to renew the Independent Treasury; to win the Oregon Territory from England; and to bring the Mexican province of New Mexico and the territory of California under the control of the United States. He reached all these goals expeditiously and efficiently. His treasury system lasted until the Federal Reserve replaced it in 1913. His tariff reduction may have influenced the economic boom of the late 1840s. By winning the Oregon Territory, he made possible the later creation of Idaho, Oregon, and Washington, as well as the western parts of Montana and Washington. He also acquired another 1.2 million square miles—eventually California, Utah, and Nevada and parts of Arizona, New Mexico, Colorado, and Wyoming—and there-

fore defined the area that would include most of the forty-eight contiguous states. Polk was responsible for adding more territory to the United States than any other president except Jefferson.

His main limitation was that as a slaveholding Southerner who accepted slavery as an unfortunate but natural institution, he failed to take a moral stand on slavery's westward expansion. Had he taken such a stand (for example, by championing the effort to halt the spread of slavery) he might have helped stem a dozen years of political wrangling that led to the Civil War.

Because he was not a known entity, both Democrats and Whigs thought that he would be easily influenced when he assumed office. They were mistaken. Even more than Tyler, he disappointed those who expected him to be tractable. "In any event I intend to be *myself* President of the U. S.," he told a member of his cabinet. He committed himself to a single term, since he did not want politics to control his decisions unduly. He expected the same commitment from his cabinet, appointing only those who had no plan of running for the presidency in 1848. The cabinet he chose was, by and large, a group of conservative Democrats. At State he put the Pennsylvania congressman James Buchanan; at the Treasury, Robert J. Walker of Mississippi; and to head the War Department, New York's William L. Marcy. To please radical Democrats of the North, he gave the Navy to the Massachusetts historian and statesman George Bancroft. His Tennessee friend Cave Johnson was his postmaster general and the Virginia congressman John Y. Mason his attorney general.

Life in the Polk White House was not as festive as it had been under John and Julia Tyler. Whereas the Tylers had made the executive mansion come alive with balls and cocktail parties, the Polks entertained sedately. Sarah Childress Polk, the president's wife of twenty years, was a Calvinistic Presbyterian who forbade dancing and card playing in the White House. But she was a charming First Lady. Black-haired, of middle size and weight, she had gregariousness and a wry wit that contrasted with her husband's humorless reserve. On Sundays he faithfully

attended the Presbyterian church with her, out of respect for her religious views. He had, however, been won over to Methodism during a camp meeting, and on his deathbed he called for the Methodist minister who had converted him, the Reverend John B. McFerrin, who administered the rites of baptism as Polk lay dying.

Polk quickly succeeded in getting several domestic measures passed. Two of his highest priorities were tariff reduction and restoring the Independent Treasury.

An agrarian Democrat in the Jeffersonian tradition, Polk had long fought high tariffs, which he believed favored northeastern manufacturing interests while interfering with free trade and agriculture. His treasury secretary, Robert Walker, examined practices at American ports to arrive at tariffs that would maximize revenue without hampering trade. Walker devised a seven-tier schedule that assigned different duties to various kinds of goods. Luxury items like alcohol and tobacco received the high rate of 75 percent. Manufactured goods like glass, paper, cotton, and iron were protected at 35 percent; raw silk, wool, and so forth, at 25 percent; and then down a graduated scale to 5 percent for other categories. Overall rates dropped from the 35 percent of the 1842 Whig tariff to an average of 25 percent.

Congress debated the Walker Tariff in the spring and early summer of 1846, with most Whigs opposing its reductions and most Democrats supporting them. Slightly revised, the bill passed in July. The lowered duties went into effect on December 1 and remained for eleven years, becoming the longest-lasting rate schedule of the nineteenth century. Polk called the tariff "the most important domestic measure of my administration." Related to the tariff reduction was the Public Warehouse Act, which also passed in 1846. This bill, a version of a successful one in England, permitted merchants to store imported goods in government warehouses for up to a year before paying duties on them.

Both the Walker Tariff and the Warehouse Act may have contributed to the robust economy of the post-1846 decade. The nation's money supply, which had bottomed out at $160 million during the re-

cession, rose steadily, quadrupling by 1855. Helped by crop failures abroad and the potato famine in Ireland, which spurred demand for American farm products, the tariff stimulated trade and increased government revenue.

The question was how to bank this revenue. After Tyler had vetoed the Whig bills for a national bank, a version of the unpopular pet bank system had gone into effect, with government monies deposited in banks around the nation. Polk despised both pet banks and the national bank. Reminiscent of Van Buren, he wanted a complete divorce of the government from private banking. Polk proposed a revival of the Independent Treasury, which the Whigs had abolished in 1841. Government deposits, consisting solely of specie, would be held in the Treasury in Washington and in independent subtreasuries in certain cities. Congress passed Polk's subtreasury bill in August 1846. Except for a brief revival of the national bank during the Civil War, the Independent Treasury, with minor modifications, lasted until the advent of the Federal Reserve System under Woodrow Wilson.

Although government revenue increased, Polk did not go along with Whig demands to spend it on internal improvements. A strict constructionist, he saw no warrant in the Constitution for federal funding of transportation projects unless they were necessary for national defense. Twice during his term Congress passed measures calling for appropriations to improve America's rivers and harbors. Polk vetoed both bills. His veto messages, reminiscent of Jackson's message about the Maysville Road, explained that the national government must not be involved in local projects, no matter how worthy. He suggested that individual states raise funds through tonnage duties and other strategies.

The Democrats' victory in 1844 had been a mandate for moving forward with the annexation of Texas, as Polk emphasized in his inaugural address. Polk set about enforcing the congressional resolution for annexation Tyler had signed. He sent commissioners to Texas to arouse support there for annexation and to establish the state's southern and western boundary as the Rio Grande, instead of the more northern

Nueces River. Relations with Mexico steadily worsened. When the resolution for annexation passed, the Mexican minister to Washington, Juan N. Altmonte, asked for his passport and went home. Mexico showed signs of preparing to invade Texas. In June 1845, Polk moved General Zachary Taylor, stationed in Louisiana, to Texas and ordered a naval buildup in the Gulf. The president warned that no invading army would be allowed "to occupy a foot of soil East of the Rio Grande."

With a force of 1,500, Taylor took defensive positions near San Antonio and Corpus Christi to deter a large Mexican force that reportedly planned to move across the Rio Grande. The invasion did not happen immediately. During the summer, Texas accepted America's terms for annexation. In December Congress admitted Texas as the twenty-eighth state of the Union.

The expansionist spirit intensified. John L. O'Sullivan's *Democratic Review* captured the nation's mood in an unsigned August 1845 article, "Annexation," which introduced the era's most memorable phrase. Absorbing Texas and California, the author wrote, was the "fulfillment of our manifest destiny to overspread the continent allotted by Providence for the free development of our yearly multiplying millions." America's democratic institutions and its Anglo-Saxon culture must push to the far limits of the continent. A huge expanse of western territory was now occupied by the "imbecile and distracted" Mexico, but not for long: "The Anglo-Saxon foot is already on its borders. Already the advance guard of the irresistible army of Anglo-Saxon emigration has begun to pour down upon it, armed with the plough and the rifle, and marking its trail with schools and colleges, courts and representative halls, mills and meeting houses."

Such ringing pronouncements, often repeated, make us think of the era as one of pervasive faith in unbridled American imperialism. But there were shades of feelings about Manifest Destiny. On one extreme were rabidly expansionist Democrats, mainly from the Old Northwest, who wanted to grasp as much western territory as possible. These expansionists dreamed of winning from England the entire Oregon Ter-

ritory, right up to 54° 40' latitude—a desire that produced the militant expression "Fifty-four forty or fight." They also wanted the territories of California and New Mexico. As time passed, some called for the seizure of all of Mexico as well as the Yucatán Peninsula and Cuba.

On the opposite side were Whigs, mainly in the Northeast, who argued that no western territory at all should be claimed by the United States, no matter what was the outcome of war or negotiation with foreign powers. The No Territory theme gained momentum, becoming a unifying factor among Whigs who were divided on other issues.

Polk took a centrist position. He had a strong desire for U.S. possession of Oregon but was willing to settle for the 49th parallel, not 54° 40', as the boundary. He wanted the Rio Grande, not the Nueces, as the southern boundary of Texas and was determined to win New Mexico and California. But he firmly resisted the all-of-Mexico idea.

Oregon, he saw correctly, could be settled by negotiation. In 1818 the United States had made an agreement with England for joint occupation of Oregon and had renewed the accord in 1827. In 1843 Tyler's minister to England, Edward Everett, offered a treaty that divided Oregon, with the territory below the 49th parallel going to America and that north of it to England. England took no action on Everett's offer. It would take three more years to arrive at a settlement that was similar to Everett's. Initially Prime Minister Robert Peel rejected Everett's formula, holding out for the Columbia River as the western section of the Canada-U.S. boundary. Polk appointed Louis McLane as the new minister to England, with an offer of the 49th parallel along with free ports for the British south of that line, with no mention of the Columbia River. Surprisingly, England's representative, Richard Pakenham, rejected the idea without discussing it with his superiors in London. Rebuffed, Polk withdrew his offer.

A delay followed. By the winter of 1846, pressure grew on the president to demand all of Oregon. In Congress, the fifty-four forty cry came not only from Westerners like Lewis Cass of Michigan, William Allen of Ohio, and Edward Hannegan of Indiana but also from John

Quincy Adams of Massachusetts. This exaggerated demand did not sway Polk but sent a message to England, which showed a willingness to compromise. In February 1847, Polk submitted to Congress a resolution establishing the U.S. boundary at the 49th parallel, bending south below Vancouver Island, which was awarded to the British. After months of haggling, a treaty with these terms was approved by Congress and signed with England.

Closure on Oregon had arrived, but at a cost to the Democratic Party. The All Oregon Democrats in the northwestern states had alienated both moderates in the East and conservative Southerners like Calhoun, who had opposed acquiring Oregon for fear of war with England. Gaining the Oregon Territory would eventually yield five new states, but it also sped the fragmentation of the Second Party System, which collapsed altogether in the 1850s.

An even stronger reason for the party fracture was "Mr. Polk's War" against Mexico in 1846–47. Rarely has a war been so successful militarily while breeding such divisions as the Mexican War. The most ardent critics were Garrison's abolitionists, who saw the war as a conspiracy by the southern slave-power to extend the South's peculiar institution. Even many who did not call themselves abolitionists came to the antiwar side when the issue of slavery extension came up with the Wilmot Proviso, which called for a ban on slavery in territories won from Mexico.

Then there were No Territory Whigs like Clay and Webster, who were in the odd position of opposing the war for political reasons while voting to fund it so as not to appear unpatriotic. In the South, Calhoun led a small but ardent group against the war, apparently because of resentment against Polk's power and doubts about whether slavery could take root in the Far West.

At the same time, the American people overwhelmingly supported the war. Victorious generals like Zachary Taylor and Winfield Scott became the heroes of popular adventure novels by George Lippard, Ned Buntline, and others. In the public mind, America was indeed destined to control all territory west to the Pacific Ocean.

President Polk at first hoped that this land could be won peacefully. He thought that Mexico might agree to the Rio Grande boundary and to the cession of New Mexico and California if the United States cancelled some $3 million of Mexican debts and made a large additional payment. Soon after taking office, in the spring of 1845, he sent a secret agent, William S. Parrott, to Mexico City to confer with officials there. By the fall, Parrott reported that the Mexicans appeared ready to negotiate with an American envoy. Polk appointed a minister, the former Louisiana congressman John Slidell, who reached Mexico City in December and spent the winter parleying with the new government of Mariano Paredes y Arrillaga. Faced with stubborn opposition, Slidell in March 1846 demanded that Paredes either deal with the United States or face an immediate rupture of relations. Paredes took the latter course.

By April, the Polk administration wanted war. In May Congress approved Polk's declaration of war against Mexico. The administration's newspaper, the *Washington Union*, pledged "to conduct war against Mexico with all the vigor in our power. . . . *We shall invade her territory; we shall seize her strongholds; we shall even* TAKE HER CAPITAL, *if there be no other means of bringing her to a sense of justice.*"

The Mexican War was fought on four fronts: California, New Mexico, southern Texas and northern Mexico, and central Mexico, where the Americans cut a swath from the coastal town of Veracruz to Mexico City. There were some forty-five battles or sieges in the war. Fighting broke out in late April 1846 and ended in March 1848.

Although Mexico had the advantage of fighting on its own turf with experienced, loyal forces, it was no match for the United States. Its population was less than half that of its foe. Heavily in debt to other nations, it had a gross national product that was steadily declining at a time when America's GNP soared during its post-recession recovery. Technologically, it was far behind the United States, which supplied its troops amply with rifles, long-range guns, ammunition, and practical supplies. Although the U.S. Army had deficiencies—most notably, untested

troops and a high desertion rate—its firepower and commanders were far superior to those of Mexico. Through shrewd use of long-range bombardment, the American Army often won battles even when heavily outnumbered. The Mexicans were victorious in only six engagements. Three others were a draw. The U.S. Army won the remainder. More than twelve thousand Americans died in the war. The cost to the nation was nearly $100 million (well over $1 billion in today's money).

The erratic, independent-minded explorer and Army officer John C. Frémont set the stage for victory in California by urging white settlers to revolt against Mexican rule. In 1846 he traversed northern California fomenting rebellion. In early 1847, he bore down on Santa Barbara, forcing a Mexican surrender there. Commodore John D. Sloat occupied Monterey and proclaimed that northern California was part of the United States. In southern California, the Americans seized, then lost, and finally retook Los Angeles after several battles. Signing the Treaty of Cahuenga with Mexico in January 1847, Frémont became the military governor of California, though he was soon succeeded by a military rival, Stephen W. Kearny.

General Kearny arrived in California after having already achieved victory in New Mexico. In early 1846, Kearny had been stationed in Kansas when he was ordered to move southward and make an attempt on Santa Fe, the capital of New Mexico. With a force of 1,700, Kearny in August took over Santa Fe without firing a shot. The same month, he claimed New Mexico for the United States, but the announcement proved premature. Kearney soon departed for California, leaving New Mexico under the control of Colonel Sterling Price. The conquered Mexicans rose up against Price in the so-called Taos Revolt, which raged until February 1847, when Price crushed them.

In Texas, Zachary Taylor in May 1846 posted impressive victories in the battles of Palo Alto and Resaca de la Palma, enforcing America's claim to the disputed territory between the Nueces and the Rio Grande. He then chased the Mexican army to Monterrey, in northeastern Mexico, where in September he engaged in a three-day battle that led to his

taking the city and reportedly committing atrocities. Taylor made an agreement allowing the Mexican army to escape with its weapons and have a two-month armistice in exchange for American control of Monterrey. President Polk disapproved of the armistice plan. Taylor's job, he insisted, was to defeat the enemy, not arrange truces.

Polk's resentment of Taylor reflected larger personal tensions. Polk wanted to appoint a single commander for all American forces in the West. The most obvious candidates were Taylor or Scott, his two best generals. But Polk disliked them both, largely for political reasons. Polk was an ultra-Democrat; they were Whigs. He declared that Taylor "was unfit for the chief commands, that he had not enough mind for the station, that he was a bitter political partisan & had no sympathies with the administration." He used similar words about Scott. In May 1846, he gave Scott the commanding position but grew frustrated when Scott delayed going to Mexico, requesting time to recruit volunteers. Scott and his associates, said Polk, were "all whigs & violent partisans, and not having the success of my administration at heart [they] seem disposed to throw every obstacle in the way of my prosecuting the Mexican War successfully." Polk withdrew his offer, and Scott stayed in Washington until the fall, when Polk realized that he was the most capable person to undertake the crucial Veracruz mission.

Uneasy about his generals, Polk also hurt himself by enabling the return to Mexico of Antonio López de Santa Anna, the former Mexican president who had been exiled in Cuba for two years. Santa Anna gave signs that if he were allowed to regain power in Mexico, he would sell America the territories it desired. Polk arranged for Santa Anna's safe passage to Mexico City only to have the dictator renege on his promise. Santa Anna remained a military thorn in America's side until the end of the war.

Santa Anna, however, was unable to prevent a decisive American victory. The beginning of the end came in March 1847 when American forces under Winfield Scott landed at Veracruz and started a twenty-day siege that led to that city's surrender. Scott then pushed across Mexico

in a brilliantly executed campaign. He won key battles at Cerro Gordo, Contreras, and Chapultepec before conquering Mexico City. He marched into the city on September 14, dispatching a unit to occupy the presidential palace, known as the Hall of the Montezumas, later commemorated by the Marine hymn. Zachary Taylor scored a huge symbolic victory in one of the war's largest battles, at Buena Vista, in which his vastly outnumbered troops reached a military draw against a twenty-thousand-strong Mexican army, thereby preventing Santa Anna from winning back much of northern Mexico.

Polk had kept up diplomatic pressure on Mexico. He appointed Nicholas P. Trist, a clerk in the State Department, as envoy to Mexico. As prickly and cantankerous as Winfield Scott, Trist botched the initial phase of his mission and was recalled by Polk in November 1847. But Trist ignored the president's calls for his return. He continued parleying with Mexican officials, arriving finally at terms for a treaty much like those Polk wanted. Signed by Trist and Mexican representatives at Guadalupe Hildago, near Mexico City, on February 2, 1848, the treaty gave the United States what later became California, Nevada, and Utah and parts of four other states in exchange for forgiving Mexico's debts (around $3.25 million) plus $15 million in cash—an amazing bargain for the United States. Polk submitted the treaty to Congress, which quickly approved it.

The Mexican War was over, but not without having created tremendous new tensions over slavery. Early in the war, when Polk had asked Congress for $2 million in funds for the war, David Wilmot, a first-term congressman from Pennsylvania, had amended the appropriation bill with the stipulation that slavery must be prohibited from any new territory won from Mexico. The House passed the measure with Wilmot's amendment, but Congress adjourned before the Senate voted on it. Every time thereafter that the Wilmot Proviso came up for a vote in the Senate, proslavery Southerners engineered its defeat.

The slaveholder Polk dismissed the Wilmot Proviso as a "mischievous & foolish amendment" that had nothing to do with America's

dealings with Mexico. But it proved to be a wedge that divided the nation. For the first time on a large scale since the Missouri crisis, America faced the painfully divisive question: Should slavery be allowed to spread westward, or should it be contained to states where it already existed? In the 1850s, this issue would bring about a new party alignment that pitted the antislavery Republican Party against the proslavery Democratic Party.

In the controversy over the Wilmot Proviso lay the seeds of the Civil War.

→ Epilogue ←
Endings, Beginnings

The Age of Jackson came to a close in 1848. In some ways, of course, that age never ended: the political, economic, and cultural forces it set in motion are still felt. But 1848 brought a sense of transition. Old Hickory had died at the Hermitage three years earlier. On February 21, 1848, John Quincy Adams collapsed in his seat in the House of Representatives; he died two days later. "Young Hickory," James K. Polk, the president who had patterned himself after Jackson, was in his last year of office. He would die only mouths after his term ended. Many of the issues that had formerly loomed so large—the bank, the tariff, conflict with England and Mexico over western territories—were matters of the past. In their place, slavery, the issue that had long been suppressed or avoided, again raised its head as a source of national conflict. The man who would succeed Polk, Zachary Taylor, was the first of four presidents between 1849 and 1861 whose main energies would be devoted to dampening tensions over slavery, often through compromise.

Zachary Taylor made no secret of his desire for compromise. He owned a large Louisiana plantation farmed by over a hundred slaves, and he believed in the South's constitutional right to maintain slavery where it already existed. But just as he rejected northern abolitionists who called for the immediate end of slavery, he also opposed Southern extremists such as John C. Calhoun, who defended slavery as a divine institution. He had opposed Polk's plan to annex western territories, even though he helped implement it as a successful general in the

Mexican War. Upholding the status quo, he dodged the slavery question and refused to take a controversial stance.

Hefty and homely, Taylor stood five eight and weighed nearly two hundred pounds. He had a large, barrel-chested upper body and short legs that made mounting a horse difficult. His prominent, slightly hooked nose, large mouth, and sideburn-accented cheekbones gave him a tough look softened by a weak jaw. Nearsighted, he squinted his heavy-browed eyes, giving him a scowl lightened by a ready smile. Unlearned and affable, the tobacco-chewing general won the down-to-earth nicknames Old Rough and Ready and Old Zack. Though he became the nation's second-highest-ranking officer, he hated pomp, preferring to wear old or mismatched uniforms rather than formal military regalia. One woman wryly called him "an indifferent specimen of the Lord of Creation . . . looking neither like the President of a great nation nor a military hero."

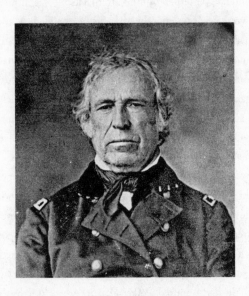

Zachary Taylor

His plain exterior belied an aristocratic background. He was descended from a long line of Virginia landowners. His father, Richard Taylor, had been a Revolutionary War officer who by the time Zachary was born, in 1784, had already left Virginia for Kentucky, starting a large plantation near Louisville, where the family soon moved. Zachary grew up there with eight brothers and sisters. He joined the Army in 1807 and rose to the level of brevet major in the War of 1812, earning distinction as a shrewd, fearless Indian fighter on the western front. During the war he wed a wealthy Maryland woman, by whom he sired six children. Having inherited a 324-acre farm, he sold it at a profit and bought a much larger tract in Baton Rouge, Louisiana. He insisted that his slaves be well fed, clothed, and housed. During the unsuccessful campaign to dislodge the Florida Seminoles, he favored kind treatment of the Indians and objected to the reenslavement of black fugitives who lived among them. His dealings with the Indians continued when he was stationed in western Arkansas as a peacekeeper among the Cherokees, Creeks, and Seminoles.

In the Mexican War, he found himself in the uncomfortable position of serving a president whose policies he opposed. In Taylor's eyes, the annexation of Texas was unconstitutional. Still, Taylor was a determined commander and expert tactician who got outstanding results from his soldiers. He won a number of battles, including major ones at Palo Alto, Resaca de la Palma, Monterrey, and Buena Vista, in which his forces were vastly outnumbered by the Mexicans. Instantly he became a national hero.

As early as June 1846, he was mentioned as a possible presidential candidate. He did nothing to promote his candidacy. In fact, he opposed it. "I am not and shall never be an aspirant for that honor," he wrote a friend; he explained that he had "always been against the elevating a military chief to that position." He could not see himself as president. He wrote his brother: "Such an idea never entered my head, nor is likely to enter the head of any sane person." He had no political experience and had never voted in a presidential election;

according to a later report, he allegedly did not even vote for himself in 1848, telling a stranger that his family was "strongly opposed" to his election.

His distance from the Washington scene actually helped him, because he seemed removed from partisan politics. Rough and Ready clubs sprang up. By March 1847, some fifteen Whig congressmen known as the Young Indians—including Alexander H. Stephens of Georgia and Abraham Lincoln of Illinois—had formed a powerful Taylor organization. Taylor agreed to run if nominated. So-called Conscience Whigs were outraged. One newspaper hyperbolically objected to the prospect of the presidency going to "one of the greatest slaveholders in the United States," who "raises babies for the market and makes merchandize of his fellow men!" But mainstream Whigs enthused over Taylor, and more and more newspapers jumped on his bandwagon, especially after his stunning victory at Buena Vista in February 1847. Support for him mushroomed over the spring and summer, although in August he could still say, "I do not care a fig about the office," pointing to the perennial Henry Clay as the most likely Whig candidate.

In September he wrote a widely reprinted letter in which he disavowed party affiliation. He said that although he had always supported Whig policies, he would not "accept a nomination exclusively from either of the great parties that divide the country," since he might then be "the slave of a party instead of the chief magistrate of the nation." He continued to finesse the party issue as late as February 1848, when he declared that he would refuse a nomination "by Whig or Democratic convention, State or National, exclusively on party grounds." Alarmed by his continued neutrality, prominent Whigs led by the Kentucky senator John J. Crittenden wrote a letter over his signature in which he conceded that he was "a Whig but not an ultra Whig."

At the Whig National Convention in Philadelphia in June, Taylor led after the first ballot, winning 111 votes to Clay's 97, Scott's 43, and Webster's 22. Strong Southern support pushed Taylor to victory on the fourth ballot. Even after winning the nomination, Taylor said he would

not try hard to win the presidency, explaining that he would serve "more from a sense of duty than from inclination."

His running mate, the former Buffalo congressman Millard Fillmore, was a more eager campaigner than he. A tall, handsome man who dressed impeccably, the silver-haired Fillmore was the self-made son of an upstate New York tenant farmer. He had risen in the Whig ranks during the 1830s and became an eloquent opponent of the Mexican War, which he considered a Southern scheme to extend slavery. During the 1848 race, he attracted many northern voters who were dubious of the slaveholding Taylor.

While the Whigs achieved a kind of balance on slavery through the Taylor-Fillmore ticket, the Democrats faced strong tensions over the issue. Their convention at Baltimore in late May opened with bitter disputes in the New York delegation over slavery. The so-called Barnburners (nicknamed after a Dutch farmer who allegedly burned his barn to get rid of rats) supported passage of the Wilmot Proviso in order to prevent the spread of slavery. Their opponents, the Hunkers, insisted that the decision on slavery should be left to the western territories themselves.

Amid the fight, mainstream Democrats chose as their presidential candidate the colorless Lewis Cass, the territorial governor of Michigan and former U.S. senator. Once a champion of the Wilmot Proviso, Cass had become its arch-opponent after accepting the notion of popular sovereignty, by which new states would decide on slavery through elections. His running mate, the army general and former congressman William O. Butler of Kentucky, shared his views.

The Barnburners, appalled by what they considered a proslavery Democratic slate, stormed out of the convention. Three weeks later, they reconvened in Utica, New York, adopting a pro-Wilmot platform that labeled slavery "a great moral, social, and political evil—a relic of barbarism which must necessarily be swept away in the progress of Christian civilization." Over the next month, Barnburners joined with Conscience Whigs, Liberty Party men, and some abolitionists in plan-

370 | WAKING GIANT

ning a mass meeting to be held in Buffalo. On August 9, the meeting of the new Free Soil Party opened under a huge tent in broiling heat.

The Buffalo convention had the excitement of a religious revival. Over two days thousands of people heard stirring addresses by forty-three speakers. The Hutchinson Family electrified the audience with its antislavery songs. Banners blazoned forth the slogans "Free soil, free speech, free labor and free men!" and "No more slave states, no more slave territory and no more compromises with slavery anywhere!" Ex-president Martin Van Buren was chosen over the New Hampshire senator John P. Hale as the Free Soil Party's presidential nominee. His running mate was the Massachusetts politician Charles Francis Adams. Among the speakers were the African Americans Frederick Douglass, Charles Redmond, Henry Highland Garnet, and Samuel Ringgold Ward.

The presence of the blacks sparked controversy. One white attendee declared that Barnburners "didn't want a 'nigger' to talk to them." Conversely, Douglass left the convention dissatisfied because it had not addressed the rights of blacks. The Buffalo platform declared that the territories must be kept for "the hardy pioneers of our own land, and the oppressed and banished of other lands"—with no mention of blacks. Within a few weeks of the convention, Douglass and other black leaders were denouncing the Free Soil Party.

To some degree, their complaint was justified. The free-soil agenda was based on the idea that the western territories should be occupied by whites, without the interference and competition of black labor, either slave or free. David Wilmot had called his measure the White Man's Proviso, explaining that "I would preserve for free white labor a fair country, a rich inheritance, where the sons of toil, of my own race and color, can live without the disgrace which association with Negro slavery brings upon free labor."

A belief in white supremacy, as some historians point out, was especially noticeable among Democrats. But it was not confined to a single party or section. It even tinged the free-soil movement as it expanded

and fed into the Republican Party, formed in the mid-1850s. Even a passionate antislavery leader like the Kentucky Whig Cassius Clay could say, "I have studied the Negro character. They lack self-reliance—we can make nothing out of them. God has made them for the sun and the banana!"

Still, the antislavery movement cannot be dismissed as hypocritical or spurious. Some of America's greatest spokespersons for freedom, from Thomas Jefferson through Harriet Beecher Stowe, Garrison, and Lincoln, at certain times expressed views that reflected the prevailing racial prejudice of their era. But these and others helped enslaved blacks make tremendous strides toward emancipation and eventual civil rights. Even racist antislavery men, while abjuring equality between whites and blacks, did not believe that blacks or any other human beings should be enslaved. For Lincoln and Stowe—and even, in short order, people like Wilmot—blacks may have been inferior, but this was not justification for keeping them in bondage. The basic humanity of blacks precluded that. It was this acceptance of blacks' humanity that separated racist proslavery from racist antislavery advocates. Simply thinking that blacks were inferior, as most white Americans did, did not automatically mean one was in favor of slavery or morally indifferent. Lincoln would be particularly eloquent about this in his debates with Stephen Douglas.

Also, to stand a chance of winning elections, the Free Soil and Republican parties had to appeal to the white males who at that time constituted the voting public.

No appeal made by the Free Soilers could hope for success in 1848, since antislavery sentiment did not yet have a strong foothold, even in the North. In the November 7 election—the first election in which every state except South Carolina cast votes for president and vice president on the same day—the Free-Soil Party garnered 10 percent of the popular vote. Although this tally was higher than that of any previous antislavery party, it lagged behind the returns of the major parties. Taylor won 47 percent of the popular vote to Cass's 42 percent. Each candidate took fifteen states; victories in populous states like New York

and Pennsylvania gave the Taylor a comfortable edge in the electoral college.

The Free Soil Party, though far from victorious, had raised the question that would soon take center stage on the national scene: How should slavery be dealt with in the newly won territories? It was this issue that lay behind the Compromise of 1850, in which the South gained a stringent fugitive-slave law in exchange for concessions on slavery in the Far West, and the Kansas-Nebraska Act of 1854, which opened up the territories for slavery by instituting popular sovereignty there. The Free Soil Party had shaken political alignments with its strong antislavery message. Soon the conflict over slavery would damage the Whig Party and give rise to a contest between the Democratic Party, largely southern and proslavery, and the new Republican Party, northern and antislavery.

Slavery was just one issue that would cause the demise of the Whigs. Another was the economy. The Democrats had long fought paper currency and promoted hard money. The hard-money argument received an unexpected boost in January 1848, when gold was discovered at the Coloma, California, sawmill of John A. Sutter on the American River, fifty miles east of Sacramento. News of the discovery spread. Soon gold-seekers were racing to the Sierra foothills from all over the Far West. In late May, a California newspaper declared, "The whole country, from San Francisco to Los Angeles, and from the sea-shore to the base of the Sierra Nevada, resounds with the sordid cry of *gold! gold! gold!* while the field is left half planted, the house half built, and every thing neglected but the manufacture of picks and shovels."

Workers who averaged $1.00 to $1.50 a day in their current jobs were lured by earnings that averaged more than ten times that amount and sometimes reached thousands of dollars daily. Within a year, argonauts arrived from the East Coast, from South America and Europe, and from as far away as Turkey, Japan, and China. For many, the long journey was well worth the effort. Over the next dozen years, an average of $55 million of gold was mined yearly in California, contributing

to a total bonanza of over $1 billion by the mid-Reconstruction years. Gold specie, once so scarce, was abundant, supported by a relaxation of credit by British banks. Two economic bulwarks of the Whigs—a national bank and paper money—seemed outdated when gold coins were readily available as an anchor against fluctuating soft currency.

Besides the gold rush, 1848 brought two movements destined to have tremendous social impact: spiritualism and women's rights. Like free soil, these movements in part reflected the cultural ferment created by the revolutions in Europe that year. The revolutions began in Sicily and France and then spread to Italy, Hungary, Prussia, Austria, and elsewhere, toppling dynastic regimes that had been in place since the Napoleonic Wars. Although the 1848 revolutions caused few permanent changes—by the next year, dynastic rule was restored through most of Europe—many Americans viewed them as inspiring revolts against tyranny.

Spiritualism was a kind of religious revolt, challenging orthodox views of the afterlife through direct communication with the dead. The movement originated in upstate New York, that fertile breeding ground of religious movements. In March 1848 in the village of Hydesville, the fourteen-year-old Maggie Fox and her twelve-year-old sister Kate heard knocking sounds in their home. Soon the sisters developed a code of raps by which they contacted the source of the sounds, allegedly the spirit of a murdered man who used the nickname Splitfoot. Neighbors flocked to the Fox home to witness Maggie and Kate, along with their older sister Leah, conversing with Splitfoot.

Word of these apparent miracles spread quickly, reaching the radical Quakers Isaac and Amy Post, who believed in the Fox sisters and took them into their Rochester home. The Fox sisters won converts among reformers in the antislavery, temperance, and women's rights movements. They got more publicity with the backing of the free-soil editor Horace Greeley and the showman P. T. Barnum. The Fox sisters attracted the interest of William Cullen Bryant, George Bancroft, James Fenimore Cooper, and other celebrities. Thousands of imitators sprang

up, holding séances in which people gathered in dark rooms to send messages to spirits by knocking on tables and receiving replies that came in the form of sounds, ghostly hands, chair-moving, table-lifting, flying objects, and so on. Spiritualism became a mass movement. By the late 1850s, there were an estimated twenty thousand professional mediums and over two million believers in spiritualism in the United States.

Eventually spiritualism gained some eleven million followers world-wide. Among notable converts were the ex-slave Sojourner Truth, the abolitionists Sarah and Angelina Grimké, William Lloyd Garrison, Harriet Beecher Stowe, Victor Hugo, William James, and Arthur Conan Doyle. In Lincoln's administration, séances were held in the White House after the death of loved ones. Artists and poets created under the guidance of spirits. The genre painter William Sidney Mount, for instance, was inspired by a spiritual letter he received from Rembrandt. A craze for so-called trance lectures and trance poetry swept the North, as traveling authors sat onstage reciting lines spoken through them by spirits. The spiritualist idea of "elective affinities" mingled with Fourierism's "passional attraction" to produce the free-love movement. "Spirit photographs" purported to show ghosts, sometimes alongside living individuals. Mary Todd Lincoln, for example, was comforted by the Boston spirit-photographer William Mumler, who presented her with a photograph of her with Lincoln's spectral form standing behind her and holding her shoulders.

Spiritualism eventually came into disrepute. For many, the excitement about otherworldly visitations caused severe anxiety, or worse. A newspaper reported in 1852: "Almost every mail brings us an account of a suicide, or a case of insanity, solely attributable to the gross delusions of the Spirit Rappers." Widespread suspicion arose over the veracity of spiritualist mediums. The Fox sisters became indigent alcoholics after Margaret confessed in 1888 that the knockings were fraudulent; Split-foot, she said, was actually the product of cracking sounds made by her toe joints. Having peaked during Reconstruction, spiritualism waned, though remnants of it survive to this day.

William Mumler's Spirit Photograph of
Abraham Lincoln Behind Mary Todd Lincoln

In late July 1848, the first convention devoted solely to women's rights took place in Seneca Falls, New York. This meeting was the outgrowth of feminist thought that had originated with the British reformer Mary Wollstonecraft, who in the 1790s had insisted that women, as rational beings, merited equal education with men. Wollstonecraft's main intellectual heir in America was Margaret Fuller, the Transcendentalist author and journalist whose 1843 tract *The Great Lawsuit* argued that, though the sexes were intrinsically different, women must be given rein to grow mentally and spiritually.

Evangelical religion and abolitionism spawned an activist feminism. Revivals and reform activity allowed American females to gather publicly and forge what the historian Nancy Cott calls the bonds of womanhood. The direct antecedent of the Seneca Falls convention was the World's Anti-Slavery Convention held in London in 1840. British abolitionists, having summoned international participants to the conference, were shocked when among America's antislavery representatives were several women. A vote was taken, and the women were excluded as delegates to the convention and forced to sit on a balcony in a curtained enclosure. William Lloyd Garrison, who had been scheduled to

speak, was so outraged that he sat glumly behind the curtain with the women.

Garrison's dedication to the cause of women was so strong that it divided the abolitionist movement upon his return home from London. The spurned women, meanwhile, let their anger simmer until July 1848, when the Philadelphia abolitionist Lucretia Mott was visiting her sister, Martha C. Wright, in Waterloo, New York. Mott and Wright met with two other Waterloo residents, Jane Hunt and Mary Ann McClintock, and with Elizabeth Cady Stanton of nearby Seneca Falls. All the women except Stanton espoused the Quaker faith, which preached the equality of the sexes. A plan was made for a "convention to discuss the social, civil, and religious condition of women." On July 19 and 20—a landmark moment in American history—260 women and 40 men gathered in the Wesleyan Methodist Church in Seneca Falls.

The convention drafted a "Declaration of Sentiments," a feminist rewriting of the Declaration of Independence. "We hold these truths to be self-evident: that all men and women are created equal," the declaration read. Among the many grievances listed in the document were America's ban on suffrage, on property rights, on equal education, and on ministerial employment for women. A third of the three hundred attendees put their signatures to the declaration, prompting loud ridicule in the press. One newspaper typically called the convention "the most shocking and unnatural incident ever recorded in the history of womanity." Another paper hooted, "What absurd stuff is all this prattle about the 'Rights of Woman!'" The attacks on women's rights would continue for years, even as the women reformers bravely held conventions and lobbied in other ways for an end to gender discrimination. Their activism led to the passage in 1920 of the Nineteenth Amendment, which gave women the vote.

How did spiritualism and women's rights relate to the overall political and social scene? Both of them were vigorous challenges to authority. Spiritualism, Orestes Brownson noted, was "breaking up churches, taking its victims from all denominations, with stern impartiality."

In the view of the reformer Thomas Low Nichols "spiritualism has been revolutionary, chaotic, disorderly." Likewise, the women's rights movement was widely seen as subversive, even among its supporters— Elizabeth Cady Stanton, for instance, called it "a rebellion such as the world had never before seen." Both reflected the militant reform spirit of the Age of Jackson.

But there was a deeper significance to these movements. Like most other reforms, they had originated in the North. They became featured in the debate over slavery. They joined the long parade of other radical phenomena—cults, prophets, sexual experiments, utopias, working-class protest, abolitionism, and Transcendentalism—that made the North appear to be the seedbed of divisive movements. In the South, spiritualism and other reforms were often held up as examples of the bizarre heresies of the North. Southerners commonly charged that the North was a chaotic society of competing "isms," in contrast to the stable, conservative South. The South's leading apologist, George Fitzhugh, devoted a chapter of his proslavery book *Cannibals All!* to "The Philosophy of the Isms—Shewing Why They Abound at the North, and Are Unknown at the South." Fitzhugh reviewed by name the whole litany of Northern religious and reform movements, insisting that they had "one common object: the breaking up of all law and government, and the inauguration of anarchy."

A Southern war song, "The Devil's Visit to 'Ole Abe,'" typically traced the North's problems to its messy mix of "infidel" reforms and religious movements. In the song, Satan says:

> I stirred up the North with its vagabond crew,
> And set witch-burning Yankeedom all in a stew,
> With its isms and schisms—fanatical trappings—
> Its free-loving humbugs, and spiritual rappings:
>> I called out its teachers,
>> (Hypocritical preachers)
>> And demagogue screechers,
> To martial your leaders to conquest and fame;

But alas! To your shame,
No victory came.

Southerners in time developed an image of themselves as a stable people of superior Cavalier stock, as opposed to Northerners, descended from the Puritans, whose harsh, persecuting spirit had supposedly given rise to the radical reforms of the present day. The "Saxon" Puritans originally had settled New England, the argument went, while many "Norman" Cavaliers inhabited the South after Oliver Cromwell drove them out of England in the 1650s.

During the Civil War, a proslavery writer, in comments that shed light on the previous two decades, declared that the real conflict was between the "cavalier element predominating in Southern civilization" and the "Puritan element which underlies the fabric of Northern civilization." Stressing this "antithesis of the Puritan and Cavalier," the writer insisted that the North's uncontrolled democracy fostered endless social revolutions there, whereas the slave system kept the South orderly and structured. Another journalist claimed that the Northern Puritan is "at once a religious fanatic and a political agitator and reformer," while the Southern Cavalier was "the builder, the social architect, the institutionalist, the conservator." Yet another contrasted "the principles of [Northern] Calvinistic *insubordinatism* and [Southern] Episcopal *subordinatism*. The first is iconoclastic in all things. The second teaches respect and reverence in all things. The first aids all effort to destroy the Constitution. The second assists all effort to maintain the Constitution."

From the Southern perspective, then, there were deep cultural differences that lay behind the slavery struggle. Slavery itself was viewed as a key element of the structured Southern system. An article on the Southern cavalier said, "The institution of domestic slavery alone has sufficed to make the South conservative and religious, and its absence to render the North anarchical and infidel." Another described slavery as "a benevolent system of tutelage by a superior race over an inferior

race," emphasizing the crucial importance of sustaining the institution: "Let us strengthen slavery by every possible appliance, regarding that institution as the very base, the corner-stone of our system, [without] which, once rudely framed, the whole superstructure will totter in the imminent peril of hopeless ruin."

The Southern view was summed up in a political cartoon called "Worship of the North," published during the Civil War. The cartoon shows a religious altar on which lies a bleeding man who represents the dying American Union. Around the altar are ugly-looking Northern politicians, all of whom had been long connected with the antislavery cause. The base of the altar is made up of stones that represent Northern society from the Southern perspective. At the bottom is a large stone labeled PURITANISM. Above this stone rise layers of bricks, each of which carries the name of something associated with the North. One brick reads SPIRIT RAPPINGS, another FREE-LOVE, and others SOCIALISM, WITCH-BURNING, ATHEISM, and NEGRO WORSHIP. The cartoon expressed the widespread Southern opinion that the Civil War resulted from Northern antislavery activism that was associated with all kinds of "infidel" reforms rooted in New England Puritanism.

Perhaps, then, the most important product of 1848 was the revolutionary spirit that energized Northern reform movements at a time when Southern proslavery sentiment was turning into a self-justifying cultural myth. The reforms that caught fire in the North fed proslavery Southern opinion. Utopian socialism, for instance, exposed Northern class divisions, providing a convenient platform for fire-eaters like George Fitzhugh and John C. Calhoun to contrast the misery of urban workers with the alleged happiness of enslaved blacks. This also explains why several Northern labor radicals, including Mike Walsh and Charles Chauncey Burr, turned ardently proslavery in the 1850s. Lamenting the plight of the North's "wage-slaves," one labor reformer typically said it was a "well-known fact that the blacks of the South enjoy more leisure time and liberty and fare quite as well as the operatives in northern or eastern manufacturing districts." As for other

Worship of the North

movements—Mormonism, Oneidan marriage, women's rights, spiritualism, and so on—they were, for the South, products of the North's lawless, confused society, with abolitionism topping the list as the most demonic of all.

An especially suggestive part of the "Worship of the North" cartoon is its upper half. Above and behind the altar are three key images: a seated black man leaning on a spear; a statue of the bearded John Brown, who is holding a spear; and, above all, two beaming suns labeled EGO. This trio embodies the South's worst fears: a slave revolt incited by an abolitionist driven by the egocentric spirit of Northern lawbreaking individualism.

This combustible combination, so threatening to Southerners, would not explode until 1859, when John Brown and twenty-one followers would invade Harpers Ferry, Virginia, in order to free slaves and incite widespread slave revolts, a plan that went awry when Brown was captured, tried, and executed. But all the ingredients of the combination

were in place by 1848. Late in 1847, Brown, the devout holdover-Puritan Calvinist who thought he was predestined to wipe out slavery, laid out his plan to invade the South. He told Frederick Douglass that he intended to liberate some enslaved blacks and escape with them into the Appalachian Mountains, which run deep into the South. Using mountain hideaways to evade capture, he would infiltrate the South and free more slaves, creating an ever-growing army of liberation and frightening slaveholders so much that they would eventually be driven to abandon slavery.

This visionary scheme, involving terror and violence, was distant from the free-soil agenda of stopping the spread of slavery through politics and from the abolitionist one of challenging it through persuasion. A year before John Brown laid out his violent scheme, the Transcendentalist reformer Henry David Thoreau had exhibited an individual's refusal to obey a corrupt government. In part because of his opposition to what he saw as the proslavery war on Mexico, Thoreau had refused to pay a poll tax, leading to his incarceration in a Concord jail. The prison experience inspired Thoreau to write "Civil Disobedience," in which he said the ethical individual was more powerful than any government.

The extreme self-reliance of Thoreau and his fellow Transcendentalists explains the EGO that crowns the anti-Northern cartoon. For proslavery Southerners, the Transcendentalists epitomized the North's anarchic individualism, which nullified all laws and customs. The proslavery orator and Democratic congressman Samuel S. Cox of Ohio typically associated "the Constitution-breaking, law-defying, Negro-loving Phariseeism of New England" with the "spawn of transcendentalism" that sings "a hymn of apotheosis to John Brown—a horse-thief and a murderer."

Though extreme, the charge had substance. When free-soil politics failed to halt slavery in the 1850s, John Brown would take the law into his own hands by going on a murderous rampage in Kansas and then raiding Harpers Ferry. His actions would have had little impact if it had not been for Thoreau and his fellow Transcendentalists, who rescued

Brown from infamy by putting him on the level of Jesus Christ. Had Brown broken the law? All the better, said Thoreau, in a nation whose laws supported so vile an institution as slavery. The Transcendentalists started the groundswell of opinion that led to Brown's sanctification in the North and demonization in the South. Brown thus became a polarizing figure who helped spark the Civil War.

Shortly before he was hanged, John Brown predicted that slavery would not be destroyed "without *verry much* bloodshed." Sadly, he was right. Lincoln himself, the quintessential free soiler eager for political solutions—and who regarded Brown as more of a hindrance than a help to the antislavery cause—would turn into the determined commander-in-chief who waged total war on the South. The war must continue, Lincoln declared, until every drop of slave blood was repaid by another drawn with the sword. His statement rang true: some 620,000 Americans would die in the Civil War—more than in all other wars in the nation's history *combined*.

All the slave-holding presidents, all the antiabolitionist mobs and laws, all the gags and compromises and straddles could not prevent cataclysmic war.

When Zachary Taylor won the presidential election in November 1848, he could not know that in thirteen years America would be in a death-struggle over the campaign issue he nonchalantly evaded.

* * * *

WHAT WERE THE LEGACIES of the Jacksonian period? Perhaps the most important was an intensified national self-confidence qualified by a painful sense that America was still far from settling on a unified vision of what a just democracy should be.

The Puritan notion of America as a city on a hill took on aggressive meaning in the Jacksonian age when it became fused with Manifest Destiny. The nation's mission was no longer just the passive one of being a model for others to see but a forceful one of actively spreading America's democratic principles—peacefully if possible but militarily if

necessary. Manifest Destiny grew mainly from expansionists within the Democratic Party who carried forward the dynamic spirit of Andrew Jackson. If many Democrats associated America's providential mission with territorial expansion, Whigs often linked it with scientific progress and strong economic institutions. Taken together, the Democratic and Whig visions defined what America eventually became: an economic and creative dynamo as well as a world superpower, buttressed by a military-industrial complex, that was prepared to defend democracy abroad when it saw fit.

Both parties ushered in techniques of popular campaigning that have become integral to the competitive two-party system. Leaders such as Jackson and Harrison introduced the now-familiar notion that personal magnetism and public image sometimes are among the most important factors in elections.

If the Jacksonian parties shaped America's future, so did the era's outliers—its philosophers, writers, showmen, reformers, cult leaders, and purveyors of panaceas. There were few phenomena in Jacksonian culture that did not have major ripple effects in later American history, up to modern times. In philosophy, the Transcendentalism of Emerson and Thoreau opened the way not only for William James's pragmatism and its heirs but also for modern civil disobedience as well as the ecology movement. In literature, Walt Whitman fathered free verse, and Poe, Hawthorne, and Melville opened pathways to modernism. In popular culture, P. T. Barnum was a precursor of show business, the Hutchinsons of pop music, and the penny newspapers of tabloid journalism. The revivalists of that era bred a string of popular preachers from Dwight Moody through Billy Sunday to Billy Graham and others. Among leaders of cults, the Jacob Cochrans and Matthiases looked forward to the Jim Joneses and David Koreshes of recent times. Alternative medicine not only has endured but has proliferated, in spite of—sometimes because of—the rise of modern medicine.

Among the outliers, the militant reformers stand out, for they embodied what was perhaps the Jacksonian age's most important lesson:

the capacity of American democracy to question itself sharply. Although the two major parties achieved significant reforms, especially the expansion of suffrage, their reforms went only partway toward establishing democratic rights. White males benefited, but women, blacks, and Native Americans often did not. The true pioneers in this regard were firm-principled reformers who worked largely *outside* the political system: William Lloyd Garrison, Elijah Lovejoy, Theodore Dwight Weld, Frederick Douglass, Lucretia Mott, and Elizabeth Cady Stanton, to name a few.

Neither the parties nor the reformers could rid America of its most egregious injustice, chattel slavery. Before engaging in foreign wars to save democracy elsewhere, America had to endure a long, internecine conflict that was a major step toward establishing it at home.

↠ Acknowledgments ↞

I appreciate the contribution of the City University of New York, which covered some of my research expenses as well as the costs of rights and reproduction for the illustrations in this book.

Special thanks go to Alexander Moudrov, who tirelessly and efficiently assisted me in tracking down and ordering images.

I very much appreciate the encouragement and advice of Sean Wilentz, Tim Duggan, and James Atlas. I also want to thank the kind and helpful staffs of various libraries, including Columbia University Library, New York University Library, New York Public Library, New-York Historical Society, the Library of Congress, Boston Public Library, the Newberry Library, Mina Reese Library at the Graduate Center of the City University of New York, Baruch College Library, and the American Antiquarian Society.

I thank the members of my immediate family—Haig Nalbantian, Aline Reynolds, Paul Reynolds, and the Aalvik family—for their caring support. Most meaningful of all is the love and inspiration I receive from my wife, Suzanne Nalbantian Reynolds. Without her, this book could not have been written.

→ Notes ←

Abbreviations

EL: Ralph Waldo Emerson. *Essays and Lectures*. New York: Library of America, 1983.

ER: Edgar Allan Poe. *Essays and Reviews*. New York: Library of America, 1984.

JMN: Ralph Waldo Emerson. *The Journals and Miscellaneous Notebooks of Ralph Waldo Emerson*, ed. William H. Gilman, et al., 16 vols. Cambridge, MA: Harvard University Press, 1960–82.

JP: James Parton. *Life of Andrew Jackson*, 3 vols. New York: Mason Brothers, 1860.

MA: John Quincy Adams. *Memoirs of John Quincy Adams, Comprising Portions of His Diary from 1795 to 1848*, ed. Charles Francis Adams, 12 vols. Philadelphia: J. B. Lippincott, 1874–77.

PJ: *The Papers of Andrew Jackson,* ed. Sam B. Smith and Harriet Chappell Owsley, 6 vols. Knoxville, TN: University of Tennessee Press, 1980.

PROLOGUE

3 *"Believers in everything"*: *ER*, 1303.

1. FORGING A NATIONAL IDENTITY

6 "and ten dollars extra": Jackson quoted in *Tennessee Gazette*, Sept. 26, 1804; Robert V. Remini, *The Life of Andrew Jackson* (New York, 1988), 51.

7 "I should have hit him": Jackson quoted in H. W. Brands, *Andrew Jackson* (New York, 2005), 137.

8 "ALMOST INCREDIBLE VICTORY!": Quoted in Robert V. Remini, *Daniel Webster* (New York, 1997), 131.

8 "His temperament was of fire": Thomas Wentworth Higginson, "Old Hickory," *Harper's New Monthly Magazine*, 69 (July 1884): 273.

11 "the great importance of establishing": "James Madison: Internal Improvements Balancing Act: Federal/State, Executive/Legislative," in *James Madison: From Father of the Constitution to President*, in Edsitement Marcopolo, National Endowment for the Humanities, http://edsitement .neh.gov/view_lesson_plan.asp?id=565, accessed July 8, 2006.

14 "The Americans would sail": *JMN*, 10: 320.

14 Steamboats met the challenge: The statistics about the economic impact of steamboats are striking. In 1817, seventeen steamboats with a total cargo capacity of 3,290 pounds ran on the Mississippi and Ohio Rivers. Eight years later, eighty boats were running on western waters, and by 1855 the number had risen to 727 boats with 170,000 pounds of capacity. Equalizing transportation prices are exemplified by the fact that in 1816 a pound of coffee cost sixteen cents more in Cincinnati than in New Orleans; by 1830 the difference had shrunk to two and a half cents because of the steamboat. See George Rogers Taylor, *The Transportation Revolution, 1815–1860* (New York, 1951), 64.

14 "released every creek": John Steele Gordon, *An Empire of Wealth* (New York, 2004), 145.

15 "The finest [steamboats] we have in Europe": Quoted in Robert E. Riegel, *Young America, 1830–1840* (1949; Westport CT, 1973), 163.

15 "little short of madness": Jefferson quoted in J. S. Gordon, *An Empire of Wealth*, 106.

16–17 "In my imagination . . . must be the most fertilizing": Nathaniel Hawthorne, "The Canal Boat," *New-England Magazine*, 9 (Dec. 1835): 398.

18 "Dismemberment of the Union . . . avert this awful calamity . . . bind the union together": *Jacksonian America, 1815–1840*, ed. Frank Otto Gatell and John M. McFaul (Englewood Cliffs, NJ, 1970), 9, 11, and 22.

18 "On the subject of national": "Bill for Improvement," *American Register* (Philadelphia, 1817), 2: 131.

18 "the improvement of our country . . . Discord does not belong": "First Inaugural Address of James Monroe," Avalon Project at Yale Law School, http://www.yale.edu/lawweb/avalon/presiden/inaug/monroe1.htm, accessed Aug. 2, 2006.

18 "an era of good feelings": *Columbian Centinel*, July 12, 1817.

20 "Turn his soul": *Thomas Jefferson: Writings*, ed. Merrill D. Peterson (New York, 1984), 886.

20 "He was not a star": Quoted in Thomas Wentworth Higginson, "The Era of Good Feeling," *Harper's New Monthly Magazine*, 68 (May 1884): 937, 946.

22 "the change, more than": Adams quoted in Joshua Leavitt, "James Monroe and His Administration," *Harper's New Monthly Magazine*, 29 (Sept. 1864): 463.

22 "The United States now enjoy": Monroe quoted in T. W. Higginson, "The Era of Good Feeling," 946.

22 "the American continents": "The Monroe Doctrine," *Primary Documents in American History*, Library of Congress Web site, http://www.loc.gov /rr/program/bib/ourdocs/Monroe.html, accessed Aug. 10, 2006.

22 "the manifestation of an unfriendly": Monroe quoted in T. W. Higginson, "The Era of Good Feeling," 946.

24 "their improvement in the arts": *The State of the Union Messages of the Presidents*, ed. Fred Israel (New York, 1967), 1: 153.

24–25 "their whole character . . . to civilize the whole": McKenney quoted in Daniel Feller, *The Jacksonian Promise* (Baltimore, 1995), 144.

27 As for new states . . . gave blacks the vote: See Alexander Keyssar, *The Right to Vote* (New York, 2000), esp. 50–55.

27 "unconquerable prejudice resulting . . . promoters of mischief": "The American Colonization Society," reprinted from the *Newark Advocate*, Apr. 22, 1984, at http://webby.cc.denison.edu/~waite/liberia/history/ acs.htm; accessed Aug. 17, 2006.

28 "What I would most desire": Abraham Lincoln, *Speeches and Writings, 1832–1858* (New York, 1989), 478.

28 "We have no wish": Quoted in Lewis Tappan, *Life of Arthur Tappan* (New York, 1870), 135.

28–29 Ironically, Liberia in fact . . . pure blacks there: See Michael O'Brien, *Conjectures of Order* (Chapel Hill, 2005), 182–83.

29 "We are to be ruined . . . we are under a bank bubble": Jefferson quoted in William A. Berkey, *The Money Question* (Grand Rapids, MI, 1876), 131–32.

30 "the whole Banking system . . . having nothing in them of the feelings": Crockett and Jefferson quoted in D. Feller, *The Jacksonian Promise*, 41 and 56, respectively.

31 "When I speak": Hugh A. Garland, "John Randolph of Roanoke," *Southern Quarterly Review*, 2 (Feb. 1857): 314.

31 "There is not a man living": Washington to Robert Morris, Apr. 12,

1786, in *The Writings of George Washington*, ed. John C. Fitzpatrick (Washington, DC, 1931–44), 28: 407–8.

31 "I tremble for my country": *Notes on Virginia*, ed. Bernard Wishy and William E. Leuchtenburg (1787; New York, 1964), 156.

31 "the most oppressive domination": Madison quoted in Matthew Spalding, "How to Understand Slavery and the American Founding," Heritage Foundation Web site, http://www.heritage.org/Research/AmericanFounding andHistory/wp01.cfm, accessed Aug. 15, 2006.

32 "from Genesis to Revelation . . . a permanently degraded people": Quoted in Alice Felt Tyler, *Freedom's Ferment* (1944; New York, 1962), 469, 474.

33 "Missouri engulfs everything": Senator John W. Walker quoted in William Sumner Jenkins, *Pro-Slavery Thought in the Old South* (Chapel Hill, 1935), 69.

33 "The great body of slaves": *Niles' Weekly Register*, July 15, 1820.

33 "dirty bargain": *Universalist Quarterly and General Review*, Jan. 1866, 45.

33 "This momentous question": Samuel Eagle Forman, *The Life and Writings of Thomas Jefferson* (Indianapolis, 1900), 390.

33 "hangs like a Cloud": Adams to Louisa Catherine Adams, Jan. 13, 1820; Adams Papers Microfilm, Reel 124, Massachusetts Historical Society.

34 "the great and foul . . . a dissolution, at least temporary . . . I dare not say that it is not to be desired": Adams quoted in William Lee Miller, *Arguing About Slavery* (New York, 1996), 187–88, 193.

2. POLITICAL FIGHTS, POPULAR FÊTES

36 "He is no literary": *JMN*, 8: 339.

36 "great man": Quoted in Robert V. Remini, *John Quincy Adams* (New York, 2002), 2.

36 "state of useless and disgraceful": *Diary*, May 16 1792, quoted in "John Quincy Adams, Sixth President of the United States." *American Whig Review* 1 (May 1845): 546.

36 "a formal coldness": Adams quoted in E. F. Ellet, *The Court Circles of the Republic; or, The Beauties and Celebrities of the Nation* (Hartford, CT, 1869), 127.

36 "a gloomy misanthropist": Adams quoted in R. V. Remini, *John Quincy Adams*, 3

36 "The devices of my rivals . . . The best actions of my life": Adams quoted in *American Catholic Quarterly Review*, 7 (Oct. 1882): 749.

38 "reverenced . . . treated them": Adams quoted in George Dangerfield,

Review of Samuel Flagg Bemis's *John Quincy Adams and the Union*, *New England Quarterly*, 29 (Sept. 1956): 400.

39 "I never had a wish to be elevated . . . I mean to be silent": *Correspondence of Andrew Jackson*, ed. John Spencer Bassett (Washington, DC, 1928), 3: 174.

39 "will be the President of the whole people": Mobile (Ala.) *Mercantile Advertiser*, Jan. 8, 1824. For a useful discussion of the election of 1824, see Paul C. Nagel, "The Election of 1824: A Reconsideration Based on Newspaper Opinion," *Journal of Southern History*, 26 (Aug. 1960): 315–29.

40 "Old Hickory, the Nation's Hero . . . 8th of January . . . John Quincy Adams / Who can write": Quoted in M. James, *The Life of Andrew Jackson*, 355, 392–93.

39–40 "His ignorance was a wall": JP, 3: 699. The earlier reference to the earth not being round is also on p. 699. The *Vicar of Wakefield* comment is on p. 695.

40 "a barbarian who could not": Adams quoted in Edward Pessen, *Jacksonian America* (1969; Homewood, IL, 1977), 181.

41 "too much regard": Quoted in Chase C. Mooney, *William H. Crawford, 1772–1834* (Lexington, KY, 1974), 250.

42 "painful": Quoted in Mary W. M. Hargreaves, *The Presidency of John Quincy Adams* (Lawrence, KS, 1985), 37.

42 "a base and infamous": *MA*, 6: 483.

43 "Whether I ought . . . To me both prospects": Josiah Quincy, *Memoir of the Life of John Quincy Adams* (Boston, 1859), 138–39.

43 "I will not take one step . . . military chieftain": Adams and Clay quoted in R. V. Remini, *John Quincy Adams*, 67, 69.

43 "abuse me for it": Clay quoted in M. W. M. Hargreaves, *The Presidency of John Quincy Adams*, 47.

43 "Clay voted for Adams": Jackson quoted in R. V. Remini, *John Quincy Adams*, 74.

43 "corruptions and intrigues": Jackson quoted in Nathan Sargent, *Public Men and Events from . . . 1817, to . . . 1853* (Philadelphia, 1875), 88.

44 "opposed to my election": *MA*, 6: 547.

44 "exclude no person": Adams quoted in M. W. M. Hargreaves, *The Presidency of John Quincy Adams*, 53.

45 "*I will VOTE*": Benton quoted in Robert V. Remini, *The Election of Andrew Jackson* (Philadelphia, 1963), 46.

45–46 "The succession of visitors . . . They crawl upon one . . . I can scarcely conceive": *MA*, 7: 200–1, 221, and 235.

46 "uncontrollable dejection": *MA*, 7: 311.

49 "Here is his Home": Marie B. Hecht, *John Quincy Adams* (New York: 1972), 416.

49 "great act of public salutation": *North American Review*, 30 (Jan. 1830): 220.

49 "to the people of the union": *Niles' Weekly Register*, Sept. 17, 1825.

49 "one of the most remarkable": *United States Literary Gazette*, Aug. 1, 1825, 327.

49 "a style of grandeur": *Western Recorder*, July 5, 1825, 107.

50 "a great cannon . . . like blows . . . a blast furnace": Emerson quoted in David L. Larsen, *The Company of the Creative* (Grand Rapids, MI, 1999), 266.

50 "Webster! Webster!": Samuel O. Goodrich, "Webster's First Bunker Hill Oration," from Goodrich's *Recollections of a Lifetime*, http://www.usgennet.org/usa/topic/preservation/epochs/vol5/pg144.htm, accessed Oct. 30, 2006.

50–51 "Fortunate, fortunate man . . . the great events . . . Let us cultivate . . . Let us develop": Daniel Webster, "The Bunker Hill Monument," *The Works of Daniel Webster* (Boston, 1853), 1: 70, 74–75, and 78.

51 "The pageant was the most": Martha J. Lamb, *History of the City of New York* (New York, 1877), 699.

52 *"Who comes there?"*: Charles Burr Todd, *The Story of the City of New York* (New York, 1907), 414.

52 "products of the west": "The Commissioner's Boat," *Western Recorder*, Nov. 8, 1825, 179.

52 "to denote the subjection": *Niles' Weekly Register*, Nov. 12, 1825, 173.

53 "It is a great day . . . Thomas Jefferson": Adams quoted in *MA*, 7: 133.

53 "a coincidence so remarkable": *The Escritoir* (Albany), July 15, 1826, 111.

53 "among the most extraordinary": *Boston Recorder and Religious Telegraph*, July 14, 1826.

53 "matter of reverence and admiration": *The Album and Ladies' Weekly Gazette*, July 12, 1826.

53 "John Adams was eight years": *Saturday Evening Post*, 5 (July 15, 1826): 2.

54 "The time, the manner": *MA*, 7: 125.

54 "The great epic of their lives": "Adams and Jefferson," *Works of Daniel Webster*, 1: 114.

54 "Never in any country": *The Papers of John C. Calhoun*, ed. Clyde N. Wilson and W. Edwin Hemphill (Columbia, SC, 1977), 10: 132–35.

55 "the cast-iron man": Harriet Martineau, *Retrospect of Western Travel* (London, 1838), 1: 243.

55 "the most dangerous stab": *The Papers of John C. Calhoun*, 10: 9–10.

58 "a vile slanderer . . . the most contemptible": "Reminiscences of Washington," *The Atlantic Monthly*, 45 (Jan. 1880): 60–61.

58–59 "the coalition of Blifil . . . I am glad the debt": N. Sargent, *Public Men and Events*, 123–24.

59 "You owe me a coat": John Randolph quoted in Merrill D. Peterson, *The Great Triumvirate: Webster, Clay and Calhoun* (New York, 1987), 141.

60 "We shall be obliged": Jefferson quoted in Robert V. Remini, *Andrew Jackson and His Indian Wars* (New York, 2001), 115.

60 "a *permanent* home": Quoted in R. E. Riegel, *Young America*, 58–59.

61 "The spirit of improvement": "First Annual Message to Congress" (Dec. 6, 1825), in John Quincy Adams Speeches, Scripps Library and Multimedia Archive, Miller Center of Public Affairs, http://millercenter. virginia.edu/scripps/diglibrary/prezspeeches/jqadams/jqa_1825_1206 .html, accessed Nov. 2, 2006.

61 "I and not Henry Clay": Adams quoted in M. W. M. Hargreaves, *The Presidency of John Quincy Adams*, 322.

61 The number of steamboats: Sidney Ratner, James H. Soltow, and Richard Sylla, *The Evolution of the American Economy* (New York, 1993), 120, 125.

62 By 1832 the labor reformer Seth Luther . . . time for education: S. Luther, "An Address to the Working Men of New England on the State of Education and on the Condition of the Producing Classes in Europe and America" (Boston, 1832), p. 35.

63 "a saddening amount": Massachusetts House of Representatives, "Report of the Special Commission on the Hours of Labor and the Condition and Prospects of the Industrial Classes," Doc. 98, *Documents* (Boston, 1866), p. 3.

65 "There appears to exist": *Mechanics' Free Press*, June 5, 1830. Historians have recently pointed out that, actually, economic inequality appears not to have been as dramatic as labor reformers suggested. Still, the perception of class divisions was widespread in the antebellum period. And this perception had basis in fact: in 1840, for example, 70 percent of the wealth in America's largest cities was controlled by the richest 5 percent of property owners. Altogether, the share of the wealth held by the richest 10 percent of Americans jumped from around 50 percent in 1774 to 73 percent by 1860, with the richest 1 percent more than doubling its share during these years. See Daniel Walker Howe, *What Hath God Wrought: The Transformation of America, 1815–1848* (New York, 2007), 538–39, and Charles Sellers, *The Market Revolution: Jacksonian America, 1815–1846* (New York, 1991), 238.

67 "the *banking system*": Quoted in Daniel Feller, *The Jacksonian Promise*, 133.

68 "a good-enough Morgan": *Flag of Our Union*, 23 (Dec. 5, 1858): 781.

68 "a state of society": *Christian Advocate*, 1 (Jan. 27, 1827): 83.

72 "great quantities": Quoted in Sean Wilentz, *The Rise of American Democracy* (New York, 2005), 301.

72 "great democratic God": Herman Melville, *Moby-Dick; or The Whale*, ed. Harrison Hayford and Hershel Parker (New York, 1967), 105.

72 "Candidates for the Presidency": Quoted in Robert V. Remini, *The Election of Andrew Jackson* (Philadelphia, 1963), 62.

73 "non-political . . . the most stupendous . . . like a Dream": Quoted in R. V. Remini, *The Election of Andrew Jackson*, 113, 115.

74 "not really desire": H. Clay to J. J. Crittenden, Feb. 14, 1828, quoted in Mrs. Chapman Coleman, *The Life of John J. Crittenden* (Philadelphia, 1873), 1: 67

75 "a new form of slander . . . the numberless calumnies": *MA*, 7: 415, 539.

75 "Ought a convicted adulteress . . . a COMMON PROSTITUTE": Quoted in R. V. Remini, *The Election of Andrew Jackson*, 152–53.

76 "base and profligate combination": *MA*, 7: 383.

78 "the triumph of the virtue . . . Responsibility so great": *PJ*, 6: 535–36.

78 "I am filled with": *Correspondence of Andrew Jackson*, ed. J. S. Bassett, 3: 447.

78 "I would rather be": Mary Clemmer Ames, *Ten Years in Washington* (Hartford, CT, 1874), 215.

78 "A being so gentle": B. F. Crary, "The Tomb of General Jackson," *The Ladies' Repository*, 15 (Dec. 1855): 716.

3. JACKSON'S PRESIDENCY: DEMOCRACY AND POWER

81 "The reign of KING MOB": Quoted in N. Sargent, *Public Men and Events*, 164.

82 "the task of *reform*": "First Inaugural Address, Mar. 4, 1829," TeachingAmericanHistory.org, http://teachingamericanhistory.org/library/index.asp?documentprint=65, accessed Dec. 1, 2006.

82 "I feel much alarmed . . . His passions . . . Nobody knows": Jefferson and Webster quoted in JP, 1: 219 and 3: 167–68, successively.

82 "a savage disposition": *Correspondence of Andrew Jackson*, ed. J. S. Bassett, 3: 256.

84 Presidents from Washington through: Statistics from David H. Rosen-

bloom, *Federal Service and the Constitution* (Ithaca, NY, 1971), 65, and Robert V. Remini, *The Life of Andrew Jackson* (New York, 1977), 185.

84 "To the victor": Marcy quoted in JP, 3: 220.

84 "The duties of all public": A. Jackson, "State of the Union Address, Dec. 8, 1829," *Historic Speeches*, http://www.presidentialrhetoric.com/historicspeeches/jackson/stateoftheunion1829.html, accessed Jan. 26, 2007.

84 "Officers in their public . . . elevate the character": A. Jackson, "Outline of Principles," Feb. 23, 1829, quoted in R. V. Remini, *The Life of Andrew Jackson*, 185.

85 "The Millennium": Quoted in R. V. Remini, *The Life of Andrew Jackson*, 175.

86 "Eaton has just married": Quoted in R. V. Remini, *The Life of Andrew Jackson*, 174.

86 "the basest man": JP, 3: 193.

87 "She is as chaste": JP, 3: 204.

87 "die in the last Ditch": *Correspondence of Andrew Jackson*, ed. J. S. Bassett, 1: 153.

87 "Liberty *and* Union": *Works of Daniel Webster*, 1: 397.

88 "a *nullification affair*": *Autobiography of Martin Van Buren*, ed. John C. Fiztpatrick (Washington, DC, 1920), 413.

88 "Our Union: it . . . Our Union, next": Jackson and Calhoun quoted in N. Sargent, *Public Men and Events*, 175.

88 "I cannot recognize": J. Calhoun to A. Jackson, May 25, 1830; *United States Telegraph*, Feb. 17, 1831.

89 "the undoubted right": James D. Richardson, *Compilations of Messages and Papers of the Presidents* (Washington, DC, 1920), 2: 512.

90 "of purely local . . . How gratifying the effect": Andrew Jackson, "Veto of Maysville Road Bill" (1830), *Andrew Jackson on the Web*, http://www.pinzler.com/ushistory/vetoofmaysupp.html ; accessed Jan. 24, 2007.

90 "Toward the aborigines": A. Jackson, First Annual Message to Congress, Dec. 8, 1830, at http://www.mtholyoke.edu/acad/intrel/andrew.htm.

91 "Every war we had": JP, 3: 634.

91 "to cast off their": Transcript of President Andrew Jackson's Message to Congress "On Indian Removal" (1830), http://www.allamericanpatriots.com/m-wfsection+article+articleid-318.html, accessed Jan. 25, 2007.

92 But it's misleading: One historian writes, "At their worst the forced migrations approached the horrors created by Nazi handling of subject peoples" (E. Pessen, *Jacksonian America*, 300). A Web site devoted to exposing "Atrocities Committed by U.S. President Andrew Jackson"

states, "The history books do not speak well of Adolph Hitler; likewise, we are demanding that Andrew Jackson's name be explained as the man who is responsible for the deaths of 4,000 Cherokee children" ("Indian Mascots and Genocide: The Shame of American Public Schools," *American Comments. A Web Magazine*, http://www.iwchildren.org/genocide/shame9.htm, accessed Feb. 1, 2007).

93 "John Marshall has made . . . still born": Jackson quoted in Francis Paul Prucha, *The Great Father* (Lincoln, NE, 1984), 212.

95 "It gives me great pleasure": Transcript of President A. Jackson's Message to Congress "On Indian Removal" (1830), at *All American Patriots*, http://www.allamericanpatriots.com/american_historical_documents_1830_andrew_jackson_message_congress_indian_removal; accessed Feb. 5, 2007.

97 "The bank, Mr. Van Buren": Jackson quoted in *Autobiography of Martin Van Buren*, ed. J. C. Fitzpatrick, 625.

97–98 "The opinion of the judges . . . that the rich and powerful . . . artificial distinctions": "President Jackson's Veto Message Regarding the Bank of the United States; July 10, 1832, The Avalon Project at Yale Law School, http:// www.yale.edu/lawweb/avalon/presiden/veto/ajveto01.htm, accessed Feb. 6, 2007.

98 "the cause of democracy": Quoted in Robert V. Remini, "The Election of 1832," *History of American Presidential Elections*, ed. Arthur Schlesinger Jr. and Fred Israel (New York, 1971), 1: 509.

98 "instances of precipitate . . . The president independent . . . great public objects": "On President Jackson's Veto of the Bank Bill. In Senate, July 10, 1832," http://facweb.furman.edu/~benson/docs/clay.htm, accessed Feb. 7, 2007.

100 "the Veto is popular . . . between the Aristocracy": Quoted in S. Wilentz, *The Rise of American Democracy*, 373.

100 "As to politics": Clay quoted in Michael J. Holt, *The Rise and Fall of the American Whig Party* (New York, 1999), 19.

100 "My opinion is": John P. Kennedy, *Memoirs of the Life of William Wirt* (Philadelphia, 1849), 2: 331.

101 "*to form a more perfect* . . . To say that any": "President Jackson's Proclamation Regarding Nullification, December 10, 1832," The Avalon Project at Yale Law School, at http://www.yale.edu/lawweb/avalon/presiden/proclamations/jack01.htm, accessed Feb. 9, 2007. The other quotations in this paragraph are also from this source.

101 "crush and hang": Jackson quoted in R. V. Remini, *The Life of Andrew Jackson*, 235.

102 "No villain": JP, 3: 487.

103 "My children . . . *My father*": *Niles' Weekly Register*, June 15, 1833, 255.

104 "There are only two": JP, 489.

105 *"Nullification will never"*: *New York American*, June 18, 1833.

106 "The worthy president": Quoted in R. V. Remini, *The Life of Andrew Jackson*, 265.

106 "Nothing but the evidence": *The Correspondence of Nicholas Biddle*, ed. Reginald C. McGrane (Boston, 1919), 221.

106–107 "the name of Andrew Jackson . . . Didn't I manage . . . receiving two or three . . . I've got my foot": JP, 3: 549–50, 552.

107 "has assumed upon": JP, 3: 541.

107 The deposits reached $22 million . . . throughout the nation: Harry N. Sheiber, "The Pet Banks in Jacksonian Politics and Finance, 1833–1841," *Journal of Economic History*, 23 (June 1963): 202.

108 The cash supply . . . quadrupled by 1836: M. J. Holt, *Rise and Fall of the American Whig Party*, 62–63.

109 "the condition of public": A. Jackson, "Seventh Annual Message to Congress," Dec. 7, 1835, *eJournal*, http://www.synaptic.bc.ca/ejournal/JacksonSeventhAnnualMessage.htm, accessed Feb. 19, 2007.

109 "dramatic but innocuous": Richard Timberlake Jr., "The Specie Circular and the Distribution of the Surplus," *Journal of Political Economy*, 48 (Apr. 1960): 111.

110 "the Panic of 1837 was not": P. Temin, *The Jacksonian Economy* (New York, 1969), 22–23.

111 "powerfulest scene and show": "Election Day, 1884," http://www.daypoems.net/poems/2186.html, accessed Feb. 10, 2007.

111 "an unbridled lust . . . means one who prefers": Quoted in M. J. Holt, *Rise and Fall of the American Whig Party*, 29.

111–12 "open, palpable . . . Are we not governed . . . ignorant, passionate": JP, 3: 541, 594.

113 "was not *born*": *Workingman's Advocate*, Feb. 7, 1835.

114 "It is high time": *Correspondence of Andrew Jackson*, ed. J. S. Bassett, 5: 374.

115 Recent historians have given: See, for example, John M. Belohlavek, *"Let the Eagle Soar!" The Foreign Policy of Andrew Jackson* (Lincoln, 1985).

118 "a settled design": B. Lundy, *The War in Texas* (Philadelphia, 1836), 3.

119 "inflammatory and incendiary": JP, 3: 587.

119 "This spirit of mob-law": *Correspondence of Andrew Jackson*, ed. J. S. Bassett, 5: 360.

120 "Am I gagged": Adams quoted in S. Wilentz, *The Rise of American Democracy*, 472.

4. GOD'S MANY KINGDOMS

123 "*for political effect*": *Correspondence of Andrew Jackson*, ed. J. S. Bassett, 5: 565.

124 "hoping for a happy": JP, 3: 650.

124 "If General Jackson": R. V. Remini, *Life of Andrew Jackson*, 341.

124 "America is . . . the religious atmosphere": Alexis de Tocqueville, *Democracy in America*, ed. J. P. Mayer (Garden City, NY, 1969), 291, 295.

125 "The Protestant has his pew": *JMN*, 10: 178.

125 "In the United States": A. de Tocqueville, *Democracy in America*, ed. J. P Mayer, 432.

126 "How can I live": J. L. Diman, "Religion in America, 1776–1867," *North American Review*, 122 (Jan. 1876): 31.

126 "The whole people": F. Trollope, *Domestic Manners of the Americans* (1832; New York, 1949), 108.

126 Together, they attracted: The statistics on religion in this and the next paragraphs are in Roger Finke and Rodney Stark, *The Churching of America, 1776–1990* (New Brunswick, NJ, 1992), especially pp. 55–56.

128 "wild, wicked boy": Cartwright quoted in R. Finke and R. Stark, *The Churching of America*, 64.

128 "Brush College": "Methodist Clerical Biography," *North American Review*, 94 (Jan. 1864): 58.

128–29 "in a manner so . . . O lord have mercy . . . O, I'm sorry you . . . if it involves": "Methodist Clerical Biography," 55–57.

129 "Bold, brazen-fronted": James Gallaher, *The Western Sketch-Book* (Boston, 1850), 33.

129 "swept down in a moment": *Autobiography of James B. Finley*, ed. W. P. Strickland (Cincinnati, 1854), 167.

130 "truly indescribable . . . *sui generis*": "Barton Stone Explains Religious Exercises," R. Finke and R. Stark, *The Churching of America*, 95.

130 "howlings and groans . . . the convulsive movements": F. Trollope, *Domestic Manners of the Americans*, 86.

130 "Take away the worship": Quoted in R. Finke and R. Stark, *The Churching of America*, 96. The other information in this paragraph is also on p. 96.

131–32 He and his allies . . . American Home Missionary Society (1826): See Mark A. Noll, *A History of Christianity in the United States and Canada* (Grand Rapids, MI, 1992), 169.

132 "If we gain the West": *The Autobiography of Lyman Beecher*, ed. Barbara M. Cross (Cambridge, MA, 1961), 2: 167.

132 "one of the greatest evils": Beecher quoted in R. Finke and R. Stark, *The Churching of America*, 98.

133 "Many ministers are finding": C. G. Finney, *Lectures on Revivals of Religion* (1835; Cambridge, MA, 1960), 273–74.

133 "If you attempt it": *Autobiography of Lyman Beecher*, ed. B. M. Cross, 1: 75.

134 "his distorted countenance": "Revival Preaching," *Trumpet and Universalist Magazine*, 2 (Oct. 10, 1829): 58.

134 "a studied vulgarity": "Review of Finney's Lectures," *The Literary and Theological Review*, 2 (December 1835): 671.

134 "The sobs and groans": F. Trollope, *Domestic Manners of the Americans*, 38.

138 "a little Oxford": Quoted in Sydney E. Ahlstrom, *A Religious History of the American People* (New Haven, 1972), 626.

140 "We do not judge": W. E. Channing, "Unitarian Christianity," May 5, 1819, http://www.transcendentalists.com/unitarian_christianity.htm, accessed Mar. 2, 2007.

140 Even at its height: See Richard S. Fisher, *A New and Complete Statistical Gazetteer of the United States of America* (New York, 1853), 16.

141 By then, the Christian Connection: The statistics here are in John Evans, *History of All Christian Sects and Denominations* (Boston, 1875), 207, and Samuel Simon, *The Church of the Redeemer* (Baltimore, 1868), 55.

143 "ultra Lutherans": S. Schmucker, *The American Lutheran Church* (New York, 1969), 92.

146 "to have the United States": Ephraim Stinchfield, *Cochranism Delineated* (Boston, 1819), 10; at The Oliver Cowderly Pages, http://olivercowdery .com/gathering/JCochran.htm, accessed Mar. 5, 2007.

146 "did but touch": William L. Stone, *Matthias and His Impostures* (New York, 1835), 298.

147 "open and gross lewdness": "Report of the Trial of Jacob Cochrane, on Sundry Charges of Adultery, Lewd and Lascivious Conduct" (Kennebunk, 1819), 4l; at The Oliver Cowderly Pages, accessed Mar. 5, 2007.

148 "Oh-a! Ho-a!": F. Gerald Ham, "The Prophet and Mummyjums: Isaac Bullard and the Vermont Pilgrims of 1817," *Wisconsin Magazine of History*, 56 (Summer 1973): 296, http://www.sidneyrigdon.com/features/ pilgrim1.htm, accessed Mar. 5, 2007.

148 "visions of divine": *Philadelphia Recorder*, 2 (Mar. 19, 1825): 351.

148 "70 or 80,000 miles": M. H. Barton, "Reformatory," *Liberator*, 14 (July 5, 1844): 108.

148 "the gratification of his own": "A Wolf in Sheep's Clothing," *Boston Recorder*, 29 (Aug. 15, 1844): 132.

149 "came home in a state": *American Quarterly Review*, 18 (Sept. 1835): 214.

150 "a divine union": *Workingman's Advocate*, 6 (May 16, 1835): 2.

151 "the most ragged": Quoted in William A. Linn, *The Story of the Mormons* (New York, 1901), 13.

151 "great zeal": Smith quoted in Richard L. Bushman, *Joseph Smith and the Beginnings of Mormonism* (Urbana, 1984), 54.

153 "with the eyes": Martin Harris quoted in A. F. Tyler, *Freedom's Ferment*, 90–91.

154 One was only fourteen: For the wives' names and brief biographies, see http://www.wivesofjosephsmith.org.

154 "with a rod of iron": *Venus's Miscellany*, July 11, 1857.

155 Some thirty thousand: Todd M. Compton, "The Four Major Periods of Mormon Polygamy," Signature Books Library, http://www.signaturebookslibrary.org/essays/mormonpolygamy.htm, accessed Mar. 8, 2007.

156 THIS SHOP IS CLOSED: Whitney R. Cross, *The Burned-over District* (New York, 1950), 307. The statistics on Millerism in the preceding paragraph are on p. 287.

156 "Our fondest hopes": Quoted in George R. Knight, *Millennial Fever* (Boise, ID, 1993), 218.

157 "We are all a little wild": Emerson quoted in David E. Shi, *The Simple Life: Plain Living and High Thinking in American Culture* (Athens, GA, 1985), 134.

160 "Hock a nick": Quoted in Edward D. Andrews, *The Gift to Be Simple* (New York, 1940), 69.

163 "Fly from intercourse . . . a day of terror": Charles Nordhoff, *The Communistic Societies of the United States* (1875; New York, 1966), 35–36.

164 "all authority . . . I shall depose": Eric Janson quoted in A. F. Tyler, *Freedom's Ferment*, 134, 137.

165 "every dish free": Noyes quoted in R. E. Riegel, *Young America*, 262.

165 "When the will of God": Noyes quoted in George W. Noyes, *The Religious Experience of John Humphrey Noyes* (New York, 1923), 306, 309.

166 "the second Eden": Alcott quoted in A. F. Tyler, *Freedom's Ferment*, 172.

167 "Christ's ideal of society": *The Dial*, 2 (1841): 227.

168 "an inevitable lack": Quoted in A. F. Tyler, *Freedom's Ferment*, 182.

169 "the pleasantest of residences": "Historic Notes of Life and Letters in New England," American Transcendentalism Web, http://www.vcu

.edu/engweb/transcendentalism/authors/emerson/essays/historicnotes. html; accessed Mar. 27, 2007.

169 seven hundred thousand American Protestants: Statistic in S. E. Ahlstrom, *A Religious History of the American People*, 548.

169 "at a period": C. M. Sedgwick, *Redwood: A Tale* (New York, 1824), xv.

169 "the prolific parent": Charles Constantine Pise, *Father Rowland* (Baltimore, 1829), 64.

169 "I investigated them all": Walter Elliott, *The Life of Father Hecker* (New York, 1891), 131.

172 "The Bishop has twenty": *Boston Evening Transcript*, Aug. 12, 1834.

5. REFORMS, PANACEAS, INVENTIONS, FADS

175 "the great activity . . . What a fertility": R. W. Emerson, "New England Reformers," *EL*, 591.

176 The amount of absolute alcohol: Statistics in A. F. Tyler, *Freedom's Ferment*, 312.

176 "regarded as a necessary": *Autobiography of James B. Finley* (Cincinnati, 1854), 248.

176 "Everybody asked everybody": T. L. Nichols, *Forty Years of American Life* (1864; New York, 1968), 1: 87.

176 "It is very hard": *Walt Whitman in Camden*, ed. Horace Traubel (1953; Carbondale, IL, 1959), 4: 486.

176 In 1820 Americans spent $12 million: Statistic in A. F. Tyler, *Freedom's Ferment*, 318.

176 "like the Egyptian angel": A. Lincoln, "Address to the Washington Temperance Society of Springfield, Illinois," *Speeches and Writings, 1832–1858*, 88.

177 "all the various . . . The drinking was apparently": L. Beecher, *Autobiography*, 2: 34.

180 "like slavery": L. Beecher, *Autobiography*, 2: 34.

181 "when the victory shall be": A. Lincoln, *Speeches and Writings, 1832–1858*, 90.

182 "a good . . . the Central African . . . the greatest of all . . . Domestic slavery": Calhoun and Hammond quoted in W. L. Miller, *Arguing about Slavery*, 132, 134.

183 "Dead niggers": Sarah H. Bradford, *Harriet: Moses of Her People* (1886), electronic edition, in *Documenting the American South* (Chapel Hill, NC, 1995), 33, http://docsouth.unc.edu/neh/harriet/harriet.html, accessed Apr. 6, 2007.

183 "my woman Siby" and the other quotations here: Stephen S. Foster, *The*

Brotherhood of Thieves (New London, 1843), 64–70.

185 "the suspicion that": "Nat Turner's Insurrection," *Atlantic Monthly*, 8 (Aug. 1861): 186.

187 "I tell you Americans! . . . the *most wretched* . . . they brand us": D. Walker, *Appeal . . . to the Coloured Citizens of the World . . . September 28, 1829*, electronic edition, in *Documenting the American South* (Chapel Hill, 2001), 45, 74, and 9, respectively, http://docsouth.unc.edu/nc/walker/walker.html, accessed Apr. 6, 2007.

188 "I am in earnest": W. L. Garrison, "To the Public," *Liberator*, 1 (Jan. 1, 1831): 1.

193 "a covenant with death": Garrison, who used this phrase several times, was echoing Wendell Phillips's declaration in his treatise *The Constitution, a Pro-Slavery Compact* (1845); in *Against Slavery: An Abolitionist Reader*, ed. Mason Lowance (New York, 2000), 245.

194 "Burn 'em out": Horace Greeley, *The American Conflict* (Hartford, 1865), 140.

194 "the most important single": *Uncollected Letters of Abraham Lincoln*, ed. Gilbert A. Tracy (Boston, 1917), xx.

194 "a shock as of": J. Q. Adams, introduction to *Memoir of the Rev. Elijah P. Lovejoy* (New York, 1838).

194 "The brave Lovejoy": *JMN*, 5: 437.

194 "Here, before God": *John Brown: The Making of a Revolutionary*, ed. Louis Ruchames (1969; New York, 1971), 189.

194 "certainly a martyr . . . We solemnly protest": Wendell Phillips Garrison, *William Lloyd Garrison, 1805–1879* (New York, 1885–89), 190.

195 "make war on slavery": Oswald Garrison Villard, *John Brown, 1800–1859: A Biography Fifty Years After* (Boston, 1910), 46.

195 "would never be submitted": Quoted in A. F. Tyler, *Freedom's Ferment*, 469.

195 "The question of *separation*": George Tucker quoted in A. F. Tyler, *Freedom's Ferment*, 544.

196 "Pistols, dirks, bowie knives": T. D. Weld, *American Slavery As It Is* (1839; Itasca, IL, 1972), p. 108.

196 "The best way": Quoted in Parker Pillsbury, *Acts of the Anti-Slavery Apostles* (1883; New York, 1969), 388.

196 "roasted an Abolitionist": G. Lippard, *The Quaker City; or, the Monks of Monk Hall*, ed. David S. Reynolds (1845; Amherst, MA, 1995), 218.

196 "by and by everybody's": Samuel Langhorne Clemens, *Adventures of Huckleberry Finn* (1885; New York, 1977), p. 89.

196 "brought Southern tactics": Albert D. Richardson, "Free Missouri. II," *Atlantic Monthly*, 21 (Apr. 1868): 498.

197 "a huge and strange": W. P. Garrison, *William Lloyd Garrison*, 229.

199 "War is on its last . . . the universal cry": "War: An Address Before the

American Peace Society . . . in 1838," *The Works of Ralph Waldo Emerson* http://www.rwe.org/comm/index.php?option=com_content&task= view&id=74&Itemid=253, accessed Apr. 10, 2007.

199 "I regard Non-Resistance": Alcott quoted in Lewis Perry, *Radical Abolitionism* (Ithaca, 1973), p. 82.

199 "the *slave's* government . . . Under a government": H. D. Thoreau, *Collected Essays and Poems*, ed. Elizabeth Hall Witherell (New York, 2001), 206.

201 "the conventional one . . . erotic stories": W. Whitman, "A Memorandum at a Venture," *Prose Works, 1892*, ed. Floyd Stovall (New York, 1964), 2: 492–93.

201 "Such puritanical mores help explain": For premarital pregnancy rates, see John D'Emilio and Estelle B. Freedman, *Intimate Matters: A History of Sexuality in America* (New York, 1988), 76.

202 "One step over": *Zion's Herald*, 8 (July 12 1837): 112.

202 By a conservative estimate: Statistics here are in Timothy J. Gilfoyle, *City of Eros* (New York, 1992), 75.

203 "that infamous bawdy . . . among our virtuous": *Morning Courier and New York Enquirer*, Oct. 5, 1833.

203 "the most foul": *New York Commercial Advertiser*, Aug. 8, 1836.

203 "calculated to promote": *Memoir . . . of the Late Rev. John R. McDowall* (New York, 1838), 213.

204 "scandalous things": *History of the Preliminary Proceedings of the Third Presbytery, in the Case of J. R. McDowall*, in the *New York Observer*, May 1836 (pamphlet reprint).

204 "the sin of LICENTIOUSNESS . . . the *rescue*": *New York Evangelist*, 5 (June 14, 1834): 96.

204 By 1841, renamed the American: Statistics in this sentence are in the *New York Evangelist*, 12 (May 29, 1841): 1.

204 "calculated rather . . . But no more": *The New-Yorker*, 3 (Apr. 8, 1837): 42.

205 "look at the lovely": *New York Evangelist*, 7 (May 21, 1836): 82.

206 By 1847 it claimed: Statistics here in *New York Evangelist*, 18 (May 13 1847): 74.

206 "the prevalence . . . a system": *Liberator*, 10 (Jan. 10, 1840): 7.

206 "is a viper": *Liberator*, 4 (Sept. 6, 1834): 144.

207 "with the tremendous": Quoted in Peter Gardella, *Innocent Ecstasy* (New York, 1985), 57.

207 "Among the hapless": *Water-Cure Journal*, 3 (June 1, 1847): 172.

207 "blights and destroys": *Boston Medical and Surgical Journal*, 26 (June 8, 1842): 284.

207 "Consumptions, spinal distortions": *Water-Cure Journal*, 3 (June 1, 1847): 172.

207 "Self-pollution": *Boston Medical and Surgical Journal*, 27 (Sept. 14, 1842): 104–5.

207 "she had long been": *Boston Medical and Surgical Journal*, 32 (Apr. 9, 1845): 196.

208 "a young child": *Boston Medical and Surgical Journal*, 17 (Sept. 6, 1837): 72.

208 "dying by the thousands": O. Fowler, *Amativeness; or Evils and Remedies of Excessive and Perverted Sexuality* (New York, 1844), 17.

208 "The reason for this": *Boston Medical and Surgical Journal*, 27 (Sept. 14, 1842): 105.

208 "the still more loathsome": S. Graham quoted in C. Sellers, *The Market Revolution*, 251.

208 Criminal prosecution for sodomy was rare: For example, of the some seventy-five thousand indictments issued by the New York district attorney's office between 1796 and 1893, there were only thirty indictments for sodomy, of which only two, in 1847 and 1849, led to conviction. All the cases involved charges of violence, force, injury, or pain. Statistics here are in Michael Lynch, "New York City Sodomy," paper presented at New York University, 1985, p. 3. Unfortunately, Lynch's death from AIDS on July 9, 1991, prevented the completion of the book he was working on. Lynch entrusted Bert Hansen with publishing his historical research.

209 "one vast Sodom": *Letters of Gallowrake* (Ravenna, OH, 1834), 28–29.

210–211 "the penitentiary system . . . We felt as if": Alexis de Tocqueville and Gustave A. de Beaumont, *On the Penitentiary System in the United States*, trans. Francis Lieber (Philadelphia, 1833), 47 and 7.

212 A warden at Auburn . . . cat o' nine tails: See *Niles' National Register*, 5 (Feb. 16, 1839): 389 and "Death in Auburn Prison," *Liberator*, 16 (Feb. 20, 1846): 31.

213 "more obedient citizens": A. de Tocqueville and G. A. de Beaumont, *On the Penitentiary System in the United States*, 59.

213 "rigid, strict": *American Notes; and The Uncommercial Traveler* (1842; Philadelphia, 185-?), 128.

215 "It is impossible": "Houses of Refuge for Juveniles," *United States Magazine*, 3 (July 1856): 76.

217 "Perhaps there are": *Christian Observer*, 29 (Oct. 1850): 156.

217 "the insane are": Quoted in Francis Tiffany, *Life of Dorothea Lynde Dix* (Boston, 1890), 62.

218 "an entire and happy": *Journal of Foreign Medical Science and Literature*, 11 (Jan. 1821): 87.

218 Usually around 60 percent: See *New York Medical and Physical Journal*, Apr.–June 1828: 190.

218 "Not only is insanity": *Journal of Foreign Medical Science and Literature*, 11 (Jan. 1821): 87.

219 *"more than nine"*: *The Friend*, 22 (Jan. 27, 1849): 145.

219 "'crazy cells,'": *The Friend*, 22 (Feb. 24, 1849): 177.

219 "hideous objects": *Home Journal*, 20 (May 12, 1849): 2.

220 "Maltreatment of mentally": *New York Times*, 156 (Apr. 23, 2007): A18.

220 "Improvements are making . . . The whole circle": Dwight and Silliman quoted in D. Feller, *The Jacksonian Promise*, 93.

223 "to encourage institutions": Quoted in D. Feller, *The Jacksonian Promise*, 88.

224 "Humbug": P. T. Barnum, *The Autobiography of P. T. Barnum* (London, 1855), 12.

225 "Anything new": Quoted in D. Feller, *The Jacksonian Promise*, 29

227 "be the means of extending": *Ladies' Repository*, 10 (1850): 61–62.

227 "Steam and electricity": Quoted in Kenneth Silverman, *Lightning Man* (New York, 2003), 243.

227 "It is an extraordinary": *Jacksonian America*, ed. F. O. Gatell and J. M. McFaul, 15.

228 "Bleed freely": *Medical Repository of Original Essays*, 2 (Apr. 1, 1816): 382.

229 "the only absolute": *Philadelphia Public Ledger*, Apr. 9, 1836.

229 "indeed a Universal": *National Police Gazette*, Sept. 4, 1847, 415.

231 "The Water Cure is applicable": *Water-Cure Journal*, 2 (June 15, 1846): 20.

231 "hasten the advent": *Water-Cure Journal*, Front Material, 1855; Duplicated Volume, APS Online; http://proquest.umi.com.monstera.cc.columbia.edu:2048/pqdweb?index=l&did=341471211&SrchMode=1&sid=9&Fmt=10&VInst=PROD&VType=PQD&RQT=309&VName=HNP&TS=1203607082&clientId=15403; accessed June 29, 2007.

232 "MESMERIC EXAMINATIONS": *Boston Medical and Surgical Journal*, 33 (Oct. 1, 1845): 184.

233 "Depress the adhesive": W. Whitman, *Notebooks and Unpublished Prose Manuscripts*, ed. Edward F. Grier (New York, 1984), 2: 888–90.

233 "When Spurzheim": H. Martineau, *Retrospect of Western Travel*, 3: 201.

235 "The nigger": Horace Traubel, *With Walt Whitman in Camden* (1907; New York, 1961), 2: 283.

6. REBELLION AND RENAISSANCE

237 "Great geniuses": H. Melville, "Hawthorne and His Mosses" (1850), reprinted in afterword to *Moby-Dick*, ed. Harrison Hayford and Hershel Parker (New York, 1967), 543.

237 "the age transfigured": W. Whitman, *Complete Poetry and Collected Prose* (New York, 1982), 23.

237 "The ideas of the time": *EL*, 627.

239 "The very character": *The Norton Anthology of American Literature*, 7th ed., Nina Baym, et al. (New York, 2007), 2: 961.

239 "the arch-Federalist": H. S. Canby, *Classic Americans* (New York, 1931), 86.

239 "The literary labours": Quoted in Stanley T. Williams, *The Life of Washington Irving* (New York, 1971), 2: 14.

240 "but I would first": Pierre M. Irving, *The Life and Letters of Washington Irving* (New York, 1863–64), 4: 167.

241 "country with no": J. F. Cooper, *Letters and Journals*, ed. James Franklin Beard (Cambridge, MA, 1960–68), 3: 331.

241 "the natural repository": Quoted in Robert E. Spiller, *James Fenimore Cooper, Critic of His Times* (New York, 1931), 250.

242 "were more ready": Isaac Clark Pray, *Memoirs of James Gordon Bennett and His Times* (New York, 1855), 255.

242 "reading all day": *Emerson in His Journals*, ed. Joel Porte (Cambridge, MA, 1982), 433.

242 "Scurrility—the truth": *Brooklyn Daily Eagle*, Feb. 26, 1847.

242 In 1828 there were . . . a dozen years: S. Ratner, J. H. Soltow, and R. Sylla, *The Evolution of the American Economy*, 127.

242 "probably beyond": *ER*, 1214.

242–243 "only chance of dying . . . or any other decent animal . . . Upon calculating": Frank M. O'Brien, *The Story of the Sun, New York, 1833–1918* (New York, 1919), 108–9, 114.

243 "bend his back": I. C. Pray, *Memoirs of James Gordon Bennett*, 255.

244 "decidedly the greatest": *ER*, 1220.

244 He once challenged . . . several days in bed: Dawn B. Sova, *Edgar Allan Poe, A to Z* (New York, 2001), 142.

244 "it is . . . the excitable": *ER*, 579.

245 "indicative of *genius*": David S. Reynolds, *George Lippard* (Boston, 1982), 8.

246 "the heresy": *ER*, 75.

246 "a weak, a vaccillating . . . villainously bad taste . . . a certain fondness": *ER*, 612, 901, and 903.

247 "a fellow by the name . . . Democracy": E. A. Poe, *Poetry and Tales* (New York, 1984), 879–80.

247 "the type and the genius": E. A. Poe, *Poetry and Tales*, 396.

248 "the truest and surest": *Collected Works of Edgar Allan Poe*, ed. Thomas O. Mabbott (Cambridge MA, 1978), 802.

249 "[W]e shall all feel": *JMN*, 4: 57.

249 "[T]he favorite word": Emerson quoted in D. Feller, *The Jacksonian Promise*, 188.

249–50 "Masses! . . .'Tis a wild democracy . . . *Manifest Destiny*": *JMN*, 6: 249, 11: 540, and 11: 89.

250 "Good is promoted . . . The Best are never": *JMN*, 7: 167, 376.

250 "the two great parties": "Politics," *Essays: Second Series* (Boston, 1844), 228.

250 "We all lean . . . I suppose the evil": *JMN*, 4: 297

251 "If you would learn": *The Complete Works of Ralph Waldo Emerson* (1904; New York, 1968), 7: 11.

251 "I confess to some . . . all lack nerve & dagger": *Emerson in His Journals*, ed. J. Porte, 240–41, 218.

251 "often mix their styles": A. de Tocqueville, *Democracy in America*, 478. See D. S. Reynolds, *Beneath the American Renaissance* (New York, 1988), 444.

251 "Taylor's muse . . . the Shakespeare of the sailor . . . the ridicule of all method": *JMN*, 5: 255, 9: 236 and 5: 287.

252 "It is this which": *The Early Lectures of Ralph Waldo Emerson*, ed. Stephen E. Whicher and Robert E. Spiller (Cambridge, MA, 1959), 1: 224.

252 "Our eyes will be": *EL*, 1250.

253 "half horse, half alligator": *Crockett's Yaller Flower Almanac for '36* (New York, 1836).

253 "a transparent eye-ball": *EL*, 10.

253 "so many walking . . . men in the world . . . are content to . . . we are lined": *EL*, 54, 66 (two) ,and 68.

253 "an appendage . . . shows God . . . is Monster . . . Why drag around . . . A foolish consistency": *EL*, 79, 81, 80, and 265 (two).

253 "See the great ball": *EL*, 454.

254 By the mid-1830s . . . lyceum convention: See D. Feller. *The Jacksonian Promise*, 152.

254 "It is a singular fact . . . the most widely known": Kenneth Walter Cameron, *Transcendental Log* (Hartford, 1932), 148, 244.

254–55 "My thoughts . . . pictures of vulgar life . . . the burlesque is": *The Journals of Bronson Alcott*, ed. Odell Shepard (Boston, 1938) 60, 81, 82.

255 "Mr. Emerson is an inveterate . . . well-known wit": *Emerson Among His Contemporaries*, ed. Kenneth Walter Cameron (Hartford, 1967), 106, 115.

255 "*bag of duck-shot*": *The Correspondence of Emerson and Carlyle*, ed. Joseph Locke Slater (New York, 1964), 371.

255 "a chaos": James Russell Lowell, *Literary Essays* (Boston, 1892), 353.

255 "with the most fragmentary": *Correspondence of Emerson and Carlyle*, ed. J. L. Slater, 185.

255 "the ungirt, the diffuse": *JMN*, 10: 79–80.

255 "the style will often be": A. de Tocqueville, *Democracy in America*, ed. J. P. Mayer, 474.

256 "with tyrannous eye . . . Our logrolling . . . has an architecture": *EL*, 465, 450.

256 "the most extraordinary": W. Whitman, *Leaves of Grass: Comprehensive Reader's Edition*, ed. Harold Blodgett and Sculley Bradley (New York, 1965), 729.

256 "In politics . . . it is easy": *EL*, 593.

257 "*Believers in everything*": *ER*, 1303.

257 "temperance and non-resistance . . . So the country": *EL*, 591, 593.

257 "tried trade": H. D. Thoreau, *A Week on the Concord and Merrimac Rivers; Walden; The Maine Woods; Cape Cod* (New York, 1985), 377.

258 "the ways by which": H. D. Thoreau, *Collected Essays and Poems*, ed. E. H. Witherell, 377.

259 "At the bottom": Chevalier and Hall quoted in E. Pessen, *Jacksonian America*, 25.

259 "he had never overheard": F. Trollope, *Domestic Manners of the Americans*, 153.

259–60 "I did not use tea . . . The generative energy": H. D. Thoreau, *A Week . . . ; Walden*, 486, 497.

260 "I heartily accept . . . There will never be": *The Norton Anthology of American Literature*, 7th ed., 2: 1857, 1872.

260–261 Within a decade Thoreau . . . initially rejected him: See David S. Reynolds, *John Brown, Abolitionist* (New York, 2005).

261 "Perhaps the value . . . Using current phrases": *The Journal of Henry David Thoreau*, ed. Bradford Torrey and Francis H. Allen (New York, 1962), 3: 327, 7: 7–8.

261 "We do not care for": "Slavery in Massachusetts," in *Collected Essays and Poems* (New York, 2001), 339–40.

261 "the startling and monstrous": *The Journal of Henry David Thoreau*, ed. B. Torrey and F. H. Allen, 4: 267.

261 "In literature": *The Writings of Henry David Thoreau* (New York, 1968), 5: 231.

261 "wild strain . . . America is the she-wolf": *The Journal of Henry David Thoreau*, ed. B. Torrey and F. H. Allen, 144, 182.

261 "We must look to": H. D. Thoreau, *Journal*, John C. Broderick et al. (Princeton, 1962), 1: 481.

262 "Town and Rural": *Knickerbocker Magazine*, Mar. 1855.

262 "Sometimes strikingly": *Graham's Magazine*, 45 (Sept. 1854): 299.

262 "seeks, at all risks": *The Recognition of Henry David Thoreau*, ed. Wendell Glick (Ann Arbor, MI, 1969), 90.

262 "sufficiently queer . . . less successful": Kenneth Walter Cameron, *Transcendental Log* (Hartford, 1973), 37.

262 "I grow savager . . . There is in my nature": For a representative sampling of reprinted Thoreau passages, see *Literary Comment in American Renaissance Newspapers*, ed. Kenneth Walter Cameron (Hartford, 1977), 37–49.

263 "We know but few . . . The head monkey . . . perchance the first news": H. D. Thoreau, *A Week . . . ; Walden*, 340, 342, and 364.

263 "He coveted readers . . . an inquiring public": *Recognition of . . . Thoreau*, ed. W. Glick, 149, 131.

263–64 "surely . . . the greatest man . . . altogether a disreputable": *The Letters of Nathaniel Hawthorne*, ed. William Charvat, et al., in *Centenary Edition of the Works of Nathaniel Hawthorne* (Columbus, OH, 1984), 15: 34–35, 230.

264 "one of the truest": *Letters of Nathaniel Hawthorne*, 17: 256.

264 "the Locofoco Surveyor": N. Hawthorne, *Novels* (New York, 1983), 156.

264 "A man's soul": *Letters of Nathaniel Hawthorne*, 15: 545.

265–66 "some editions of books . . . took occasion . . . German by birth . . . aided by those": N. Hawthorne, *Tales and Sketches* (New York, 1982), 809, 815, 817, and 818.

267 "a d—d mob": *Letters of Nathaniel Hawthorne*, 17: 303.

267 "the grand reformer": N. Hawthorne, *Tales and Sketches*, 312.

267 "this great power": "Hawthorne and His Mosses," *Norton Anthology of American Literature*, 7th Edition, 2: 2311.

268 "all sort of good . . . the forerunner . . . but if study": Julian Hawthorne, *Hawthorne Reading* (Cleveland, 1902), 64, 39, and 107.

268 "A Show of wax-figures": *American Notebooks*, ed. Claude Simpson, in *Centenary Edition of the Works of Nathaniel Hawthorne* (Columbus, OH, 1972), 7: 176 See also p. 178.

269 "a significant red letter": S. Judd, *Margaret: A Tale of the Real and Ideal, Blight and Bloom* (Boston, 1845), 253.

269 "the nauseous amour . . . made for the market . . . strongly of incipient . . . Brothel Library": A. C. Coxe, *The Church Review* (Jan. 1851), in

Kenneth Walter Cameron, *Hawthorne Among His Contemporaries* (Hartford, 1968), 17.

271 "I am the poet": The manuscript drafts, along with other writings by Whitman, appear on *The Walt Whitman Archive,* created by Kenneth M. Price and Ed Folsom, http://www.whitmanarchive.org/; accessed June 8, 2007.

272 "not be for the eastern": W. Whitman, *Complete Poetry and Collected Prose* (New York, 1982), 15. The next quotation in this paragraph is on p. 42.

272 "calculated for popular": Melville letter to John Murray, June 15, 1846, quoted in Merrill R. Davis, *Melville's Mardi: A Chartless Voyage* (1952; New Haven, 1967), 24.

273 "immune from democratic": Duyckinck quoted in Michael Paul Rogin, *Subversive Genealogy: The Politics and Art of Herman Melville* (Berkeley, 1983), 73.

273 "nationality in its purest": Mathews quoted in *The Native Muse: Theories of American Literature,* ed. Richard Ruland (New York, 1972), 1: 302.

274 "is bound to carry": H. Melville, "Hawthorne and His Mosses" (1850), in appendix to *Moby-Dick; or, The Whale,* ed. H. Hayford and H. Parker, 543. The quotations in the next paragraph are in *Moby-Dick,* pp. 104–5.

275 "the most famous": Debby Applegate, *The Most Famous Man in America: The Biography of Henry Ward Beecher* (New York, 2006).

275 "In all the Italian . . . There were angels . . . government, *government*": Beecher quoted in James Jackson Jarves, *The Art-Idea,* ed. Benjamin Rowland Jr. (1864; Cambridge, MA, 1960), 156.

276 "Hyperbole and exaggeration": *The John-Donkey,* Mar. 25, 1848.

276 "inflate their imaginations": A. de Tocqueville, *Democracy in America,* 488.

276 "I desire to speak": H. D. Thoreau, *A Week . . . ; Walden,* 580.

277 "the Sea Serpent": G. C. D. Odell, *Annals of the New York Stage* (New York, 1927–49), 2: 506.

277 "no artists commensurate . . . a homegrown production": "A Painting Three Miles Long," *Littell's Living Age,* 14 (July–Sept. 1847): 594.

278 "six handsome . . . twenty-three of the most . . . by a young lady": G. C. D. Odell, *Annals of the New York Stage,* 5: 397, 494, and 398.

278 "the sight of such things": *The Uncollected Poetry and Prose of Walt Whitman,* ed. Emory Holloway (Gloucester, MA, 1972), 1: 191.

279 "love for the wild": Allston quoted in Barbara Novak, *American Paintings of the Nineteenth Century* (New York, 1969), 45.

279 "a young gentleman": *The Correspondence of Washington Allston,* ed. Nathalia Wright (Lexington, KY, 1993), 559.

279 "Next to my own country": *American Monthly Magazine*, 7 (May 1836): 435.

280 But, as Barbara Novak notes: B. Novak, *American Paintings of the Nineteenth Century*, 57.

280 "His genius": *Boston Pearl, and Literary Gazette*, 4 (Nov. 8, 1834): 74.

280 "courtesies, deferences": *Correspondence of Washington Allston*, ed. N. Wright, 629–30.

281 But as time passed . . . Jackson's archrival: David Bjelajac, *Millennial Desire and the Apocalyptic Vision of Washington Allston* (Washington, DC, 1988), 131.

281 Perhaps there is ominous . . . freed from bondage: See Sarah Burns, *Painting the Dark Side* (Berkeley, 2004), ch. 3.

282 "I often think . . . every newspaper . . . the downfall . . . fearful season . . . vice, profligacy": Cole quoted in S. Burns, *Painting the Dark Side*, 1, 22–23.

284 "We have become": *Diary of Philip Hone*, ed. Bayard Tuckerman (New York, 1889), 1: 260.

284 "primeval forests": Quoted in B. Novak, *American Paintings of the Nineteenth Century*, 61.

285 "I think that every": *Diary of Philip Hone*, ed. B. Tuckerman, 1: 74.

285 "that the beauty . . . The way-side": *American Art, 1700–1960, Sources and Documents*, ed. John W. McCoubrey (Englewood Cliffs, NJ, 1965), 109.

286 "It is now generally": "Cole and Durand," *New York Evening Post*, Apr. 23, 1847, 2.

290 "primitive looks . . . have been blasted . . . gradually rises": *George Catlin and His Indian Gallery*, ed. George Gurney and Therese Thau Heyman (New York, 2004), 11, 28.

290 "an emblematic exploiter": *George Catlin and His Indian Gallery*, ed. G. Gurney and T. T. Heyman, 20–21.

292 "The paintings of W. S. Mount": *American Whig Review*, 14 (Aug. 1851): 122.

292 "paint for the many . . . A painter's studio should be": Quoted in B. Novak, *American Paintings of the Nineteenth Century*, 151.

292 "I must paint": Alfred Frankentstein, *William Sidney Mount* (New York, 1975), 9.

292 "His heads of Negroes": *American Whig Review*, 14 (Aug. 1851): 124.

294 "mob-cratic influence": Bingham quoted in Paul C. Nagel, *George Caleb Bingham* (Columbia, MO, 2005), 27.

297 In 1818 Scudder's . . . outdone the next year . . . the Clarke Dwarves . . .

"the largest elephant" ... In 1832 there appeared ... wax figures ... "Santa Anna's Wooden" ... three Shaker women ... "Snow White Ne-groes": G. C. D. Odell, *Annals of the New York Stage*, 2: 514, 567, 543; 3: 546, 593–94; 4: 548, 667; 5: 58, 306.

298 "We live in times": G. C. D. Odell, *Annals of the New York Stage*, 4: 122.

298 "the only genuinely indigenous": Richard Moody, *America Takes the Stage* (Bloomington, IN, 1955), 32.

299 "Turn about an'": Charles Hamm, *Yesterdays: Popular Song in America* (New York, 1979), 118.

299 "oddities, peculiarities ... sports and pastimes": Robert C. Toll, *Blacking Up* (New York, 1974), 30, 34.

300 "prejudice at the North ... The prejudices of the north": *The Black Abolitionist Papers*, ed. C. Peter Ripley, 4 (Chapel Hill, 1991): 202; and W. L. Garrison, *Park Street Address*, July 4, 1829, American Antiquarian Society.

300 "Nigger lips": *Negro Protest Pamphlets* (New York, 1969), 40.

301 "White man come ... A happier day ... Poor mass did ... My mammy was": Quoted in R. C. Toll, *Blacking Up*, 83, 81, 49, 41.

303 "simple, fresh": *Brooklyn Star*, Nov. 5, 1845.

303 "absolutely indescribable": John Wallace Hutchinson, *The Story of the Hutchinsons* (Boston, 1896), 1: 117.

303 "the turbulent era": Michael Feldberg, *The Turbulent Era: Riot and Disorder in Jacksonian America* (New York, 1980).

304 "spit all over": R. C. Toll, *Blacking Up*, 12.

305 "When he was": Horace Traubel, *With Walt Whitman in Camden* (Carbondale, IL, 1992), 7: 295.

305 "the downfall": Richard Moody, *The Astor Place Riot* (Bloomington, IN, 1958), 43.

306 "American style of acting": *The Uncollected Poetry and Prose of Walt Whitman*, ed. E. Holloway, 2: 322–23.

306 "vehemence and rude ... the audiences of the United States ... the injudicious and ignorant": Macready quoted by R. Moody, *The Astor Place Riot*, 29, 44, and 29.

307 "I feel I cannot ... *He is not an artist*": Montrose J. Moses, *The Fabulous Forrest* (1929; New York, 1969), 226, 203.

7. PARTY POLITICS AND MANIFEST DESTINY

310 "illustrious predecessor ... a great, happy": "Inaugural Address of Martin Van Buren, Mar. 4, 1837," The Avalon Project at Yale Law School

(1996–2007), http://www.yale.edu/lawweb/avalon/presiden/inaug/vanburen.htm; accessed Apr. 4, 2007.

311 "So they go": *The Diary of George Templeton Strong*, ed. Allan Nevins and Milton Halsey (New York, 1952) 1: 62.

312 "rowed to his objects": Quoted in Richard H. Brown, "The Still Muffled Oars of Martin Van Buren," *Reviews in American History*, 12 (Dec. 1984): 490.

316 "Such a dereliction": R. W. Emerson to President Martin Van Buren, April 23 1838, in *The Works of Ralph Waldo Emerson*, http://www.rwe.org/comm/index.php?option=com_content&task=view&id=79&Itemid=252; accessed Feb. 3, 2007.

318 The Postal Department profited: Statistics from Major L. Wilson, *The Presidency of Martin Van Buren* (Lawrence KS, 1984), 172.

319 "fraud and corruption": "Speech at Springfield, Illinois," Dec. 18, 1839, *Collected Works of Abraham Lincoln* (New Brunswick, NJ, 1953), 158.

320 "anything that shall": Webster quoted in M. F. Holt, *Rise and Fall of the Whig Party*, 92.

322 "My friends are not . . . I am the most": Quoted in M. L. Wilson, *Presidency of Martin Van Buren*, 195.

323 "Give him a barrel": *Baltimore Republican*, Dec. 11, 1839.

323 "In the White House": Illinois State Historical Society publication, vol. 20 (Springfield, 1889), 162.

324 "We will vote for": *Michigan Historical Collections*, vol. 28 (Lansing: Michigan Historical Commission, [n.d.]), 398.

324 "Old Tip he wears": Quoted in David E. Johnson, "American History: 1840 U.S. Presidential Campaign," http://www.historynet.com/culture/politics/3026611.html, accessed Apr. 5, 2007.

325 "Down with the Whigs": Quoted in M. F. Holt, *Rise and Fall of the Whig Party*, 111.

325 "High-cockalorum": Noah Brooks, "American Politics II: The Passing of the Whigs," *Scribner's* 17 (Feb. 1895): 209.

327 "William Henry Harrison, President": "Recollections of an Old Stager," *Harper's New Monthly Magazine* 47 (Oct. 1873): 754.

327 "bilious pleurisy": Norma Lois Peterson, *The Presidencies of William Henry Harrison and John Tyler* (Lawrence KS, 1989), 41.

328 "Sir, I wish you": Benjamin Perley Poore, *Perley's Reminiscences of Sixty Years in the National Metropolis* (Philadelphia, 1886), 266.

328 "a political sectarian": *MA*, 10: 457.

328 "mild and pleasant": C. Dickens, *American Notes*, 156.

329 "I can never consent": Tyler quoted in Ruth C. Silva, *Presidential Succession* (Ann Arbor, MI, 1951), 18–20.

330 "supremely ridiculous": Quoted in N. L. Peterson, *The Presidencies of William Henry Harrison and John Tyler*, 69.

330 "pride, vanity . . . the character of crimes": Horace A. Cleveland, *Golden Sheaves Gathered from the Fields of Ancient and Modern Literature* (Philadelphia, 1869), 529.

331 "compelled to differ": Tyler quoted in N. L. Peterson, *The Presidencies of William Henry Harrison and John Tyler*, 85.

331 "His Accidency": M. F. Holt, *Rise and Fall of the Whig Party*, 137.

332 In fact, federal . . . Van Buren combined: See D. H. Rosenbloom, *Federal Service and the Constitution*, 65.

332 "We have numberless": Tyler quoted in N. L. Peterson, *The Presidencies of William Henry Harrison and John Tyler*, 147.

333 "The air of heaven": F. Trollope, *Domestic Manners of Americans*, 161.

333 "a disgrace": Quoted in Robert Seager II, *And Tyler Too* (New York, 1963), 177.

333 "Eastward I go only": H. D. Thoreau, "Walking," *Norton Anthology of American Literature*, 5th ed., Nina Baym et al. (New York, 1998) 1: 1960–61.

334 "Bodies of men, women": *California Star* (San Francisco), Apr. 10, 1847; "Log entries for April, 1847," http://www.donnerpartydiary.com/apr47 .htm, accessed June 10, 2007.

335 "The more vetoes": Clay quoted in Mrs. Chapman Coleman, *The Life of John J. Crittenden* (Philadelphia, 1873), 1: 185–86.

335 "mere cipher . . . I have been accused": Tyler quoted in N. L. Peterson, *The Presidencies of William Henry Harrison and John Tyler*, 105, 106.

336 "a sad state": *Papers of J. C. Calhoun*, ed. C. N. Wilson, 16: 392–93.

336 "arbitrary, despotic": Botts quoted in N. L. Peterson, *The Presidencies of William Henry Harrison and John Tyler*, 169.

336 "serve out his time": *Diary of Philip Hone*, ed. Allan Nevins (1927; New York, 1969), 2: 645.

339 "as a set-off": *Letters and Times of the Tylers*, ed. Lyon G. Tyler (1884–86; New York, 1970), 2: 248.

340 "any attempt": James D. Richardson, comp., *Messages and Papers of the Presidents*, 20 vols. (Washington, DC, 1913), 5: 2065. See also Edward P. Crapol, "John Tyler and the Pursuit of National Destiny," *Journal of the Early Republic*, 17 (Autumn 1997): 467–91.

344 By 1844 . . . barrel of flour there: Richard R. John Jr., "Private Mail Delivery in the U.S.: A Sketch," *Business and Economic History*, Second

Series (vol. 13, 1986): 140, https://www.h<->net.org/~business/bhcweb/
publications/BEHprint/v015/p0135-p0148.pdf, accessed Apr. 15, 2007.
Much of my discussion here of postal history is indebted to this article.

344 By 1843 a senator . . . private companies: R. R. John Jr., "Private Mail
Delivery," 142.

346 Although this claim . . . supports it: See especially Edward P. Crapol,
John Tyler: The Accidental President (Chapel Hill, NC, 2006), 64–67.

348 "essential to the peace": Calhoun quoted in Abiel Abbott Livermore,
The War with Mexico Reviewed (Boston, 1850), 23.

349 "Clay's position": Glyndon G. Van Deusen, *The Life of Henry Clay* (Bos-
ton, 1937), 374–75.

350 "Our strongest man": Quoted in Arthur Charles Cole, *The Whig Party in
the South* (Gloucester, MA, 1962), 115, n. 48.

351 "Though I occupy": *Polk Diary*, ed. Milo Milton Quaife (Chicago,
1910), 2: 360.

351–52 He convened . . . only four times: See Paul H. Bergeron, *The Presidency
of James K. Polk* (Lawrence, KS, 1987), 36.

353 "In any event": Quoted in Eugene I. McCormac, *James K. Polk* (Berke-
ley, CA, 1922), 287.

354 "the most important": Polk quoted in P. H. Bergeron, *The Presidency of
James K. Polk*, 188.

354–55 The nation's money supply . . . by 1855: S. Ratner, J. H. Soltow, and R.
Sylla, *Evolution of the American Economy*, 166.

356 "to occupy a foot": Polk quoted in Charles Grier Sellers, *James K. Polk,
Continentalist, 1843–1846* (Princeton, 1966), 227.

356 "fulfillment of our . . . The Anglo-Saxon foot": "Annexation," *United
States Democratic Review*, 17 (July–Aug. 1845): 5, 9.

359 "to conduct war": Quoted in David M. Pletcher, *The Diplomacy of An-
nexation* (Columbia, MO, 1973), 456.

361 "was unfit for": *Polk Diary*, 2: 225.

361 "all whigs": Polk quoted in P. H. Bergeron, *The Presidency of James K.
Polk*, 79.

362 "mischievous & foolish": *Polk Diary*, 1: 75.

EPILOGUE: ENDINGS, BEGINNINGS

366 "an indifferent specimen": Quoted in K. Jack Bauer, *Zachary Taylor* (Ba-
ton Rouge, 1985), 272.

367 "I am not . . . Such an idea": Taylor quoted in K. J. Bauer, *Zachary Taylor*,
216–17.

368 "strongly opposed": Taylor quoted in K. Jack Bauer, *Zachary Taylor*, 247.

368 "one of the greatest": Quoted in K. J. Bauer, *Zachary Taylor*, 219.

368 "I do not care": Taylor quoted in K. J. Bauer, *Zachary Taylor*, 227.

368–69 "accept a nomination . . . by Whig or Democratic . . . a Whig but not . . . more from a sense": Taylor quoted in Elbert B. Smith, *The Presidencies of Zachary Taylor and Millard Fillmore* (Lawrence, KS, 1988), 40–2.

369 "a great moral, social": Quoted in S. Wilentz, *The Rise of American Democracy*, 618.

370 "Free soil, free speech . . . No more slave": Quoted in Frederick J. Blue, *The Free-Soilers* (Urbana, IL, 1973), 74–75.

370 "didn't want a 'nigger'": Quoted in S. Wilentz, *The Rise of American Democracy*, 624.

370 "the hardy pioneers": Quoted in F. J. Blue, *The Free-Soilers*, 295.

370 "I would preserve": *Congressional Globe*, Session of the Twenty-ninth Congress, Appendix, 317–18.

370 white supremacy, as some historians point out: See, for example, D. W. Howe, *What Hath God Wrought*, 510, 544–45.

371 "I have studied the Negro": Clay quoted in David L. Smiley, *Lion of Whitehall: The Life of Cassius M. Clay* (Madison, WI, 1962), 29.

372 "The whole country": *The Californian* (San Francisco), May 29, 1848; quoted in Rolander Guy McClellan, *The Golden State* (Philadelphia, 1872), 256.

374 "Almost every mail": *German Reformed Messenger*, 17 (July 28, 1852): 3715.

375 the bonds of womanhood: N. F. Cott, *The Bonds of Womanhood* (New Haven, 1977), 53–66.

376 "convention to discuss": *Seneca County Courier*, July 14 1848.

376 "We hold these truths": *History of Woman Suffrage*, ed. Elizabeth Cady Stanton, Susan B. Anthony, and Matilda Joslyn Gage (New York, 1881), 1: 70.

376 "the most shocking": Quoted in S. Wilentz, *Rise of American Democracy*, 621–22.

376 "What absurd stuff": *Seneca Democrat* quoted in D. W. Howe, *What Hath God Wrought*, 848.

376 "breaking up churches": O. A. Brownson, *The Spirit-Rapper: An Autobiography* (Boston, 1854), 138.

377 "spiritualism has been": T. L. Nichols, *Forty Years of American Life* (London, 1864), 251–52.

377 "a rebellion such as": Quoted in Judith Wellman, *The Road to Seneca Falls* (Urbana, IL, 2004); 208.

377 "one common object": G. Fitzhugh, *Cannibals All! or, Slaves Without Masters* (Richmond, VA, 1857), 287.

377 "I stirred up the North": Rev. E. P. Birch, "The Devil's Visit to 'Ole Abe,'" in *Civil War Song Sheets*, in *America Singing*, Library of Congress, http://memory.loc.gov/cgi-bin/ampage, accessed Sept. 22, 2007.

378 "cavalier element . . . antithesis of the Puritan": Frank H. Alfriend, "A Southern Republic and a Northern Democracy," *Southern Literary Messenger*, 37 (May 1863): 283. See also Jan C. Dawson, "The Puritan and the Cavalier: The South's Perception of Contrasting Traditions," *Journal of Southern History*, 44 (Nov. 1978): 597–614, and William Robert Taylor, *Cavalier and Yankee* (New York, 1963).

378 "at once a religious . . . the builder": J. Quitman Moore, "Southern Civilization: or, The Norman in America," *DeBow's Review*, 32 (Jan.–Feb. 1862): 7, 8.

378 "the principles of": "The Relative Political Status of the North and the South," *DeBow's Review*, 22 (Feb. 1857): 128.

378 "The institution of domestic": George Fitzhugh, "Bonaparte, Cromwell, and Washington," *Debow's Review*, 28 (Aug. 2, 1860): 154.

378–79 "a benevolent system . . . Let us strengthen": F. H. Alfriend, "A Southern Republic," 286, 289.

379 "Worship of the North": Unattributed political cartoon, Boyd Stutler Collection of John Brown, West Virginia Archives.

379 "well-known fact that": The reformer John Finch quoted in David Roediger, *The Wage of Whiteness* (New York, 1991), 77.

381 "the Constitution-breaking": S. S. Cox, *Eight Years in Congress, from 1857–1863* (New York, 1865), 283.

382 "without *verry*": *John Brown: The Making of a Revolutionary*, ed. Louis Ruchames (1969; New York, 1971), 167.

➔ Selected Sources and Readings ⬅

PROLOGUE

Arthur M. Schlesinger Jr.'s landmark *The Age of Jackson* (1945) remains an influ-
ential overview. From a liberal-Progressive standpoint, Schlesinger interprets
Jackson, Van Buren, and other Democrats as representatives of a post-Jeffersonian
working-class ethos, pitted against a Hamiltonian mentality allied with capital-
ism. A number of historians have questioned Schlesinger's Progressive thesis,
pointing out that Jackson and his followers did not monopolize working-class
loyalty and that an emerging capitalist mentality was visible everywhere. Books
along this line include Richard Hofstadter's *The American Political Tradition and
the Men Who Made It* (1948), Bray Hammond's *Banks and Politics in America from
the Revolution to the Civil War* (1957), and Lee Benson's *The Concept of Jacksonian
Democracy* (1961). Edward Pessen in *Jacksonian America* (1969; 1977) argues that
far from being the era of the common man, the Jacksonian age saw great eco-
nomic inequality. Robert H. Wiebe in *The Opening of American Society* (1984)
stresses expansion in his discussion of social change. Efforts to view the nine-
teenth century through a Marxist lens, such as William A. Williams's *The Con-
tours of American History* (1961), Alexander Saxton's *The Rise and Fall of the White
Republic* (1990), Allan Kulikoff's *The Agrarian Origins of American Capitalism*
(1992), and John Ashworth's *Slavery, Capitalism, and Politics in the Antebellum
Republic*, vol. 1 (1995), have had notably mixed results.

Since the rise of cultural studies, overviews have often encompassed such
topics as Native Americans, African Americans, women, and religious and re-
form movements. Breadth of coverage, however, has not resulted in agreement
on key issues. Charles Sellers's *The Market Revolution: Jacksonian America, 1815–
1846* (1991) defines the major development of the period as a rapid shift from a
subsistence economy to a market economy—a shift that Sellers finds largely del-
eterious, as it allegedly dampened the free, individualistic spirit of an earlier age.
In contrast, Daniel Walker Howe's mammoth *What Hath God Wrought: The*

Transformation of America, 1815–1848 (2007) casts doubt on the notion of a market revolution and argues that instead there occurred revolutions in transportation and communication, which not only improved quality of life but also fed the forces of democracy for some groups, especially women. With a dedication to John Quincy Adams, Howe's book challenges the phrase "the Age of Jackson" and joins other volumes that rehabilitate Old Hickory's predecessor while questioning the allegedly democratic results of Jacksonian politics. In Howe's treatment, Andrew Jackson becomes a charismatic leader but also a retrograde lawbreaker and an imperialistic white supremacist, while the religious and moral impulse often associated with the Whigs is the breeding ground of progressive reforms (the priggish Floride Calhoun and her ilk, for instance, become nascent feminists). Another sprawling tome, Walter A. McDougall's *Throes of Democracy: The American Civil War Era 1829–1877* (2008), takes the ambiguous stance that antebellum Americans became experts in "creative corruption"—energy and enterprise combined with self-deception, greed, and violence.

Chapters 6 through 20 of Sean Wilentz's *The Rise of American Democracy: From Jefferson to Lincoln* (2005) provide an exhaustive examination of the political scene, with special attention to the expansion of voting rights for white males that helped define Jacksonian democracy. While focusing on politics, Wilentz also provides insights into evangelical religion and certain reforms. With its sympathetic treatment of Jackson, Wilentz's book goes a long way to recuperating Old Hickory's stature. Another tome, Walter A. McDougall's *Throes of Democracy* (2008), takes the ironic stance that Americans of all classes and regions became experts in "creative corruption"—energy and enterprise combined with self-deception, greed, and violence.

Robert E. Riegel in *Young America, 1830–1840* (1949; 1973) provides a colorful social history of the 1830s. John William Ward's *Andrew Jackson, Symbol for an Age* (1955) traces images of Jackson in popular culture. Glyndon G. Van Deusen's *The Jacksonian Era* (1959) is a competent overview of the era's politics, with particular attention to the New York Whigs. In *The Jacksonian Promise* (1995), Daniel Feller reminds us that there was a powerful optimistic current in American society—a point also made in Irving Howe's sparkling but discursive *The American Newness* (1986). Harry L. Watson's *Liberty and Power: The Politics of Jacksonian America* (1990) uses states' rights versus nationalism as its central theme. A useful college textbook is *Inventing America* (2005), ed. Pauline Maier, et al., vol. 1, with a section on 1815–48 by Merrit Roe Smith.

Valuable primary documents related to Jacksonian America can be found in *Jacksonian America, 1815–1840*, ed. Frank Otto Gatell and John M. McFaul (1970); *Jacksonian Panorama*, ed. Edward Pessen (1976); and *Major Problems in the Early Republic, 1787–1848*, ed. Sean Wilentz (1992).

1. FORGING A NATIONAL IDENTITY

Robin Reilly's *The British at the Gates* (1994) and Robert V. Remini's *The Battle of New Orleans* (1999) are the best studies of Jackson's famous victory. Connections between rising nationalism and the American System are ably described in George Dangerfield, *The Era of Good Feelings* (1952) and *The Awakening of American Nationalism* (1965); Maurice G. Baxter, *Henry Clay and the American System* (1995); and Edward Skeen, *1816: America Rising* (2003). Especially useful studies of Henry Clay are Robert V. Remini's biography *Henry Clay: Statesman for the Union* (1991) and Merrill D. Peterson's *The Great Triumvirate: Webster, Clay and Calhoun* (1988), which follows the intertwined careers of these three leaders. For post-1815 politics, see Ralph Ketcham, *Presidents Above Party* (1984); Stephen Skowronek, *The Politics Presidents Make* (1993); and Marshall Folletta, *Coming to Terms with Democracy* (2001).

The classic history of roads, steamboats, canals, and railroads is George Rogers Taylor, *The Transportation Revolution, 1815–1860* (1951). Useful supplements to Taylor, each with fresh information, are Nathan Miller, *The Enterprise of a Free People* (1962); Ronald E. Shaw, *Erie Water West* (1966); Oliver O. Jensen, *The American Heritage History of Railroads in America* (1975); Ronald E. Shaw, *Canals for a Nation* (1990); James Arthur Ward, *Railroads and the Character of America, 1820–1887* (1986); John Seelye, *Beautiful Machine* (1991); Carol Sheriff, *The Artificial River* (1996); Russell Bourne, *Floating West: The Erie and Other American Canals* (1992); James Dilts, *The Great Road* (1993); *The National Road* (1996), ed. Karl Raitz; John Lauritz Larson, *Internal Improvement* (2001); Andrea Sutcliff, *Steam* (2004); and Harold Evans, *They Made America* (2004).

Harry Ammon's *James Monroe* (1971) and Noble E. Cunningham Jr.'s *The Presidency of James Monroe* (1996) demonstrate that Monroe was firmly in charge of his star-studded cabinet and was largely responsible for several achievements. Gary Hart in *James Monroe* (2005) associates Monroe's importance with building a standing army. Accounts of the Monroe Doctrine and its contexts can be found in Dexter Perkins, *History of the Monroe Doctrine* (1963); Ernest May, *The Making of the Monroe Doctrine* (1975); and *The Monroe Doctrine* (1976), ed. Donald Dozer. For the expansion of voting rights in America, see Chilton Williamson's *American Suffrage* (1960) and Alexander Keyssar's *The Right to Vote* (2000). For the disenfranchisement of blacks, see Leon Litwack, *North of Slavery* (1961).

Good sources on colonization are P. J. Staudenraus, *The African Colonization Movement* (1961); James Wesley Smith, *Sojourners in Search of Freedom* (1987); Katherine Harris, *African and American Values* (1988); Amos J. Beyan, *The American Colonization Society and the Creation of the Liberian State* (1991); Lamin Sanneh, *Abolitionists Abroad* (1999); and Eric Burin, *Slavery and the Peculiar Solution*

(2005). Colonization sentiment among blacks is analyzed in Floyd J. Miller's *The Search for a Black Nationality* (1975). An excellent discussion of Liberia and Southern society is provided by Michael O'Brien in *Conjectures of Order* (2005).

Murray N. Rothbard's *The Panic of 1819* (1962) describes the economic downturn of 1819–22. The Missouri crisis is examined in Glover Moore's *The Missouri Controversy* (1951) and Robert Pierce Forbes's *The Missouri Compromise and Its Aftermath* (2007), supplemented by Richard H. Brown's "The Missouri Crisis, Slavery, and The Politics of Jacksonianism," *South Atlantic Quarterly*, 65 (1966): 55–72.

2. Political Fights, Popular Fêtes

Robert V. Remini in *John Quincy Adams* (2002) makes a strong case for viewing positively Adams's roles as secretary of state, president, and congressman.

Samuel Flagg Bemis traces Adams's difficult domestic dealings in *John Quincy Adams and the Union* (1956) and his early foreign-policy successes in *John Quincy Adams and the Foundations of American Foreign Policy* (1965). Paul C. Nagel's *John Quincy Adams* (1997) details Adams's private troubles. Marie B. Hecht's *John Quincy Adams* (1972) and Lynn Hudson Parsons's *John Quincy Adams* (1998) are both balanced and readable biographies. In *The Presidency of John Quincy Adams* (1985), Mary Hargreaves shows that Adams's presidency was more successful than was once thought.

Andrew Burstein's *America's Jubilee* (2001) re-creates the patriotic occasions of the mid-1820s. For accounts of Lafayette's tour, see especially J. Bennett Nolan's *Lafayette in America Day by Day* (1934) and Fred Somkin's *Unquiet Eagle* (1967). Len Travers in *Celebrating the Fourth* (1997) interprets the deaths of Adams and Jefferson on July 4, 1826, as the real beginning of the Age of Jackson.

Sydney Nathans's *Daniel Webster and Jacksonian Democracy* (1973), Irving H. Bartlett's *Daniel Webster* (1978), and Robert V. Remini's *Daniel Webster* (1997) give a sense of Webster's political skills while chronicling his private struggles. Superior biographies of Calhoun include John Niven's *John C. Calhoun and the Price of Union* (1993) and Irvin H. Bartlett's *John C. Calhoun* (1993). Notable considerations of Antimasonry include Paul Goodman's *Towards a Christian Republic* (1988) and William Preston Vaughan's *The Antimasonic Party in the United States* (1983).

The classic treatment of early workers' parties and the labor movement is John R. Commons, et al., *History of Labour in the United States* (1918; 1966). Informative discussion of labor movements can also be found in Bruce Laurie, *Artisans into Workers* (1989); Edward Pessen, *Most Uncommon Jacksonians* (1967); Ronald Schultz, *The Republic of Labor* (1993); Jonathan Glickstein, *American Exceptionalism, American Anxiety* (2002); and Mark Lause, *Young America* (2005). Diana Muir's *Reflections in Bullough's Pond* (2000) explores the industrial revolution in New England. In *Women at Work* (1979), Thomas Dublin describes the changing

Lowell workforce. Other studies of industrialism include John Kasson, *Civilizing the Machine* (1976); *Yankee Enterprise* (1981), ed. Otto Mayr and Robert Post; Thomas Cochran, *Frontiers of Change* (1981); Jonathan Prude, *Working-Class America* (1983); Teresa Murphy, *Ten Hours' Labor* (1992); and Peter Temin, *Engines of Enterprise* (2000). William E. Wilson in *The Angel and the Serpent* (1964) provides a history of Robert Owen's New Harmony community. For Frances Wright's reform activities in America, see Celia Morris Eckhardt's *Fanny Wright* (1984). Robert V. Remini's *The Election of Andrew Jackson* (1963) and Lynn Parsons's *The Birth of Modern Politics* (2009) colorfully capture the memorable election of 1828.

3. JACKSON'S PRESIDENCY: DEMOCRACY AND POWER

James Parton's three-volume *Life of Andrew Jackson* (1860) is still a useful source of information. Marquis James's biography *The Life of Andrew Jackson* (1938) has narrative flair and manifests a Progressive appreciation of Jackson. The most detailed biography of Jackson is Robert V. Remini's three-volume opus *Andrew Jackson and the Course of Empire, 1767–1821* (1977), *Andrew Jackson and the Course of American Freedom, 1822–1832* (1981), and *Andrew Jackson and the Course of American Democracy, 1833–1845* (1984), abridged as *The Life of Andrew Jackson* (1988). These volumes are invaluable resources and suggestive interpretations of Jackson as the champion of the working class. In *Andrew Jackson* (2008), Remini highlights old Hickory's military career. Sean Wilentz's *Andrew Jackson* (2005) is a concise biography that squarely faces Old Hickory's failings while constructing a persuasive defense of the president. H. W. Brands's *Andrew Jackson* (2006) is a readable recap of Jackson's life, stressing his military experience and his often violent private encounters. Jon Meacham's *American Lion* (2008) is an engaging portrait of Jackson. Psycho-biographies of Jackson include James C. Curtis's *Andrew Jackson and the Search for Vindication* (1976) and Andrew Burstein's *The Passions of Andrew Jackson* (2003).

John F. Marszalek's *The Petticoat Affair* (1997) and Catherine Allgor's *Parlor Politics* (2000) consider the Eaton scandal in relation to gender roles and politics. For a discussion of the Kitchen Cabinet, see Richard B. Latner's *The Presidency of Andrew Jackson* (1979). Glyndon Van Deusen's *The Jacksonian Era* (1959) and Donald B. Cole's *The Presidency of Andrew Jackson* (1993) judiciously survey Jackson's political accomplishments. Louis Masur's *1831: Year of Eclipse* (2001) analyzes several phenomena that made this year a turning point.

Coverage of Jackson's Indian removal policies is given in several books by Francis Paul Prucha—notably *American Indian Policy in the Formative Years* (1962), *Indian Policy in the United States* (1981), and *The Great Father* (1984)—as well as in Angie Debo's *A History of the Indians of the United States* (1970) and Ronald N. Satz's *American Indian Policy in the Jacksonian Era* (1975). Robert V.

Remini, a strong Jackson partisan, puts Indian removal in the best possible light in his books *The Legacy of Andrew Jackson* (1988) and *Andrew Jackson and His Indian Wars* (2001). For a more negative view, see Alfred A. Cave's "Abuse of Power: Andrew Jackson and the Indian Removal Act of 1830," *The Historian*, 65 (2003): 1330–53. Anthony F. C. Wallace in *The Long, Bitter Trail* (1993) suggests that Jackson pretended to preserve the Indians but actually coveted their lands. Michael P. Rogin's *Fathers and Children* (1975) attributes Old Hickory's paternalism to psychological conflicts. The most reliable histories of the long effort to uproot the Seminoles are John T. Sprague, *The Origin, Progress and Conclusion of the Second Florida War* (1964); John Mahon, *History of the Second Seminole War* (1967; 1991); F. P. Prucha, *Sword of the Republic* (1969); Virginia Peters, *The Florida Wars* (1979); and David and Jeanne Heidler, *Old Hickory's War* (1996).

For the 1832 race, see Samuel Rhea Gammon Jr., *The Presidential Campaign of 1832* (1922). Interpretations of the nullification controversy can be found in Frederic Bancroft, *Calhoun and the South Carolina Nullification Movement* (1928); Chauncey S. Boucher, *The Nullification Controversy in South Carolina* (1928); Merrill D. Peterson, *Olive Branch and Sword* (1982); Richard E. Ellis, *The Union at Risk* (1987); Peter Knupfer, *The Union as It Is* (1991); and Don Fehrenbacher, *Sectional Crisis and Southern Constitutionalism* (1995). Increasing Southern secessionist sentiment is traced in William W. Freehling's monumental *The Road to Disunion*, 2 vols. (1990, 2007). Another pioneering study of the South is Eugene Genovese, *Roll, Jordon, Roll* (1974).

Robert V. Remini in *Andrew Jackson and the Bank War* (1967) sensibly takes a middle ground between those who side with Jackson in the war and those, such as Reginald Charles McGrane in *The Panic of 1837* (1924) and Thomas Payne Govan in *Nicholas Biddle* (1959), who support Biddle. The bank controversy is also a focus of Ralph Caterall's *The Second Bank of the United States* (1903) and Howard Bodenhorn's *History of Banking in Antebellum America* (2000). Peter Temin in *The Jacksonian Economy* (1970) builds a convincing, though sometimes hyperbolic, defense of Jackson's often-criticized economic policies. Marvin Meyers in *The Jacksonian Persuasion* (1957) details the rise of a probusiness policy among the Democrats. Sean Wilentz's *Chants Democratic* (1984) explores the "republicanism of the streets" that resulted from economic and social change. Christine Stansell in *City of Women* (1986) originally merges women's studies with urban history.

An impartial economic history of America is *The Evolution of the American Economy* (1993) by Sidney Ratner, James H. Soltow, and Richard Sylla. Other useful books on the economy are Douglass North, *The Economic Growth of the United States* (1961); *Yankee Enterprise*, ed. Otto Mayr and Robert Post (1981); David Hounshell, *From the American System to Mass Production* (1984); Winifred Rothenberg, *From Market-Places to a Market Economy* (1992); Walter Licht, *In-*

dustrializing America (1995); *The Cambridge Economic History of the United States* (1996–2000), ed. Stanley Engerman and Robert Gallman, vol. 2; Robert E. Wright, *The Wealth of Nations Rediscovered* (2002); David Nye, *America as Second Creation* (2003); David R. Meyer, *Roots of American Industrialism* (2005); and *The Economy of Early America*, ed. Cathy Matson (2006). Daniel Walker Howe's *The Political Culture of the American Whigs* (1979) and Michael F. Holt's *The Rise and Fall of the American Whig Party* (1999) provide scrupulous accounts of the Whigs. In *The Mind of America, 1820–1860* (1975), Rush Welter elaborates on the conflict between liberal Democrats and conservative Whigs.

The definitive study of Jackson's foreign policy is John M. Belohlavek's *"Let the Eagle Soar!"* (1985). Good sources for the Texas revolution are Marquis James, *The Raven* (1929); D. W. Meinig, *Imperial Texas* (1969); Andreas Reichstein, *Rise of the Lone Star* (1989); Paul Lack, *The Texas Revolutionary Experience* (1992); and Stephen Hardin, *Texian Iliad* (1994). The political debates over slavery are well covered in William Lee Miller's *Arguing about Slavery* (1996).

4. GOD'S MANY KINGDOMS

Sydney E. Ahlstrom's epic *A Religious History of the American People* (1972) surveys American religious history through the 1960s. Also illuminating are Mark A. Noll's books *A History of Christianity in the United States and Canada* (1992) and *America's God* (2002), which emphasize evangelicalism in its native and international contexts. Roger Finke's and Rodney Stark's *The Churching of America, 1776–1990* (1992) provides statistics on American religion. Other useful overviews are *Religion in American Life* (2003), ed. John Butler, et al., Richard W. Fox's *Jesus in America* (2004), and Jon Meacham, *American Gospel* (2006).

Histories of revivals include William Warren Sweet, *Revivalism in America* (1944); Timothy Smith, *Revivalism and Social Reform in Mid-Nineteenth Century America* (1957); William G. McLoughlin Jr., *Revivals, Awakenings, and Reform* (1978); Curtis Johnson, *Islands of Holiness* (1989); Jon Butler, *Awash in a Sea of Faith* (1990); Iain H. Murray, *Revival and Revivalism* (1994); and Ellen Eslinger, *Citizens of Zion* (1999). Paul E. Johnson's *A Shopkeeper's Millennium* (1978) probes the economic bases of revivals. Broad cultural contexts are brought to bear in Richard Carwardine's *Transatlantic Revivalism* (1978) and George M. Thomas's *Revivalism and Cultural Change* (1989). The relationship between popular religion and print culture is the focus of David S. Reynolds, *Faith in Fiction* (1981); *Communication and Change in American Religious History*, ed. Leonard Sweet (1993); Wayne Fuller, *Morality and the Mail in Nineteenth-Century America* (2003); Candy Gunther Brown, *The Word in the World* (2004); and David Paul Nord, *Faith in Reading* (2004).

For the history of individual leaders, denominations, or sects, see, for example, David Hempton, *Methodism* (2005); John Wigger, *Taking Heaven by Storm* (1998); Gregory Willis, *Democratic Religion* (1997); Vincent Harding, *A Certain Magnificence: Lyman Beecher and the Transformation of American Protestantism* (1991); Charles Hambrick-Stowe, *Charles G. Finney and the Spirit of American Evangelicalism* (1996); Robert Bruce Mullin, *Episcopal Vision/American Reality* (1996); Diana Hochstedt Butler, *Standing against the Whirlwind: Evangelical Episcopalians in Nineteenth Century America* (1995); David Robinson, *The Unitarians and the Universalists* (1985); Daniel Walker Howe, *The Unitarian Conscience* (1970); H. Larry Ingle, *Quakers in Conflict* (1986); Thomas Hamm, *The Transformation of American Quakerism* (1988); Paul P. Kuenning, *The Rise and Fall of American Lutheran Pietism* (1988); Jonathan Sassi, *A Republic of Righteousness* (2001); Herbert A. Wisbey Jr., *Pioneer Prophetess: Jemima Wilkinson, the Publick Universal Friend* (1964); Catherine A. Brekus, *Strangers and Pilgrims* (1998); Paul E. Johnson and Sean Wilentz, *The Kingdom of Matthias* (1995); Dan Vogel, *Joseph Smith* (2004); Richard Bushman, *Joseph Smith* (2005); Jan Shipps, *Mormonism* (1985); Claudia L. Bushman and Richard Bushman, *Building the Kingdom: A History of Mormons in America* (2001); Leonard Arrington, *Brigham Young* (1985); George R. Knight, *Millennial Fever and the End of the World* (1993); Ronald L. Numbers and Jonathan L. Butler, *The Disappointed: Millerism and Millenarianism in the Nineteenth Century* (1987); and Ruth Doan, *The Miller Heresy* (1987). Whitney R. Cross's *The Burned-over District* (1954) and Mary Ryan's *Cradle of the Middle Class* (1981) discuss enthusiastic religion in upstate New York.

Historians of utopian experiments in America rely largely on three nineteenth-century sources: John Humphrey Noyes, *History of American Socialisms* (1870; 1961); Charles Nordhoff, *The Communistic Societies of the United States* (1875; 1966); and William A. Hinds, *American Communities and Cooperative Colonies* (1878; 1908). Later important books on utopian communities include Lewis Mumford, *The Story of Utopias* (1922); Alice Felt Tyler, *Freedom's Ferment* (1944); and Mark Holloway, *Heavens on Earth* (1951). More recent surveys are Donna Lawson, *Brothers and Sisters All Over This Land* (1972); Edward K. Spann, *Brotherly Tomorrows* (1989); Michael Fellman, *The Unbounded Frame* (1973); *America's Communal Utopias* (1997), ed. Donald Pitzer; and Robert Sutton, *Communal Utopias and American Experience*, 2 vols. (2003–4). Communal sexual practices and marital relationships are considered in Raymond Lee Muncy, *Sex and Marriage in Utopian Communities* (1973); Hal D. Sears, *The Sex Radicals* (1977); Lawrence Foster, *Religion and Sexuality* (1981); and Louis J. Kern, *An Ordered Love: Sex Roles and Sexuality in Victorian Utopias* (1981). One of the most suggestive studies of utopias is Carl J. Guarneri's *The Utopian Alternative* (1991).

American Catholicism is covered in Jay Dolan, *Catholic Revivalism* (1978) and *In Search of American Catholicism* (2002); Charles Morris, *American Catholic* (1997); and Dale Light, *Rome and the New Republic* (1996). Portraits of the two leading Protestant converts to Catholicism include David J. O'Brien's *Isaac Hecker* (1992) and Arthur M. Schlesinger Jr.'s *Orestes Brownson* (1939). For a good account of immigration, see John Higham's *Send These to Me* (New York, 1975). David S. Reynolds's *Faith in Fiction* (1981) and Jenny Franchot's *Roads to Rome* (1994) consider both pro-Catholic and anti-Catholic social and cultural tendencies. The most detailed study of anti-Catholicism remains Ray A. Billington's *The Protestant Crusade* (1938). For anti-Catholic violence and nativism, see especially Thomas J. Curran's *Xenophobia and Immigration* (1975) and Michael Feldberg's *The Philadelphia Riots of 1844* (1975).

5. REFORMS, PANACEAS, INVENTIONS, FADS

A. F. Tyler's *Freedom's Ferment* (cited above) ranges informatively over religious and reform movements. Also illuminating is Ronald G. Walters's *American Reformers, 1815–1860* (1978), which roots reformers in the missionary impulse and traces their institutional results. Reform is related to economic change in Steven Mintz's *Moralists and Modernizers: America's Pre-Civil War Reformers* (1995) and to Puritan stewardship in Clifford Griffin's *Their Brothers' Keepers* (1960).

Enlightening studies of temperance reform include Ian R. Tyrell, *Sobering Up* (1979); W. J. Rorabaugh, *The Alcoholic Republic* (1981); Mark Lender and James Martin, *Drinking in America* (1982); Lenard Blumberg and William Pittman, *Beware the First Drink!* (1991); and Thomas Pegram, *Battling Demon Rum* (1998). Nicholas Warner's *Spirits of America* (1997) and *The Serpent in the Cup*, ed. David Reynolds and Debra Rosenthal (1997) evaluate the cultural impact of temperance.

A House Divided, ed. Mason Lowance (2003), contains many useful primary documents about the discussion of slavery, as does *Early American Abolitionists*, ed. James Basker (2005). Pioneering histories of slavery include several of David Brion Davis's books, such as *The Problem of Slavery in Western Culture* (1966), *The Problem of Slavery in the Age of Revolution* (1975), *Slavery and Human Progress* (1984), and *Challenging the Boundaries of Slavery* (2003). Also valuable are Duncan Rice, *The Rise and Fall of Black Slavery* (1975); Robert Blackburn, *The Overthrow of Colonial Slavery* (1988); and Hugh Thomas, *The Slave Trade* (1997). Among the most revealing portraits of the lives of slaves are Kenneth Stampp, *The Peculiar Institution* (1956); Lawrence Levine, *Black Culture and Black Consciouness* (1977); Peter Kolchin, *American Slavery* (1993); Ira Berlin, *Many Thousands Gone* (1998); and Marie Schwarz, *Born in Bondage* (2000). The profitability

of slavery is the focus of books like John Meyer, *The Economics of Slavery* (1964); Robert Fogel and Stanley Engerman, *Time on the Cross* (1974); and R. Fogel, *Without Consent or Contract* (1989). For Southern defenses of slavery, see James Oakes, *The Ruling Race* (1982); William Scarborough, *Masters of the Big House* (2003); and Elizabeth Fox-Genovese and Eugene Genovese, *The Mind of the Master Class* (2005). Important studies of abolitionism include Aileen S. Kradi-tor, *Means and Ends in American Abolitionism* (1967); Lewis Perry, *Radical Aboli-tionism* (1973); Celia M. Azevedo, *Abolitionism in the United States and Brazil* (1995); Henry Mayer, *All on Fire: William Lloyd Garrison and the Abolition of Slav-ery* (1998); Douglas M. Strong, *Perfectionist Politics* (1999); and Richard S. New-man, *The Transformation of American Abolitionism* (2002). Accounts of women's role in abolition appear in Julie Roy Jeffrey's *The Great Silent Army of Abolitionism* (1998) and Anna M. Speicher's *The Religious World of Antislavery Women* (2000). Excellent studies of the Underground Railroad include Fergus M. Bordewick's *Bound for Canaan* (2005) and Karolyn Smardz Frost's *I've Got a Home in Glory Land* (2007). For examinations of resistance to slavery, especially slave rebellions, see Stephen Oates, *The Fires of Jubilee* (1975); Eugene Genovese, *From Rebellion to Revolution* (1979); Mary Kemp Davis, *Nat Turner Before the Bar of Judgment* (1999); *Rebels, Reformers, and Revolutionaries* (2002), ed. Douglas Egerton; and David Brion Davis, *Inhuman Bondage* (2006). The late, militant phase of aboli-tionism is described in John Stauffer's *The Black Hearts of Men* (2002) and David S. Reynolds's *John Brown, Abolitionist* (2005). Proslavery arguments are analyzed in Elizabeth Fox-Genovese and Eugene Genovese, *The Mind of the Master Class* (2005).

For an accounts of violence in this period, see Leonard Richard, *Gentlemen of Property and Standing* (1970); Dickson Bruce, *Violence and Culture in the Antebel-lum South* (1979); Michael Feldberg, *The Turbulent Era* (1980); Paul Gilje, *The Road to Mobocracy* (1987) and *Rioting in America* (1996); and David Grimsted, *American Mobbing, 1828–1861* (1998). The standard histories of peace reform are Merle Curti's *The American Peace Crusade, 1815–1860* (1929) and Charles De-Benedetti's *The Peace Reform in American History* (1980).

For a discussion of conventional women's roles, see especially Barbara Wel-ter's *Dimity Convictions* (1976) and Ann Douglas's *The Feminization of American Culture* (1977). Timothy Gilfoyle's *City of Eros* (1992) covers the rise of prostitu-tion in Manhattan; see also Christine Stansell, *City of Women* (cited above) and Patricia Cline Cohen, *The Murder of Helen Jewett* (1998). Sexual mores are pre-sented in G. J. Barker-Benfield's *The Horrors of the Half-Known Life* (1976) and in John D'Emilio's and Estelle B. Freedman's *Intimate Matters* (1988). Alan Hunt's *Governing Morals* (1999) and Paul Boyer's *Urban Masses and Moral Order in America* (1978) consider American moral reform groups, as does Helen

\n\n\n\n\n\n\n

Lefkowitz Horowitz in *Rereading Sex* (2002). In *Cosmos Crumbling* (1994) Robert H. Abzug connects the evolution of reform to religious shifts. The alarm over masturbation is detailed in Jayme A. Sokolow, *Eros and Modernization* (1983); Jean Stengers and Anne van Neck, *Masturbation: The History of a Great Terror* (1984; 2001); and Thomas W. Laqueur, *Solitary Sex* (2003). Stephen Nissenbaum's *Sex, Diet, and Debility in Jacksonian America: Sylvester Graham and Health Reform* (1980) grounds health reform in increasing anxieties about the human body.

American prison reform is discussed in certain sections of Michel Foucault's *Discipline and Punish* (1978), Larry E. Sullivan's *The Prison Reform Movement* (1990), and Norval Morris and David J. Rothman's *The Oxford History of the Prison* (1995). David J. Rothman's *The Discovery of the Asylum* (1971) explores institutions that combated crime, poverty, insanity, and juvenile delinquency. For changing treatments of the mentally ill, see Mary Ann Jimenez's *Changing Faces of Madness* (1977) and Lynn Gamwell and Nancy Tomes's *Madness in America* (1995). Useful studies of Dorothea Dix included Thomas H. Brown's *Dorothea Dix* (1998) and David Gollaher's *Voice for the Mad* (1995). Ernest Freeberg's *The Education of Laura Bridgman* (2001) and Elisabeth Gitter's *The Imprisoned Guest* (2001) are rich in detail about Samuel Gridley Howe and his famous patient.

For scientific exploration in its cultural contexts, see Herbert Hovenkamp, *Science and Religion in America* (1978); *Benjamin Silliman and His Circle* (1979), ed. Leonard Wilson; Hugh Slotten, *Patronage, Practice, and the Culture of American Science* (1994); Nina Baym, *American Women of Letters and the Nineteenth-Century Sciences* (2002); and Aaron Sachs, *The Humboldt Current* (2006). Besides Harold Evans's *They Made America* (cited above), histories of inventions include Roger Burlingame's *March of the Iron Men* (1938) and Harold I. Sharlin's *The Making of the Electrical Age* (1963). For the telegraph, see Lewis Coe, *The Telegraph* (1993); Menahem Blondheim, *News Over the Wires* (1994); Jill Lepore, *A is for American* (2002); and Kenneth Silverman, *Lightning Man* (2003).

Broad coverage of changing medical practices appears in Richard Harrison Shryock, *Medicine and Society in America, 1660–1860* (1960); Joseph Kett, *The Formation of the American Medical Profession* (1968); William G. Rothstein's *American Physicians in the Nineteenth Century* (1972); John S. Haller, *American Medicine in Transition* (1981); and James H. Cassedy, *Medicine in America* (1991). Charles Rosenberg's *The Cholera Years* (1962; 1987), Martin Pernick's *A Calculus of Suffering* (1985), and Sheldon Watts's *Epidemics and History* (1997) describe epidemics. For various types of alternative medicine, see James Harvey Young, *The Toadstool Millionaires* (1961); Robert C. Fuller, *Mesmerism and the American*

Cure of Souls (1982); Jane B. Donegan, *Hydropathic Highway to Health* (1986); Arthur Wrobel, *Pseudo-Science and Society in Nineteenth-Century America* (1987); Norman Gevitz, *Other Healers: Unorthodox Medicine in America* (1988); Charles H. Lippy, *Being Religious, American Style* (1994); James C. Whorton, *Nature Cures: The History of Alternative Medicine in America* (2002); and Simon Singh and Edzard Ernst, *Trick or Treatment?* (2008).

The backgrounds and popularization of phrenology are featured in John D. Davies's *Phrenology, Fad and Science* (1955) and Madeline B. Stern's *Heads and Headlines: The Phrenological Fowlers* (1971). Charles Colbert's *A Measure of Perfection: Phrenology and the Fine Arts in America* (1997) explores this pseudoscience's impact on pre–Civil War painters and sculptors, and Taylor Stoehr's *Hawthorne's Mad Scientists* (1978) gives examples of its literary repercussions.

6. Rebellion and Renaissance

A classic overview of early-nineteenth-century American literature, stressing close textual analysis, is F. O. Matthiessen's *American Renaissance* (1941). David S. Reynolds in *Beneath the American Renaissance* (1988) and *Walt Whitman's America* (1995) traverses canonical and popular literature, showing how major writers imported themes and devices from their contemporary culture. Volumes like Cathy N. Davidson's *Revolution and the Word* (1986), Lawrence Buell's *New England Literary Culture* (1986), Eric J. Sundquist's *To Wake the Nations* (1993), Nina Baym's *American Women Writers and the Work of History* (1995), and Timothy B. Powell's *Ruthless Democracy* (2000) encompass forgotten writers in reconsidering literary history. Criticism today is eclectic, drawing on transnationalism, postcolonialism, ecology, and gender studies.

A notable study of Washington Irving is Jeffrey Rubin-Dorsky's *Adrift in the Old World* (1988). Analyses of Cooper in relation to Jacksonian society include Robert E. Spiller, *Fenimore Cooper: Critic of His Times* (1931); John F. Ross, *The Social Criticism of Fenimore Cooper* (1933); John P. McWilliams Jr., *Political Justice in a Republic: James Fenimore Cooper's America* (1972); William Kelly, *Plotting America's Past: Fenimore Cooper and the Leatherstocking Tales* (1982); and Wayne Franklin's *James Fenimore Cooper: The Early Years* (2007).

Representative histories of print culture, publishing, and newspapers are William Charvat, *Literary Publishing in America* (1959; 1993); Bernard Weisberger, *The American Newspaperman* (1961); Gerald Baldasty, *The Commericalization of News in the Nineteenth Century* (1992); William Huntzicker, *The Popular Press* (1999); Ronald J. Zboray, *A Fictive People* (1993); and R. J. Zboray and Mary S. Zboray, *Literary Dollars and Social Sense* (2005). For changes in printing technol-

ogy, see Judith McGaw, *Most Wonderful Machine* (1987). The sensationalism of penny newspapers is entertainingly described in Andie Tucker's *Froth & Scum* (1994) and Patricia Cline Cohen's *The Murder of Helen Jewett* (cited above). Michael Schudson in *Discovering the News* (1978) associates the penny newspapers with the rise of impartial journalism, a point reiterated by Dan Schiller in *Objectivity and the News* (1981). See also James L. Crouthamel's *Bennett's New York Herald and the Rise of the Popular Press* (1989) and Isabelle Lehuu's *Carnival on the Page* (2000). For further information on popular sensationalism, see David S. Reynolds, *George Lippard* (1982); Karen Halttunen's *Confidence Men and Painted Women* (1982) and *Murder Most Foul* (1998); and Shelley Streeby, *American Sensations* (2002). Matthew Goodman in The Sun and the Moon. (2008) discusses Richard Adams Locke's moon hoax in relation to the rise of taldoid journalism.

Poe's relation to his contemporary culture is featured in Sidney P. Moss, *Poe's Literary Battles* (1963); Kenneth Silverman, *Edgar A. Poe* (1991); Terence Whalen, *Edgar Allan Poe and the Masses* (1999); and Dawn B. Sova, *Edgar Allan Poe, A to Z* (2001).

A few works that deal specifically with political and social contexts of Transcendentalism are Len Gougeon, *Virtue's Hero* (1990); Robert D. Richardson Jr., *Emerson: The Mind on Fire* (1995); Albert J. von Frank, *The Trials of Anthony Burns* (1998); *Transient and Permanent*, ed. Charles Capper and Conrad Edick Wright (1999); Peter S. Field, *Ralph Waldo Emerson: The Making of a Democratic Intellectual* (2002); Philip F. Gura, *American Transcendentalism* (2007); and Arthur I. Ladu, "Emerson: Whig or Democrat," *New England Quarterly*, 13 (Sept. 1940): 419–41.

For the rise of consumerism, see Richard Bushman, *The Refinement of America* (1992); John Crowley, *The Invention of Comfort* (2001); and Timothy Breen, *The Marketplace of Revolution* (2004). Contextual studies of Thoreau include Edward H. Madden's *Civil Disobedience and Moral Law in Nineteenth-Century American Philosophy* (1968); Robert D. Richardson Jr., *Henry David Thoreau* (1986); Leonard N. Neufeldt's *The Economist: Henry Thoreau and Enterprise* (1989); and Steven Fink, *Prophet in the Marketplace* (1992). Valuable political-social approaches to Hawthorne are Sacvan Bercovitch, *The Office of the Scarlet Letter* (1991); Richard H. Millington, *Practicing Romance* (1992); Lauren Berlant, *The Anatomy of National Fantasy* (1991); Lawrence Sargent Hall, *Hawthorne: Critic of Society* (1944); and Brenda Wineapple, *Hawthorne* (2003).

James Thomas Flexner's *That Wilder Image* (1962) describes American painters' search for an indigenous style of directness and stylelessness. Barbara Novak connects the rise of this brushstrokeless art to optimistic currents in American society in *American Painting of the Nineteenth Century* (1969; 2007) and *Nature and Culture* (1980; 2007). John Wilmerding expands on this interpretation in

American Light: The Luminist Movement (1980). Poststructuralist and Marxist approaches are tapped to reveal political meaning in art in Elizabeth Johns's *American Genre Painting* (1991) and Angela Miller in *The Empire of the Eye* (1993). Along with optimism, Sarah Burns notes in *Painting the Dark Side* (2004), went an interest in horror, transience, and social ills.

A subtle study of Barnum is Neil Harris's *Humbug* (1973). The definitive biography is A. H. Saxon's *P. T. Barnum* (1989). Other provocative studies include Bluford Adams's *E Pluribus Barnum* (1997) and Benjamin Reiss's *The Showman and the Slave* (2001). For primary materials related to Barnum, see the *Colossal P.T. Barnum Reader*, ed. James W. Cook (2005). For histories and analyses of the minstrel show, see especially Robert C. Toll, *Blacking Up* (1974); Eric Lott, *Love and Theft* (1993); Dale Cockrell, *Demons of Disorder* (1997); Rosemary K. Bank, *Theatre Culture in America* (1997); W. T. Lhamon Jr., *Raising Cain* (1998); William J. Mahar, *Behind the Burnt Cork Mask* (1999); and John Strausbaugh, *Black Like You* (2006). Rewarding discussions of both minstrels and the Hutchinson Family Singers can be found in Charles Hamm's *Yesterdays: Popular Song in America* (1979) and Russell Sanjek's *American Popular Music and Its Business* (1988). See also D. Cockrell, ed., *Excelsior: Journals of the Hutchinson Family Singers* (1989). Perceptive overviews of nineteenth-century American melodrama include David Grimsted, *Melodrama Unveiled* (1968); Bruce A. McConachie, *Melodramatic Formations* (1992); and Jeffrey D. Mason, *Melodrama and the Myth of America* (1993).

For individual studies of important actors, see especially Stephen M. Archer, *Junius Brutus Booth* (1992); Richard Moody, *Edwin Forrest* (1960); and Alan Seymous Downer, *The Eminent Tragedian William Charles Macready* (1966). John F. Kasson's *Rudeness and Civility* (1990) and Nigel Cliff's absorbing *The Shakespeare Riots* (2007) explore the contexts and events of the Astor Place Riot.

7. PARTY POLITICS AND MANIFEST DESTINY

For the rise of the two-party system, see Richard P. McCormick, *The Second American Party System* (1966); Richard Hofstadter, *The Idea of a Party System* (1969); Ronald Formisano, *The Birth of Mass Political Parties* (1971); Major Wilson, *Space, Time, and Freedom* (1974); M. J. Heale, *The Presidential Quest* (1982); Joel Silbey, *The Partisan Imperative* (1985); Lawrence Frederick Kohl, *The Politics of Individualism* (1989); Michael F. Holt, *Political Parties and American Political Development* (1992); John Ashworth, *'Agrarians' & 'Aristocrats'* (1993); John Gerring, *Party Ideologies in America* (1998); Mark Neely, *American Political Culture in the Civil War Era* (2005); and Yonatan Eyal, *The Young America Movement and the Transformation of the Democratic Party* (2007). Michael F. Holt's *The*

Political Crisis of the 1850s (1978) and William Brock's *Parties and Political Conscience, 1840–1850* (1979) trace the eventual collapse of the second party system.

Sound biographies of Van Buren include John Niven, *Martin Van Buren* (1983); Donald B. Cole, *Martin Van Buren and the American Political System* (1984); and Ted Widmer, *Martin Van Buren* (2004). Robert V. Remini in *Martin Van Buren and the Making of the Democratic Party* (1959) emphasizes the Magician's role in forming the party of Jackson. In *The Presidency of Martin Van Buren* (1984) Major L. Wilson takes a more positive view of Van Buren's presidency than was once held. For the depression of 1837–42, see especially James Roger Sharp, *The Jacksonians versus the Banks* (1970); John McFaul, *The Politics of Jacksonian Finance* (1972); and William Shade, *Banks or No Banks* (1972). Various dimensions of Van Buren's foreign policy are examined in Albert Corey, *The Crisis of 1830–1842 in Canadian-American Relations* (1941); Reginald Stuart, *United States Expansionism and British North America* (1988); and Kenneth Stevens, *Border Diplomacy* (1989).

Robert Gray Gunderson's *The Log-Cabin Campaign* (1957) investigates the Whigs' co-optation of the Democrats' electioneering strategies. Freeman Cleaves's *Old Tippecanoe* (1990) gives solid coverage to the foreground to Harrison's brief presidency. Norma Lois Peterson's *The Presidencies of William Henry Harrison and John Tyler* (1989) ably treats its topic, with informative accounts of these presidents' relationship with Congress.

Oliver Perry Chitwood's detailed exploration of Tyler's life and career, *John Tyler, Champion of the Old South* (1939), is still useful. Robert Seager II in *And Tyler Too* (1963) takes a dim view of Tyler's presidency, focusing on his private life. For a more positive interpretation of Tyler, see Robert J. Morgan's *A Whig Embattled* (1954) and Edward Crapol, *John Tyler, the Accidental President* (2006). Dan Monroe's *The Republican Vision of John Tyler* (2003) argues that Tyler distanced himself from parties because of his republican values. Roy M. Robbins in *Our Landed Heritage* (1942; 1976) analyzes the Preemption Act of 1841. For the background of the Webster-Ashburton Treaty, see Frederick Merk, *Fruits of Propaganda in the Tyler Administration* (1971); Howard Jones, *To the Webster-Ashburton Treaty* (1977); Howard Jones and Donald Rakestraw, *Prologue to Manifest Destiny* (1997); and Francis Carroll, *A Good and Wise Measure* (2001).

Administration of many government agencies is detailed in Leonard White's *The Jacksonians: A Study in Administrative History* (1954). For the movement to annex Texas, see Frederick Merk, *Slavery and the Annexation of Texas* (1972); David Pletcher, *The Diplomacy of Annexation* (1973); Richard Winders, *Crisis in the Southwest* (2002); and Joel Silbey, *Storm Over Texas* (2004). The Oregon is-

sue is examined thoroughly in Frederick Merk's *Manifest Destiny and Mission* (1963) and *The Oregon Question* (1967).

C. G. Sellers Jr. in *James K. Polk, Jacksonian, 1795–1843* (1957) traces Polk's long evolution in Tennessee politics; his *James K. Polk, Continentalist: 1843–1846* (1966) carries Polk's biography through the early part of his presidency. Charles A. McCoy's *Polk and the Presidency* (1960), Paul B. Bergeron's *The Presidency of James K. Polk* (1987), Thomas Leonard's *James K. Polk* (2004), and Sam W. Haynes's *James K. Polk and the Expansionist Impulse* (1997; 2006) give convincingly sympathetic treatments of Polk's administration. John Seigenthaler's biography *James K. Polk* (2004) describes Polk as personally unappealing but politically efficient. In *Slavemaster President* (2003) William Dusinberre discusses Polk's status as a slaveholder. A comprehensive recent biography is Walter R. Borneman's *Polk* (2008).

The expansionist impulse of the Polk years are analyzed in William Goetzman, *When the Eagle Screamed* (1966); Shomer Zwelling, *Expansion and Imperialism* (1970); Reginald Horsman, *Race and Manifest Destiny* (1981); Thomas Hietala, *Manifest Design* (1985); William Weeks, *Building the Continental Empire* (1996); *Manifest Destiny and Empire* (1997), ed. Sam W. Haynes and Christopher Morris; Linda Hudson, *Mistress of Manifest Destiny* (2001); and Robert F. May, *Manifest Destiny's Underworld* (2002). Bernard DeVoto describes the winning of the Far West in *The Year of Decision, 1846* (1943). For information on the Mexican War, see Justin H. Smith, *War with Mexico* (1919); Gene Brack, *Mexico Views Manifest Destiny* (1975); K. Jack Bauer, *The Mexican War* (1974); John Weems, *To Conquer a Peace* (1974); Robert W. Johannsen, *To the Halls of the Montezumas* (1985); and Richard Winders, *Mr. Polk's Army* (1997). C. W. Morrison's *Democratic Politics and Sectionalism* (1967) shows the profound impact of David Wilmot's antislavery proviso.

EPILOGUE: ENDINGS, BEGINNINGS

Balanced portraits of Taylor include K. Jack Bauer's *Zachary Taylor* (1993) and Elbert B. Smith's *The Presidencies of Zachary Taylor and Millard Fillmore* (1988). Eric Foner's *Free Soil, Free Labor, Free Men* (1970; 1995) illuminates free-soil politics and its impact on the national debate over slavery. For racism in American society, see Anthony Gronowicz, *Race and Class Politics in New York City Before the Civil War* (1998); David Roediger, *The Wages of Whiteness* (1991; 2007); and George Fredrickson's books *White Supremacy* (1980), *The Black Image in the White Mind* (1987), and *The Arrogance of Race* (1988). A thoughtful study of the

cultural effects of the 1848 revolutions is Larry J. Reynolds's *European Revolutions and the American Literary Renaissance* (1988).

A lively biography of the Fox sisters is Barbara Weisberg's *Talking to the Dead: Kate and Maggie Fox and the Rise of Spiritualism* (2004). For spiritualism's cultural contexts, see Geoffrey K. Nelson, *Spiritualism and Society* (1969); R. Laurence Moore, *In Search of White Crows* (1977); Russell M. Goldfarb and Clare R. Goldfarb, *Spiritualism and Nineteenth-Century Letters* (1978); and Anne Braude, *Radical Spirits: Spiritualism and Women's Rights in Nineteenth-Century America* (1989).

Solid accounts of the growth of the American women's rights movement include Miriam Gurko, *The Ladies of Seneca Falls* (1974); Keith E. Melder's *Beginnings of Sisterhood* (1977); Ellen DuBois, *Feminism and Suffrage* (1978); Blanche Glassman Hersh, *The Slavery of Sex* (1978); Judith Wellman, *The Road to Seneca Falls* (2004); and Lori Ginzburg, *Untidy Origins* (2005). For women's activism grounded in religion and reform, see Caroll Smith-Rosenberg, *Religion and the Rise of the American City* (1971); Nancy Hewitt, *Women's Activism and Social Change* (1984); Lori Ginzburg, *Women and the Work of Benevolence* (1990); Nancy Hardesty, *Your Daughters Shall Prophesy* (1991); Sylvia Hoffert, *When Hens Crow* (1995); and Nancy Cott, *The Bonds of Womanhood* (1977; 1997).

→ Index ←

Page numbers in *italics* refer to illustrations.

Rapp, George, 161
Rappites, 125, 161–62
reaper, mechanical, 2, 220, 226
Record of Crimes in the United States, The, 268
Redmond, Charles, 370
Redskins, The (Cooper), 241
Reed, Dave, 300
Reed, Luman, 287
Reed, Rebecca, 171
"Regal Splendor of the Presidential Palace, The" (Ogle), 322
religion, 123–74, 218, 220, 266–68; art and, 280–81, 285, 288–89; democracy and, 125, 126, 127, 137, 138, 143; emotion and, 126, 127, 129–30, 132, 173; immigrants and, 125, 143, 161–64, 170–73; Native American, 288–89; politics and, 127, 133; toleration and, 125; utopian communities and, 157–69, 199. *See also names of specific sects*
religious revivals, 126–36, 139, 146, 149, 151, 383; anxious bench and, 134; camp meetings and; Channing's views on, 140; circuit riders and, 126, 128, 129, 132; "exercises" or bodily movements at, 129–30; temperance and, 178
Rensselaer School (now Rensselaer Polytechnic Institute), 222
Representative Men (Emerson), 237
Republican Party, Republicans, 181, 371; as antislavery, 292, 303, 363, 372; rise of, 111, 292
"Resistance to Civil Government" (Thoreau), 260
Retreat in Hartford, 218
Retrenchment Society, 149
revolvers, 2, 183, 226
Reynolds, J. N., 274
Rhode Island, 65, 100, 105; Dorr Rebellion in, 26, 339–40
Ricardo, David, 62
Rice, Thomas Dartmouth, 299
Richmond, Va., 71, 184
Rigdon, Sidney, 153

"Rill from the Town-Pump, A" (Hawthorne), 267
Rio Grande, 355, 356, 357, 359, 360
riots, 173, 238, 303, 306, 307
Ripley, George, 167, 249
Ripley, Sophia Dana, 167
"Rip Van Winkle" (Irving), 239
Ritchie, Thomas, 71
roads, 11, 12–13, 17, 18, 56, 61, 90, 121, 355
Robards, Rachel Donelson. *See* Jackson, Rachel Donelson Robards
Robinson, Horseshoe, 252
Robinson, Richard, 205, 243
Rocky Mountains, 22, 60, 222, 334, 338
Rogers, Mary C., 247
Rogers, Nathaniel P., 198
Rogers, Roger, 268
Roman Catholicism, 1, 112, 132, 169–73
Romanticism, 237, 249, 280, 296
Rome, N.Y., 16, 133
Roosevelt, Theodore, 23
Rosamund (Culbertson), 171
Rosas, Juan, 116
Ross, Chief John, 94
Royall, Anne, 45
Ruiz, José, 314
Rumsey, James, 13
Rush, Benjamin, 32, 177, 196–97, 218, 221, 227–28
Rush, Richard, 44
Rush-Bagot Treaty, 21
Russia, 37, 38, 75, 115
Rustic Dance after a Sleigh Ride (Mount), 291–92

Sabbath and Bible Conventions, 257
Sabine, Elijah R., 128
Saco, Maine, 145, 146
St. Louis, Mo., 48, 193, 230, 290, 344
Salem Murder, 268
Salmagundi (Irving), 239
Sandwich Islands, 340–41
Sandy Hook, N.J., 52
Santa Anna, Antonio López de, 117, 361, 362

Senate, U.S., 114, 312, 324; BUS and, 97; Calhoun as head of, 55; Clay in, 9, 59, 107, 111–12, 322, 327, 330,